VAN GOGH

VAN GOGH

D.M. Field

THE WELLFLEET PRESS

WELLFLEET

Published in 2004 by
Wellfleet Press
A division of Book Sales, Inc.
114 Northfield Avenue
Edison. NJ 08837 USA

ISBN 0-7858-1818-9

Printed in China

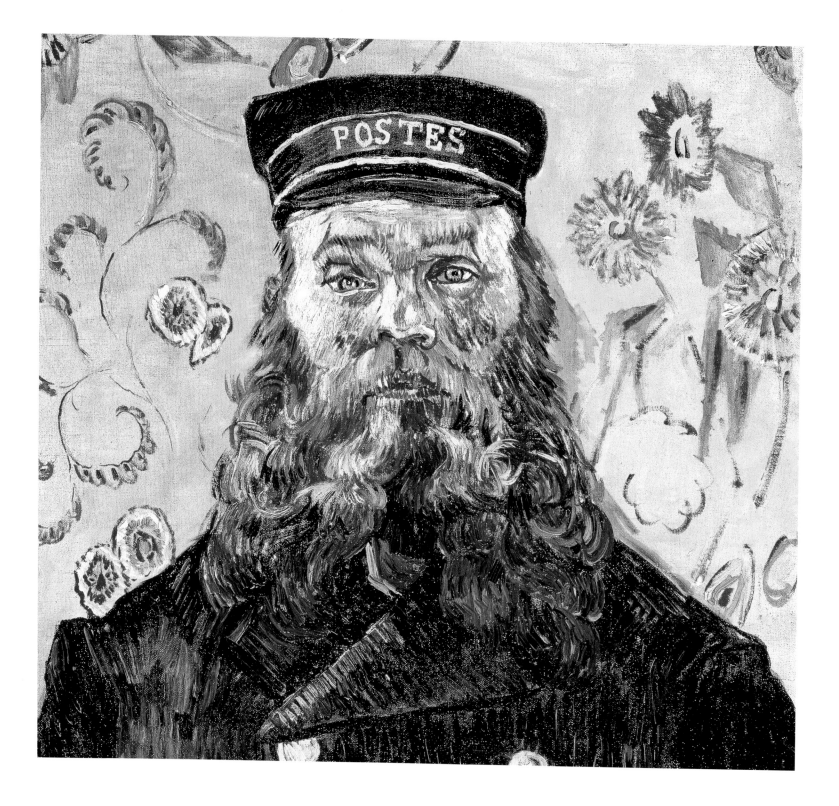

CONTENTS

CHAPTER ONE
SON OF THE MANSE

RIGHT
Portrait of Theodorus Van Gogh, 1881
Pencil and black ink, 13 x 9⁷⁄₈in
(33 x 25cm)
Private collection

The artist's father was only 59 when Vincent made this study, but time had not dealt kindly with him. His relationship with his eldest son was a burden he had to bear.

OPPOSITE
Portrait of the Artist's Mother, 1888
Oil on canvas, 16 x 12³⁄₄in
(40.5 x 32.5cm)
Christie's Images, London

That this is an excellent likeness is borne out by a photograph, from which this was probably painted, but to which Vincent objected, owing to its lack of colour, leading him to paint this for himself.

In nineteenth-century middle-class families, aunts and uncles were often in abundant supply. The future artist, Vincent van Gogh, was especially well-provided with uncles, and he belonged to a large family himself. Although he had only one brother near his own age, that brother would prove to be, not least in the eyes of posterity, by far the most important person in his life. Without Theo, there would have been no Vincent – as we know him.

Vincent's paternal grandfather, after whom he was named, was one of six brothers. He was a pastor, a minister in the Dutch Reformed Church. The ministry was one of two disparate professions that many of his immediate ancestors embraced. The other was art, though the van Goghs were dealers in art rather than practising artists. No less than three of Vincent's uncles followed this line. Vincent's father, Theodorus (Dorus in the family), took the other direction and became a minister, like his father. There were of course exceptions, attracted by neither the Church nor the Art Gallery, like Vincent's Uncle Jan who went into the navy and rose to be an admiral, and his Uncle Willem, who became a tax inspector.

For the young Vincent and his brother Theo, the most influential of their uncles was 'Uncle Cent' (short for Vincent), whose small art dealership prospered to such an extent that he became, when quite young, a director of the powerful firm of Goupil et Cie, based in Paris with branches in half a dozen Western capitals. Theodorus was

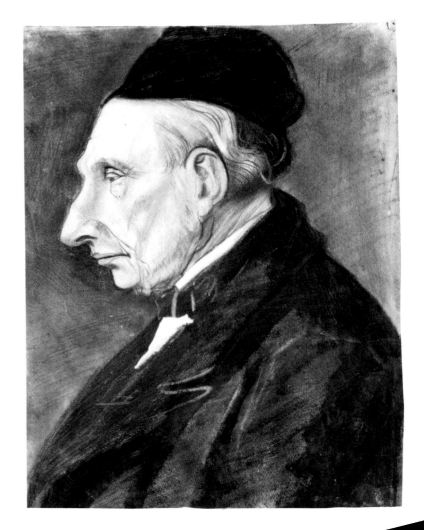

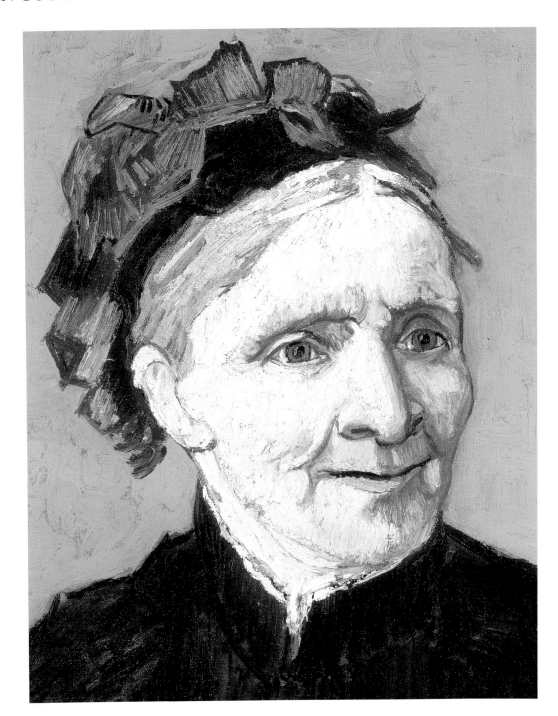

Uncle Cent's favourite among his siblings. The two men had even married two sisters, lived not far apart, and often met. Uncle Cent and his wife (Aunt Cornelia) had no children of their own and therefore took a special interest in their nephews and nieces.

The wife of Dorus and mother of Vincent and Theo was called Anna Cornelia Carbentus. She came from a substantial family in The Hague. A warm-hearted, affectionate woman of keen intelligence, she shared her husband's love of nature, but if any element in Vincent's artistic gifts were inherited, it came not from the art-dealing van Goghs, but from his mother, whose love of nature was expressed in watercolours and drawing of more than average amateur talent. He also shared with her an attractive (and to us invaluable) gift for the now almost lost art of letter-writing.

Anna Carbentus was nearly three years older than her husband and was thirty-three when she married him in 1851. Their chances of producing the customary large family did not look hopeful, especially when their first child, a boy, died at birth. However, a second son was born one year later – to the day – on 30 March 1853. This eerie coincidence was emphasized by the bestowal on the second child of the same name as the first: Vincent Willem van Gogh.

Almost everything in Vincent's life has been suspected by someone of contributing to his psychological problems, but in spite of speculation to the contrary, there is little solid evidence to suggest

SON OF THE MANSE

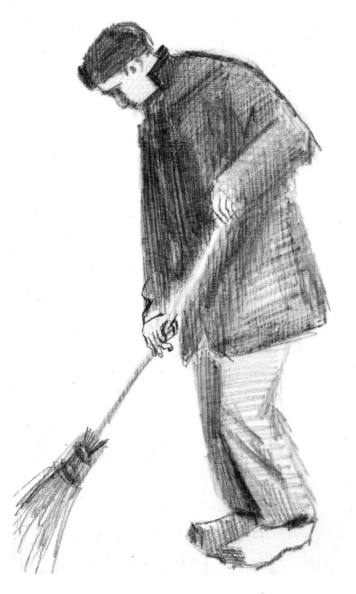

The Street Cleaner, 1882
Charcoal on paper
Gemeentemuseum, The Hague

that Vincent felt any morbid sense of identification with his still-born brother and namesake. Whether being a 'replacement' child, conceived in mourning, had any responsibility for the difficulties of his nature cannot be proved or disproved.

Theodorus and Anna, in spite of their late start, went on to produce five more children, including Theo (Theodorus), born in 1857. The future artist had, it seems, friendly but not particularly close relationships with his three sisters (all of whom were to outlive him by at least forty years), although he later fell out with the eldest, Anna, and was closest to the youngest, Wilhemien (Wilhemina, or Wil). A third son, Cornelius (Cor), was born in 1867, but being fourteen years younger, he was never an intimate of Vincent.

Vincent's father has sometimes been portrayed as a rigid, unimaginative, narrow-minded man, and a bad sort of parent for Vincent. But the evidence, interpreted without bias, suggests that his true character was almost the direct opposite. A gentle man of great tolerance, though occasional severity, he had the bad luck to have an eldest son who, while devoted in his own way to his father, was almost impossible to deal with, and became for his father a material and moral burden of oppressive weight.

The pastor was not a great success in his profession, at least as measured in worldly terms. Essentially a moderate man, always inclined to compromise, Theodorus van Gogh found himself

VAN GOGH

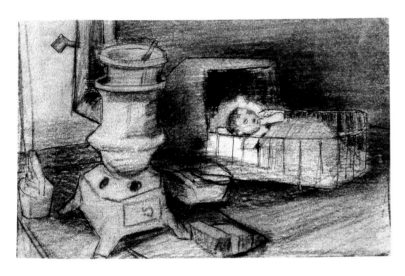

handicapped by the doctrinal rifts within the Dutch Reformed Church, a communion that had been greatly subject to internal conflicts ever since the Reformation. On the one hand, broadly speaking, were the traditionalists, the party of the right, orthodox and rigid, while on the other were the modernists, equally stiff-necked and averse to compromise. There was a third, more moderate, evangelical group between these two, but Theodorus was not much in favour with them either.

Though a conscientious minister, genuinely loved by his flock, he seems to have been an indifferent preacher, and that was an undoubted drawback in terms of his professional progress. Nor was

his stature impressive, though he was undoubtedly handsome. The fact that he remained for so long unmarried may also have told against him. In fact, he had some difficulty getting a living at all, since none of the power-wielding groups regarded him favourably, and when at last he did, he was relegated to a succession of small rural livings in North Brabant, in the south of the Dutch kingdom, where Protestants were in a minority and the Roman Catholic parish priest often held superior social sway. Moreover, it was a profoundly rural, relatively primitive area, and, although Theodorus's father had held a living in Breda for many years, that was still a country town, in marked contrast to the urban, mercantile provinces of the north, where the van Goghs came from (Theodorus's predecessors for two or three generations were born in The Hague.)

His first living, to which he was appointed in 1849, was the village of Zundert, not far from the Belgian border (Belgium had been independent since 1831). Although then usually called Groot ('Great') Zundert, that probably referred to the area it covered rather than the number of souls, or to any other distinction, even though in earlier times the main road from the south ran through it and it was the first stage for changing horses for coaches from Antwerp, about 20 miles (32km) away. In those days it boasted some notable visitors, including Napoleon, but then came the railways, and Zundert, bypassed by the railway, soon lapsed into a backwater.

The Cradle, 1882
Pencil on paper, 13 x 9⅞in (33 x 25cm)
Rijksmuseum Vincent van Gogh, Amsterdam

Vincent often included sketches in his letters, of which this is an example. The baby is the child of his lover in The Hague.

Man with His Head in His Hands,
c. 1882
Pencil and chalk, heightened with white
Rijksmuseum Kröller-Müller, Otterlo

Vincent made several versions of this, a
subject that evoked in him a powerful,
sympathetic response, including a late
painting (see page 358).

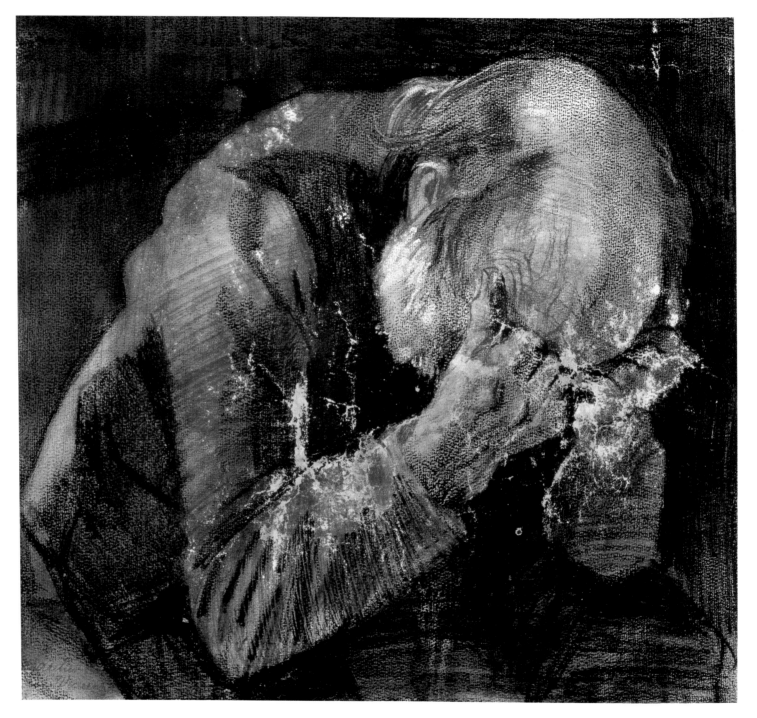

VAN GOGH

VINCENT AT SCHOOL

The parsonage at Zundert, where Vincent was born and grew up, is no longer standing but appears in contemporary prints as a solid, pleasant, not very large house in vernacular style (curved eaves, shutters) facing the main street. Of Vincent's childhood we know comparatively little, since by the time he became famous there were few people left who remembered him. Moreover, their memories of him proved remarkably contradictory: such testimony is always likely to be corrupted by the later fame of its subject. Some thought him 'strange', others strangely unchildlike, but on the whole Vincent does not seem to have been abnormal as a child, although moody, even morose, and not much of a mixer, therefore not very popular with his peers.

His occasional tantrums could have been put down to his brilliant red hair – no doubt this was the explanation preferred by his endlessly indulgent mother. The hair was a surprise, as no others in his family are known to have shared this characteristic. Nor did he share the clean-cut good looks of his father, uncles and brothers, although there seems no reason to think, as many did, that he was particularly ugly. A photograph of him taken when he was about thirteen shows regular features, a sensitive mouth, broad, high forehead below a thick and curly mane – and a remarkably intense gaze. The clear gaze immediately struck Picasso, when he was shown this photograph in 1958, as strongly reminiscent of the young poet Rimbaud, the alienated genius of French letters (and Vincent's almost exact contemporary) who recorded his tortured existence in *A Season in Hell* (1873).

He inherited his mother's love of nature, and such was his knowledge of insect behaviour and his meticulous collecting and record-keeping that the earliest signs suggested he might become a naturalist. He was always interested in the immediacy of life, in the farms and villages and country people around him, who would be his first subjects as an artist. In spite of his later passionate identification with the conditions of the poor, he had no interest in politics or events on a national or international scale.

Vincent's letters throughout his life show that major events often passed him by, and to some extent this also applied to major developments in painting. Like most young children, he drew and made models, and his dexterity was admired by the local carpenter whose shop Vincent would sometimes visit. His father noticed his ability at drawing, something Vincent clearly enjoyed, but there was little sign of exceptional talent, let alone artistic genius.

This judgement has often been contradicted, chiefly on the evidence of an early drawing of a snarling dog, done at the age of nine, which would certainly make eyeballs pop if done by a nine-year-old today. In fact, some authorities have questioned its authenticity on the grounds of its quality, but middle-class children in the nineteenth

RIGHT and OPPOSITE
Fritillaries in a Copper Vase, 1886
Oil on canvas, 28³/4 x 23⁷/8in
(73 x 60.5cm)
Musée d'Orsay, Paris

Vincent painted many still lifes during the early weeks of his Paris period, partly perhaps because he was cramped for space. This rich example retains the dark colours that would soon disappear from his palette.

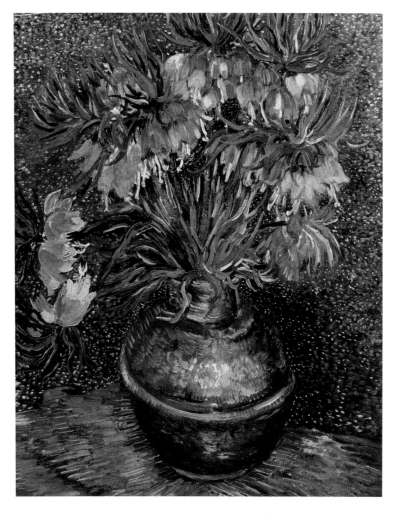

century were generally far better instructed in drawing – indeed in other arts too – than they are today. Moreover, this drawing was almost certainly not an original, drawn from life or from memory, but copied from a print (although no one has traced the source). It is certainly evidence of great proficiency, but not of altogether exceptional talent.

Other early drawings include a careful and attractive sketch of a bridge (a favourite van Gogh subject), from about the same time, and a drawing, *Farm and Wagon Shed*, done two years later as a birthday present for his father. Its provenance was inscribed on the back by the fond recipient.

One of his sisters in later years remembered a significant incident from early childhood in which Vincent destroyed his model of an elephant because he thought his parents praised it too much. Many children experience such an inexplicable ambivalence of emotions but Vincent was troubled all his life by that kind of emotional schizophrenia.

Most people are usually more concerned with the petty round of their own lives than they are with great issues of the day, and the people among whom Vincent grew up were rooted to the earth and the seasons and the diurnal labours of rural craft and farm. Even in the parsonage of Zundert, the conversation was likely to be mainly about parish matters.

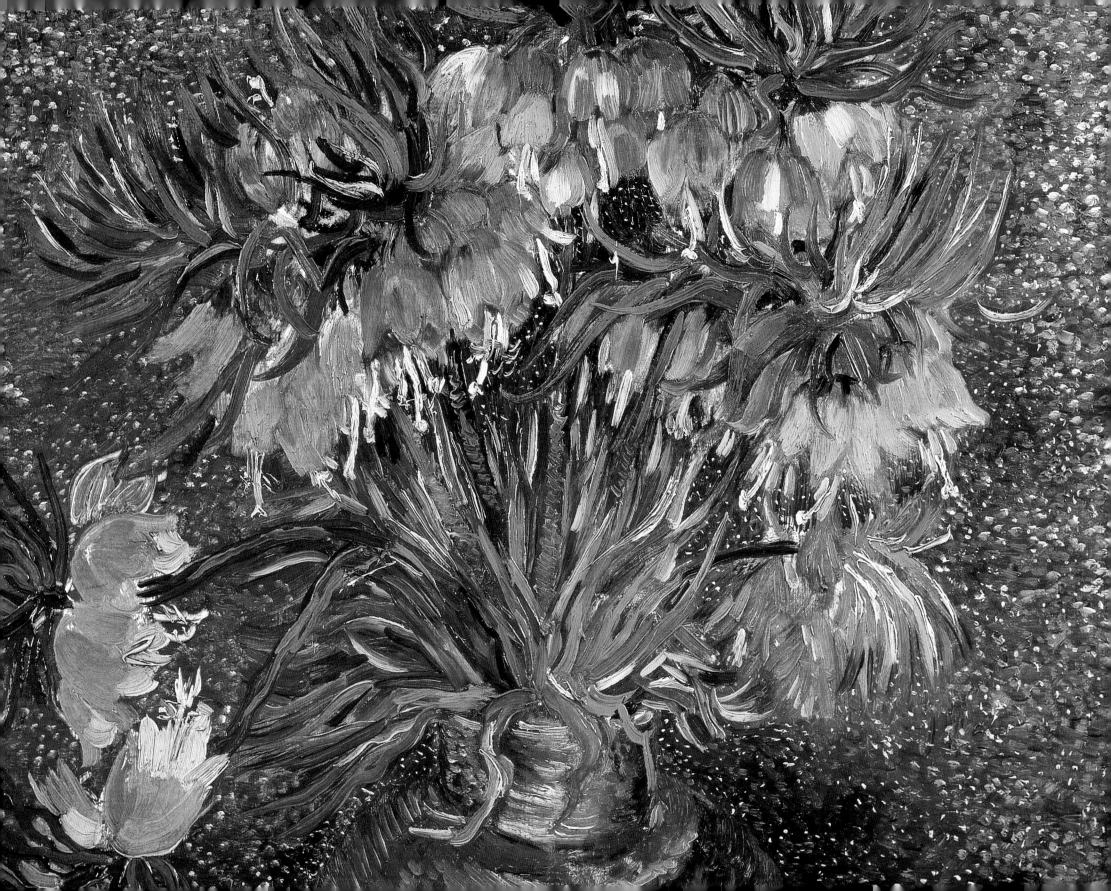

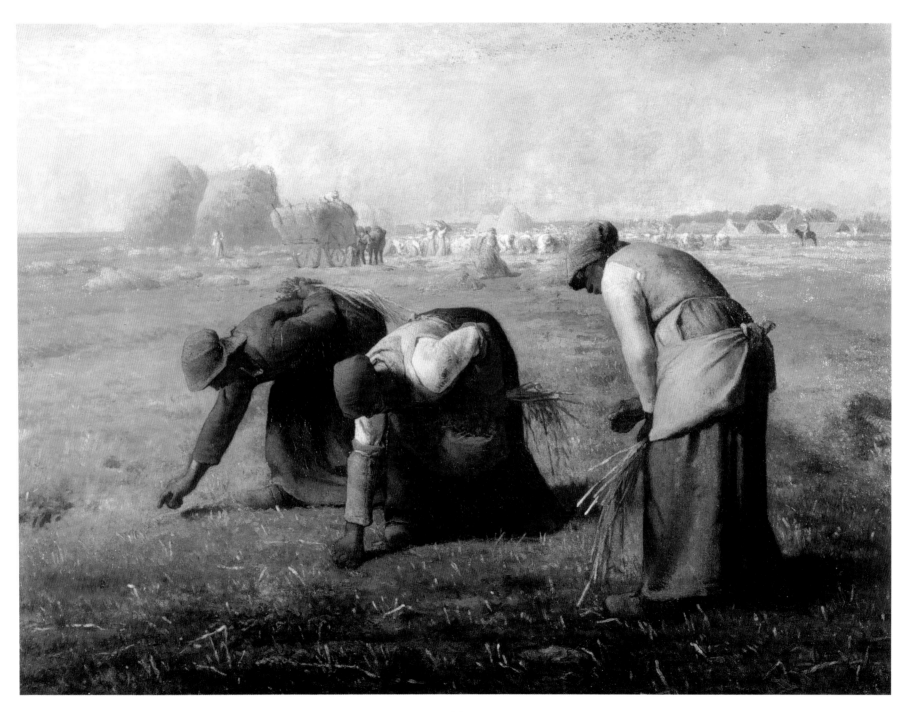

VAN GOGH

Nor was Vincent's education very inspiring. He attended the village school in 1861, where there was one schoolmaster, said to have been frequently inebriated, and over a hundred pupils, with different ages mixed in together for lack of suffcient classrooms. The introverted Vincent, who had no close friends other than his younger brother, and preferred going off on long walks on his own to playing with other boys of his age, was unlikely to learn much in those conditions. He remained there for little more than a year before his father, already anxious about the influence on his eldest son of the rough farm lads who formed the bulk of the student body, withdrew him and undertook to teach him at home.

This may well have been a rewarding task, for Vincent was highly intelligent and a great reader, with an inborn love of books and knowledge, but two years later, when he turned eleven, it was obvious that some more formal education was required. Vincent's parents may well have felt nervous about sending him away from home for the first time, but there was no alternative. At Zevenbergen, less than 20 miles (32km) away, there was a small boarding school run by an elderly Protestant pastor, Jan Provily, whom they knew. He was licensed to teach mathematics, science and languages, and was assisted by his son, also a qualified language teacher. This strength in languages was incidentally fortunate, as Vincent, who remained at the school for two years, turned out to have a special gift for them.

Otherwise, his schooldays seem to have been undistinguished. Like most boys, he found leaving home for the first time an unpleasant shock and he was thoroughly miserable. When his father visited him after two weeks to see how he was getting on (a bad idea, guaranteed to exacerbate homesickness), the normally unresponsive Vincent threw himself into his arms in floods of tears, and we know from a letter to Theo written many years later that he was devastated at being uprooted and sent away from home. Of course, boarding school was a common experience among middle-class boys in that period, and most if not all of them no doubt had similar feelings, at least for a short time. But Vincent was ill-suited by nature to cope with blows that to most people meant no more than a few days of unhappiness.

One fellow-pupil remembered Vincent as 'a silent boy', but otherwise his two years at Zevenbergen passed without recorded incidents of much note, as did the shorter period following, which he spent at a state grammar school in Tilburg, where he boarded out with a local family and first experienced town life . This was a very unusual school, with many highly accomplished teachers, a relaxed, liberal attitude and progressive curriculum. No less than four hours a week were devoted to art, which was taught by a man, C.C. Huysmans, who had not only been a successful artist in Paris but was also a born teacher. He was willing to take the class

OPPOSITE
Jean-François Millet
The Gleaners, 1857
Oil on canvas, 32⁷/₈ x 43¹/₃in
(83.5 x 110cm)
Musée d'Orsay, Paris

Strange as it may seem to us, of all Vincent's artistic heroes, Millet was probably the most influential. This particular work took the Salon by storm in 1857, and became one of Vincent's icons when he came across a print of it at Goupil's.

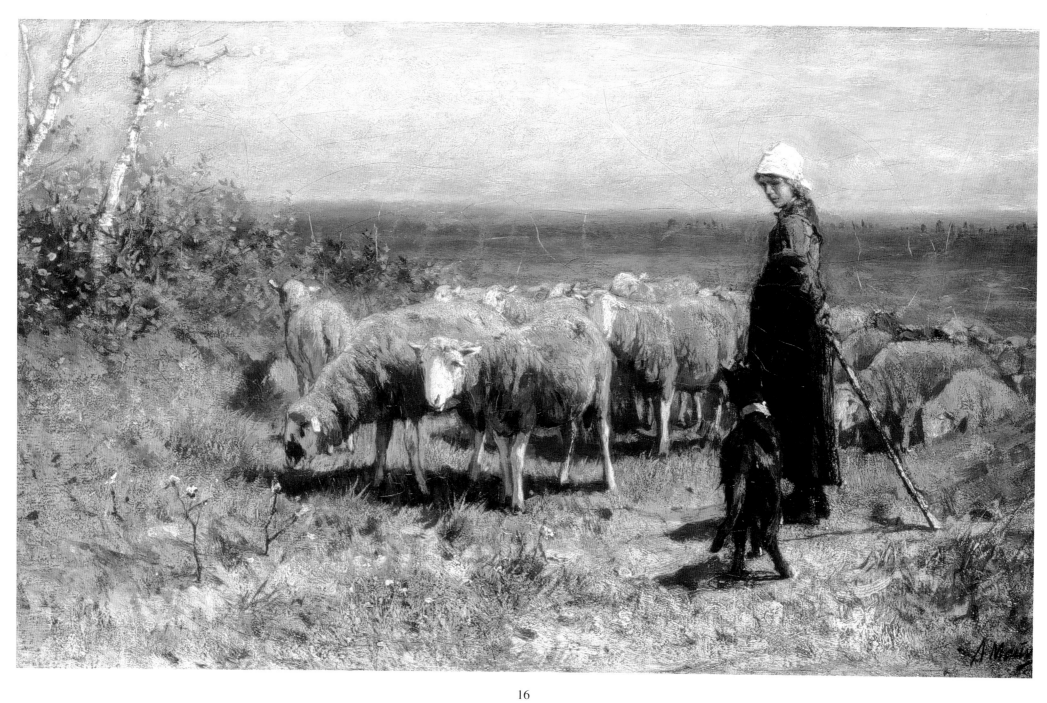

outside to let them paint from nature, which at that date must have been rare. Unfortunately, Vincent was not there very long, leaving school finally in March 1868 on the eve of his fifteenth birthday.

On one occasion, probably at the end of Vincent's first term, Theodorus asked one of the Honcoop boys, sons of the widow who helped at the parsonage, to go to Tilburg to fetch Vincent home. The lad was older, as well as bigger and stronger than the rather weedy-looking Vincent. They travelled by train from Tilburg to Breda, and from there on foot, a walk of at least 10 miles (6km). Vincent was carrying a large and heavy parcel, and after a time the Honcoop boy offered to carry it for him. 'No thank you,' was the answer, 'Everyone must carry his own parcel.' The phrase is said to have become proverbial in Zundert. But Vincent's parcel was more of a burden than most of us have to carry.

The incident also demonstrated that besides liking to be independent, Vincent's strength and stamina were greater than they appeared. He was, like his father, a great walker, and when quite young would roam alone, later with Theo, for many miles through the countryside on his nature rambles. He became adept at catching insects for his collection and watching birds and animals without startling them. When he came to paint still lifes, he worked from the first with the botanical accuracy that is evident in the famous Sunflowers and Irises of his later years.

FIRST STEPS IN THE ART BUSINESS

Vincent's schooling seems to have ended abruptly. It must have been before the end of the school year, but we do not know why he should have left at that time. It may have had something to do with the departure of Huysmans and his replacement by a much less attractive teacher. Did some crisis result in his removal, or was he, as seems most likely, simply so unhappy with the new regime that he packed up and went home? At any rate, it was not because he was an academic failure, as his accomplishments, especially in languages, suggest that he had made the best of his education. But clearly that was the end of it.

Apart from the cost, any possibility of university had disappeared with the premature curtailment of his schooling. Nor did he leave in order to plunge into some remunerative occupation, for Vincent remained at home in Zundert for the next fifteen months, apparently doing nothing in particular. He was rescued from idleness by his fond uncle and godfather, Uncle Cent.

Uncle Cent had begun his career, when about the same age as his nephew and namesake had now reached, working in a shop selling artists's materials in The Hague. In spite of a fragile constitution, a vague and unspecified condition that affected several members of the van Gogh family, his career advanced rapidly, and within a couple of years he had his own gallery.

OPPOSITE

Anton Mauve

The Shepherdess

Oil on canvas, 12 x 20in (30.3 x 50.6cm)

National Museum and Gallery of Wales

Short and stormy though it may have been, Vincent's association with Anton Mauve was very important. Mauve was the man who got Vincent interested in oils, and as his handling of light suggests, Mauve was not immune to some of the same concerns as the Impressionists, though his methods may have been more conventional. (See page 22 and 63 et seq.)

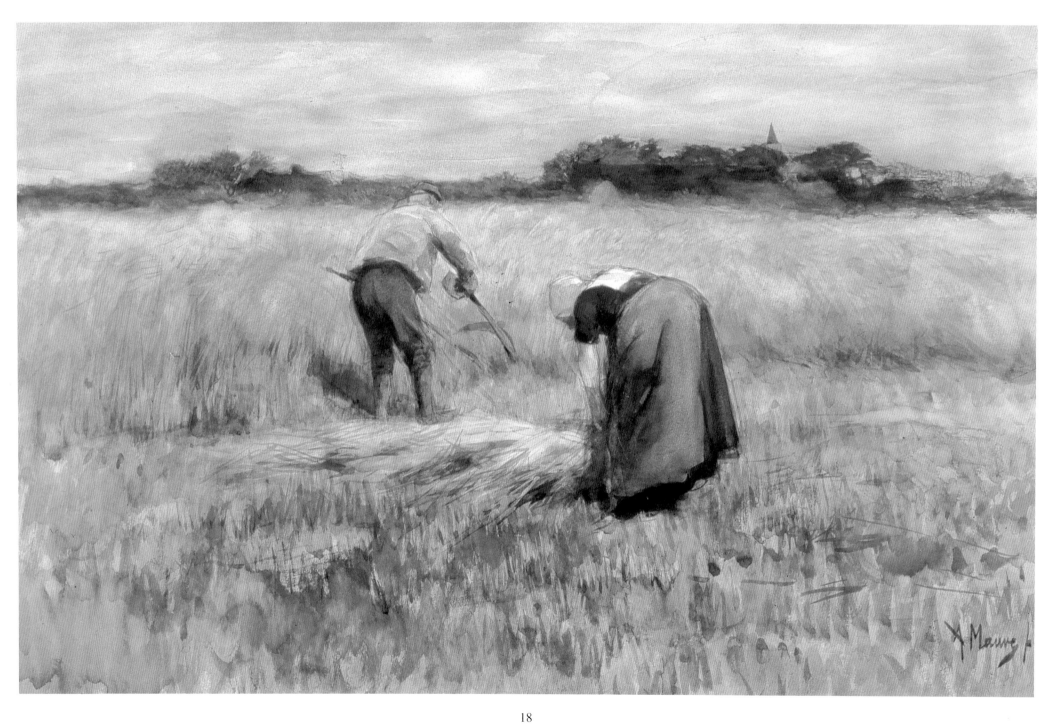

VAN GOGH

The bread and butter of art dealers at that time was the more or less 'Classical' or 'Romantic' history painting of the academy – serious, meticulously painted scenes drawn from religion, Classical mythology and history that formed the content of the annual exhibitions at the Salon in Paris and lesser centres. The leading artists (led by Jean Léon Gérôme – a painter of large and highly finished scenes from ancient history), though famous then are now derided or forgotten (perhaps unfairly: they had the misfortune to be overtaken by the great revolution in art led by the Impressionists).

Uncle Cent saw some future in a younger generation of artists who, thanks to the invention of ready-mixed paint in tubes, were able to work in oil in the open air, painting from nature (something impossible to do when colours had to be ground and mixed in the studio). The leading group was the so-called Barbizon School, named after a village in the Forest of Fontainebleau where Jean-François Millet, Théodore Rousseau and other more or less like-minded painters gathered. Among their influences, besides Corot and, to some extent the English landscapist Constable, were the Dutch landscape and genre painters of the seventeenth century. Among the French, Holland, with Rembrandt, Vermeer and all the great painters of the seventeenth-century Dutch school, still commanded the kind of artistic prestige later accorded to Paris in the nineteenth century.

Partly through Uncle Cent's patronage, a similar group to the Barbizon painters formed in The Hague and, besides selling French works to the Dutch, he was soon able to sell Dutch works to the French, although the stock-in-trade was overwhelmingly copies of the traditional, academic subjects, or portraits. The Barbizon painters remained famously impoverished. As the top dealer in The Hague, the elder Vincent often did business with the leading Paris gallery, founded by Adolphe Goupil (whose daughter married Gérôme). He made such an impression there that the two firms entered into a formal association and in time he became a director of Goupil et Cie and thus one of the most influential art dealers in Europe.

Although now chiefly resident in France, with a villa in the south as well as a house in Paris, on visits to his favourite brother Uncle Cent talked to his nephews at length about art and the business of art dealing. Without anything said, it is clear that he was mindful of family tradition and was hoping for heirs to follow him in his business.

Vincent had felt a deep-seated compulsion to find some cause in life from an early age, something that would make him useful to society. Later he wrote, 'I feel instinctively that I am good for something, that there is some point in my existence ... What use could I be ... What service could I perform?' At fifteen he had no idea what that would be. As he had always listened with fascination

OPPOSITE
Anton Mauve
The Corn Harvest
Watercolour, 17^{7}/$_{8}$ x 27^{1}/$_{8}$in
(45.3 x. 69cm)
Gemeentemuseum, The Hague

SON OF THE MANSE

to Uncle Cent's stories about the art world, the suggestion that he should join the firm of Goupil on probation seemed to solve the immediate problem of what he was going to do.

We do not know whether he felt any great enthusiasm in acceding to the plans made for him by his family. Though Vincent generally blamed himself rather than others for his difficulties, later in life he would express some resentment at the way his life had been ordered by others. They might have answered in their defence that someone had to manage his affairs since he was not very good at doing so himself.

At the age of sixteen, Vincent started his apprenticeship at Goupil's branch in The Hague. It was his first experience of city life, although The Hague, notwithstanding its status as the official capital of the kingdom, was more like a small, seventeenth-century town, an unusually attractive one with its airy streets and squares and absence of heavy industry. Nearby were woods and lakes and the charming little fishing port of Scheveningen, with its dunes and sands.

It is not surprising that artists found The Hague attractive, although few of them lived there permanently (more arrived shortly, some from Paris after the disasters of the Franco-Prussian War and the Commune). The term 'Hague School', as such terms often do, included artists with little in common except an association with the place, but although many were outdoor painters and influenced by

Barbizon, they were generally rather conservative, looking back to the glories of the Dutch Golden Age in the seventeenth century. They were conservative not only in their art, but in life, for they were mostly solid, middle-class citizens, not easily distinguished at a glance from the average banker or lawyer. The association of art with bohemianism and decadence still lay in the future, although Paris was already beginning to show the way.

Vincent would stay in The Hague for four years, which in terms of both professional and social activities was perhaps the most satisfactory period of his life. He lodged with an amiable family who knew his parents, and he had several relatives from his mother's side of the family to visit, especially the hospitable 'Aunt Fie' (Sophie Carbentus), wife of one of his mother's brothers.

At Goupil he was at first employed on clerical work in the offices behind the showrooms, later graduating to the front as a 'salesman', which required some superficial knowledge of art and also the ability to be civil, if not obsequious, to wealthy clients. It is difficult to imagine Vincent in such a role, but he seems to have managed it to everyone's satisfaction. Naturally, he picked up a great deal of knowledge about art in these years, and he was a keen learner. As well as visits to the Mauritshuis, a minute or two's walk from the gallery, he took himself off to view the collections in Amsterdam, including what became the core of the future

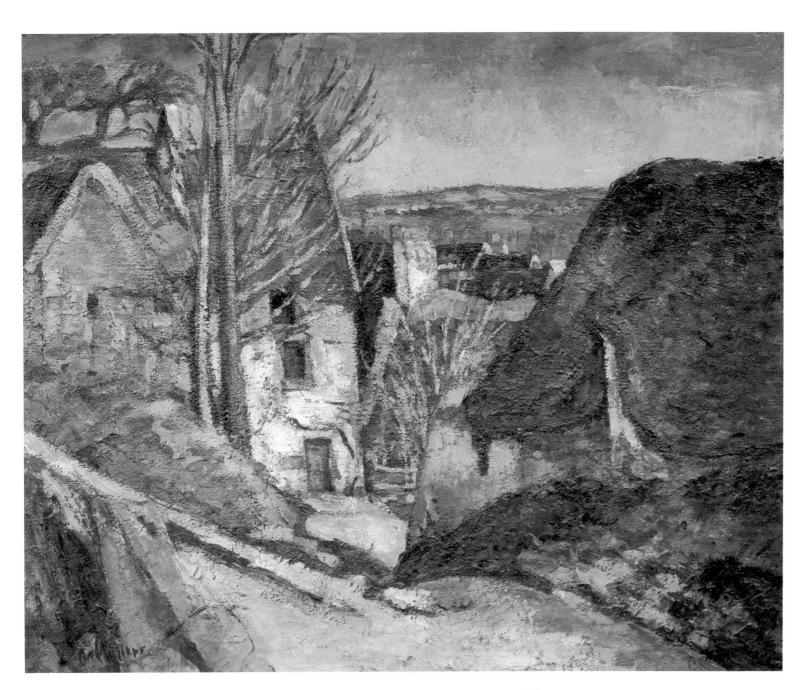

Paul Cézanne
The House of the Hanged Man, Auvers, 1873
Oil on canvas, 21⁷/₈ x 26¹/₄ in
(55.5 x. 66.5cm)
Musée d'Orsay, Paris

Cézanne exhibited at the First Impressionist Exhibition. He was at odds with many of the tenets of the Impressionists, but less so with Pissarro who, like him, was more concerned with form. Pissarro was largely responsible for sending Cézanne and his palette out into the open air, with fortuitous results.

SON OF THE MANSE

Rijksmuseum, and to Brussels, where he stayed with another of his father's brothers, Uncle Hein (Hendrik), while visiting the annual Salon. On the way he probably saw from the train his first view of the worst results of the Industrial Revolution in filthy factories and desperate poverty.

At the museums he seems not to have been especially impressed by the great set pieces of the Old Masters, nor by, for instance, Rubens's splendid nudes; at least he made no comments on them so far as we know (nor did he remark on the single Monet that was on view in the Salon). His taste was always for the humbler, domestic scene, the Dutch or Flemish landscape, and of course the Barbizon painters, especially Millet, until then known to him only through engravings.

Millet's great pictures of peasant life made him the first and perhaps greatest of Vincent's artistic heroes. But he was also devoted to Jules Breton, an artist who painted somewhat similar subjects to Millet but with – it seems to us – a great deal less conviction and a great deal more sentimentality, although with extreme accuracy of detail. Sometimes, Vincent's critical judgements, often surprising, were influenced by his personal predilections but, other things being equal, he would look more kindly on a painting of working peasants than on paintings of society ladies or the festivities of ancient Greeks.

Not that he condemned the latter. His comments on pictures throughout his life reveal him as the most positive of critics. He seldom has anything very harsh to say, but is continually picking out features or details that appeal to him, and he finds these in all kinds of art, including works that we may be sure held little overall appeal for him. His enthusiasm, wide sympathies and open-minded generosity were among his most attractive personal qualities.

Vincent also got to know the leading artists of The Hague School, such as Josef Israëls, twenty years his senior, whose paintings of the life of the fisherfolk at Zandvoort made a strong impression on him. But the artist of this school whom he knew best was Anton Mauve.

Though influenced by Millet and the Barbizon painters, in some ways Mauve was, so to speak, ahead of them. In his landscapes, for instance, his attempts to catch the immediate impact of light echoed the contemporary efforts of the French Impressionists. Though nearly twice Vincent's age, he could be regarded as a friend and, partly because they often met at Aunt Fie's, where Mauve was courting one of Vincent's cousins, they saw a good deal of each other. Mauve gave an impression of confidence and self-satisfaction, which Vincent, lacking those qualities, may have found attractive. In another respect he was more like Vincent, in that he suffered occasional fits of acute depression. The period of his greatest influence in Vincent's life, however, came some years later.

Besides what seems to have been quite a busy social life – for in

VAN GOGH

artists or the general public, but it was not particularly demanding either and he settled in well. At the end of the year he received a rise in his £90-a-year salary.

He dutifully visited the galleries, but was not much impressed by English art. He admired occasional religious scenes, painted with congenial Pre-Raphaelite realism by such as Holman Hunt and Millais, but found the Victorian taste for Gothic rather strange, and the annual exhibition of the Royal Academy, certainly far inferior to the Paris Salon, did not please him. He went so far as to describe one of the theatrical ancient Roman fantasies of Edward Poynter (a future director of the National Gallery) as 'awful'. Current developments in art more or less passed him by. He seems never to have heard of Whistler, William Morris, the Pre-Raphaelites, or the Aesthetic Movement ('art for art's sake'), and was oblivious to the rising interest in Japanese art. He did, however, discover to his pleasure the illustrated newspapers, with their engravings of everyday life that usually carried a message of social criticism, by illustrators such as Luke Fildes.

However, the main reason why Vincent was so happy during this year in London was that he had fallen in love.

Contemporaries, and posterity also, tended to see van Gogh as a savage, a wild man, the ultimate 'bohemian' artist, socially irresponsible if not actually mad. But there was one part of him,

destined to be frustrated by the difficulties of his temperament, that yearned for a simple bourgeois existence, a settled home life with an affectionate wife, and of course children, whom he adored. He had plenty to give, and an overwhelming love for people, especially the poor, the unfortunate, the frail and the vulnerable. His failure to acquire a family was probably behind his yearning to establish an artistic community around him – the hope that lay behind his efforts to attract Gauguin to Provence. Vincent wanted to belong. He never did.

For all his good instincts, he could not manage intimate relations with an individual – at least, not for any length of time. He had plenty of friends, but he antagonized many of them and drove others to distraction (yet, at a distance, their affection usually survived). Even Theo, that paragon of fraternal loyalty, found living with Vincent hard on the nerves.

When the powerful element of sex was added, disaster threatened. He was so thoroughly enveloped in his own emotions that he could not conduct even normal human relations. It was, for instance, quite characteristic that he was in love for the best part of a year with 19-year-old Ursula Loyer, his landlady's daughter, who lived in the same house and whom he saw every day, without ever betraying to her a sign of his feelings. Nor did he ever wonder, as he silently admired Ursula across the supper table, if the frequent

OPPOSITE
Claude Monet
Regatta at Argenteuil, 1872
Oil on canvas, 18⁷⁄₈ x 29¹⁄₂in (48 x 75cm)
Musée d'Orsay, Paris

Boats and water, another favoured Impressionist subject.

presence at the evening meal of a former lodger, a young, good-looking, unmarried engineer, had any significance.

As we are often told, people were more reticent about sex in the nineteenth century, but Vincent cannot have been entirely ignorant. It would be odd if he had never discussed the matter with boyhood friends. He had seen plenty of sensual pictures. He had known and had lived under the same roof as married couples, and had witnessed courtships, such as that of Anton Mauve with his cousin Jet (they had just become officially engaged). He had read a little book, *L'Amour*, by the historian Jules Michelet, which discoursed on contemporary notions of femininity (and incidentally remarked that an Englishwoman made the ideal spouse).

He seems to have supposed that feelings between a man and a woman were necessarily mutual even though unstated, therefore that Ursula felt the same for him as he did for her. Vincent's inability to look at a situation from another person's point of view seems extraordinary to us, and suggests that a degree of autism may have been among his problems.

The first that Ursula knew of Vincent's feelings was his announcement, in early summer 1874, that it was about time they thought about getting married. Horrified, she flatly rejected him, explaining that she was already secretly engaged to the young engineer.

Overwhelmed, Vincent sank into severe depression, which developed into what might be regarded as his first serious mental breakdown. He moped, took no interest in life, and his work suffered. As his summer holiday was due, he went home.

His parents were shocked at his appearance and behaviour, yet underestimated the seriousness of his condition. After all, he had always been subject to moods, and they assumed that he would soon pull out of the present one. He would not tell them what was wrong, only that there were 'secrets' in the Loyer household. He could not bring himself to do anything, yet he could not face up to the fact that he could not have Ursula. After a while, he took up drawing again, which his parents thought was a hopeful sign, and filled several sketchbooks – for little Betsy Tersteeg, daughter of the Goupil manager in The Hague who was born not long after Vincent arrived there – with simple naturalistic sketches of such subjects as a bird on its nest, a spider on its web, an old woman knitting and a stagecoach on the road.

In due course he returned to London, this time accompanied by his 18-year-old sister Anna, who was going to look for work while she improved her English. She took a teaching job in Welwyn, north of London, so Vincent saw little of her. Extraordinarily, he had returned to the Stockwell house, where the atmosphere must have been grisly, but after a month even he had enough sense to move out.

VAN GOGH

All the joy had gone out of life. He now led a solitary existence, spending his evenings in his new lodgings reading the Bible.

His behaviour had already caused concern at Goupil's and disturbing reports had reached Paris. No doubt Uncle Cent was consulted, and it was finally agreed that Vincent should be recalled to headquarters.

A GLIMPSE OF THE ARTIST'S LIFE IN PARIS

In Paris in October 1874, Vincent took lodgings in Montmartre, then beyond the city's boundaries and still undeveloped. He chose the area not because of its associations with artists and other bohemian types, but because it was cheap. Goupil's had a branch on the Boulevard Montmartre, which was relatively liberal in terms of trade, but Vincent was employed at the more conservative main branch in the Place de l'Opéra.

In spite of his aversion to human contacts, he became friends with a young Englishman at Goupil's, Harry Gladwell, son of a London dealer, and they often spent their evenings together. Not, of course, in the lively bars and dance halls of Montmartre: they embarked on reading the Bible to each other, aiming to complete the whole book, Old and New Testaments, between them. On Sundays, Vincent walked down the Butte into the city to attend one of the Protestant chapels.

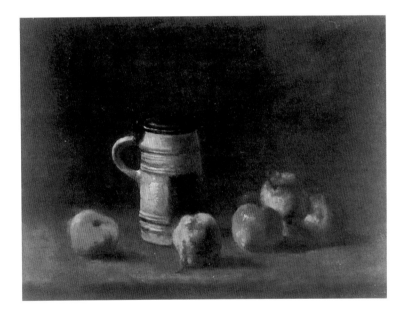

Still Life with Beer Mug and Fruit, 1881
Oil on canvas, 17¹/₂ x 22⁵/₈in
(44.5 x 57.5cm)
Von der Heydt Museum, Wuppertal

He had also discovered *The Imitation of Christ* by the fifteenth-century Augustinian monk, Thomas à Kempis, and was strongly attracted by Thomas's ideal Christian community governed by clear rules.

Religion was one of two powerful elements in his nature and, notwithstanding his drift away from conventional worship and belief in later years, it remained so after he turned against its contemporary form and institutions and appeared to have given himself entirely to his other consuming interest, art. But the two

were intimately connected, and art was not so much a substitute for religion as another form of it. Even at this time, after the Sunday service, he would continue his worship in another sphere by going to the Louvre, where admission on Sundays was free.

By now Vincent knew enough about art to have fairly firm tastes. This proved inconvenient to his employers, as it transpired that he was losing sales by his efforts to persuade a customer that the work he was interested in buying was inferior and recommending something that he, Vincent, considered more worthy.

At this time the art world was entering a dramatic period of change. Not long before Vincent arrived in Paris, the First Impressionist Exhibition opened in April 1874. It featured works by Monet, Renoir, Pissarro, Degas, Cézanne, Berthe Morisot, Sisley, all now household names but at that time largely unknown artists who, without exception, had failed to get their work accepted regularly, if at all, by the annual Salon – the measure of what was good and, of more immediate importance to the artists, what was saleable.

It is difficult now to comprehend the intense hostility aroused by the Impressionists. It was not only that the critics – and the art establishment in general – did not like these pictures (those bright colours, frivolous subject matter, etc.), they also did not consider them 'art' at all. They were not proper pictures, merely 'impressions', with paint slapped on as if by a boisterous child at play. There was no evidence that their creators could actually 'paint' at all. These people showed no evidence of craftsmanship. The critics had not liked Courbet either, but no one had doubted his ability to paint. These new so-called artists were making a mockery of art, cocking a snook at long-cherished values with their open-air daubs.

There was more to all this than the familiar antagonism between the old and established and the new and liberated. The Impressionists appeared as perverse radicals, dangerous revolutionaries, threatening to undermine everything that art meant. As in many extreme reactions to unfamiliar developments, there was an element of fear at the bottom of it.

By the time Vincent arrived in Paris the First Impressionist Exhibition had closed but, however shut-off socially from the art world he had become, it is hard to believe that he had heard nothing about it. Still, it clearly held little significance for him. He was entirely unaware that an artistic revolution was taking place in Paris almost before his eyes. But then, so was practically everyone else.

After only a couple of months in Paris, Vincent was sent back to Goupil's London office in December 1874. By the middle of May 1875, he was back in Paris, this time lasting at the Goupil office there for nearly a year. At Christmas, he went home, remaining there over the New Year. 'Home' had changed again. His father was now

the pastor at Etten, a somewhat larger village west of Breda, the move producing another small but useful increment in stipend.

The Christmas season was always a busy time for dealers in art, but Vincent had not been granted leave. He had simply left. Probably, were it not for the influence of Uncle Cent, he would have been shown the door long before this, but Uncle Cent was contemplating retirement and other changes were taking place at the top. The elderly founder of Goupil's was on the point of withdrawing from the business. None of his surviving sons was interested in taking over, and the new boss was Léon Boussoud. On Vincent's return, he was summoned to Boussod's office. A parting of the ways was inevitable, and Vincent made no effort to argue, so that whether he was eventually fired or whether he resigned on 1 April 1876 is immaterial. Boussod, not ungenerously, offered him three months' notice.

Indeed, there was no alternative – even Vincent's father conceded that; as he was obviously unhappy where he was, he had best leave.

Vincent was twenty-three years old and unemployed, with no money and no obvious prospects. What was to become of him?

Theo, who knew that his beloved elder brother had been making many drawings, suggested he might become an artist. His mother also spoke of his 'delightful talent'. She wished he could find something to do connected with nature or art. Vincent himself still wanted to return to London, to be near Ursula even if he could not see her. He thought that, like his sister, he might get a job teaching. He applied for many advertised posts with discouraging results, but was eventually offered work at a private school in the seaside town of Ramsgate, on one month's probation. The post was unpaid, but board and lodging were provided. He jumped at it.

CHAPTER TWO
AMONG THE MINERS

There were signs that Vincent's mental state was improving. He was more hopeful, ready to speak about the future, and was taking more interest in his surroundings. On the train to Ramsgate in spring, 1876, he wrote to his parents: 'I am looking across the vast expanse of meadows, and everything is very quiet; the sun is disappearing again behind the grey clouds, but sheds a golden light over the fields.'

Ramsgate, popular with day-trippers by steamer from London, was a pleasant town built on rising ground above the harbour, but the school, despite its view of the boats in the harbour, left something to be desired. It was clearly run on a shoestring, and its main raison d'être was to turn a profit for its proprietor. Vincent observed that the floor of the boys' washroom was rotten and one of the window panes was broken.

The Potato Harvest, c. 1884
Pencil, pen and brown ink, 2 x 5¹/₈in
(5 x 13cm)
Noortman, Maastricht

Ox Cart in the Snow, c. 1884
Pencil, pen and brown ink, 2 x 5¹/₃in
(5 x 13.5cm)
Noortman, London

The proprietor, Mr. Stokes, was away, as term had not yet begun, and, observing that the boys were bored, Vincent told them stories and took them for walks. When he did arrive, Mr. Stokes proved pleasant enough. The boys seemed to like him, and there was none of the violence and cruelty that affected some English boys'

schools in that era. Stokes told him he planned to move the school quite soon to Isleworth, a village beginning to develop into a suburb west of London.

The move occurred two months later, and Vincent took the opportunity to undertake one of his marathon walks, via Canterbury,

to Lewisham in south London, where he stayed a night at the home of Harry Gladwell, now back from Paris, then on to Welwyn to visit his sister Anna – well over 125 miles (200km) altogether.

The school at Isleworth was no great improvement on Ramsgate. Vincent's one month's probation was long past but his employer maintained a studied silence on the matter of a salary. Vincent's mind turned to alternative occupation. Brief acquaintance with the East End slums had made him keen to help in one of the missions that sought to bring some material and spiritual comfort to that benighted area (the Salvation Army, which Vincent admired, had been founded just a decade earlier). None of the missions to which he applied would accept him, however, because of his youth, as well perhaps because of his somewhat unprepossessing appearance, foreign accent and excitable temperament. Nor did he have better luck with the missions to seamen (where knowledge of other languages was useful), or among the coal-mining towns of the North.

He was beginning to feel discouraged when he became acquainted with a Non-Conformist clergyman, Thomas Slade-Jones, who lent him what Vincent most needed – a sympathetic ear – and eventually offered him a job, again as an assistant teacher but with the added attractions of a small salary and of being allowed to take part, even preach, at services in the two chapels of which Mr. Jones

was the incumbent. In spite of their disagreements, Vincent admired his father and consciously hoped to emulate him.

Meanwhile, he continued to display the energy and stamina in simply getting around for which Victorians today seem so extraordinary. In November 1876, 'I made a long hike to London. I left here [Isleworth] at four o'clock in the morning, and at half-past six was in Hyde Park ... From there I went to Whitechapel, the poor part of London; to Chancery Lane and Westminster; to Clapham to visit Mrs. Loyer (mother of Ursula, who was now married) ... I also went to Mr. Obach's [his superior when working for Goupil's in 1873] to see his wife and children again ... then I went to Lewisham, where I arrived at the Gladwells at half-past three ... I spent about three hours with them ... From here I also wrote to Harry [who had returned to Paris]... At half-past ten in the evening I was back here, having used the underground railway part of the way ...'. We may think, thank goodness for the 'underground railway', but it cannot have saved Vincent's boots very much wear as the District Line to Richmond had not yet been completed.

Religion was becoming more and more important. Increasingly, it dominated Vincent's letters to Theo, in which he peppered them with recommendations of religious books and passages of the Bible that he ought to study. He had found another favourite in Bunyan's *Pilgrim's Progress*.

His father, while a dutiful Christian minister, was no great preacher, and Vincent was no better. In his case, his difficulties arose from more than poor oratorial skills. He tended to put people off; there was something extreme, almost fanatical about him. A gesture such as dropping one's gold watch into a collection plate, rather than inspiring people with generosity, is more likely to make them feel uncomfortable at such an excessive gesture. And there was something joyless about his religion. He once said, when he was depressed, that he preferred a grim grey evening to a brilliantly sunny morning, and not all his congregation at chapel wanted to be told that sorrow is somehow better than enjoyment.

'Woe is me,' Vincent wrote, 'if I do not preach the Gospel; if I did not aim at that and possess faith and hope in Christ, it would be bad for me indeed.' Or again, 'It is a delightful thought that in the future, wherever I go, I shall preach the Gospel.' His behaviour became odder. His letters to Theo became more erratic, ranting, even hysterical – the symptoms of a burgeoning religious mania.

TOWARDS A VOCATION

At Christmas, Vincent went home to Etten. His parents had been warned by Theo that all was not well with their eldest son. Once more, he seemed to have embarked on a career only for it to end in precipitate failure. Although, when he arrived at Etten, he seemed

normal enough, more worrying than his failures in England was his mental state. His father was at any rate determined that he should not return to England, which seemed to have a destructive effect on his mental stability, nor was Theodorus keen on the idea of mission work. Some quieter occupation seemed desirable. Once more, Vincent gave himself up to the directions of his family. We know from later evidence that he resented this, but he now accepted his father's verdict on his future.

Uncle Cent, who had moved back to a grand mansion built for him at Princenhage not far away, was called in to help. He had almost lost patience with Vincent after he had, as it seemed, self-destructed at Goupil's, but could not refuse his brother's request and duly found Vincent a position with a bookseller in Dordrecht named Braat, over whom he had some leverage. In January 1877, Vincent moved to Dordrecht on a week's trial.

Dordrecht was subject to floods, and one night Vincent, in his lodgings not far from the bookshop, awoke to the sound of lapping water in the square below his window. He rushed across to the shop, and began energetically shifting stock from the basement to an upper floor. This saved his employer considerable loss, and he was at once confirmed in his post.

The good impression he had made that night did not last, however. Vincent was not interested in the work and his behaviour –

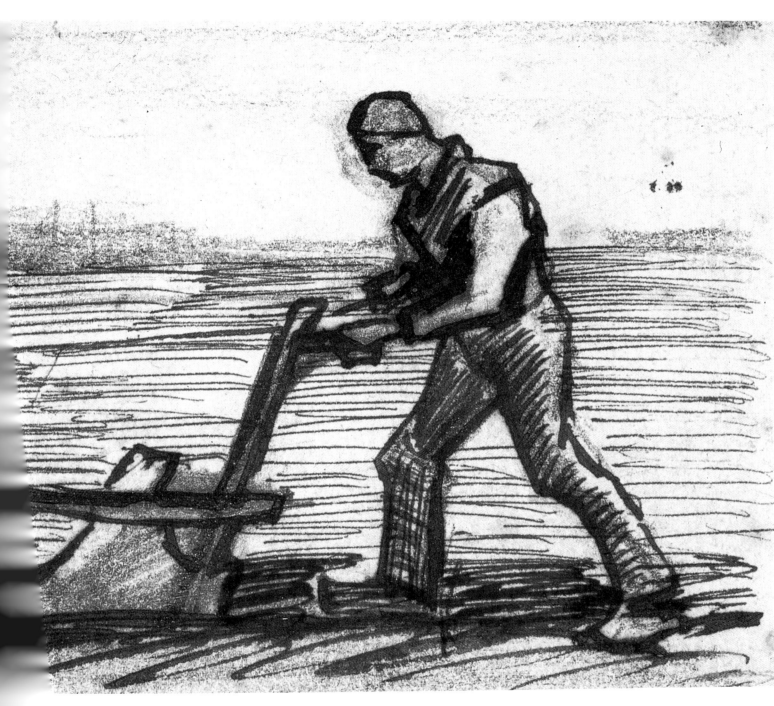

At the Plough, c. 1884
Pencil, pen and brown ink, 2$^{1}/_{8}$ x 6in
(5.5 x 15cm)
Noortman, London

periods of enthusiasm and good nature alternating with moods of uncommunicative self-absorption, intense optimism one day, profound despair the next, the pattern of his whole life – frightened off the customers. One day his employer, checking to see if he was getting on with the stock-checking, found him busy making a translation of the Bible (into three languages!). Nor did he admire Vincent's sketches, which he considered worthless. Vincent himself showed little social sense. He did become friends with one fellow-lodger, a teacher named Gorlitz who left a sympathetic record of him, but others tended to laugh, and not kindly, at his peculiarities.

His letters showed no sign of the rapidly deteriorating situation, although to Theo, for whom he acquired books presumably at discount price, he harped on obsessively about his desire to study the Bible and 'to find out what is known about Christ'. He went to church, including Lutheran and Roman Catholic services, at least three times on Sundays. He was also convinced that his father, who had been ill, dearly wanted him to enter the ministry. 'I know his heart is yearning that something may happen to enable me to follow his profession,' he told Theo. 'Father always expected it of me – oh, that it may happen and God's blessing rest upon it.' His father ranked among his heroes, along with a growing number of writers and artists, the latter an extraordinarily mixed collection (so it seems to us), with, for instance, Rembrandt and Jules Breton bracketed

together as worthy of equal admiration. But he admired his father, the man of God, even more than all these.

In the end, Vincent's father and family, however doubtfully, reached the conclusion that Vincent ought to pursue the vocation to which he was so devoted. Since Vincent himself refused to deviate from this intention or even to listen to contrary arguments, they perhaps had little choice but to agree. Uncle Cent, not unreasonably in view of all his efforts on behalf of his recalcitrant nephew, was less agreeable. When Vincent wrote to ask his advice about going into the ministry, he answered brusquely that he was unable to help and therefore their correspondence had best cease.

There were formidable obstacles. Vincent had now passed his twenty-fourth birthday, he was long past university age, but he could not enter the ministry without academic qualifications. In May he left for Amsterdam to study for the entrance exam for theological college. At least he did not have to pay for board and lodging, for he could stay with Uncle Johannes (Jan), who now commanded the Amsterdam naval yard, and being a widower with grown-up children, lived alone in his grand official residence. The jolliest of the van Gogh uncles, Uncle Jan had little in common with his nephew but appears to have been the least critical of him.

Large families have their uses, and over the years of muddle and confusion Vincent's formed a considerable support group. Another

uncle, Johannes Stricker, who was married to one of the Carbentus sisters, was also a Protestant minister, a more successful one than Theodorus, and a considerable scholar as well. He was to help with the coaching, and he secured a first-rate teacher, Dr. Mendes da Costa, not much older than Vincent but already a professor of classics, as tutor in Latin and Greek.

They got on well together. Mendes da Costa was a perceptive man and saw in Vincent qualities that most others overlooked. All the same, Vincent did not find his studies easy. Some of his biographers have expressed surprise that he should have had so much trouble with Latin and Greek, given his facility in languages, and there is reason to think that he was simply unsympathetic to their study. He certainly seems to have spent a lot of time when he might have been working wandering around the city, sometimes with Uncle Jan as his guide, browsing in bookshops, or sketching. He used to complain to Mendes da Costa that ancient languages were irrelevant to the work he wished to do. 'Mendes, do you seriously believe that such horrors [Latin and Greek] are indispensable to a man who wants to do what I want to do: give peace to poor creatures and reconcile them to their existence here on earth?' Secretly, Mendes rather agreed.

There was another complication. Visiting his Stricker uncle he met Cornelia (Kee) Vos, his uncle's married daughter and therefore Vincent's cousin. She was dressed in black, in mourning for the death of her infant son, and her serious mien reminded him of Ursula. She was, for Vincent, an incarnation of the image that ran mysteriously through his life, his vision of a Lady in Black, which originated in an anonymous seventeenth-century French painting, *Woman in Mourning*.

Vincent took to calling at the Vos house, where Kee's husband was seriously ill (he died soon afterwards), after Sunday morning service at Pastor Stricker's chapel. To his delight, she one day gave him a copy of Thomas à Kempis's *Imitation of Christ*. Vincent's feelings, as with Ursula, filled him with a heightened delight in life, a sign of his fixation, and of ominous portent. The edition of *Imitation of Christ* that Kee gave him was in the original Latin and Vincent's attempt to translate this complex work, at a time when he was a mere beginner in the language, added to his frustration.

Vincent had to complete his studies in one year, but after nine months the prospects were looking decidedly poor, so much so that even his father joined the coaching team, helping his son with Latin on his visits to Etten. Vincent promised to try harder, but facts had to be faced. After Theodorus himself had been to Amsterdam to see Mendes da Costa, all parties came to the gloomy conclusion that the attempt to get Vincent through the forthcoming examination was doomed to failure, and his studies came to a premature end. He returned to Etten.

RIGHT
The Sower, c. 1881
Pencil, pen and brown ink, 2¹/₈ x 5¹/₂in
(5.5 x 14cm)
Noortman, Maastricht

One of many examples of Vincent's
frequent reworkings of this subject from
Millet (see also pages 44 and 46).

SHORT-LIVED MISSIONARY TRAINING

Although he could not be a minister, Vincent was still determined to
carry the Gospel to the poor, but some training was required for even
the most basic mission work. A school running a three-year course
for mission workers had recently been founded at Laeken, now an
elegant suburb but then outside Brussels. His father knew of it and
went with Vincent to see it, accompanied also by Vincent's Isleworth
benefactor, the 'Reverend Jones' (as Vincent always referred to him)
who, characteristically, had remained sympathetic to Vincent after
his unexplained retreat to Brabant.

Vincent spent a few weeks in preparation at Etten, writing
several trial papers, one of which was on a Rembrandt painting of
the Holy Family. He continued to draw things that caught his eye
(including a 'hasty little sketch' of a tavern, *Au Charbonnage* ('At
the Colliery'), while telling himself he should cut down on this
activity 'as it would probably keep me from my real work'.

In August 1878 he began his course at the mission school. There
were only three pupils, and Vincent initially made a good impression
with his obvious intelligence and warm enthusiasm. His tendency,
evident for some time, to shun ordinary comforts and subject himself
to harsh conditions caused some difficulties. As it was, he seldom ate
proper meals, and he declined to sit at the table, as requested, in
class, preferring to balance his notebook on his knee. When he

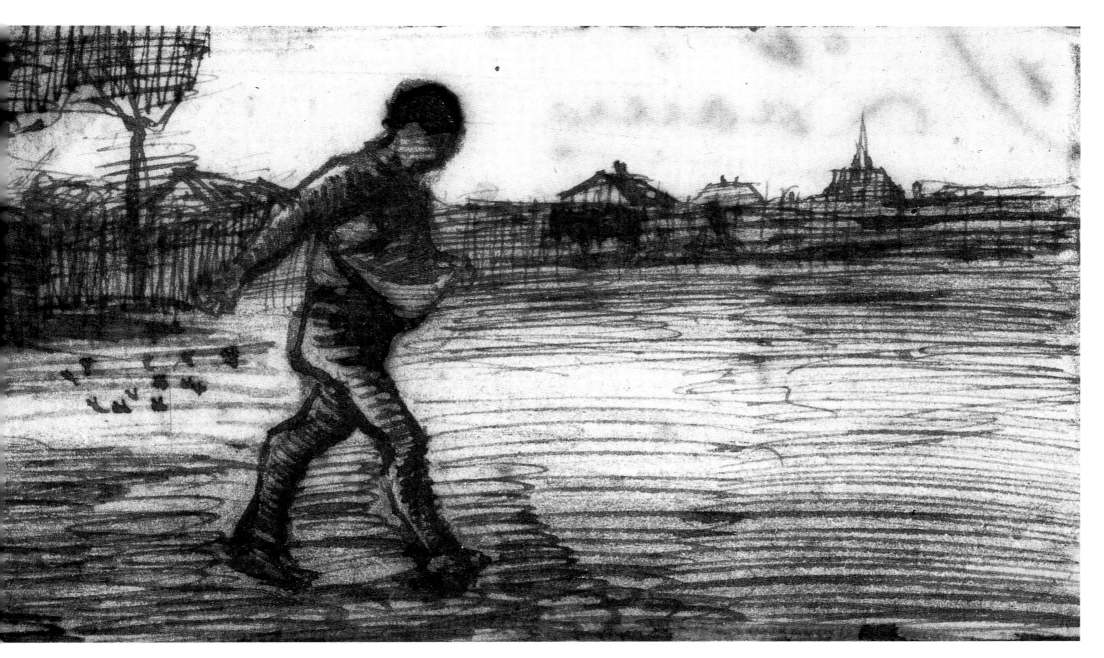

answered a question whether a certain noun was in the dative or accusative with 'I really don't care, sir', he failed to impress his teachers with his determination to do well.

Eccentricity was one thing, but an incident in class one day caused greater dismay. During a French lesson, the word *falaise* ('cliff') came into the discussion and Vincent (who hardly needed lessons in French but was frustrated by the lack of opportunity to draw) asked if he might draw a cliff on the blackboard. Not surprisingly, permission was refused, but at the end of the lesson, Vincent went up and began to draw a cliff for his own satisfaction. A younger student crept up behind him and, as a prank, tugged suddenly at his jacket. Vincent whirled around, his face 'blazing with indignation and wrath', and struck the boy with his fist. Vincent had given plenty of evidence of mental instability before, but this seems to have been the first outbreak – an instantaneous, brief reaction – of physical violence.

After the three-month trial period, Vincent was told that he must give up the course, the reason given being his poor performance as a speaker. The two ministers who ran the school may have been using that as a safe excuse, but it was also, no doubt, quite genuine: for an evangelical missionary, the power to impress and convince in speech is, after all, a vital requirement.

His teachers felt bad about it, especially as Vincent was the son of a fellow-minister, and when Theodorus asked them to give his son one last chance, they agreed that he should go the coalfields as an unpaid assistant for a probationary period. If he proved satisfactory, he would be considered for a regular position, although on a temporary basis.

A HARSH LIFE AMONG THE INDUSTRIAL POOR

Vincent had seen poverty among the farm workers of North Brabant, but it was of a different kind from the slums of East London. The rural life of the peasants, as depicted by Millet for instance, had a pastoral, almost romantic aspect. In East London, Vincent had seen a different, harsher kind of poverty, and the conditions of the mining families in the Borinage were still more shocking.

The Borinage was a coal-mining region in the south of Belgium, around Mons, where the inhumanity of the Industrial Revolution was displayed at its very worst. The whole bleak area was polluted by the results of mining, the air permanently tinged a dirty yellow and stinking of sulphur fumes, the only significant landmarks the black piles of slag around the mines. Vincent described it for Theo in passages that confirm his literary gifts, for if he had not been a painter he might well have been a writer. The striking similarity of his descriptions have often been compared with those of Zola, a few years later, in his novel *Germinal*, set in the similar coalfields of northern France.

VAN GOGH

A miner took him down the pit, 2000ft (600m) below ground. He thought the scene would make a picture, 'something new and unheard of – or rather, never before seen. Imagine a row of cells in a rather narrow, low passage, shored up with rough timber. In each of those cells a miner in a coarse linen suit, filthy and black as a chimney-sweep, is busy hewing coal by the pale light of a small lamp ... The water leaks through in some, and the light of the miner's lamp makes a curious effect, reflected as in a stalactite cave.'

Young children, boys and girls, also worked in the mine, and there was a stable 'with about seven old horses which pull a great many of those carts [to where] they are pulled up to the surface ... The villages here look desolate and dead and forsaken; life goes on underground instead of above.' The people were ignorant and uneducated, most of them unable to read or write, yet intelligent and skilful and terribly hard-working. They had 'a strong mistrust of anyone who is domineering. With miners one must have a miner's character and temperament, and no pretentious pride or mastery, or one will never get along with them or gain their confidence.'

Recognizing that good works counted for more than fine words, Vincent was soon living in conditions as bad as the poorest mining family, moving from his comfortable lodgings in Wasmes, where he was looked after by the local baker's wife, into a hut and sleeping on straw, his appearance as dirty as those who worked down the pit. He wore a shirt made of old sacking and no shoes or socks. When the baker's wife remonstrated, reminding him of his heritage in a family of respectable ministers, he replied, 'Esther, one should imitate the good Lord; from time to time one should go and live among His own.' She was worried enough to summon his father, who heroically made his way to Wasmes, attended some Bible readings with Vincent, and obtained his promise, no doubt sincerely made but not kept, to reform his lifestyle. His salary of 50 francs a month would certainly have paid for little more than the bare essentials, but he took charity further than the Good Samaritan, literally giving all he had to the poor.

Accidents, often caused by explosions of firedamp (consisting of methane and other combustible gases), were frequent in the Borinage, and Vincent worked tirelessly to help the injured, tearing up his own linen, what was left of it, to make bandages. For many nights in a row he sat by the bedside of one badly injured miner, and can take some credit for saving his life. He allowed himself only one indulgence, his pipe and tobacco. Years later he would recommend smoking as a means to combat depression.

Like St. Francis, Vincent, the nature-lover, extended his charity to all living creatures. When he bought cheese, it was probably not for himself but for the mice in his hovel. He was once seen to pick

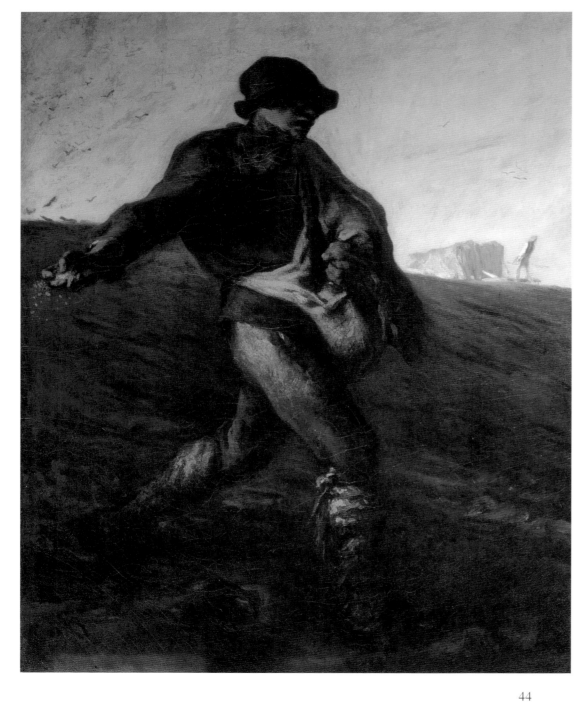

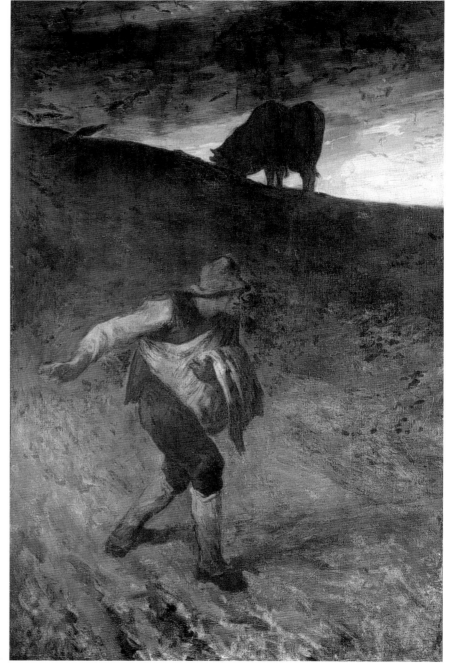

up a caterpillar from the ground and place it carefully on a nourishing leaf.

In spite of his selflessness and identification with the people whose welfare he had espoused, he was undoubtedly seen as a peculiar character, and although he made friends with some miners' families, he remained in general an oddity, an outsider. His goodness aroused affection, even admiration, but his eccentricities also prompted some mockery. Children jeered at him in the street. Besides Bible readings in the homes of some of the miners, he delivered sermons in a meeting house (oddly known as *le salon du bébé* – 'the baby's room', perhaps in connection with the Nativity) in Wasmes, which was made from two cottages knocked together. According to him, he preached in the evenings to a small but very attentive congregation.

But preaching remained a weakness. When the official report was made at the end of his probationary period, it said, 'If a talent for speaking, indispensable to anyone placed at the head of a congregation, had been added to the admirable qualities he displayed in aiding the sick and wounded [and] to his devotion to the spirit of self-sacrifice ... Mr. van Gogh would certainly have been an accomplished evangelist ...' But lacking that vital ability, it concluded that he could not be retained.

As at Laeken, we may suspect that indifferent performance as a preacher was a convenient reason to discharge him, and that, without wishing to utter such an unChristian judgement, the committee thought he had taken self-mortification too far and were troubled by his lifestyle and filthy appearance. When Vincent returned to Brussels to plead with Pietersen, one of his former teachers, the door was opened by the minister's daughter, who was so frightened by this grimy apparition that she ran off, shouting for her father.

Although a member of the committee which discharged him, Pietersen had always been sympathetic to Vincent and, being interested in art himself, was fascinated to see his drawings of miners. It is unfortunate that few of these have survived, as he later thought of this period as the time when he 'began to draw', and that he was on the verge of his last, greatest change of direction. One witness recalled that Vincent used to go and 'sit on the slag-heaps, making drawings of the women while they were picking up coal or as they went away loaded with sacks'. It is certain that his interest in art remained as strong as ever, indeed stronger, whatever the vicissitudes of the coalfields.

Pietersen's appreciation of the drawings may have been the trigger for Vincent's decisive movement towards a career in art: the day after his visit he bought a good-quality sketchbook and, aware that his sketches were crude, he also acquired a well-known manual on drawing. But Pietersen also encouraged him in his determination

OPPOSITE LEFT
Jean-François Millet
The Sower, 1850
Oil in canvas, 40 x 32^1/$_2$in
(101.6 x 82.6cm)
Museum of Fine Arts, Boston, Mass.

OPPOSITE RIGHT
Jean-François Millet
The Sower, 1847–48
Oil in canvas, 37^1/$_2$ x 24^1/$_8$in
(95.3 x 61.3cm)
National Museum and Gallery of Wales

to carry on with his mission work in the Borinage, although no longer in the service of the Church. Vincent probably thought the Church might eventually take him back, which was unrealistic. Pietersen possibly thought Vincent would grow out of his desire for self-mortification, which he did, if only partially.

In a letter to Vincent's parents, Pietersen made a strikingly intelligent and elegant judgement about their eldest son. 'Vincent', he wrote, 'strikes me as someone who stands in his own light.' That remark could be read in two different senses, both of them, in different ways, true.

He made a brief vist to his parents in Etten, where his mother observed that he spent much of his time reading Dickens's *Hard Times*, which attacks the vicious social effects of rampant industrial capitalism. Theo arrived, and apparently criticized Vincent for failing to adopt some useful calling. Although they parted on good terms, Vincent was going through another spiritually destructive period in which he was manifesting feelings of persecution, and his resentment, grumbling on, led to a long break in the correspondence between the brothers.

He went back to the Borinage, this time to another village, Cuesmes, a few miles south-west of Mons. Initially, he shared lodgings with another evangelist next door to a mining family, the Decrucqs. Conditions were no better here, and therefore neither were

OPPOSITE and LEFT
The Sower, 1881
*Pencil, pen and brown ink, 23⁵/8 x 17³/4in
(60 x 45cm)
Private collection*

AMONG THE MINERS

Vincent's. He even gave away money he was sent by his father, who could not easily afford it. Decrucq took him down another mine, and although politics were alien to him, he was incensed at the working conditions and miserly wages. He went to see the employers to seek improvement, but was sent off with a threat to have him 'shut up in the madhouse'. Socialism and the working-class movement had not yet penetrated the Borinage (though they were very soon to do so), yet the miners were talking of a strike and of setting fire to the mine. Vincent is said to have talked them out of that. The Decrucqs were especially grateful to him because he nursed their small son through an attack of typhoid. Sad to say, the boy died later in a mining accident, aged eight.

Vincent's rejection of the most basic amenities – the Decrucqs heard him crying desperately at night, trying to sleep without blankets in a particularly cold winter – must have affected his constitution. He was probably also suffering from malnutrition, as he ate little but crusts, potato peelings and other scraps. Yet his remarkable stamina remained unaffected, for one day he decided, for reasons that can only be guessed at, to call on his hero Jules Breton, who had recently built a house for himself in Artois, less than 40 miles (60km) away. In wet and icy weather, sleeping under hedgerows or woodpiles, he walked all the way there in one week. He took one look at the splendid bourgeois mansion in which Breton now resided, and lost his

nerve. He slunk away, and walked all the way back to Cuesmes.

But in some strange way, this aborted visit may have been another trigger. Already, Vincent had almost given up preaching. He no doubt felt that since the Church had given up on him, he should give up on the Church. This, and the knowledge that he would never follow in the footsteps of his father, must have added to the spiritual torment of this winter. Drawing occupied more and more of his time. He even had a customer of sorts. His father, visiting him, had admired a map he had made of the Holy Land, and ordered four copies at ten guilders apiece.

If his religious urge had become less compelling, it did not mean that he was becoming an agnostic. Art, too, had a missionary purpose; it had to be a creation for, and of, the people. Vincent was as much an evangelist when he drew as when he preached. In a long and famous letter of July 1880, in which he repaired the breach with Theo, he reviewed his own life and prospects with notable realism and comprehension, though not without an understandable degree of self-justification. In that letter he spoke of Rembrandt, Shakespeare and the Christian Gospels as all having the same virtue, the same purpose: 'I think that everything which is really good and beautiful – of inner moral, spiritual and sublime beauty in men and their works – comes from God.' The two strands, art and religion, in the sense of service, ran parallel through his life, one or other of them ascendant but both always present. It was religion, or at least social conscience, that

led him both to work with the poor and to become an artist.

In October 1880 Vincent sadly left the Borinage, though it long remained in his memory and passing time made it seem more romantic in his imagination. Before he left, he went to say goodbye to one of the local ministers, Pastor Bonte. As he plodded off down the road in bare feet, head bent, carrying his pathetic possessions on his shoulder, children shouted after him, 'He's mad! He's mad!' The minister stopped them, and said to his wife, 'We took him for a madman, and perhaps he's a saint.'

Vincent had made the great breakthrough. He had decided to be an artist. Of course he knew a great deal about the subject, for which he had felt real passion in his days with Goupil's, if not even earlier. He had also been taught art at school by a good teacher and had been drawing and sketching off and on, but lately quite intensively, for many years. He had made copies of works he admired (at least five of Millet's *The Sower*, page 44); he had learned much by reading and looking, and had almost mastered, for instance, the art of perspective, which had always been a trying problem (though he was still complaining of its difficulties years later). He had even sold one or two drawings, if only to well-wishers like his father (the maps of the Holy Land) and Pietersen, who bought a couple of drawings of miners.

Nevertheless, he was well into his twenty-eighth year, penniless, except for the 60 francs a month his father was giving him, and inexperienced, and although he showed ability, it was not an exceptional talent. If he had made his aborted pilgrimage to Jules Breton with the vague hope of being taken on as an assistant, the most likely explanation for his journey, he would surely have been disappointed. Breton, his great fame notwithstanding, was a kindly, humane man, but he was the most meticulous of painters, renowned for his minute, Pre-Raphaelite accuracy of detail. Vincent's rough, crude sketches would not have impressed him.

CHAPTER THREE
APPRENTICESHIP

Vincent realized he needed professional help and advice. He was hoping to come to an arrangement with an established artist so that he could enter his studio to learn and practise, and to this end went to Brussels to see Goupil's manager there. It was rather an odd approach, as he could hardly expect to be welcomed with open arms after his record with the firm, but an additional complication, of which he was unaware, was that the manager, Schmidt, happened to be involved in a legal dispute in which he was about to be sued by

The Young Gardener, 1881
Black chalk and watercolour, 18½ x 24in (47 x 61cm)
Rijksmuseum Kröller-Müller, Otterlo

The subject was probably the Van Goghs's gardener, Piet Kaufman (see page 58).

members of the van Gogh family. Still, Schmidt did give him the sensible enough advice that he should apply for entry to the Brussels Academy (Ecole des Beaux-Arts).

In mid-October, barely three weeks after his previous letter from Cuesmes, in which he had made no mention of his plans, he wrote to Theo at Goupil's, Paris (now, properly, Boussod & Valadon), from whom he hoped for financial as well as professional help. Theo, a fast learner and hard worker, had, unlike his elder brother, made great progress in his professional career since beginning at Goupil's in the Place de l'Opéra at the age of twenty-one in 1878, and had become a significant member of the art establishment. He had had a piece of luck after he had only been in Paris for a few months, when at a major exhibition organized to celebrate the emergence of the Republic from the disasters of the Franco-Prussian War and the Commune, Theo had been left in charge of Goupil's stand in the specially built Palais de Trocadéro (demolished in 1937), which housed the exhibits related to art and culture. In that capacity, and alone on the stand, he came face to face with the president, the grand though politically dubious (to say the least) Comte de Mac-Mahon, the man who had crushed the Commune. With the great dignitaries of the state looking on, the president engaged the young Dutchman in a brief conversation, to which Theo responded with aplomb; the President, satisfied, nodded and moved on.

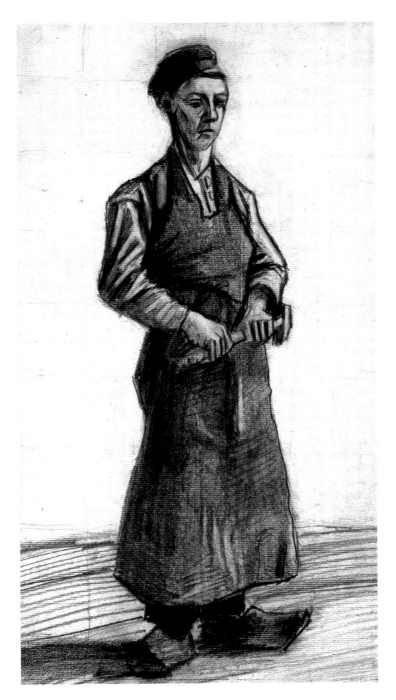

The Young Blacksmith, 1882
Black chalk and pencil on paper,
17³/4 x 9¹/2in (45.1 x 24.2cm)
Private collection

This is alternatively known as The Young
Carpenter.

The incident made Theo famous and he was subsequently appointed to head Boussod & Valadon's second gallery in the Boulevard Montmartre.

Theo had realized that there was more to contemporary art than the tradition represented by the now elderly Gérôme and other stars of the Salon; at his gallery he now took a more open approach, cultivating artists still excluded from the official approval of the academy. While not forsaking the establishment, he also moved socially in far more 'advanced' circles. He was often to be found at Le Chat Noir, a somewhat scandalous, bohemian cabaret frequented by all kinds of more or less doubtful characters on the fringes of the cultural world mingling with respectable figures like himself, and later associated with the magazine of the same name.

In 1879 Theo attended the Fourth Impressionist Exhibition and was smitten by the work of Caillebotte, Cassatt, Degas, Monet, Pissarro, Rouart and others he saw there. The change it made to his whole view of art would also affect his brother, Vincent, for whose support Theo would soon become almost solely responsible. His almost unique loyalty and generosity to his brother over a decade sprang partly from a belief in Vincent's talent, but rather more from fraternal devotion. They became almost like two halves of the same person, and Vincent did not exaggerate when, years later, he said that Theo ought to be regarded as co-author of his work.

RIGHT and OPPOSITE
In the Rain, 1882
Watercolour on vellum, 11¹/₄ x 8¹/₄in
(28.5 x 21cm)
Gemeentemuseum, The Hague

This is otherwise known as Scheveningen Women and Others under Umbrellas.

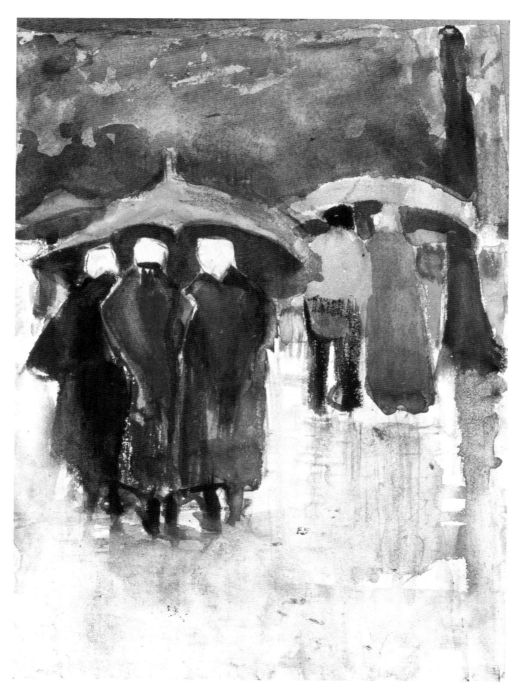

ups and downs, usually related to his progress, or lack of it, with his drawings. He must have produced a great many at this period, his formidable will power overcoming semi-starvation and poorish health, but very few of them have survived. Some he drew from a model: an old man, a poor labourer, a young boy, no doubt other neighbours, posed for him. He copied Bargue's exercises and made a full-size sketch of a human skeleton, for which he glued five pieces of paper together, and others of animal skeletons that he begged or borrowed from the School of Veterinary Science. Other drawings he said were influenced by the illustrators he had admired – as much for their social content as their skill – in London. At this time Vincent thought of himself as aspiring to such work.

While he still loved landscapes, 'I love ten times more those studies from life'. He sent a couple to Theo, remarking, 'I see perfectly well that they are not good, but they are beginning to look like something.' And 'I shall make more progress – I feel it, and know it.' Yet it is strange that Vincent, with his powerful desire to devote his art to the lives of poor and simple people, seemed to think only of the peasants of North Brabant or the miners of the Borinage in that category, not the urban underclass of Brussels or any other city.

During the winter of 1880–81 van Rappard attended classes at the Academy, and Vincent probably went with him. We know little of what he was doing at that time because there was another, though

shorter, breach in his correspondence with Theo. The slight paranoia evident in the letter with which Vincent renewed contact in January may be an indication that he had experienced another mental 'down', though he seems to have recovered soon afterwards.

In April 1881 van Rappard moved on to Utrecht and Vincent, hearing that Theo was expected for Easter, returned to Etten. He was tired of the city, never his favourite milieu, apart from the expense, and wanted to draw in the countryside. His father had recently been ill, and his convalescence had probably not been helped by a visit he had made to Brussels. Vincent, influenced by van Rappard, had at least bought himself some decent second-hand clothes, but his rejection of the Church, his rough style of life and, to his father's eyes, unpromising drawings, offered no grounds for optimism, nor any likelihood that he would cease to require financial support in the future.

ARTISTIC PROGRESS, EMOTIONAL DISASTER

For some time life at Etten went smoothly enough. Vincent spent many hours sketching in the countryside, sometimes accompanied by van Rappard, who stayed nearly two weeks. Theo came when he could, and the brothers went on long walks over the heath, Vincent probably doing most of the talking, Theo the listening. Vincent wanted Theo's advice on some drawings he talked of sending to a magazine.

RIGHT and OPPOSITE
The State Lottery, 1882
Watercolour, 15 x 22³/₈in (38 x 57cm)
Rijksmuseum Vincent van Gogh,
Amsterdam

This watercolour shows how Vincent was
learning to handle a large group of people
without sacrificing animation.

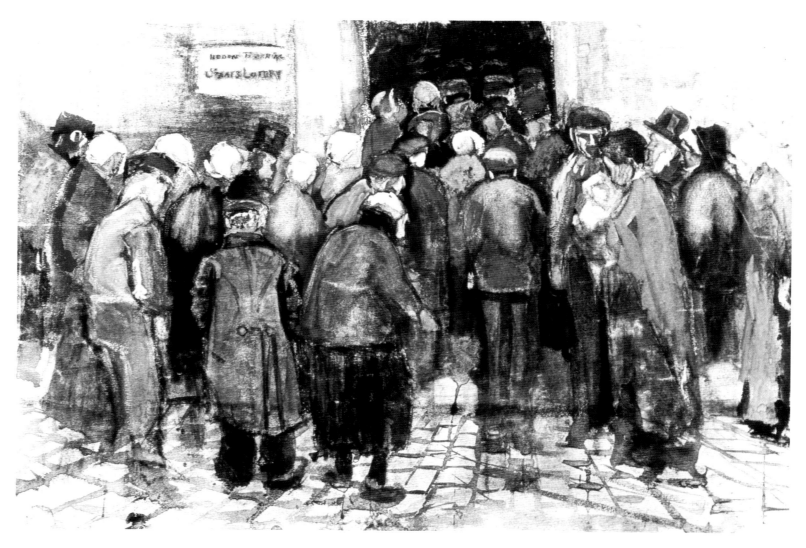

APPRENTICESHIP

OPPOSITE

Memories of the Garden at Etten, 1888
Oil in canvas, 28³/4 x 36¹/4in
(73 x 92cm)
Hermitage Museum, St. Petersburg

This was painted at Arles under Gauguin's
influence (see Chapter Eight).

He drew intensively, preferably out in the countryside and, if it was raining, in village workshops – the blacksmith's forge or the carpenter's shop. These interiors gave him more difficulties with perspective, and in his figures his modelling was still crude. Recognizing his continuing need for guidance, he went to The Hague to see his old boss and friend, Tersteeg, and his cousin Anton Mauve, now, at 43, one of the leaders of The Hague School.

Vincent was making progress nonetheless. His drawing, *The Young Gardener*, page 50, for example, though possibly based (like many others) on a Millet subject, shows his growing mastery of figures. The accusation that van Gogh could not draw is still sometimes heard, and indeed has been made against many other modern masters, but it is quite as unjust when applied to Vincent as to most others. Moreover, while it is easy to pick out faults and inadequacies, many of the most moving works in the history of art are not, when closely examined, technically perfect, and there is the additional consideration with Vincent that some supposed faults are quite conscious, the result of deliberate negligence, something that, like studying Greek and Latin, was irrelevant to his aims rather than the result of accident or ignorance.

As he was himself so acutely aware, he lacked the academic training that was the basis of the careers of most artists. He had to figure things out for himself, with what help he could muster from his own experiments and experience, from Bargue and from admired masters such as Millet. If indeed he had enjoyed the benefits of art-school training, it is a moot point whether he would have turned out a better artist; one is inclined to think not. Vincent was determined to succeed so that he could earn a living, and never was a man more determined than he.

He was aware that he was improving. 'I have learned to measure and to observe and to seek for broad lines', he reported to Theo. 'So what seemed impossible before is gradually becoming possible now, thank God.' This sense of progressing, despite occasional recessive periods, explains his general contentment at this time. But his easy equilibrium was to be disrupted in August, when his cousin, Kee Vos, came to stay, Vincent's mother having invited her out of sympathy.

Kee's husband had recently died and she was again in mourning, still 'The Lady in Black'. Her serious mien and greater maturity (Vincent seems generally to have been drawn to older women) made a powerful appeal to her all-too vulnerable cousin who, already nursing a fond image of her from their meeting in Amsterdam in 1877, fell hook, line and sinker. They seem to have enjoyed each other's company. Kee was especially appreciative of his kindness to her four-year-old son, and as Vincent loved children, there is no reason to suppose that his avuncular affection for the boy was designed merely to enlist the mother's sympathies.

It was Ursula all over again. Vincent was in seventh heaven, though keeping his feelings to himself, until one day they all came flooding out. Kee was appalled. 'No, no, never!' she exclaimed, words that rang through Vincent's head for a long time afterwards. She left immediately, but as with Ursula, Vincent was unable to take no for an answer. There was one difference, however. Instead of sinking into depression, nursing his grief and refusing to let anyone know its cause, he stridently proclaimed his feelings. He was determined to follow his love to Amsterdam, but his father refused to provide the fare and Theo failed to respond to his brother's appeal. When van Rappard arrived for another visit in October, he found Vincent so impossible that he soon left again.

In November, Theo finally gave in and sent money. Vincent left for Amsterdam and went straight to the house of Kee's parents, the Strickers. She was not there. The old minister said she had left the house, but Vincent suspected she was hiding away upstairs somewhere. A lamp was burning on the table and Vincent held his hand deliberately over the top of the flame, swearing that he would not move it until they allowed him to see their daughter. Pastor Stricker hastily blew out the lamp (the burn was superficial). Impasse ensued. Finally, he left.

This defeat left Vincent in an angry mood. He went to The Hague, to call on Mauve, who noticed the damage to his hand,

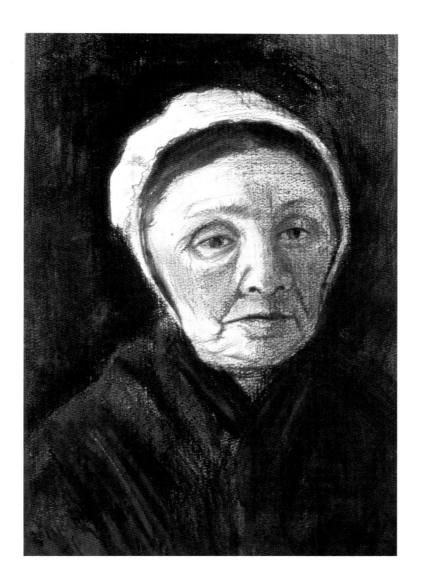

which Vincent somehow explained away. Mauve had already told him he ought to take up painting and, producing a still life, began to explain some basics about colour. But Vincent was clearly not paying full attention.

That evening he went off by himself into the city and picked up a prostitute. She was not particularly beautiful, nor even feminine, he told Theo, and she had the hands of a working woman. Characteristically, he went on to say that 'she reminded me of some figure by Chardin or Frère, or perhaps Jan Steen'. She was 'very good to me, very kind ... We talked about everything ... and I had a more interesting conversation than, for instance, with my very learned, professorial cousin.'

At least this disaster had a less damaging effect on him than his failure with Ursula, but he never forgot Kee. Marc Edo Tralbaut, one of the foremost experts on van Gogh thirty years ago, believed that in the painting usually known as *Memories of the Garden at Etten*, painted at Arles in late 1888 (page 59), the younger of the two women portrayed (the elder is his mother) is not his sister Wilhemien (Wil), as generally supposed since she was the daughter who remained unmarried and looked after her old mother, but Kee Vos.

Vincent's mood may have been less depressed, but it did not produce an easier atmosphere at home. His feelings this time were not of failure and despair but of anger and resentment. His parents

OPPOSITE
Beach at Scheveningen in Stormy Weather, 1882
Canvas on cardboard, 13^1/2 x 20in (34.5 x 51cm)
Stedelijk Museum, Amsterdam

This excellent seascape is one of only about twenty-five surviving oils from Vincent's period in The Hague, though he probably painted about three times as many.

LEFT
Head of an Old Woman in a Scheveninger Cap, 1882–83
Charcoal, black and brown chalk, 14^1/8 x 14^1/8in (36 x 36cm)
Gemeentemuseum, The Hague

The model may have been the mother of Sien, Vincent's lover in The Hague, who was hardly 'old', at least by our standards.

were equally angry over his behaviour at the Strickers's house. He quarrelled badly with his long-suffering father who, according to Vincent, became so worked up that he roundly cursed him. Vincent left for The Hague.

He came back a few weeks later for Christmas, but his behaviour had not improved. He was thoroughly difficult and wounded his father by refusing to go to church on Christmas Day. Theodorus told his son he had better leave, and Vincent returned to The Hague the same day

IN THE HAGUE AGAIN

In more ways than one, his residence in The Hague, which lasted from January 1882 to September 1883, was a major turning point in the life of Vincent van Gogh. Above all, perhaps, it marks his rejection of the Church and his adoption, in effect, of art rather than Christianity as his religion. His refusal to go to Church at Etten on Christmas Day was not merely a show of pique directed at his father. Not only did he cease attending divine service, he also no longer read the Bible. Yet this change was not such a fundamental one as it appeared. While he was now hostile to organized religion in general, one thing that did not change was his powerful humanity, his encompassing sympathy for the poor and oppressed, which arguably was always the chief motive driving his commitment to

evangelism. He was, however, thoroughly disgusted with the religious establishment and the ministers who formed it. 'There really are no more unbelieving and hard-hearted and worldly people than clergymen ...'

This new hostility to the clergy was fuelled by his anger at the behaviour of members of his family, including Pastor Stricker, the really quite blameless father of Kee. Much worse was his father, whom he had always looked up to and once hoped to emulate. Theodorus had entirely forfeited his son's respect by losing his temper and swearing at him. This undoubtedly shook Vincent, but he characteristically found little at fault in his own behaviour while roundly condemning his father's. When Theo, on hearing (belatedly) of the events at Etten, responded with a firm defence of their parents and – most unusually – sharp criticism of his brother ('childish and impudent'), Vincent was quite undismayed.

The period at The Hague also marks the first stage of Vincent's career as a serious artist. He completed hundreds of works, mainly drawings (many of them now lost), which demonstrate that he had passed the stage of being merely promising. Some of the credit for this should go, and Vincent indeed gave it, to Anton Mauve.

It would be tempting to see his older relation (by marriage) as a kind of substitute father figure, but in fact their relationship, before the inevitable falling-out, was brief, a matter of weeks rather than

months. Mauve received Vincent as both needy relative and eager student with considerable warmth and was generous with both time and money, lending him 100 guilders to pay for furniture (Vincent said he was quite willing to sleep on the floor, as he had done in the Borinage, but Mauve persuaded him he ought to have a bed).

Vincent admired Mauve's work and Mauve was full of praise for Vincent. He viewed his prospects optimistically. 'I will help you earn money, you may be sure that now your hard years are over and the sun is rising for you – you have worked hard and honestly deserve it.' He got him a place at the Pulchri studio, where he was able to draw figures from life and meet other artists.

OPPOSITE
Wood with Girl in White, 1882
Oil on canvas, 15³/₈ x 34¹/₄in
(39 x 59cm)
Rijksmuseum Kröller-Müller, Otterlo

This is one of the best known of Vincent's early oils. The theme of a girl in white against a tree was inspired (according to Marc Edo Tralbaut) by an English illustrator, Perry McQuoid. The depth of the impasto in this and the painting on the left cannot easily be conveyed by photographs.

ABOVE LEFT
Cow Lying Down, 1883
Oil on canvas, 11⁷/₈ x 19⁵/₈in
(30 x 50cm)

For a time at least, Mauve seems to have enjoyed his role as instructor. How much he was responsible for technical improvements, in figures especially, or indeed in what way he influenced Vincent's work in general is not easy to say, but without doubt Mauve's most important contribution was to persuade him to take up colour, at first watercolour; he had sent Vincent a paintbox while he was still in Etten.

'Yesterday,' Vincent reported to Theo in late January, 'I had a lesson from Mauve on drawing hands and faces so as to keep the colour transparent. Mauve knows things so thoroughly, and when he tells you something he exerts himself and doesn't just say it to hear himself talk, and I exert myself to listen carefully and to put it into practice.' As always, he worked with determination. 'I must try to forget some things I taught myself, and learn to look at things in quite a different way ... It takes a lot of effort before one has a steady eye for the proportion of things.' His success can be best be seen in some of his ink drawings of local people, and in watercolours of landscapes, including many of Scheveningen.

Vincent had seen his professional future as a commercial artist, an illustrator who could draw well enough to match those responsible for the woodcuts in the English and French newspapers, including Daumier and Doré, whom he so much admired. That admiration continued, and Vincent accumulated a sizeable collection

OPPOSITE

Man with a Spade Resting, 1882
Pencil and chalk, 23 x 16in
(58.5 x 40.7cm)
Private collection

LEFT

The Bakery on de Geest, 1882
Pencil and charcoal on vellum, 8 x 13¹/₄in
(20.4 x 33.6cm)
Gemeentemuseum, The Hague

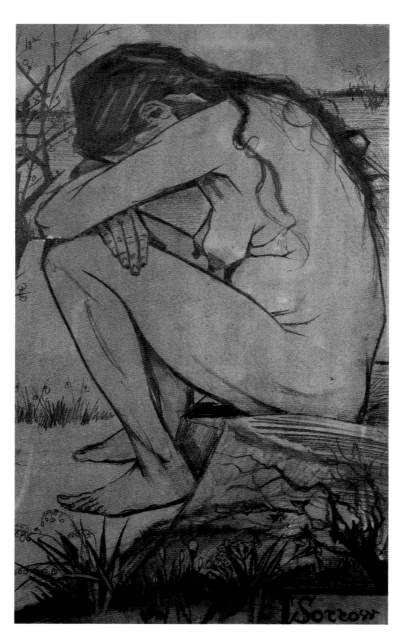

RIGHT and OPPOSITE
Sorrow (Sien), 1882
*Pencil, pen and ink, 17¹/₂ x 10⁵/₈in
(44.5 x 27cm)
Walsall Art Gallery, England*

*The title of this famous drawing of Sien
was inscribed by Vincent himself. It is
perhaps the most memorable image among
all his graphic work.*

of prints while in The Hague – which, as he acknowledged, really belonged to Theo, having been bought with his money. But he was about to move forward again.

Vincent was intimidated at the prospect of tackling the more complex technique of painting in oils, but Mauve helped to disperse his reservations and, having made the breakthrough, of course Vincent took to oils with single-minded enthusiasm. He soon advanced well beyond Mauve's aesthetic, laying on the impasto so thick that the painting is virtually three-dimensional, like a sculpted relief, and working it with his fingers as well as his brush, as in his picture of an almost surrealistic, masticating *Cow Lying Down* (page 63) or in *Wood with Girl in White* (page 62), though the earliest oil paintings that we have date from August 1882, after the end of his association with Mauve. He would also sometimes squeeze the paint straight from the tube on to the canvas.

Another friend from whom he expected help and encouragement was the dealer Tersteeg, with whose family he had been so friendly on his earlier stay in The Hague. Tersteeg was now on close terms with Theo, through their business association. Vincent assumed his relationship with the Tersteegs would continue in the old way, and at first Tersteeg was encouraging. In the summer of 1882 Vincent went on walks with the Tersteeg children he had played with as toddlers, now aged nine and thirteen. He surprised them by walking along the

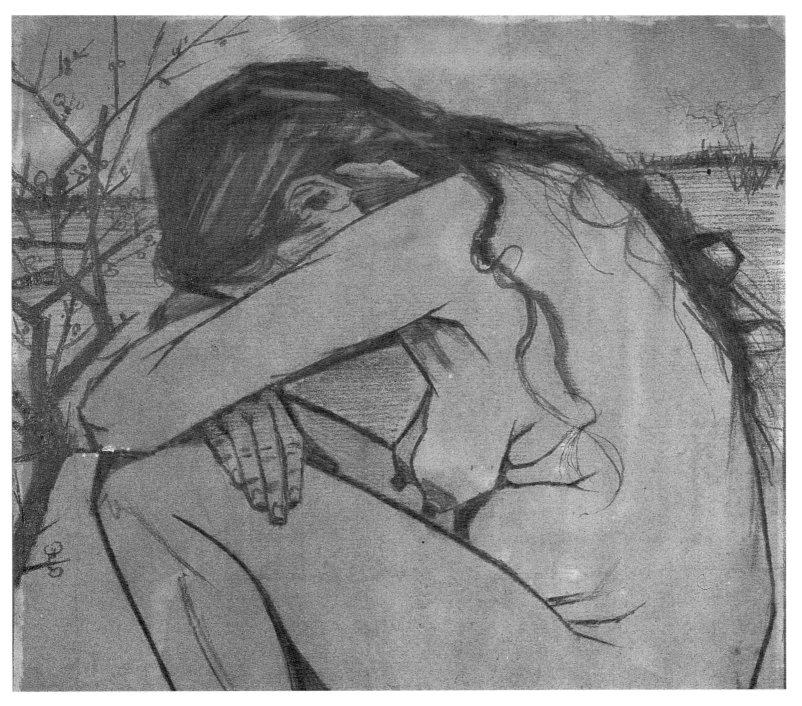

tops of the dunes on a very hot day when they preferred to take advantage of the shade. When asked why he courted sunstroke, he answered, 'It is a sacrifice I must make for art.' Perhaps he meant that he wanted to see the countryside, not particularly beautiful it must be said, stretched out before him in the sunshine, but what the children made of such a remark we can only guess.

He also hoped that Tersteeg would take some of his work but, after buying one small drawing, Tersteeg disappointed him. Indeed, he soon became markedly unfriendly, frankly suggesting that Vincent was a poor graphic artist and mocking his aspirations to be a painter. Their relationship deteriorated to such an extent that Tersteeg threatened to use his influence with Theo to stop Vincent's regular allowance.

He was also commissioned by his Uncle Cor (Cornelius), the dealer in Amsterdam, who wanted a dozen views of The Hague. Vincent completed them quickly, and back came an order for six more. Although the fee was small, it really looked as if he was on the way to being a self-supporting artist, but Cornelius never acknowledged the second batch (he only paid for the first) and there were no more orders from Amsterdam.

Vincent had also quarrelled with Mauve. For all his apparent confidence, Mauve suffered, though to a lesser degree, from a problem similar to Vincent's: a tendency towards manic depression. His attitude depended to some extent on his mood, and while, if

pleased, his praise of Vincent's work was excessive, when displeased he was unreasonably angry. Within a few weeks of his arrival in The Hague, Vincent noticed that Mauve's attitude towards him was cooling sharply. He put it down to illness and difficulties with his own work, which may certainly have had something to do with it. But one day Mauve drew some caricatures of him, which Vincent said were good but 'drawn with hatred'. Increasingly, when he called at Mauve's house, he was told that he was out or unavailable. Finally, he stopped calling.

In these matters we are usually dependent on the testament of Vincent himself, and no doubt they would look rather different if we also had the other side of the story. The difficulties of Vincent's temperament were always liable to bring his relationships to a disastrous end, and he did tend to quarrel with all too many of the people to whom he was closest.

The cause of one quarrel with Mauve, which in fact proved the last, was a disagreement over drawing from plaster casts. Vincent had practised this discipline when tutoring himself with the aid of Bargue's exercises, but he never liked such disciplines and at this time had given it up entirely. He sought to paint the nature of things, their inner spirit, and a plaster cast has no spirit. Mauve's advocacy of the practice irritated him, especially when Mauve spoke to him about drawing from casts 'in a way such as the worst teacher at the academy would have spoken'.

Vincent did not react immediately, but when he got home he was seized by a fit of temper and swept all the casts into the coal bucket so that they were smashed. Then he said to Mauve, 'Man, don't mention plaster to me again, because I can't stand it.' Mauve's response was a frigid note saying he did not want to see him again for two months. After most of that time had elapsed, Vincent wrote to congratulate him on a recently finished painting, but Mauve did not reply. Vincent wrote again in conciliatory vein, ending with an acknowledgement of his 'feeling of gratefulness and obligation toward you'. Again, Mauve did not reply.

Some time later, they met by chance walking among the dunes. Vincent invited him to visit so that they could talk things over. 'I will not come and see you, that's all over.' Vincent was silent. 'You have a vicious character,' Mauve declared, whereupon Vincent turned and walked away.

Clearly, the ruptures with Mauve and Tersteeg and the mysterious silence from Uncle Cor were not merely the outcome of difficulties of temperament or disagreements over plaster casts. The trouble was, once again, Vincent's lifestyle (which no doubt inspired Mauve's accusation of a 'vicious character'); namely, that he was living with a 'woman of the streets'. In fact things got so bad at one stage that not only did Tersteeg, after visiting Vincent's new ménage, declare that the artist was mad, but that his father, as Vincent learned from Theo's tip-off, was making inquiries about having him

confined to an asylum. Fortunately, this was taken no further.

Although he was content to be part of it for four years, Vincent, as always taking in little beyond his own immediate concerns, had apparently forgotten just how strait-laced society in The Hague, including the art world, really was. Tersteeg was a good example: he was a handsome, extremely well-groomed and well-tailored professional gentleman whose ambitions were encompassed by his profession and whose ideas were perhaps shrunk by the weight of social convention. Mauve had tried to persuade Vincent to smarten up: besides buying him a bed, he made some endeavour to improve his incurably shabby appearance, urging him to obtain clothes that were not both ill-fitting and worn-out, though whether this had much effect we may doubt. A poor old woman who used to model at the Pulchri studio was so shocked by Vincent's destitute appearance that she would bring him a share of her food.

Even Vincent was not entirely oblivious to the fact that his new relationship would cause consternation: significantly, he delayed telling Theo of the affair for several months. But he seems to have been unaware how shocked respectable people would be.

Vincent had gone to a prostitute in reaction to his rejection by Kee, and may have gone to others. Some of his biographers believe that this first one, with whom he had clearly struck up some kind of bond, was the woman he subsequently lived with in The Hague, though the balance of evidence suggests he met her later; Vincent

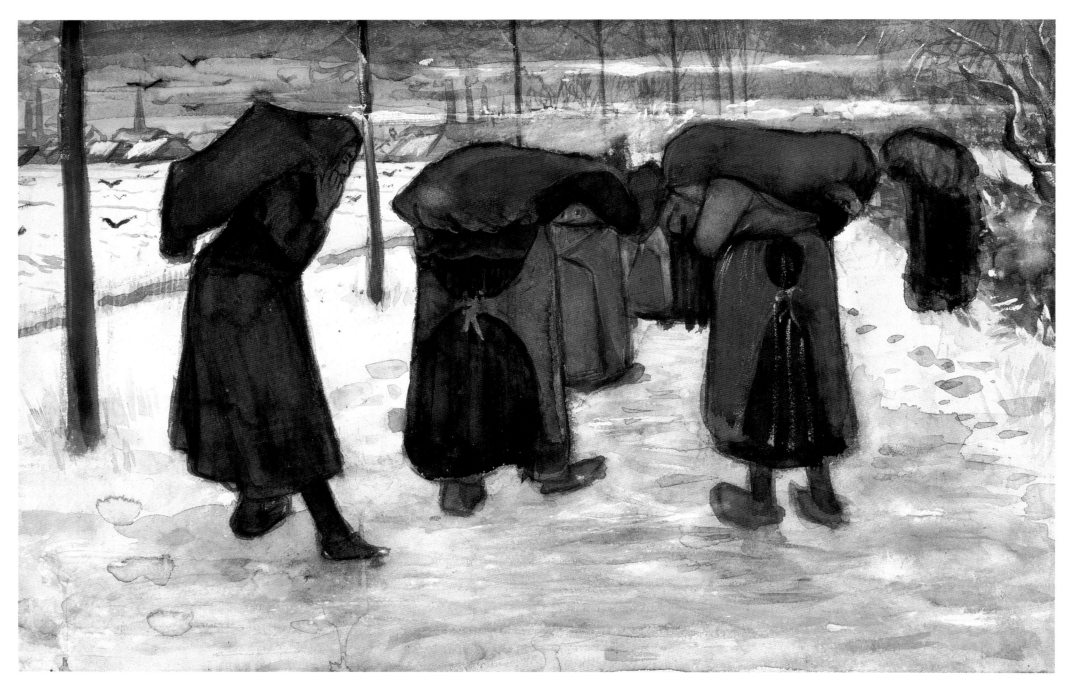

himself said he met her in late January. She was the only woman with whom, for a time, he experienced a shared household and family life. Knowing how a part of him longed for simple domesticity – 'You can give me money, yes,' he told Theo in 1884, 'but you cannot give me a wife and child' – that is sad.

Known to Vincent as Sien, her name was Clasina Hoornik. Whether or not she was his first, he admitted meeting her on the streets. She was three years older than he, with an illegitimate daughter aged five, and was pregnant with another child, whose father's identity was not known, possibly not even by Sien herself. She was the eldest child in a large but apparently not particularly poor family, and she seems to have taken to prostitution as the simplest way to make a living. It was not a good solution, certainly not long-term: she was probably never beautiful, and at nearly thirty-three she was tired, worn-out, dependent on alcohol and looked older than her years.

As one of life's lost sheep, she aroused all Vincent's pity and sympathy for those who suffer. He took her over as his model to save her from the streets, providing her with food, a bed, protection and, in his way, love. Such was his blissful ignorance of human nature that he quite genuinely supposed that 'every man worth a straw would have done the same'. Soon he was contemplating marriage, on the grounds that it was the only way to help her,

OPPOSITE
Women Miners Carrying Sacks of Coal, 1882
Watercolour heightened with white, 12¹/₂ x 19⁵/₈in (32 x 50cm)
Rijksmuseum Kröller-Müller, Otterlo

LEFT
Orphan Man Sitting with a Young Girl, 1882
Black chalk and pencil on paper, 19¹/₄ x 10¹/₄in (48.9 x 26cm)
Christie's Images

There are many sympathetic drawings of 'orphan men' – old men from the almshouse in The Hague.

71

'otherwise misery would force her back into her old ways, which end in a precipice'. Theo, in a kindly and tolerant response, firmly advised against marriage.

Sien was not an ideal model, being too indolent to maintain a pose for long, but she learned gradually, and Vincent thought she was responsible for his improvement in figure drawing. He may have been right. The pencil sketch that Vincent himself inscribed (in English) *Sorrow* (page 66) was done in April, with unsparing realism combined with deep affection. It is his best-known portrait of Sien, and he thought it was his best work to date. While no great work of art, it forms a telling rebuttal to Tersteeg's accusations of incompetent draughtsmanship. Vincent later made an engraving of it.

With Sien's pregnancy nearing term, Vincent became ill, so far as we know his first serious illness since childhood in spite of his notorious lack of care for his own welfare. The trouble turned out to be, not unexpectedly, venereal disease, presumably caught from Sien, and while she prepared to leave with her mother for the maternity hospital in Leyden, Vincent entered the City Hospital in The Hague, where he underwent the very painful and unpleasant contemporary treatment for gonorrhoea. It lasted for three weeks, and he accepted the situation stoically; he seems to have had strong resistance to physical pain and discomfort, an aspect, perhaps, of his powerful will.

Released after three weeks, he hurried to Leyden to find that Sien had given birth in a forceps delivery after long and painful labour the night before.

Now Vincent really had a family, and although we can be sure relations between him and Sien did not run smoothly, and it is odd and endearing to hear of him trying to persuade her to do some housework, he was genuinely devoted to them, and soon acquired more spacious accommodation. Of course, he was besotted with the new arrival, little Willem. He was not in the least concerned that the child was not his, nor that the father was unknown. His affection was expressed in letters to Theo. The baby, he said, absolutely refused to eat baby food ('a kind of porridge'), yet 'he bites resolutely at a piece of bread, and swallows all kinds of eatables with much laughing and cooing and all kinds of noises ... He often sits with me in the studio on the floor in a corner, on a few sacks; he crows at the drawings ... on the wall. Oh, he is such a sociable little fellow!'

Naturally, he drew the child frequently, one of the most attractive drawings being a sketch of 1882, called *The Cradle* (page 9), in which the baby is cosily ensconced next to a stove.

He was also painting more and more in oils, even apologizing to Theo for writing so often on this subject because 'painting is such a joy to me'. He had largely overcome his difficulties with perspective, having had a perspective frame made for him, similar, he pointed out, to the instrument described by Dürer, and used by members of the seventeenth-century Dutch school. He sent Theo a

careful drawing of it, and a precise description: 'I have just come back from the blacksmith, who made iron points for the sticks and iron corners for the frame. It consists of two long stakes; the frame can be attached to them either way ['portrait' or 'landscape'] with strong wooden pegs. So on the shore or ... in the fields one can look through it like a window. The vertical lines and the horizontal line of the frame and the diagonal lines and the intersection, or else the division in squares ... help one make a solid drawing and ... indicate the main lines and proportions.'

His methods were in some ways old-fashioned in the context of contemporary developments in art. His palette was traditionally dark, with small hint yet of the revolution wrought by Impressionist sunlight and fresh air, and although he made preliminary studies in the open air, he always finished his paintings in his studio, when even members of The Hague School had arrived at the notion of the finished painting straight from nature. In other respects, he was showing signs of finding his own way, strongly dependent on an instinct to imbue the painting with his own feelings. It has been remarked on the basis of Vincent's paintings of 1882–83 that, certain idiosyncrasies notwithstanding, he might have become a successful practitioner in the manner of The Hague School.

It would be wrong to suppose that the hostility of people like Tersteeg and Mauve made him an outcast. He had fruitful and encouraging contacts with other painters, particularly Jan

Weissenbruch, who, although nearly thirty years his senior, had made friends with Vincent as a tyro art dealer more than twelve years before. A successful landscape painter even then, Weissenbruch was a good-natured, carefree man with none of the neuroses that afflicted artists like Mauve – or Vincent himself. 'Merry Weiss', Vincent called him. He was known, or so he said, to be a ferocious critic, but he lavished praise on Vincent's watercolour landscapes and especially his ink drawings ('these are the best'). Vincent admired his work and was probably influenced by him, perhaps lightening his colours in his Scheveningen landscapes in accordance with Weissenbruch's landscapes. Weissenbruch told Mauve that Vincent 'draws confoundedly well', a welcome antidote to the Tersteeg school of criticism.

Another artist of some fame to whom Vincent showed his work was Jan Bosboom, best known for architectural interiors in the warm colours that proclaimed him an admirer of Rembrandt. Vincent was also on friendly terms, at least for a time, with other artists such as Willem Maris, one of three brothers who were all successful members of The Hague School, and the landscape painter Theophilus de Bock .

He went sketching with a painter named Georges-Henri Breitner, soon to gain a high reputation in the Netherlands, though largely forgotten now, and their association is reflected in their adoption of similar subjects, notably *The Soup Kitchen*, the sort of social-

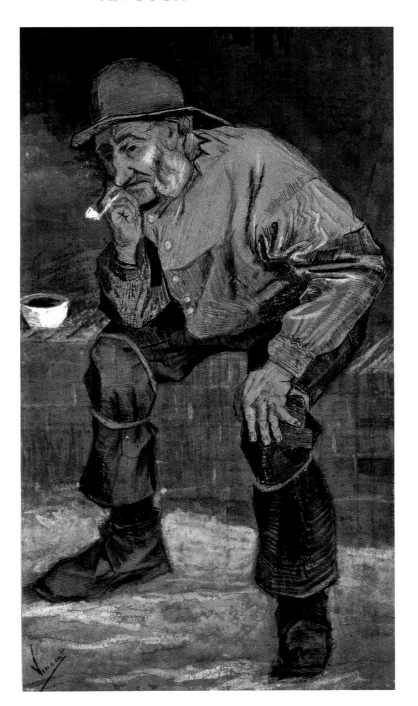

comment subject to which Vincent was still strongly drawn, and one he wrestled with over several weeks. So far as this type of subject was concerned, he was powerfully influenced at this time and later by the novels of Emile Zola. His reading also included English authors, especially Dickens and George Eliot, and early in 1883 he was reading a book in German.

Another friend, with whom he kept in touch mainly by letter – quite frequently to judge by the references to him in Vincent's letters to Theo – was van Rappard. So different in character, they were artistically in sympathy, and van Rappard, under Vincent's powerful influence, came to share his unusual enthusiasm for the English illustrators. He did make occasional visits to The Hague, and on his second visit, in May 1883, the two friends went off to Utrecht together. Van Rappard had been painting in the bleak, thinly inhabited fens and heaths of Drenthe, in the north-east of Holland and Vincent, who regularly became restless and pined for the countryside after a period living in a city, found van Rappard's account of that remote region appealing.

He was probably relieved to get away from home for a few days. Family life was not working out. Although Vincent had long been trying to convince himself that Sien was improving, in fact she was deteriorating, increasingly idle, given to fits of temper, again drinking heavily, threatening to drown herself when frustrated in

OPPOSITE
Peat Boat with Two Figures, 1883
*Canvas on panel, 14¹/₂ x 21⁷/₈in
(37 x 55.5cm)
Private collection*

LEFT
Old Man with a Pipe, 1883
*Pen and ink with charcoal, heightened
with white, 18¹/₈ x 10¹/₄in
(46 x 26cm)
Gemeentemuseum, The Hague*

*The sou'wester marks this man, with his
clay pipe, as a fisherman.*

anything and, worst of all, showing signs of resuming her old profession. The situation was aggravated by the presence of her mother, whom Vincent had invited to stay out of sympathy. She seems to have encouraged her daughter's vices and even to have tried to turn her against Vincent.

It must have been clear even to Vincent that this relationship was doomed. He was reluctant to admit it, but the tenderness and affection he had once shown when writing of Sien disappeared from his letters. He now referred to her simply as 'the woman'. As for Sien, she had probably never loved him, perhaps was incapable of love, and had long forgotten her earlier feelings of gratitude.

Vincent, as he often complained to Theo, was by now almost penniless; an irate tradesman to whom he owed money knocked him down one day when he said he could not pay. He pressed Theo to send a promised sum earlier than planned and, in what he admitted was a desperate move, took a large sketch to Tersteeg, along with some prints he had borrowed long before and never returned. He did not really expect him to buy the sketch, but hoped to re-establish their relations on a more amiable basis with a view to future sales. Tersteeg was civil but cool, and showed no sign of reviving his interest in Vincent's work.

Van Rappard, who had also helped him out financially by advancing a loan, paid another visit in August. He was going back

actie ~~his~~ *active en u opwekken* -

OPPOSITE *and* LEFT
Man Pulling a Harrow, c. 1883
Pen on paper
Rijksmuseum Vincent van Gogh,
Amsterdam

to Drenthe, and Vincent was tempted to join him. His eagerness for a rural environment, manifested in increasing visits to Scheveningen, was clearly not provoked solely by the oppression of city life nor by his feeling that he could live there more cheaply.

Theo was also applying gentle pressure, advising him that he must leave the sluttish Sien; when he too came to The Hague and saw Vincent's domestic situation with his own eyes, he increased the pressure, urging Vincent to act on his own inclination to join van Rappard in Drenthe and suggesting tactfully that it was his duty to obey his calling, which meant leaving Sien (and possibly costing Theo less money!). Vincent at first refused to contemplate deserting his little family, but he knew in his heart that Theo was right.

In the end, the parting with Sien was reasonably amicable. According to Vincent's account, they discussed the matter calmly, Vincent explaining that he had to get away for the sake of his work, and Sien accepting the fact. He hoped she might get a job or make a 'marriage of convenience'. Her family would look after the children.

According to one account, when Vincent left by train for the north-east in September, 1883, Sien and her two children came to the station to see him off.

Miserable creature though she no doubt was, Vincent recognized that she could not be held responsible for the poor hand that Fate had dealt her. Sien was the only woman with whom Vincent had shared his life. Henceforth, his sexual relations with women were confined entirely to brief commercial transactions.

When Vincent returned to The Hague the following year to collect some of the paintings and drawings he had left there, things were not as bad as he may have feared. Sien was working as a washerwoman and the children were living with various members of her family. That she had made this effort at respectability strengthened his feeling of guilt towards her, though he realized they could not renew their relationship. Later, she left The Hague and no doubt slipped from the path of virtue, wandering from place to place until, in 1901, she married a man in his fifties in Amsterdam, a 'marriage of convenience' for the sake of the children. Three years later, she carried out the threat she had often made to Vincent in her fits of anger and drowned herself. As Sydney Smith remarked, 'Life's a sorry business at best'.

In the Orchard, 1883
Lithograph
Christie's Images, London

The original drawing of this subject has apparently not survived.

CHAPTER FOUR
NUENEN

RIGHT
Head of a Peasant Woman, 1884
Oil on canvas, 15¹/8 x 10³/8in
(38.5 x 26.5cm)
Musée d'Orsay, Paris

RIGHT
Head of a Peasant Woman, 1884
Oil on canvas, 15¹/8 x 10³/8in
(38.5 x 26.5cm)
Musée d'Orsay, Paris

OPPOSITE
Head of a Peasant Woman, 1884
Oil on canvas, 4³/4 x 3¹/2in (12 x 9cm)
Rijksmuseum Vincent van Gogh,
Amsterdam

To most eyes, the countryside of the Drenthe is not very attractive, an endlessly flat fenland of black earth under a grey sky, the horizon uninterrupted except by the occasional drawbridge or the sail of a peat barge, moving silently and mysteriously across the landscape in a canal below the level of the land. Over a century ago, this region was practically deserted, bereft of cities or towns, with only a scattering of villages of much size or even substantial houses, and hardly touched by the growth of industry. The mud-built cottages of the peasants, with their mossy roofs sloping down almost to the ground, seemed to blend with the earth. It was Vincent's mission to paint the peasants' life of toil and hardship .

He was pleased with the landscape, which he described as 'picturesque', and with the solitude. 'I see no possibility,' he told Theo, 'of describing the country as it ought to be done; words fail me.' His painter's eye saw, and in due course his canvases revealed 'level planes or strips of different colour, getting narrower and narrower as they approach the horizon. Accentuated here and there by a peat shed or small farm, or a few meagre birches, poplars, oaks – heaps of peat everywhere, and one constantly meets barges with peat or bulrushes from the marshes. Here and there lean cows, delicate of colour, often sheep – pigs. The figures which now and then appear on the plain are generally of an impressive character; sometimes they have an exquisite charm.'

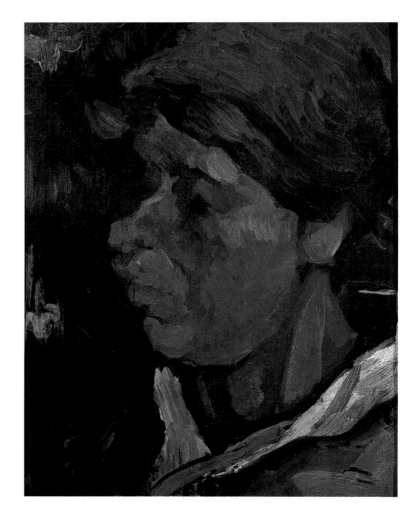

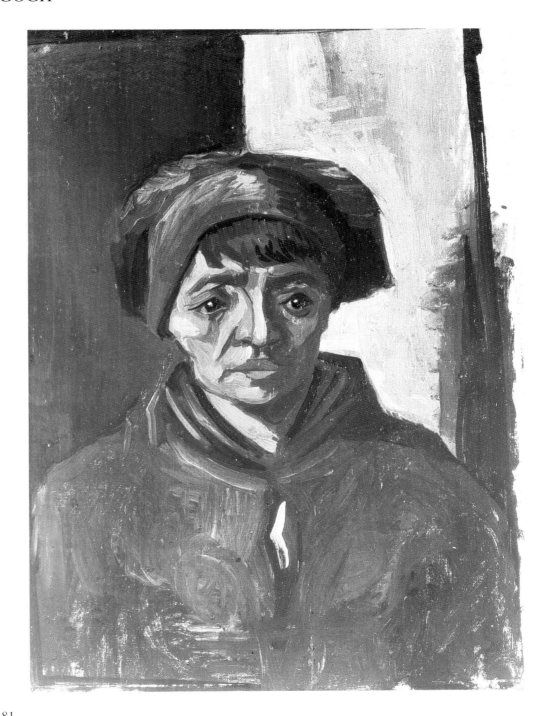

His desire for solitude created a conflict, however, for while desiring rural quiet and calm, he also longed to mix with artists, and after a month in pre-arranged lodgings at Hoogeveen, in the south of the region and accessible by railway, he moved by peat barge eastward to Nieuw-Amsterdam, not far from the German border, which, as he knew from van Rappard and others in The Hague, was often visited by artists. He stayed in a small, canalside hotel run by Hendrik Scholte, although his host was at first reluctant to admit such a ruffianly figure and it took Vincent a little time to win over his young children.

It was the grim aspect of the countryside that particularly appealed to him. One day he got Scholte to drive him in a cart to Zweeloo, a famously old place which had been visited by many artists, including Mauve and van Rappard. In fact, there was no one there now, and Zweeloo itself had nothing much to interest him, though he made a very accurate watercolour of the plain, barn-like church. But he enjoyed the journey: 'The sky, smooth and clear, luminous, not white but a lilac which can hardly be deciphered, white shimmering with red, blue and yellow in which everything is reflected, and which one feels everywhere above one, which is vaporous and merges into the thin mist below – harmonizing everything in a gamut of delicate grey ... When one has walked through that country for hours and hours [which he had to do to get

RIGHT
Ploughman and Potato Reaper, 1884
Oil on canvas, 27³/4 x 67in (70.5 x 170cm)
Von der Heydt Museum, Wuppertal

*Vincent made many studies of agricultural
scenes at Nuenen in the summer of 1884,
some of which he worked up into
paintings. This is one of only four
survivors.*

home], one feels that there is really nothing but that infinite earth –
that green mould of corn or heather, that infinite sky. Horses and
men seem no larger than fleas. One is not aware of anything, be it
ever so large in itself; one only knows that there is earth and sky.'

Every morning, unless the weather was threatening, he would set
off, walking across the countryside, his eye ever alert for a
promising subject. He was painting as much as drawing, beginning
to become engaged with theories of colour (of which he could have
learned more from Mauve had their relationship not been cut short),
and using paint to create form, abandoning the classical emphasis on
clear outlines and adopting a technique that evolved from his own
experience, though in essence an old one – using lighter colours
among generally dark tones to give solidity to objects. There is
nothing 'picturesque' in Vincent's portrait of Drenthe, as he
accentuated its darker, grimmer aspects. Perhaps his mood was
partly responsible. He was torn by guilt over his desertion of Sien,
and when, walking over the heath, he met a poor woman with a
small child, tears sprang to his eyes.

A letter from Theo brought disquieting news. Theo had fallen
out with his employers, apparently as a result of the poor
performance of the upstairs gallery in the Boulevard Montmartre,
which under Theo had been made over to relatively avant-garde
painters, including Impressionists. Messrs. Boussod and Valadon

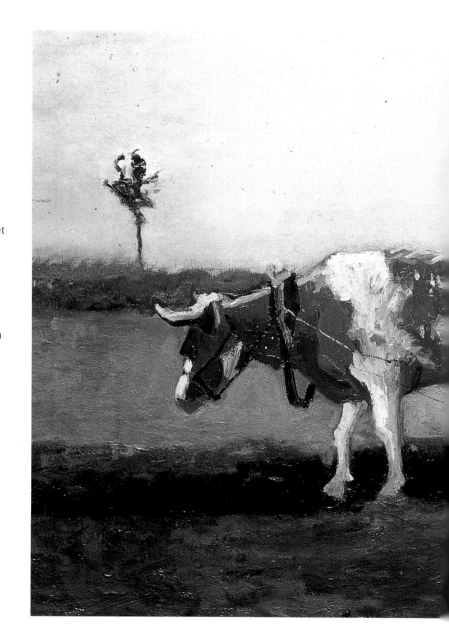

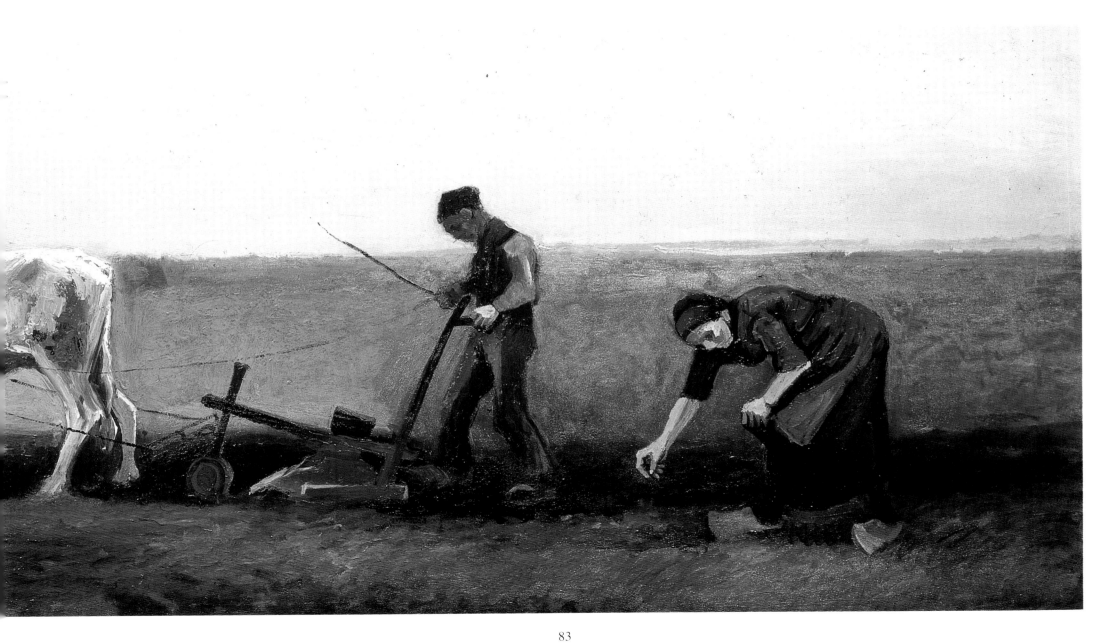

OPPOSITE
Two Rats, c. 1884
*Oil on panel, 11^1/$_2$ x 16^1/$_4$in
(29.1 x 41.3cm)
Christie's Images*

objected, not to the aesthetics but to the profits, or rather the lack of them. Few pictures sold and, more significantly, they fetched only a fraction of the price of the established Goupil artists. Theo was fed up, and was contemplating emigrating to the United States to set up his own gallery in New York. He knew he could get the financial backing he would require from the man who had taken over Goupil's branch in New York.

But what would this mean for Vincent? Not only would Theo no longer be able to support him financially, at least not for the foreseeable future but, hardly less vital, he would be deprived of the moral support provided by their occasional meetings and their correspondence, which at times amounted to almost a daily exchange of letters.

Rather unusually, Vincent showed some of his brother's tact in his response, insisting that Theo must do what was right for him and not worry about Vincent. For a time he was in near-despair at the prospect of Theo's departure, but in the end it never happened. Theo's good relations with his bosses were restored a few months later, perhaps helped by Theo's first sale of an Impressionist (a Pissarro), though his decision to abandon the plan may have been largely due to his realization that, if he went, Vincent was lost.

Another notion of Vincent's that became for a time something of an *idée fixe* was that Theo himself should become an artist. 'So, boy,

do come and paint with me on the heath, in the potato field, come and walk with me behind the plough and the shepherd ... I am so deeply convinced of your artistic talent that to me you will be an artist as soon as you take up a brush or a piece of crayon ...' Probably the idea was inspired by the desire for Theo's company, combined with Vincent's instinctive aversion to the bourgeois establishment to which art dealers as well as pastors belonged, but it was a singularly impractical idea, even by Vincent's standards. Not only would Theo be unable to support him, he would be unable to support himself!

Meanwhile, winter was drawing in, outdoor painting was increasingly restricted and would soon become impossible. Vincent, penniless as usual, was unsure where to go next. Although he had not been home for so long, the rupture with his parents had dimmed and they had recently shown signs of wishing for reconciliation, further encouraged when he left Sien. More than once his father had sent him money. With nowhere else to go, Vincent decided to go home.

Typically, he went suddenly, without much notice and no clear indication of his plans. He left one morning, telling the Scholtes he would return – soon, they supposed, and that was no doubt what he intended at the time – and walked for six hours in the December sleet to the railway station at Hoogeveen. In his room he left piles of

85

NUENEN

OPPOSITE

Church at Nuenen with Churchgoers, 1884

Oil on canvas, 16⅓ x 12⅝in
(41.5 x 32cm)
Rijksmuseum Vincent van Gogh,
Amsterdam

This is one of the 'trifles', as he called them, that Vincent painted for his mother while she was laid up with a broken leg.

drawings, paintings and artists' equipment. When he did not reappear, the Scholtes locked the room up and apparently touched nothing for years, although they did occasionally give away a drawing as a cheap gift to a friend or relative, some of which have survived. Eventually, it became obvious that 'the painter-chap' was never coming back. One of the daughters reported that 'nobody thought anything of those strange things', and her sister finally 'burned the lot in the stove'.

WITH THE FAMILY AGAIN

In December 1883, home was no longer in Etten. Theodorus had made yet another move, his last as things turned out, to the village of Nuenen, near Eindhoven. Although it brought another small rise in salary, it could hardly be seen as promotion as the village was small, the church smaller, and the house was dilapidated. Moreover, the district was predominantly Roman Catholic. Dorus's little church was dwarfed by the spanking new Catholic parish church at the other end of the street, and his social stature was markedly inferior to that of the Roman Catholic priest.

Although Theodorus had one or two wealthy individuals in his congregation, most of the people were desperately poor. The agricultural recession was making it difficult to survive as a farm worker, and the peasants were reduced to conditions of the harshest poverty. At that time, the relief of the poor was the responsibility, not of the government, but of the churches and religious organizations, and Dorus was most occupied with his work as the local governor of the Society for the Promotion of Welfare rather than the usual pastoral care. Otherwise, the main occupation of the district was weaving, which was mostly still organized on the basis of a cottage industry, each man working at home, doing piecework at a miserable rate.

When Vincent arrived on his father's doorstep, his greeting was less enthusiastic than that accorded to the Prodigal Son. He was as shabby as ever, as eccentric and, it soon appeared, even more aggressive than before, hardly likely to be a peaceful presence in the household and certain to cause, at the least, hostile gossip in the community. Still, he was there. They could only hope that his stay would be brief. Meanwhile, a large wooden storage shed attached to the house was converted into a serviceable studio.

Family fears were soon realized as Vincent proved as intractable as ever. He declined to moderate his hostility to the Church, ranting against the clergy and all organized religion, apparently oblivious to the work his father was doing to help the poor. At the same time, he resented what he considered his family's failure to understand him, and blamed all his difficulties on his father for driving him out of the house two years earlier, just as he blamed him for driving Theo into

the soulless existence of an art dealer when he should have followed the far superior occupation of artist.

Lunch at the Nuenen parsonage, according to an account by Vincent's sister Elizabeth, was an uncomfortable occasion. While the rest of the family sat around the table, Vincent crouched in a corner eating nothing but dry bread and examining a drawing on a chair next to him, taking no part in the conversation except to make a sudden, unexpected interjection, thereafter returning to his solitude.

After a time, however, the atmosphere improved. Father and son had a long heart-to-heart talk when they reached some kind of compromise, though as usual it was chiefly Vincent's family that had to make the concessions. One thing Dorus could never understand was why Vincent did not make more effort to earn some money by his work, believing that if he became self-supporting he would become a better-adjusted individual. It was an understandable feeling. For all his protests, Vincent was above all intent on expressing his feelings in art as well as he was able. Of course he would have liked to have been financially independent, but money was not his first consideration and in the last analysis he was content to scrape by on handouts. Moreover, as Theo, a prominent Parisian art dealer, was unable to sell any of Vincent's work, it is unlikely that Vincent himself would have had much success, even if he had devoted greater efforts to salesmanship.

VAN GOGH

In January 1884, Vincent's mother broke her leg, and her quixotic son became her devoted nurse, abandoning everything, even his painting (not entirely of course: a little picture of the church at Nuenen (page 87), and other 'trifles', were done as gifts for her). The accident may have made him realize how much he loved her, and the displacement in his life of religion by art is reflected in the ascendancy in his affections of his mother, amateur painter and nature-lover, over his father, minister of religion.

The relative calm prevailing in Nuenen was soon to be disturbed again by another awkward situation with Vincent at its centre, though it is uncertain how much, if at all, he was to blame. The house next door belonged to a moderately successful businessman named Begeman, one of the small group of Dorus's more prosperous parishioners. He had an unmarried daughter, Margot, who had lived a very sheltered life of domestic activities and charitable works. Though a kindly creature, she was decidedly plain and, being over 40 years old, Vincent's senior by more than a decade.

When Anna van Gogh was recuperating from her accident, Margot frequently came round to help, and she and Vincent got on well, ominously so in the opinion of the family, all too sensitive to Vincent's difficulties with the opposite sex. Margot was the prime mover, for she seems to have fallen in love, but Vincent did not

discourage her. Her own family were even more concerned than Vincent's. Her sisters, also unmarried, were jealous, although Vincent was no great catch, and her father was one of those selfish men who thought his daughters' duty was to stay at home and help him. Margot may have talked of marriage but her family would never have allowed it, although Vincent himself was apparently willing.

Margot's mental stability was fragile, and even Vincent became so worried by her neurotic state that he consulted a local doctor about her. Indeed, things were worse than he realized. One day she fell down in a fit and, when he managed to get a word out of her, she admitted she had taken poison. She was very ill for some time, and was sent away to recuperate under the care of a medical relative for many months. In the village, of course, people talked of nothing else, and even his own family, seemingly with little justice, blamed Vincent. The scandal appeared to have affected his father's health, and he was forced to resign his position as governor of the welfare society.

His relations with his family were unharmonious, and with middle-class parishioners, like the Begemans, non-existent, since they were repelled by a man apparently without any social graces and given to wearing amazingly shabby clothes, including a fur hat which his friend Kerssemakers described as resembling a drowned

Peasant Woman by the Hearth, c. 1885
Oil on canvas laid on board,
11³/8 x 15³/4in (29 x 40cm)
Musée d'Orsay, Paris

Vincent made innumerable studies of
peasants in 1884–85, including several of
seated women engaged in some domestic
task or other, such as sewing or, as here,
peeling potatoes.

WIDENING ARTISTIC HORIZONS

tomcat. Vincent was always totally indifferent to his appearance and equally to its effect on others. The peasants no doubt thought him crazy when, walking about the place, he would suddenly squat and make a frame with his hands around a view that caught his interest, or scratch around seeking the ideal place to put his easel, which he would mark by scraping the ground with his foot. A friend once had a rendezvous with him at the main railway station in Amsterdam, and found him sitting on the steps sketching the street scene and surrounded by a large, half-amused crowd of whose presence he appeared to be quite unaware.

He did have friends, or friendly acquaintances, in the area, mainly among people from lower down the social scale, who were not put off by his oddness, and he had disciples too. One of them, a young student, son of the printer who provided a lithographic stone for Vincent's best-known painting from this period, *The Potato Eaters*, left a vivid record of Vincent's appearance on first meeting. 'There he was, standing before us, that short, square-built little man, called by the rustics "the little painter fellow". His sunburned, weather-beaten face was framed in a somewhat red and stubbly beard. His eyes were slightly inflamed, probably from his painting in the sun. If it had not been Sunday, he would certainly have been wearing his blue blouse ... While he was talking about his work, he mostly kept his arms folded across his chest.'

The local gathering place for those interested in art was Jan Baijens's shop in Eindhoven, only 3 or 4 miles (6 or 7km) from Nuenen and then still a quite small town. The shop was an ironmonger's, but it also sold a few artists' supplies and even oil paints that were made up on the premises (they were not always of the best quality).

It was probably at Jan Baijen's shop that Vincent met Antoon Hermans, a retired goldsmith and something of an exception to the general run of Vincent's circle, as he was a fairly rich man. Hermans seems to have approached Vincent with a view to getting some lessons from him, and later came up with the idea for a set or murals on the theme of The Seasons to decorate a room in his house. The idea was that Vincent should make the initial designs and, once approved by Hermans, paint the pictures on canvas, from which Hermans himself would copy them onto the walls. The subject matter seems to have owed much to Millet, and included another version of *The Sower* to represent Spring, but the project fell apart when Hermans took too many liberties with Vincent's canvases, introducing figures of his own.

Vincent had several other 'pupils', which in itself bears witness to the self-confidence as an artist he had now acquired. They included a young man called van de Wakker, whom he considered talented. In gratitude for his advice, van de Wakker invited him

OPPOSITE
The Potato Eaters, 1885
Oil on canvas, 31⁷⁄₈ x 44⁷⁄₈in
(81 x 114cm)
Rijksmuseum Vincent van Gogh, Amsterdam

Vincent's first great masterpiece sums up his love of the country and its working people and his corresponding instinctive aversion to the bourgeoisie. He would write to his sister Wilhemien a few years later, 'What I think of my own work is that the painting of the potato eaters that I made in Nuenen is after all the best I have done.'

NUENEN

OPPOSITE

Weaver at the Loom, Facing Right, 1884
Oil on canvas, 14½ x 17¾in (37 x 45cm)
Christie's Images, London

Although many are probably lost, nearly
30 paintings and drawings of weavers, not
to mention spinners and workers
performing other tasks in the textile
industry, have survived from 1884.

home, where his mother cooked a slap-up supper, only for the incorrigible Vincent to ruin the occasion by refusing to eat anything except his usual diet of dry bread and a scrap of cheese.

He sometimes went out painting with Anton Kerssemakers, an Eindhoven tanner and talented amateur painter. It was Kerssemakers who first noticed Vincent's strange fascination with a ruined tower, all that remained of the old, abandoned Catholic church in Nuenen. It is such a frequent presence in the background of his Nuenen paintings that it has prompted the supposition that Vincent may have sometimes inserted it in a view from which it would not have been visible, or at least deliberately chosen a view because it included the tower. However, its significance, if any, is a matter of conjecture. It was largely demolished soon afterwards, but Vincent continued to draw the ruined stump.

Kerssemakers once asked him why, unlike other artists, he signed his pictures with his first name, 'Vincent'. The painter's answer was that he did so because foreigners made such a hash of pronouncing 'van Gogh'. Some of his biographers, especially those with psychological interests, have suggested other explanations, but considering how the name is usually pronounced today in Britain or America, or indeed France, his explanation seems perfectly reasonable.

All the amateur artists who knew him at this time were impressed by his procedure: how he approached the canvas with total confidence, totally focused and, with a paint-laden brush attacked it with swift, energetic and unhesitating strokes, producing the image of a figure or a tree with uncanny speed and never making a correction. On the other hand, none was greatly impressed with the results, some finding his work strange if not downright ugly.

His output in these two years in Brabant was prodigious. Figures of peasants, especially women, are most common. 'I have here', he wrote in the summer of 1885, 'some figures: a woman with a spade, seen from behind; another bending to glean the ears of corn; another seen from the front, her head almost on the ground, digging carrots. I have been watching those peasant figures here for more than a year and a half, especially their action, just to catch their character.'

But he found an interesting subject in almost anything on which his eye alighted. His new studio, which he had hired in the house of the sexton at the Roman Catholic Church (to the consternation of the Protestant community), was in no time a perfect jungle of objects, including odd things he had picked up on his expeditions, or the bird's nests collected for him by local boys (but only after the nesting season), as well as fast-growing piles of paper, board and canvas (he seems to have been indifferent to whether he painted in oils on wood or canvas). His friend Kerssemakers described the chaos: a 'stove, which had never known a brush or stove polish, a

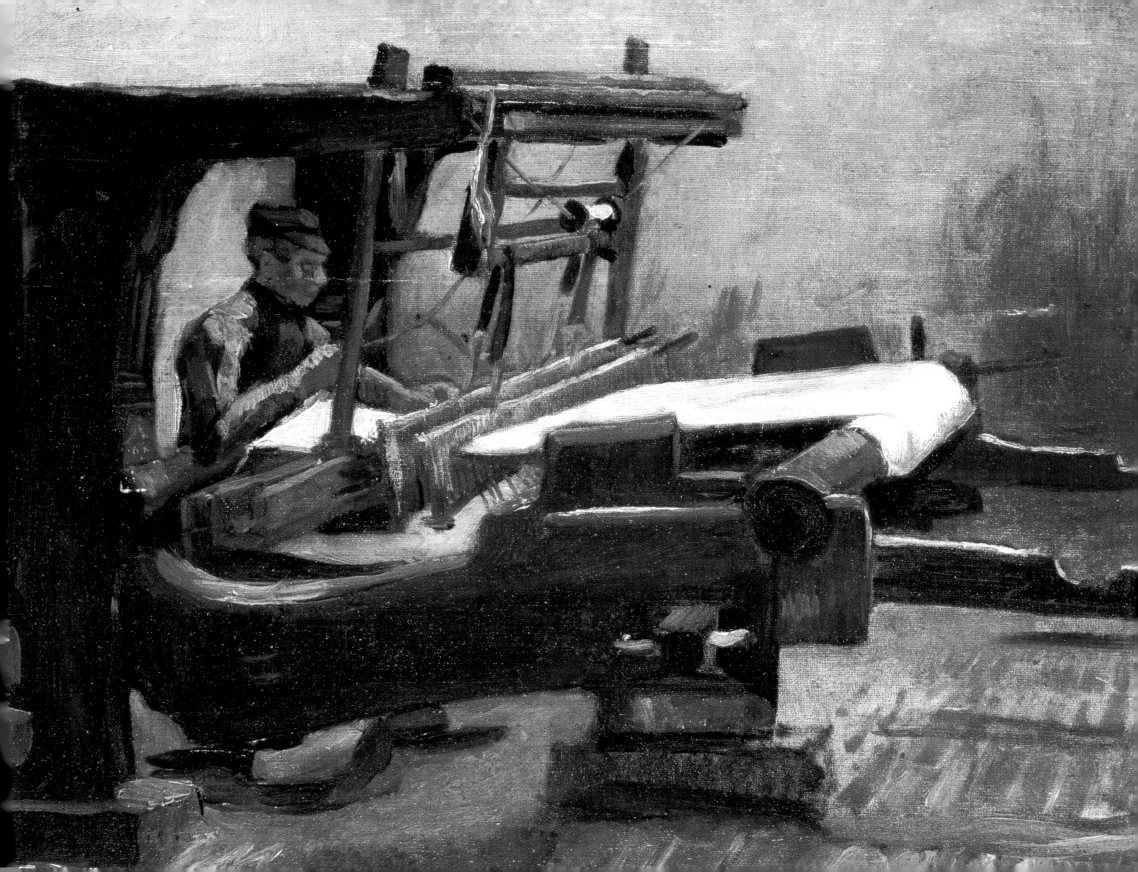

ABOVE
Weaver, Facing Right, 1884
*Pen washed with bistre, 10¹/₄ x 8¹/₄in
(26 x 21cm)
Rijksmuseum Vincent van Gogh,
Amsterdam*

He was as eclectic about materials and style as he was in subject matter. In drawings he used lead, charcoal, chalk or ink, the latter variously applied with nib, reed pen (he found suitable reeds in the local marshes) or brush. Sometimes he used wash, then watercolour, then gouache. Frequently he employed several different techniques in the same work.

Most of his painting was done out-of-doors, or in the homes and workshops of his subjects. He became particularly interested in depicting the Brabant weavers at their looms, a subject that had first occurred to him before he left the Borinage and, perhaps encouraged by a remark of van Rappard, he embarked on his now well-known series in 1883–84.

He liked the huge machines, which filled the whole room of the cottage so thoroughly that one wonders how Vincent got himself inside it, although in one or two there is just room in the corner for a baby in his high chair, parked where his father can keep an eye on him while mother is out on some errand. Some drawings, in fact, betray distortions of scale resulting from being too close to the subject.

The technical detail of the loom machinery fascinated him, and at first it was the loom that dominated, with the shadowy operator quite vaguely indicated as 'the spook in the machine' (Vincent's description to van Rappard). Later paintings, of which there were

small number of chairs with frayed cane bottoms, a cupboard with at least thirty different bird's nests, all kinds of mosses and plants ..., some stuffed birds, a spool, a spinning wheel, a complete set of farm tools, old caps and hats, coarse bonnets and hoods, wooden shoes, etc., etc.'

THE POTATO EATERS

The Weavers series and other work of the time demonstrates that Vincent had passed the stage of being merely promising, and was now an accomplished and highly unconventional artist of considerable powers. Moreover, his intense, individual style had already developed into what would lead to his being acknowledged, years later, as the 'father' of Expressionism.

'Expressionist' is a term that can be applied to a great many artists to some degree, but in a more restricted way it applies to a movement in Western art, characteristic of northern Europe and

at least ten, such as that on page 96, now at Otterlo, pay him more attention, commanding the machinery but at the same time imprisoned by it. The weavers may have had to slave from dawn till dusk on a task of numbing tedium, but at least they earned a living and had a family to comfort them, accomplishments that evaded Vincent. In a moment of impatience with Theo (of which there were more than usual in this period), he complained that although his brother give him money, he could not give him a wife and children.

OPPOSITE RIGHT
Weaver, Facing Right, 1884
Oil on canvas, 18⁷⁄₈ x 18¹⁄₈in
(48 x 46cm)
Collection H. R. Hahnloser, Berne

FAR LEFT
Weaver, Facing Left, with Spinning Wheel, 1884
Oil on canvas, 24 x 33¹⁄₂in (61 x 85cm)
Museum of Fine Arts, Boston

LEFT
Weaver Standing in Front of Loom, 1884
Pencil and pen, heightened with white,
10⁵⁄₈ x 15³⁄₄in (27 x 40cm)
Rijksmuseum Kröller-Müller, Otterlo

NUENEN

Germany especially, which is generally seen as a development from Impressionism. The Expressionists, however, abandoned the intrinsic naturalism of the Impressionists – their eagerness to catch and realize the moment of seeing – and sought greater personal expressiveness by deliberate distortion or exaggeration of both form and colour.

Van Gogh, of course, had arrived at that stage via his own personal journey. He knew virtually nothing, at this stage, of the Impressionists. Having, as it were, travelled so far in advance of developments of which he was practically unaware, it is not surprising that people failed to appreciate his art. Though fundamentally naturalistic, he paid little regard to traditional conventions, leaving out details that he considered superfluous, emphasizing form here and disregarding it there, distorting outlines, representing people as near-caricatures, and caring nothing about 'finish'. Most people thought his work crude, even sordid, and questioned whether he had much talent.

Theo, visiting Nuenen, was a little dismayed by Vincent's work, but for different reasons. In Paris, Theo was naturally well aware of the Impressionists and, though he was unable to sell many of their pictures, he was closely involved with some of them, especially Camille Pissarro, a personal friend. He perceptively saw Pissarro as a link between the Impressionists and the new generation of artists

OPPOSITE
Weaver, Seen from the Front, 1884
Oil on canvas, 27¹/₂ x 33¹/₂in (70 x 85cm)
Rijksmuseum Kröller-Müller, Otterlo

LEFT
Peasant Women Winding Bobbins, 1884
Gouache on paper laid down on board,
13³/₄ x 16¹/₂in (35 x 42cm)
Christie's Images

VAN GOGH

struggling to move onward beyond the great Impressionist dawn, who were regarded by more confident artists like Monet, for example, as heretics, deviants from the Impressionist ideal, since many of them, such as Cézanne and the younger Gauguin, had exhibited in the Impressionist exhibitions alongside Monet and Pissarro. (As always, we must be wary of allowing the names attached to 'movements' and groups of artists by critics and the public lure us into thinking that hard, finite lines can be drawn between them.)

Vincent in Brabant was still using the dark, oppressive colours characteristic of his work in Drenthe. He tried to persuade van Rappard to adopt these tones and was, at first, deaf to Theo's suggestion that he should lighten his palette, though he would come round later ('I certainly do not want to always paint dark ... '). He still looked to The Hague painters, and considered that the colour revolution, which we associate with the Impressionists, had been led by Josef Israëls. Nevertheless, he was becoming very interested in colour and was gradually discovering for himself much the same phenomena as the Impressionists exploited.

The colour revolution dated to the work of Eugène Chevreul, a long-lived (1786–1889) professor of chemistry who became interested in optics when hired in the 1820s by Gobelins, the famous tapestry makers, to find out why the colours of certain yarns seemed to lose brightness when woven into a tapestry. Chevreul's researches resulted in the doctrine of complementary colours: When any two of the three primary colours (red, blue and yellow) are mixed – say, red and yellow which make orange – the third primary (blue) is the complementary, and when placed adjacently the two colours, orange and blue in this case, enhance each other. The essence of Impressionist theory was that every primary colour has its complementary within the shadow it casts, and this, it is held, is the secret of the Impressionists' bright and colourful pictures.

However, the Impressionists were not the first to appreciate the implications of Chevreul's discoveries. Another of Vincent's heroes, the great Eugène Delacroix (died 1863), a hugely intelligent painter whose *Journal* is the only personal account of an artist's life and work.

Delacroix reasoned that what worked for strands of yarn could equally be applied to brush strokes. He did not go anywhere near as far as the Impressionists, but he did employ touches of otherwise unexpected complementary colour (e.g. green in rosy flesh tones) to impart greater vividness. He was also aware that Chevreul had warned that if too many complementary colours were employed closely together in a woven fabric they would have the opposite effect, cancelling each other out and resulting in an overall impression of dullness.

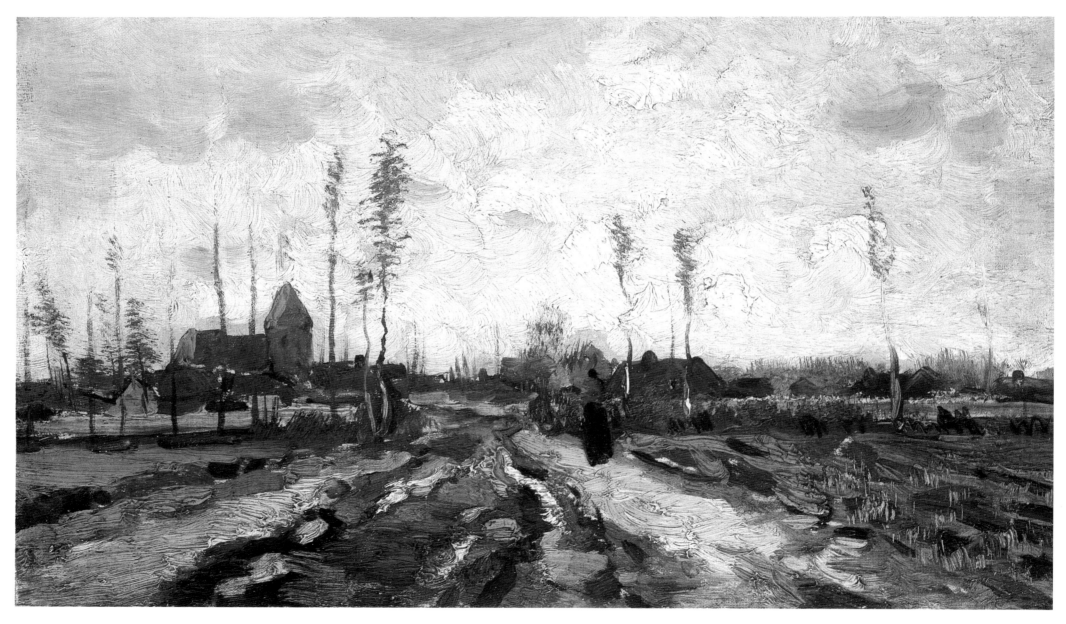

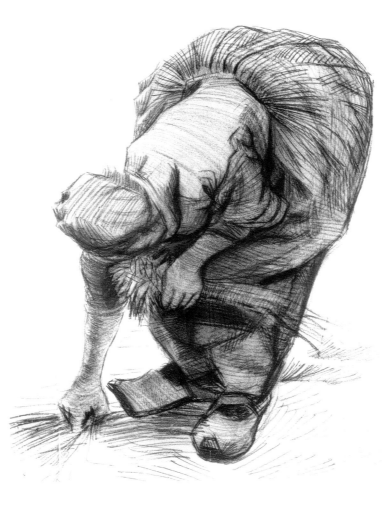

OPPOSITE
Landscape with Church and Houses, 1885
Oil on canvas, 8⁵/₈ x 14¹/₂in (22 x 37cm)
Christie's Images, London

This landscape was probably painted six months earlier than the autumn landscape on page 98, at about the time when Vincent was working on The Potato Eaters.

FAR LEFT
Peasant Woman from Neunen, 1885
Oil on board, 18¹/₈ x 10⁵/₈in (46 x 27cm)
Christie's Images, London

LEFT
Peasant Woman Gleaning, 1885
Black chalk on paper, 20¹/₄ x 16¹/₃in
(51.5 x 41.5cm)
Museum Folkwang, Essen

PAGES 102 and 103
Head of a Peasant Woman, 1885
Oil on canvas, 18¹/₄ x 14in (46.4 x 35.6cm)
National Gallery of Scotland

Vincent had no doubt seen paintings by Delacroix in Paris a decade earlier, but that was long before he became interested in these matters himself through following his own way. In the summer of 1884 he wrote that he had noticed how 'a reddish grey, hardly red at all, will appear more or less red according to the colours next to it. And it is the same with blue and yellow'.

Another sharp divide between the van Gogh of the Brabant period and the Impressionists was their very different subject matter. The great popularity of the Impressionists (later if not then) was the result not only of their bright and airy colours but, arguably anyway, of their hedonistic subjects – jolly scenes of picnics by the river, holiday-makers by the sea, parties in gardens or cafés, trees in blossom, sailing boats, horse races, circuses and ballet. It is all a far cry from Vincent's dark pictures of worn and weary peasants and their labours in the field and at the loom.

In March 1885, when Vincent was working on the great masterpiece of his Brabant period, his father died. His health had been poor for some time, but it was a shock when, returning from service, he dropped dead on his own doorstep. We have no evidence of the effect of this event on Vincent, which he seems to have deliberately avoided mentioning. Given his character, it would be strange if he were not profoundly moved, in spite – perhaps because – of the cool relations between father and son. It did cause a brief

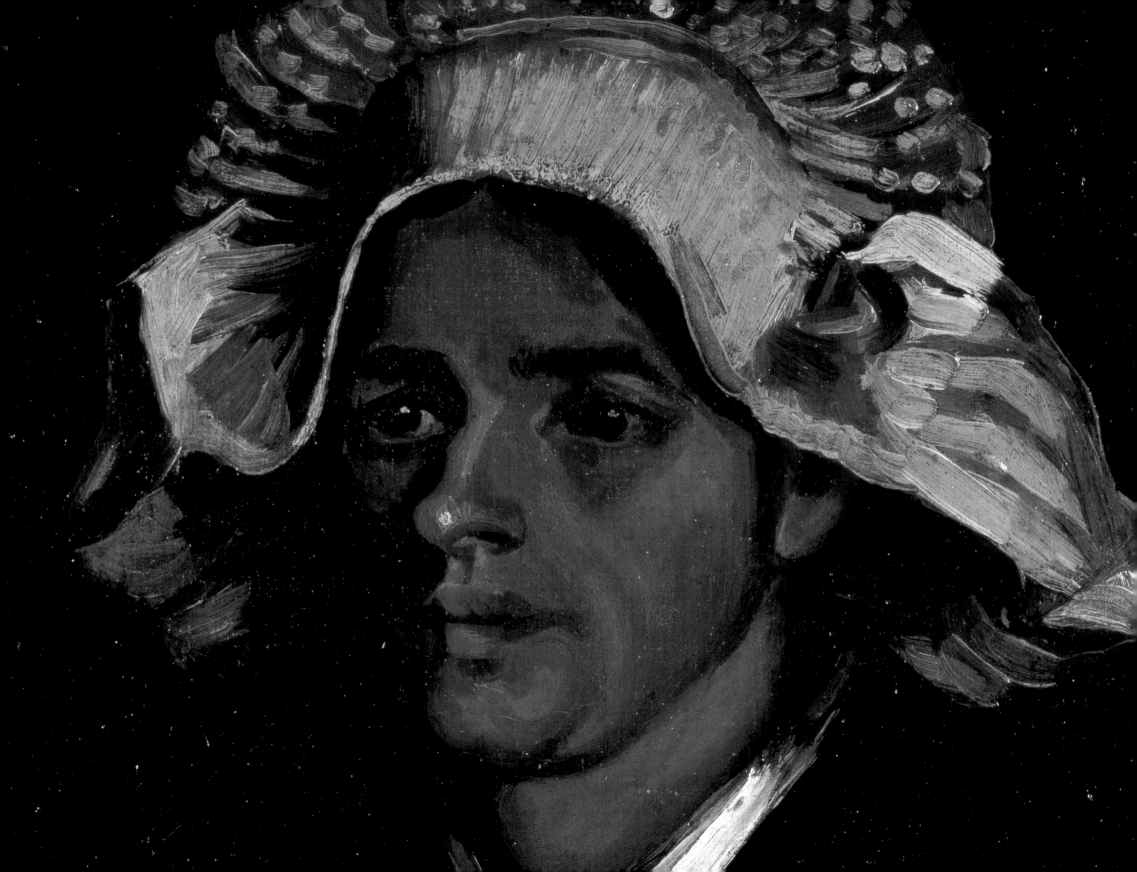

OPPOSITE
Two Peasants Planting Potatoes, 1885
Oil on canvas, 13 x 16¹/₈in (33 x 41cm)
Kunsthaus, Zurich

and temporary halt in his work, akin to writer's block, which he eventually got himself out of by setting up a vase of flowers and painting a still life, always the first lesson he imposed when teaching an aspiring painter. But it is unlikely that his father's death left Vincent with any feelings of guilt – at the time. He did paint a picture of his father's empty chair, with pipe and tobacco, a resonant image for him that would find expression again in Arles.

Dorus was buried in the churchyard within sight of the old Catholic church tower, now scheduled for demolition. Before it came down, Vincent attended an auction of what moveables could be sold, and did a picture of it. Later he painted the stunted remains of the tower after it had been knocked down.

Vincent had done hundreds of drawings of figures of peasants, including a powerful series of fifty heads, and for some time he had contemplated a group portrait. That posed a whole new set of problems. The first of them was simply to find willing sitters! Among the local people with whom he was on friendly terms was the de Groot family, several members of which he drew or painted individually. He happened to drop in on them one evening in February or early March just as they were preparing to begin their simple evening meal of potatoes and coffee under the dim light of a single oil lamp. This was the scene he painted in *The Potato Eaters*, the summation of his work among the Brabant peasants. (See page 90.)

Van Gogh is famous for his productivity. In Arles he sometimes produced two finished paintings in a day, and his rate of production in his Brabant period was hardly less – nearly 200 paintings and considerably more drawings in a little over two years. That does not mean he never spent much time on a given painting. *The Potato Eaters* occupied him for many weeks, admittedly a period that included his father's death, and besides three versions of the painting, we also have at least three drawings, as well as an engraving. The actual painting may have been relatively rapid, though there was much unwonted scraping and overpainting, and certainly a lot of forethought involved.

Technically, a common problem with group portraits is achieving a satisfactory composition. Vincent's first sketch included four figures, Cornelia de Groot, her two brothers, and her grown-up daughter, for whom Vincent clearly felt a certain tendresse (and was suspected by village gossips of rather more than that when she mysteriously became pregnant), but however he shifted them about he could not arrange them satisfactorily, so, to achieve a more harmonious balance, he introduced a fifth figure, the young girl in the foreground with her back to the viewer, which overcame the awkward problem of a vacant space in the centre. He knew this work was going to be special, telling Theo he would not send it 'unless I know for sure there is something in it'.

The first version was painted on the spot, the second done from memory in his studio. It depicts a very primitive, almost animal-like scene. 'I intended to keep conscientiously in mind the suggestion to the viewer that these people eating their potatoes under the lamp and putting their hands in the plate' – actually they are using forks! – 'have also tilled the soil, so that my picture praises both manual labour and the food they have themselves so honestly procured. I intended that the painting should make people think of a way of life entirely different from our own civilized one. So I have no wish whatever for anybody to consider the work beautiful or good.' Indeed, it was unlikely that anyone would. Accuracy of form is sacrificed to expressiveness, and some of the individual figures are close to caricature.

Nevertheless, Vincent had achieved his purpose: 'In painting these peasants I thought of what had been said of those of Millet, that they "seem to have been painted with the very soil they sow".' In fact, Vincent's peasants are the more convincing, showing the evidence of their hard life in their creased and weary faces, rough and calloused hands. Millet's are a good deal more spruce.

Theo had no more luck selling *The Potato Eaters* than his brother's drawings (Vincent suggested he might find a buyer in Le Chat Noir), but he found it very difficult to sell the Impressionists, even Renoir. More socializing than commercial transactions went on

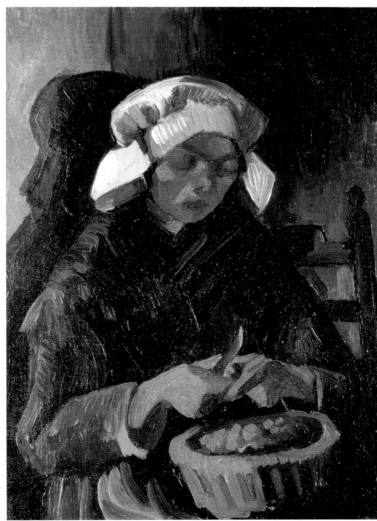

OPPOSITE
Lane with Poplars, 1885
Oil on canvas, 30³/4 x 38¹/2in (78 x 98cm)
Museum Boymans-van Beuningen,
Rotterdam

Vincent seems to have had a liking for
straight lines of trees. This lane, lined with
poplars, was near the parsonage and
appears in many works of the Nuenen
period.

FAR LEFT
Peasant Woman Digging, 1885
Oil on canvas, 16¹/2 x 12¹/2in (42 x 32cm)
Barber Institute of Fine Arts, University of
Birmingham, England

LEFT
A Peasant from Neunen Peeling
Potatoes, 1885
Oil on canvas, 16¹/4 x 11⁷/8in
(41.3 x 30.2cm)
Christie's Images

Rembrandt
The Jewish Bride, c. 1662
Oil on canvas, 47⁷/₈ x 65¹/₂ inches
(121.5 x 166.5cm)
Rijksmuseum, Amsterdam

This is the painting which Vincent is said to have spent an entire day contemplating.

in the upper rooms of the gallery in the Boulevard Montmartre.

Another who did not like *The Potato Eaters* was Anton van Rappard. What he in fact saw was a print of the lithograph that Vincent made of the first version of the painting, which he said was done 'in one day, from memory'. Van Rappard had been a good friend for five years; he had last visited Nuenen a few months earlier and, as of old, they had gone out painting together. Van Rappard understood Vincent very well, and was always careful not to upset him unnecessarily by immoderate criticism. But *The Potato Eaters* was altogether too much for him. 'You will agree with me', he began, 'that such work is not meant seriously.' He criticized the composition and the shocking inaccuracy of the painting ('What on earth is that kettle doing? It isn't standing, it isn't being lifted up, so what then?'). After a string of criticisms, he concluded, 'while working in such a manner you dare to invoke the names of Millet and Breton. Come on! In my opinion art is too sublime a thing to be treated so nonchalantly.'

Van Rappard's view was of course perfectly reasonable, on his terms; Millet himself would no doubt have been equally disgusted. His comments merely illustrated the gulf between his own rather conventional aims and the fierce ambitions of Vincent, of which van Rappard understood nothing. Vincent sent the letter back with only a brief comment. Van Rappard made efforts at reconciliation through an intermediary, their correspondence continued for a time, and van Rappard later spoke very fondly of his memories of Vincent, but it was the end of their friendship.

MOVING ON

Besides all the the disapproving relations who had appeared for his father's funeral, Vincent had also quarrelled irretrievably with his eldest sister, Anna, and as a result he moved out of the parsonage, although for the time being he remained in Nuenen. He had been painting his peasant figures, which now show more adept modelling

and greater solidity, and his impressive series of heads, and was still thinking he would 'go and paint the miners' heads one day'. *The Potato Eaters* is often and justly seen as homage to the miners of the Borinage as well as to the peasants of Brabant. There is something about the dark, cramped cottage suggestive of the miners' hovels; in fact in the summer of 1885 Vincent had been reading Zola's *Germinal*, which describes the life of the miners in an area across the border in northern France, much the same as the Borinage. It contains passages closely resembling descriptions in Vincent's letters of 1879. In another coincidence, *The Potato Eaters* anticipated, by a much shorter period, Zola's novel *Earth* (*La Terre*, published in 1887) about the brutal existence of the peasants.

Inconveniently, his source of models for his peasants' heads was abruptly ended when the local priest forbade his parishioners to pose for him. The priest was alarmed by the rumours about Vincent and the de Groot girl (her name, coincidentally, was Sien, and she is probably the subject of the accomplished and lovingly painted *Head of a Peasant Woman*, page 102, in the Scottish National Gallery). Vincent returned to still lifes and his collection of birds' nests, which reminded him of peasants' cottages, but his time in Nuenen was clearly running out. His mother would soon be leaving for good, since the house belonged to the church and would be required for the new minister, while the disfavour of the Roman Catholic church made it awkward for the sexton to keep the notorious painter as a tenant.

Vincent made one or two trips with Kerssemakers to Antwerp and, in October, to Amsterdam where the Rijksmuseum had recently opened. This was the famous occasion on which Vincent parked himself in front of Rembrandt's *Jewish Bride* (opposite) in the morning and told Kerssemakers to come back for him at the end of the day. Stimulated by recent discussion of the subject with Theo, and perhaps by his confrontation with Rubens's glowing nudes on the occasion of his visit to Antwerp, Vincent was obsessed by the problem of colour. What was the secret? Whatever it was, it was there, in front of him, in Rembrandt's wonderful painting. As promised, he was still there when Kerssemakers returned for him.

In his last months in Nuenen Vincent painted a number of landscapes. Some of these have survived, though a vast amount of his work at Nuenen was lost because, as in Drenthe, Vincent simply abandoned it and no one else wanted it. There is a slight but perceptible lightening of the colours already evident, for instance, in the bright foliage of *Lane with Poplars* (page 106), a painting done in November 1885 of a lane near Nuenen.

CHAPTER FIVE
ANTWERP

Portrait of a Woman with a Red Ribbon, 1885
Oil on canvas, 23⅝ x 19⅝in (60 x 50cm)
Private collection

Referring to this portrait, painted around Christmas 1885, Vincent wrote that he was trying to express 'something voluptuous and at the same time cruelly tormented'.

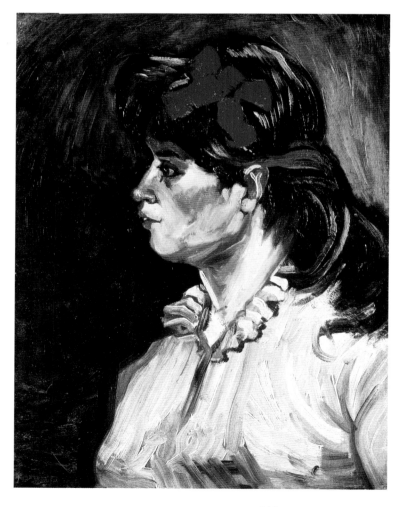

Vincent contemplated going to Antwerp almost as soon as he left Drenthe. One reason for choosing that destination was his belief that he would be able to sell some of his work there. Van Rappard had thought it might be a good idea to go, though not immediately, and another friend, Hermans the retired goldsmith, had offered to pay his fare. In October 1884 he was reading books used by the Antwerp Academy, and in spite of his generally low opinion of academies and his own unfortunate experience in Brussels, Theo's criticisms had made him aware of his ignorance in important areas and encouraged him to seek professional assistance. In particular, he wanted someone to teach him more about colour.

In May 1885 he was calculating how many of his peasant figures he could send to Theo and how many he could take to Antwerp. At the end of November, when he was unable to get models and the weather was getting too cold for working outdoors, he finally travelled to Antwerp. He assumed he would be returning to Nuenen in due course – in fact he had left his native land forever – and left behind a large collection of paintings and other works. Practically all of them seem to have ended up being thrown on a bonfire, dumped with the rubbish, or being otherwise summarily discarded.

In Antwerp he had a rather small room on what was then the rue des Images, which looked out on the somewhat unprepossessing

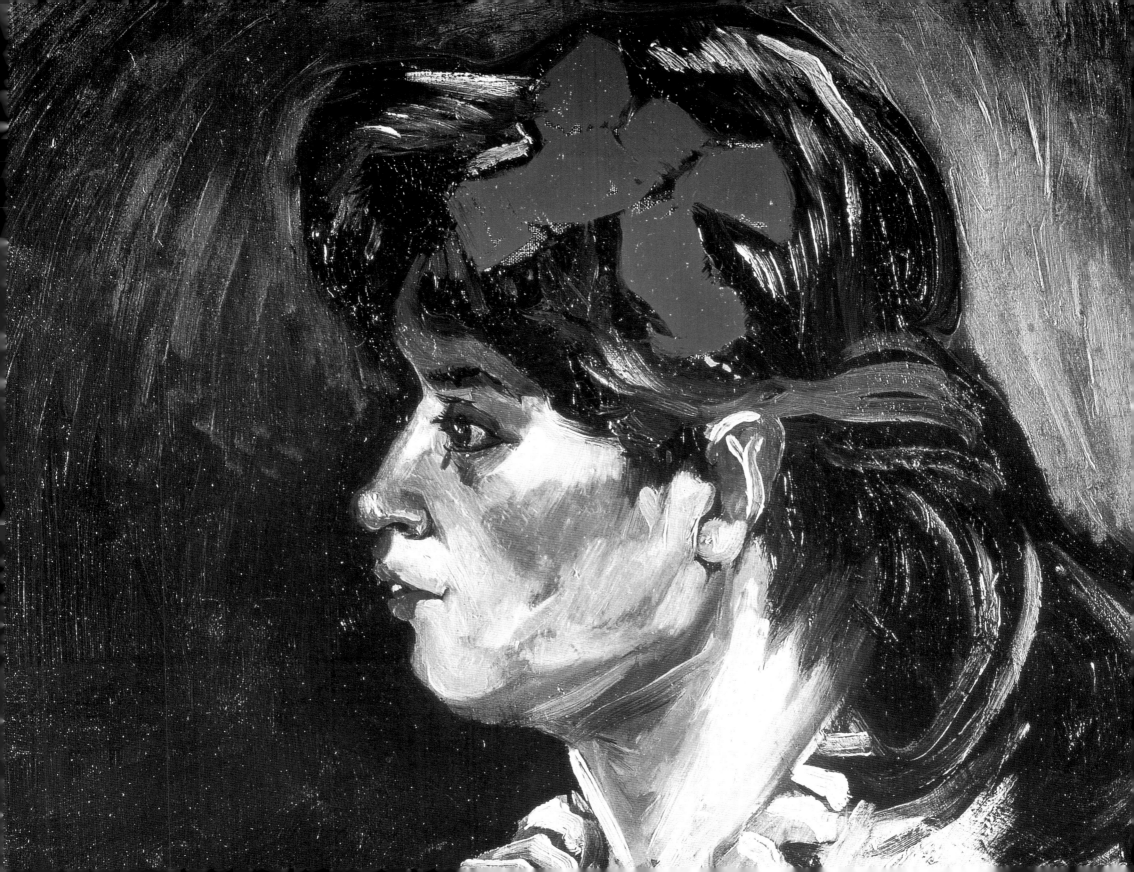

ANTWERP

backs of other houses, visible in his painting of the view from his window (now in Amsterdam) on a wintry day. The rent was 25 francs a month, heating and lighting extra, but it did have the advantage of being immediately above a colour shop.

Vincent always liked to pin prints onto the walls of his various more or less scruffy lodgings, and he livened up his room in Antwerp with Japanese prints.

Vincent's isolation from the world of art and artists and, even more, his lack of interest in what was happening beyond his immediate orbit, resulted in him often being behind the times. His ignorance of the Impressionists was one example. Another was his belated discovery of Japanese prints.

Japanese artists had developed the art of making colour prints from a number of wood blocks – a different block for each colour – in the 18th century, and the works of Hiroshige, Hokusai, Utamaro and other masters of the 'Floating World' had been all the rage among artists in London when he was there in the early 1870s. They had appeared in paintings by Manet in the 1860s, having first arrived in Europe as packaging around imported porcelain. Their large areas of bright, flat colour, flowing lines, asymmetrical composition and generally 'popular' quality had a powerful impact on many artists, the Impressionists in particular. Initially, it was the colour that entranced Vincent, though he later came to see many other virtues in them, including their propensity for a high-level

perspective and unusual angles. They were very cheap, and he collected them in Antwerp and later in Paris, eventually accumulating about four hundred.

His first impression of Antwerp was of 'unfathomable confusion'. He went sight-seeing, sketchbook in hand and with sales in mind, drawing the Steen, the Cathedral and the Grand Palace, and representing Gothic architecture, basically unsympathetic to him, crudely but quite effectively. Local dealers, unfortunately, would not buy them, though some made encouraging comments and told him to come back when business was better.

The area of the city that most attracted him was the docks, which drew forth the best of his descriptive powers. 'As to the general view ... at one moment it is more tangled and fantastic that a thorn hedge, so confused that one finds no rest for the eye, and gets giddy, is forced by the whirling of colours and lines to look first here, then there, without being able, even by looking for a long time at one point, to distinguish one thing from another ... Now one sees a girl who is splendidly healthy, and who looks or seems to look loyal, simple and jolly; then again, a face so sly and false that it makes one afraid, like a hyena's. Not to forget the faces damaged by smallpox, having the colour of boiled shrimps, with pale grey eyes, without eyebrows, and sparse sleek thin hair, the colour of real pigs' bristles or somewhat yellower ... It would be fine to work there, but how and where? For one would soon get into a scrape. However, I have

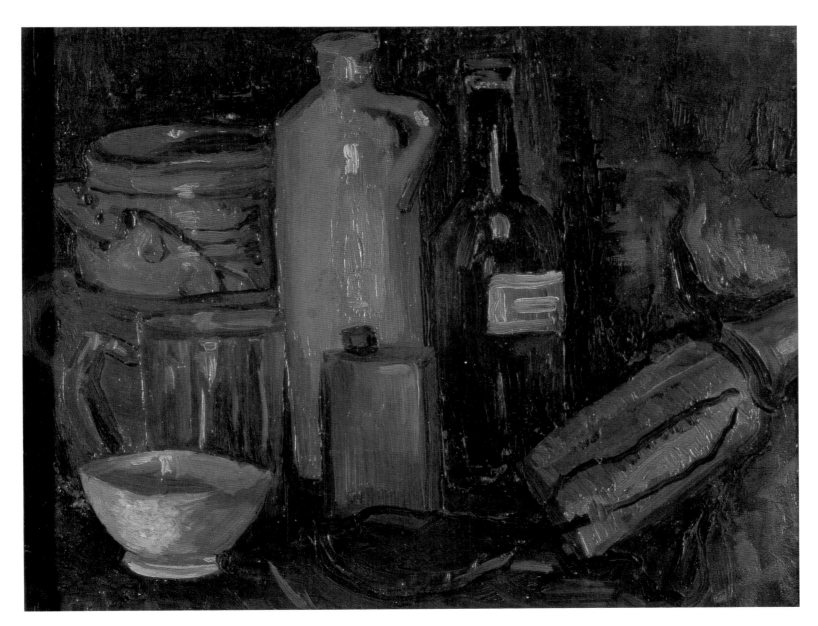

***Still Life with Pots, Bottles and Flasks,
1884***
*Oil on canvas, $11^{5}/_{8}$ x $15^{1}/_{2}$in
(29.5 x 39.5cm)
Gemeentemuseum, The Hague*

ANTWERP

RIGHT
Portrait of a Woman in Blue, 1885
Oil on canvas, 18¹/₈ x 15¹/₈in
(46 x 38.5cm)
Rijksmuseum Vincent van Gogh,
Amsterdam

This painting shows the influence of
Rubens on Vincent, particularly in the
flesh colour.

OPPOSITE
Sunflowers, Roses and Other Flowers in
a Bowl, 1886
Oil on canvas, 195/8 x 24in (50 x 61cm)
Städtische Kunstalle, Mannheim

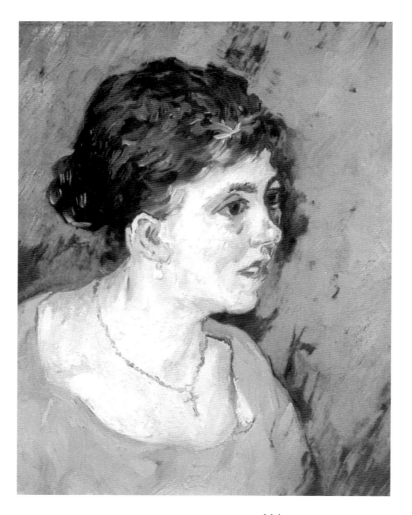

trudged through quite a number of streets and back streets without adventure, and I have sat and talked quite jovially with various girls who seemed to take me for a sailor.'

The streets were certainly well provided with the kind of girls with whom Vincent could make up for the (presumed) chastity of his two years in Nuenen although, again, lack of funds may have limited such activities.

The seamy low life fascinated him, as it did other artists. As well as colour and confusion, there was plenty of action. Attracted by a commotion in a street near the harbour he found, 'In broad daylight, a sailor ... being thrown out of a brothel by the girls, and pursued by a furious fellow and a string of prostitutes, of whom he seemed rather afraid – at least I saw him scramble over a heap of sacks and disappear through a warehouse window.' The mingled races and types offered striking images. In the taverns, 'Flemish sailors, with almost exaggeratedly healthy faces, with broad shoulders, strong and plump, and thoroughly Antwerp folk, [were] eating mussels, or drinking beer, and all this ... with a lot of noise and bustle – by way of contrast – a tiny figure in black with her little hands pressed against her body comes stealing noiselessly along the grey walls. Framed by raven-black hair – a small oval face, brown? orange-yellow? I don't know. For a moment she lifts her eyelids, and looks with a slanting glance out of a pair of jet black eyes. It is a

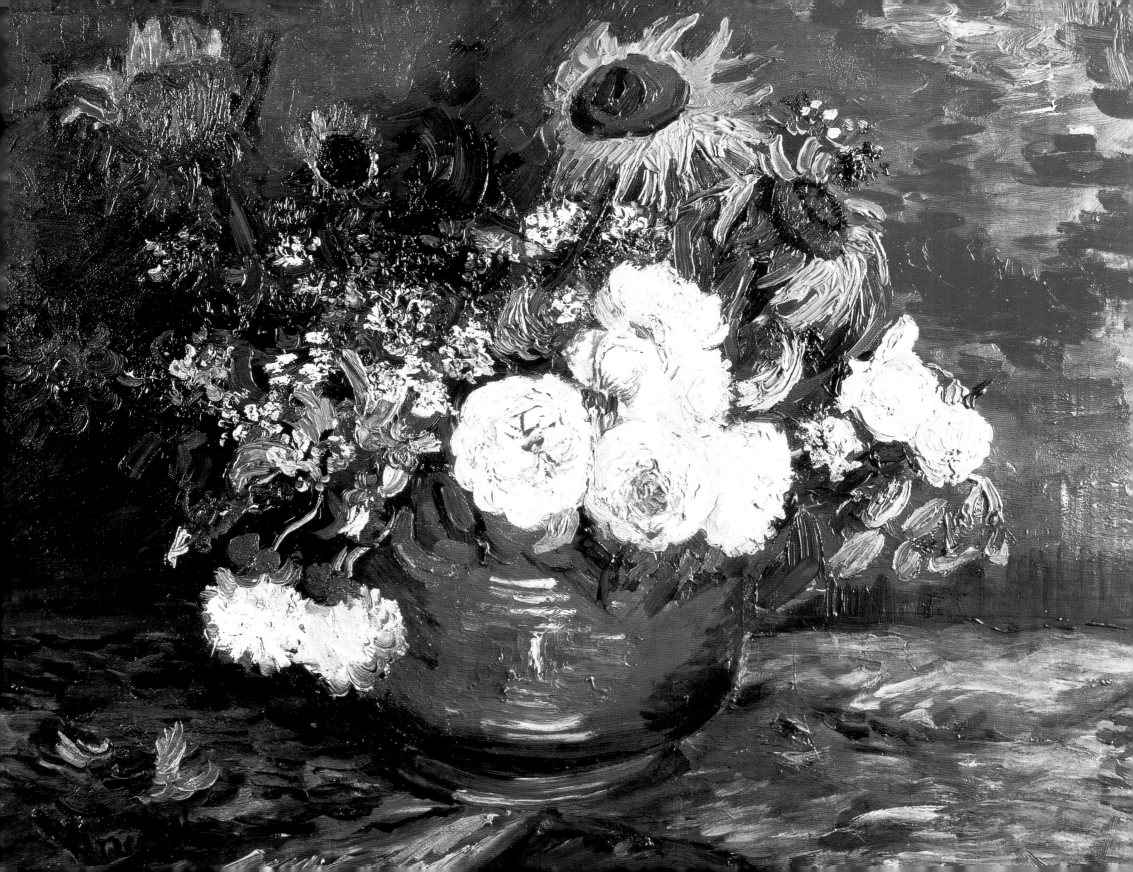

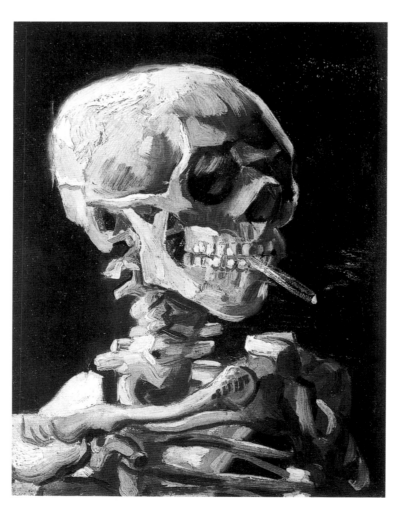

Skull with a Burning Cigarette, 1886
Oil on canvas, 12³/₄ x 9³/₈in (32.5 x 24cm)
Rijksmuseum Vincent van Gogh,
Amsterdam

Chinese girl, mysterious, quiet like a mouse ... What a contrast to that group of Flemish mussel eaters.'

Naturally, he went to the museums, where he found much to admire. He went to the Town Hall to inspect the proficient if soulless works of Baron Leys (1815–69), a kind of Belgian equivalent of Gérôme, whose gigantic, patriotic history paintings had gained him his title. Always a kind critic, Vincent found much to admire in them, though he was surprised that works supposed to be true frescoes had faded so much in the few years since they had been done. But of far more significance for him than any other was the most famous of Antwerp's artists, the great master of the Northern Baroque, Rubens.

Vincent must have seen many works of Rubens in Paris, London and indeed Antwerp on his previous visit, but he seldom mentions him until now, when suddenly nearly every letter contains some reference to him. They were radically different individuals (as men as well as artists) and perhaps he needed time to, as it were, adjust his sights.

'I like Rubens for his ingenuous way of painting, his working with the simplest means', although, did not Theo agree, his religious subjects were rather too 'theatrical' – a predictable reaction of a Dutch Protestant confronted by the Catholic Baroque! '...What he can paint is – women – like Boucher and better – there

116

especially he gives one most to think about and there he is at his deepest. What he can do – combinations of colours – what he can do is – paint a queen, a statesman ...'. The punctuation expresses his excitement.

'Combinations of colours', that was crucial. He puzzled over how Rubens get those flesh tones – especially in portraits of women like the two blonde women in his *St. Theresa in Purgatory* or, he might have added, the figures of the Sirens (greatly admired by Delacroix) in his large painting *Marie de Médicis Arriving in Marseille*, which Vincent might have seen in Paris. In this respect, Rubens was superior to the Dutch masters, Frans Hals, even Rembrandt. Vincent might have considered that Rubens's nearest challenger (and closest successor) in this respect was Renoir, who was of course Vincent's contemporary, but at that time Renoir's work was probably unknown to him.

Rubens helped to lighten Vincent's palette, perhaps without his being fully aware of it, as is suggested by his rather naive remark that his Nuenen paintings seemed to look darker in the city than they had in North Brabant. It was change in time, not in place that was responsible for this subjective judgement. Examining Rubens's portraits again and again, he was 'quite carried away by his way of drawing the lines in a face with streaks of pure red'. He adopted Rubens's custom of mixing carmine ('the colour of wine') and

white, although at first with rather mixed results. Soon he had added four new colours to the nine he customarily used in Nuenen, all of them bright colours: cobalt ('a divine colour'), carmine ('warm and spirited'), the 'right kind of brilliant yellow', and vermilion. Study of Rubens also demonstrated that coloured, rather than black outlines offered more scope in, for instance, conveying movement.

No doubt Rubens's influence was also responsible for a new fondness for painting portraits (including his own, of which he completed at least two in oils during his Antwerp period). 'I prefer painting people's eyes to cathedrals, however solemn and imposing the latter may be – a human soul, be it that of a poor beggar or of a streetwalker, is more interesting to me.' Though it was not easy, with his lack of resources, to persuade models to sit for him – instead of a fee he sometimes offered a copy of the painting – he managed to find a blonde girl, who is presumably the subject of *Woman in Blue* (page 114), now in Amsterdam. Of another study, of a dark-haired woman, he told Theo, 'I have brought lighter tones into the flesh, white tinted with carmine, vermilion, yellow, and a light background ...' The influence of Rubens is plain to see.

The difficulty in obtaining models was especially annoying because there were so many good-looking women in Antwerp. At one place of entertainment he was unimpressed by the production but fascinated by the audience: 'There were splendid women's

ANTWERP

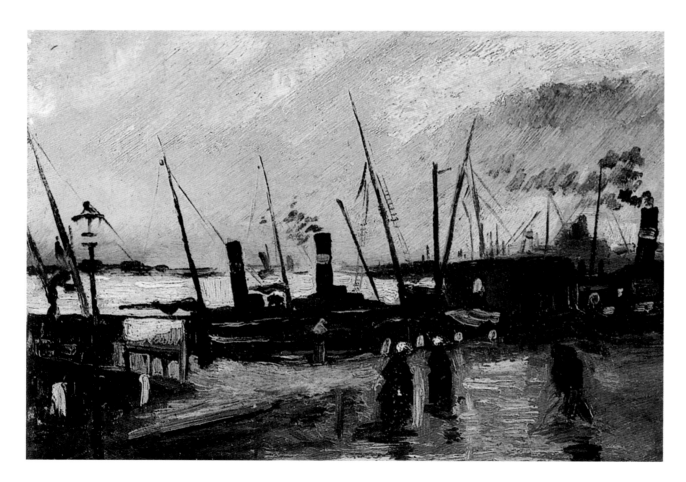

heads, really extraordinarily fine, among the good middle-class folks on the back seats.' He was less impressed by German girls, present in great numbers and, it seemed to him, looking much alike. 'It seems that one sees that same race everywhere, just like Bavarian beer, it seems to be an article exported wholesale.' Such prejudice, unusual in Vincent, may be ascribed to the lingering effect of the Franco-Prussian War and the Siege of Paris.

He was desperate to sell some work because he was short of money. Since his topographical scenes had had no success, he wondered if he would do better to concentrate on figures. Again, lack of models was an obstacle. As it was, Theo's allowance did not cover all his costs. The supplies he needed to paint, although he said he had found a relatively cheap source, were a major expense, for no artist went through paint, brushes and canvas at a greater rate than Vincent. Having paid the rent, there was little money for food, and he was again starving himself, some days eating nothing at all, though he smoked heavily. In February 1886 he reckoned he had eaten only six or seven hot meals since moving out of the family home eight months earlier. Inevitably, his health was affected. He admitted to Theo that he sometimes felt faint, and as he was quite unable to chew, he was finally forced to consult a dentist about his teeth. Ten of them had to be pulled out, and the dentist's bill was 50 francs, a large sum for him. His digestion, not

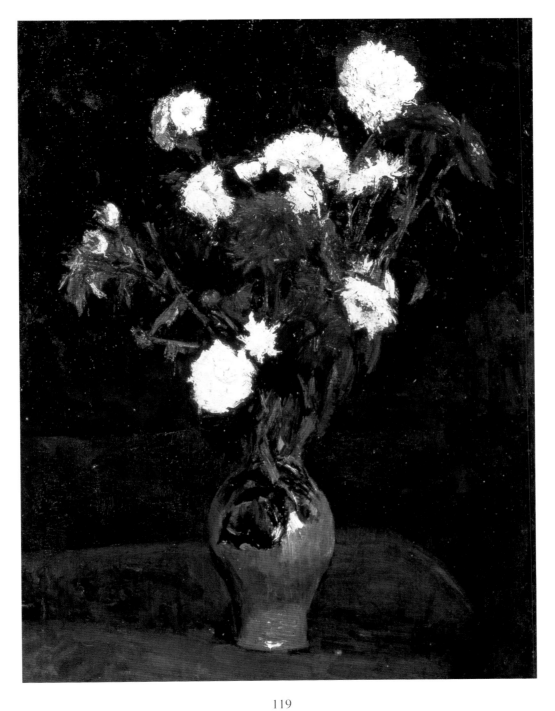

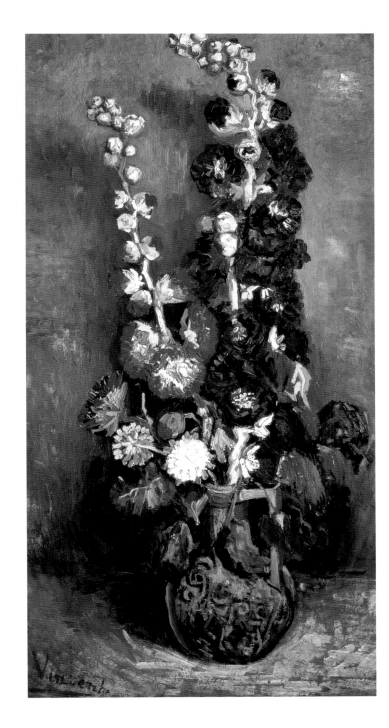

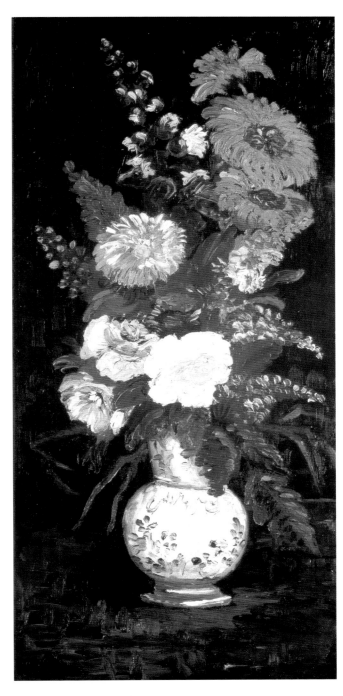

FAR LEFT and PAGE 123
Vase of Hollyhocks, 1886
Oil on canvas, 35⁷/₈ x 19⁷/₈in
(91 x 50.5cm)
Kunsthaus, Zurich

LEFT and PAGE 122
Vase of Asters and Other Flowers, 1886
Oil on canvas, 27¹/₂ x 13³/₈in (70 x 34cm)
Gemeentemuseum, The Hague

surprisingly, was poor, and he seems to have consulted a doctor about that. He was also coughing up phlegm, and he had contracted syphilis (something he did not report to Theo). The disease was then incurable, and though it could be controlled the treatment was unpleasant. Most sufferers eventually entered a long period of remission, but there could be long-term effects, sometimes on the brain. To Vincent's fear that he would die before he had achieved his artistic ambitions was added the fear of madness.

It was perhaps under the influence of these depressing thoughts that he painted the small canvas, *Skull with a Burning Cigarette* (page 116), a weirdly Surrealist image and utterly unlike him. Vincent was not a satirist but, bearing in mind that this canvas was painted at about the time he was attending Antwerp's Academy of Fine Arts, it may have been intended as a mocking comment on contemporary academic teaching.

AT THE ANTWERP ACADEMY

Since his own brief experience in Brussels, Vincent had often condemned the academy, which he regarded, perhaps not unjustly, as 'a mistress who prevents a more serious, a warmer, a more fruitful love from awakening in you' (letter to van Rappard in 1881). His decision to attend the Antwerp Academy was partly motivated by the availability of free models, which he was hard-pressed to obtain on his own. He also expected to learn, for instance, about the

Impressionists, in whom his interest had been aroused by reading extracts from Zola's novel, *L'Oeuvre* (Work), although he was still far from understanding their principles.

In that expectation he was to be disappointed. At the academy, conservatism reigned; the elderly and pompous director, Charles Verlat, was an admirer of Courbet, but in general he and his staff hardly looked beyond conventional history painting in the manner of Baron Leys. Verlat also painted painfully phoney genre pictures of peasants, and monkeys in human costume performing human activities: these were thought frightfully amusing. It was characteristic of him that he would not allow the study of the female nude at the Academy except from plaster casts, thus virtually rejecting one of the fundamentals of European art for over 300 years. Since Vincent was not alone in wishing to work from living models, groups of students used to club together to hire a model outside the Academy, and on a few occasions Vincent later joined one of these groups. One result was an accomplished sketch of a standing female nude which is, paradoxically, rather academic in style.

He started at the Antwerp Academy in January 1886, among a large class of students from all over Europe, many of whom were still in their teens. Not surprisingly, they regarded Vincent, looking even older than his years in his drowned-cat fur cap and his farmer's smock, with an easel created by ripping the side off a wooden box, as a grotesque figure of fun. Their ragging was sometimes less than

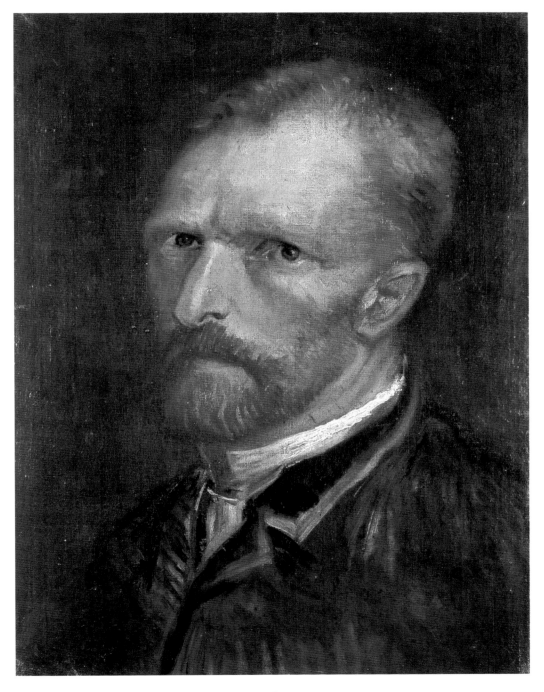

LEFT and PAGE 126
Self-Portrait, 1886
Oil on canvas, 15^1/$_2$ x 11^5/$_8$in
(39.5 x 29.5cm)
Gemeentemuseum, The Hague

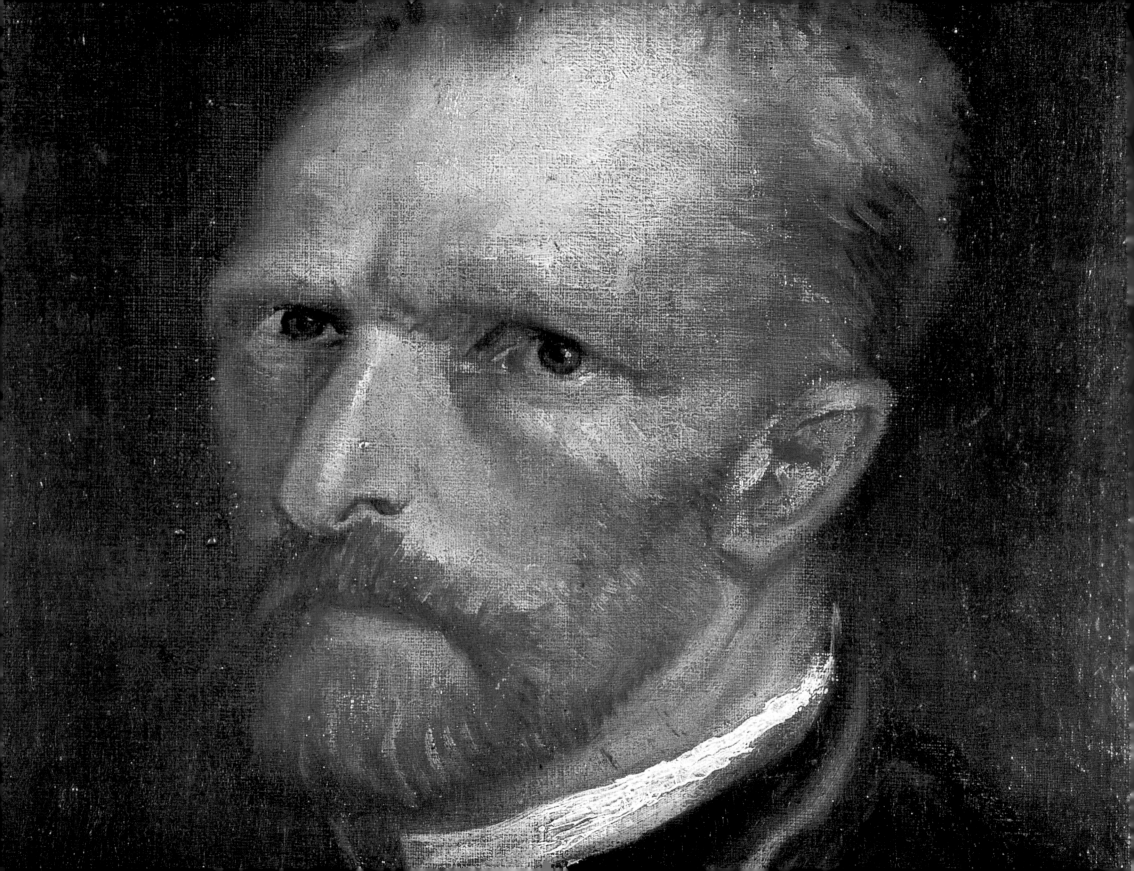

good-humoured, but one or two were more mature, among them a young Londoner, Horace Lievens, who subsequently enjoyed a modest career as a professional artist in England. He did a portrait of Vincent, making him look about 60 years old.

At the Academy, the emphasis remained firmly on outline, and colour was regarded merely as what you put between the lines; but Vincent had passed far beyond that stage. He was soon banished from the painting class because Verlat considered that he needed to learn how to draw. He had provided examples of his work in advance, and Verlat accepted him on the basis of two portraits, so it is rather strange that he should have come to this absurd conclusion.

Vincent won no more approval when he joined the drawing class with the youngest students, since his drawing from a cast of a Classical Greek figure looked more like a healthy Flemish peasant and mother than an elegant and asexual goddess. Really, Vincent did not need all this and it is surprising he put up with it as long as he did. However, it is interesting to note that his subsequent thoughts on plaster casts and the Classical nude were less negative than they had been in The Hague when he swept Mauve's casts into the bin. However, he did not put up with the regime for very long. One day the drawing master tore up one of his efforts in rage. Vincent happened to be upset about this time by news from the Borinage, where the miners had at last gone on strike but were being starved into submission, and he too lost his temper. He told the drawing master in words of one

syllable exactly what a real woman ought to look like.

He had nothing to learn from the Academy, because he was on a totally different track. For instance, Vincent wondered how a painter like Millet or Delacroix made his figures appear so three-dimensional, so that, as Vincent put it, 'they have backs even when one sees them from the front'. As usual, he himself provided the best assessment of the differences between him and the aims of the Academy. When he compared a study of his with those of other pupils, '... it is curious to see that they have almost nothing in common. Theirs have about the same colour as the flesh, so, seen close up, they are very correct – but if one stands back a little, they appear painfully flat – all that pink and delicate yellow, etc., etc., soft in itself, produces a harsh effect. The way I do it, from nearby it is greenish-red, yellowish-grey, white-black and many neutral tints, and most of them colours one cannot define. But when one stands back a little it emerges from the paint, and there is airiness around it, and a certain vibrating light falls on it. At the same time, the least little touch of colour which one may use as highlight is effective in it. But what I lack is practice...'

THE LURE OF PARIS

Vincent may have continued to visit the Academy unofficially after his tirade against the drawing master, but he was still unwell and underfed, and it was clear that his options in Antwerp were shrinking. Although his experience had been to a large extent

ANTWERP

disillusioning, in later times he thought more fondly of this brief period – only three months – in Antwerp, which he considered much preferable to Brussels; he had undoubtedly made some sort of progress, notwithstanding the disappointments of the Academy and his dissatisfaction with his own work. But he still wanted some sensible professional guidance, and he knew from Theo and from artists who had been recently in Paris the reputation of the studio of Fernand Cormon, which attracted many painters later to rise to international eminence. Paris also had the advantage of containing many avant-garde artists, among whom Vincent was likely to be better received. But where would he live? Paris would not be any cheaper than Antwerp.

There was a possible solution to this problem which must have been highly attractive to the lonely and hard-up Vincent. He could stay with Theo, his greatest friend as well as his brother. But he was not so completely indifferent to the feelings of others as to be unaware that this solution might hold rather less appeal for Theo than it did for him.

Throughout the months in Antwerp, Vincent was pressing his brother to send more money more quickly, and telling him how underfed and consequently weak he was: '... the end of the month will certainly be terrible unless you can help me a little more'... As to the money, do what you can ... Do try to keep me afloat these two weeks, for I want to paint some more figures ... So I must ask you most urgently, for heaven's sake don't put off writing, and send me much or little, according to what you can spare, but remember that I am literally starving ... The 50 francs you sent ... helped me get through the month, though from today on it will be pretty much the same' – all this within a month of his arrival in Antwerp! He brushed aside Theo's explanation that he had creditors to pay off. Did not Theo realize that 'I must paint!' Those creditors could surely wait.

He first mentioned Paris as a destination in the unspecified future, a future that depended 'so much on the relations I must establish in town, either here in Antwerp or later on in Paris'. He makes the same point later in the same letter (written in early January, 1886) adding an inquiry as to whether Theo would object if he should live in Antwerp 'for some time, and afterwards perhaps ... in a studio in Paris'. About a week later, 'I think it will do no harm if we see each other in Paris after a while'. Then, 'if I come to Paris, I shall be perfectly contented with a cheap little room in some remote quarter'.

The first suggestion of Cormon's studio, in February, seems to have been made by Theo, so to some extent he had only himself to blame for Vincent's eagerness to attend it. From then on, the move to Paris ceases to be merely a long-term prospect and becomes an imminent intention.

It is not difficult to guess Theo's feelings. Whether his brother

would turn out to be a genius, or whether he was only moderately talented – Theo had made both judgements at different times – there was no doubt that he would be an undesirable flatmate. Theo's apartment was small – there was certainly no room for a painter's studio – and he was having problems with a demanding mistress. On the other hand he recognized that Paris was the logical next destination for Vincent. Meanwhile, he prevaricated.

One thing that might have kept Vincent in Antwerp for longer would have been some commercial success, and thus some additional income. Now that they were no longer the spearhead of the avant-garde, Theo was able to sell the work of some Impressionists (Monet, Sisley, Pissarro), but he had not succeeded in selling anything of his brother's elsewhere, which Vincent, most unfairly, had complained about. Whether specifically forbidden or not Theo dared not show any of Vincent's 'monstrosities', as his superiors called them, in the gallery on the Boulevard Montmartre, so he could only show them privately to friendly clients. Hoping someone else might do better, Theo traded on his friendship with a rival dealer and neighbour, Alphonse Portier, to persuade him to take some of Vincent's work, but in spite of admiring *The Potato Eaters*, canvassing his friends, and setting prices very low, Portier too failed to sell a single van Gogh.

Vincent once aptly remarked that people felt the same dread in admitting him to their house as they would a big rough dog with wet paws, but in February 1886 Theo's fear that his ruffianly brother would suddenly decide to come to Paris was partly alleviated by Vincent's suggestion that, now that spring was coming, he might return to the country for a season. That, however, proved only a passing notion, not a serious intention, and Vincent's importuning became more pressing. He even worked out how they could both live in an apartment and share a studio (what did he think Theo would want with a studio?). After some delay Theo replied, warning that Vincent could not come to Paris before June at least.

He arrived at the beginning of March. The first Theo knew of it was a note, scrawled in black crayon and delivered by hand to the gallery in the Boulevard Montmartre. 'My dear Theo, do not be cross with me for having come all at once like this; I have thought about it so much, and I believe that in this way we shall save time. Shall be at the Louvre from midday on or sooner if you like ... We'll fix things up, you'll see. So, come as soon as possible. I shake your hand, Vincent.'

It was characteristic of Vincent to act without warning – though in this case it was also no doubt a strategically sound decision – and characteristic, too, that he, an inveterate frequenter of galleries, should fix a rendezvous in the Louvre, where he could hardly wait to check his new understanding of Delacroix's colour (he said later that Delacroix had a greater influence on him in this respect than the Impressionists). He did not have long to wait. Needless to say, poor Theo appeared as requested, and on time.

129

CHAPTER SIX
PARIS

OPPOSITE
Terrace of a Café (La Guinguette), 1886
Oil on canvas, 19¹/₂ x 25³/₈in
(49.5 x 64.5cm)
Musée d'Orsay, Paris

Vincent's arrival in what, in retrospect, seems the ideal environment, at least for that stage of his career, marks another turning point. Most remarkably, the initial result was that he appears to have painted nothing at all for several weeks, an almost unique lapse in his phenomenal rate of production. Whether the cause was the need to take his bearings, look around, make adjustments, or whether, more prosaically, it followed from the absence of a studio to work in, no one can say, but it cannot have been entirely the latter. Such logistical problems were never enough to stop him working, and in any case the situation was still unchanged when he did return to his palette, although his subject matter – still lifes of bunches of flowers plus the odd self-portrait – may have been dictated by the shortage of space. On the other hand, he was anxious to make some sales, and still lifes seemed to be the most likely subjects.

It was not until June that the brothers moved into a larger apartment in the rue Lepic (the building still stands), near the top of the Butte, or mound, of Montmartre, where the unlovely basilica of Sacré Coeur was then rising. The apartment had a separate bedroom for Vincent and a studio, though rather inadequate, and it commanded fine views over the city while, from the back, open countryside was just visible in neighbouring Clichy.

Another effect, more serious for biographers, of his move to Paris was that his correspondence with Theo came to an end.

Vincent's letters form something close to an incidental autobiography, or at least provide a rich and fertile basis for biographies, throughout the artist's career. Although there had been gaps before for one reason or another, Vincent generally wrote more often than once a week, and usually at considerable length, but their joint household in Paris naturally negated the need for written communication. Except for two brief periods when Theo was on vacation in the Netherlands, it was not resumed until Vincent left for Arles two years later.

Paris – 'the French air clears up the brain and does good' – brought about dramatic changes of several kinds. Vincent was entirely open to French influences, notably (but not exclusively) the Impressionists and their successors, and under their influence, both in style and subject matter his art was transformed in a very short time. He abandoned the dark earth colours of Drenthe and Nuenen, although not overnight, for they are still evident in some early Paris paintings, including still lifes and landscapes such as *Roofs of Paris* (*c.* May 1886). Also, he adopted French permanently as his first language.

'There is much to be seen here,' he wrote to the English artist, Horace Lievens, who had befriended him at the academy in Antwerp, 'for instance Delacroix, to name only one master. In Antwerp I did not even know what the impressionists were, now I

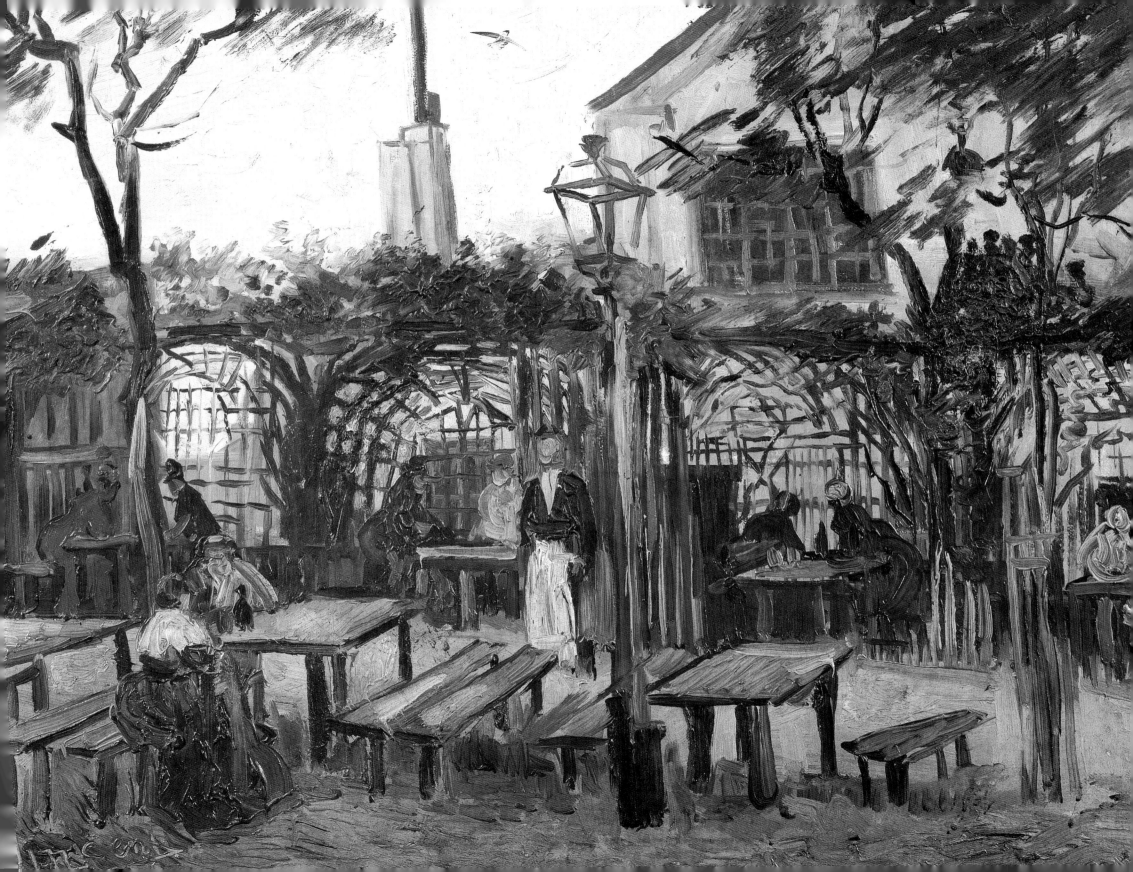

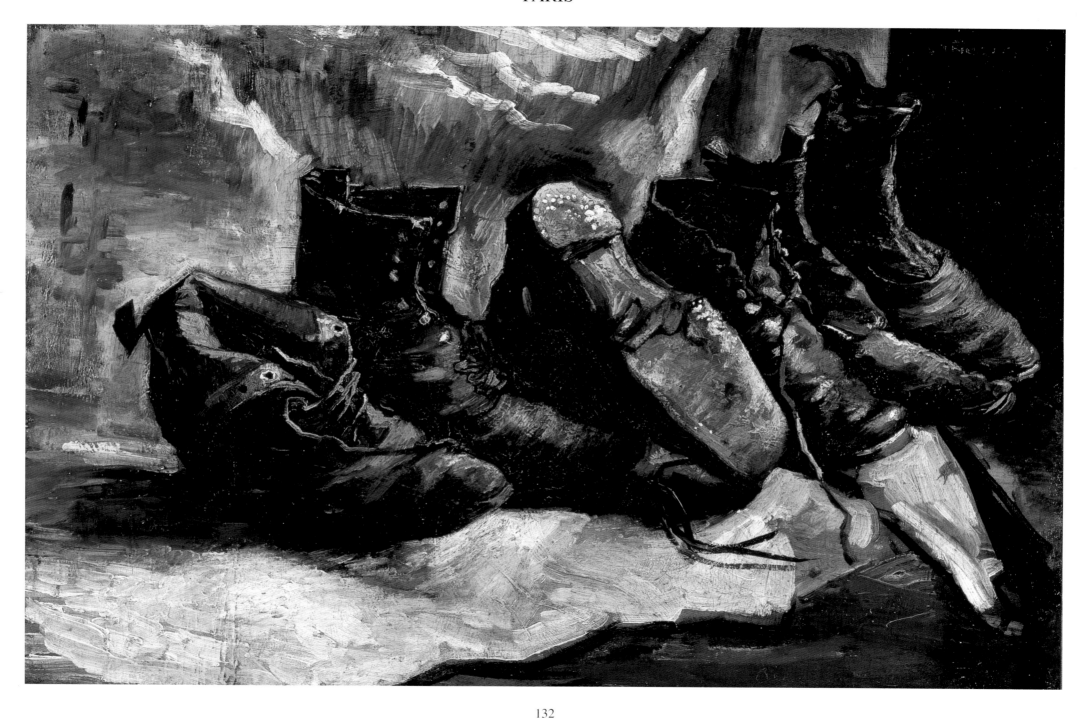

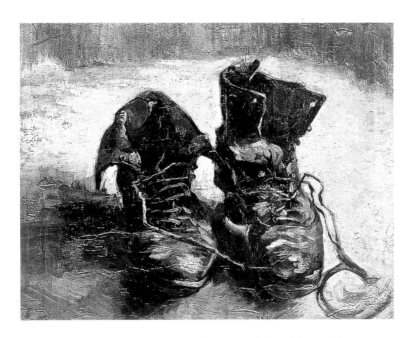

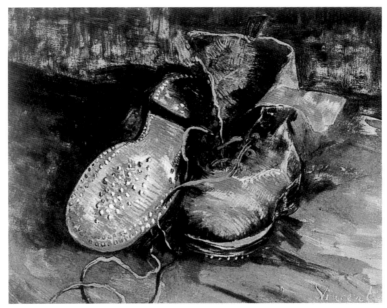

OPPOSITE
Three Pairs of Shoes, 1886
Oil on canvas, 19 x 28in (48.3 x 71.1cm)
Fogg Art Museum, Harvard University Art Museums

FAR LEFT
A Pair of Shoes, 1886
Oil on canvas, 14³/4 x 17³/4in
(37.5 x 45cm)
Rijksmuseum Vincent van Gogh, Amsterdam

LEFT
A Pair of Shoes, 1887
Oil on canvas, 13³/8 x 16¹/3in
(34 x 41.5cm)
The Baltimore Museum of Art: The Cone Collection

Vincent was always a walker of amazing stamina, and his series of boots and shoes stands as an affectionate testament to his pedestrian travels. These pictures are certainly evocative, although some of the interpretations put upon them are rather far-fetched.

have seen them and though not being one of the club yet I have much admired certain impressionists' pictures – Degas nude figure – Claude Monet landscape.' The life and labours of the peasants disappeared from his canvases, although they were not forgotten and perhaps an exception should be made for his famous series of boots and shoes which, whether in the form of his own well-worn footwear or the clogs of the Dutch peasants, were always a favourite theme. In the most famous of the series, the 'pair' actually consists of two left

boots, a detail that has provoked much psychological theorizing but was perhaps more likely an oversight.

In Paris he felt freer, less isolated, and his health improved along with his dress (the first self-portrait in Paris shows him in a Homburg hat and black coat, page 168, beard neatly trimmed, the picture of a city gent) and his eating habits. His aversion to alcohol disappeared, and he took to drinking not only wine but also that 'mother's milk' of the bohemian fringe, absinthe.

PARIS

View of Roofs and Backs of Houses, 1886
*Oil on cardboard, 11⁷/₈ x 16¹/₈in
(30 x 41cm)
Rijksmuseum Vincent van Gogh,
Amsterdam*

*This sketch does not seem to have been
painted from the Van Gogh apartment. As
it is on cardboard, perhaps it was a quick
sketch done from a friend's window.*

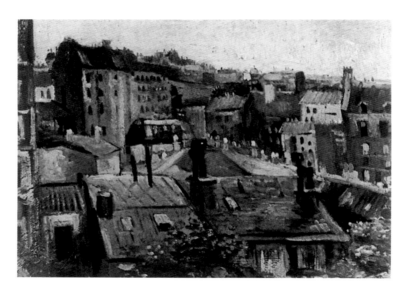

Soon after they had moved into the apartment in the rue Lepic,
Theo wrote to their mother: 'We like the new apartment very much;
you would not recognize Vincent, he has changed so much, and it
strikes other people more than it does me ... He is in much better
spirits than before and many people here like him ... he has friends
who send him every week a lot of beautiful flowers which he uses
for still life ... If we continue to live like this [a more loaded "if"
than Theo was prepared to admit to his mother], I think the most
difficult period is past, and he will find his way.'

In Theo's gallery, Vincent was now able to inspect some of the

finest works of the Impressionists. They were no longer total
outcasts, and in the two years that Vincent was in Paris, Theo sold
no less than twenty Monets, and although he had much less success
with the others – Sisley, with seven, was next best – and prices were
low, public taste was slowly changing. Renoir, for instance, was to
have a great popular success in 1887 with *Les Grandes Baigneuses.*

IMPRESSIONISM AND AFTER
Impressionism was developed in the 1870s, largely by Monet and
Renoir, and first hit the wider public's awareness at the sensational
First Impressionist Exhibition of 1874, which also included paintings
by Pissarro, Sisley, Cézanne and Degas, among others. Neither this
exhibition nor the seven which followed it, were given this title by
their organizers, who preferred 'Société anonyme des artistes,
peintres, sculpteurs, graveurs etc'. The 'Impressionist' title, first
bestowed by sneering critics, snatching at the title of Monet's
Impression: Sunrise in that first exhibition, caught the public
imagination and has lasted to this day.

To the modern eye, Impressionist pictures are among the most
easily enjoyable – pleasant, happy scenes, kind on the eye and not
too demanding of the mind. In spite of the astonishingly violent
response they provoked in the conventional art world in the 1870s,
they do not seem particularly revolutionary to us, and in a sense they

134

Pierre-Auguste Renoir
Les Grandes Baigneuses, 1884–87
Oil on canvas, 45⅝ x 67in (116 x 170cm)
Pennsylvania Museum of Fine Art,
Philadelphia

This famous painting, by one of the great founding figures of Impressionism, is nevertheless in several ways hardly 'Impressionist' at all. These nymphs are painted with an almost Classical precision, although, it must be said, their actions are not entirely convincing. Like many others, Renoir was restless under the label 'Impressionist'.

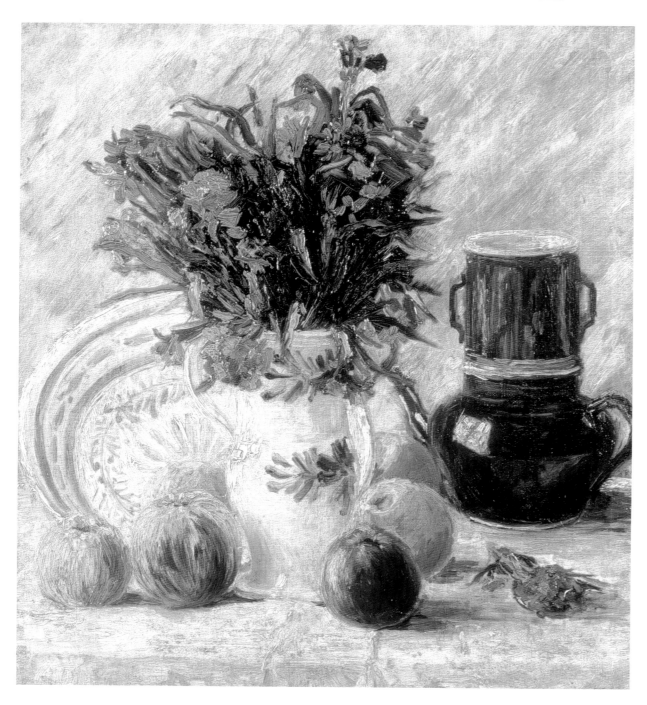

were not so revolutionary as they seemed even then. After all, they did not depart from realism, even if it was not the realism of the academies, and, like all Western art since the Renaissance, they represented above all a way of seeing.

But the Impressionists painted what they saw, as it were at a glance, a superficial, transitory view wherein all is about to vanish into shimmering light and colour. Monet wanted to paint what he thought a blind person would see on suddenly regaining sight, and Pissarro, warning a young painter against the tyranny of precise outlines, which inhibit feeling, said, 'Don't proceed according to rules and principles, but paint what you observe ... Paint generously and unhesitatingly, for it is best not to lose the first impression.' 'Impressionism', a name bestowed in scorn, was really more apt than many other labels attached to art movements.

The Impressionists abandoned many conventional rules, but without insisting on any hard and fast rules of their own. In theory at least, anyone was free to adopt his own style or to disregard everyone else's, but the idea that these paintings were knocked off without thought or discipline was misleading. Much hard work lay behind them, and the mechanics of the whole business of painting were crucial. The extraordinary natural light that pervades these pictures is achieved by analysis of tone and colour, including the use of complementary colours in shadows and, as in watercolours, of the

white space of the canvas. Colours are usually applied with shortish dabs of the brush, which work together to create form.

Although the need to get the whole picture done very quickly on the spot resulted in enormous numbers of them, there was nothing easy about it. A painter like Monet worked extremely hard. His description of his effort to get down on canvas what he saw in nature conveys the agony of creation, a titanic struggle of the kind more often associated with an artist like Michelangelo.

For all its virtues, Impressionism had its limits. Even at the start, those who exhibited at the First Impressionist Exhibition were a disparate bunch, with Cézanne, for example, far removed from Monet (though equally effortful), and the movement began to disintegrate quite quickly. By the time of the Fourth Impressionist Exhibition (1879), several of the original exhibitors had withdrawn, and the Eighth, held in 1886, the year that van Gogh arrived in Paris, was the last.

A younger generation had appeared, including those now known under the general label of 'Post-Impressionists', who were dissatisfied with the limitations of Impressionism, and largely rejected naturalism, though their ideas took them in different directions. One of them, Paul Gauguin, who exhibited with the Impressionists in the early 1880s, expressed the crucial cause of complaint. 'The Impressionists study colour exclusively for

OPPOSITE
Vase of Flowers with a Coffee Pot and Fruit, 1887
Oil on canvas, 16¹⁄₈ x 15in (41 x 38cm)
Von Heydt Museum, Wuppertal

LEFT
Path to the Entrance of a Belvedere, 1887
Watercolour, 12³⁄₈ x 9³⁄₈in (31.5 x 24cm)
Rijksmuseum Vincent van Gogh, Amsterdam

PARIS

RIGHT
Vase with Poppies, Cornflowers, Peonies and Chrysanthemums, 1886
Oil on canvas, 39 x 31¹/₈in (99 x 79cm)
Rijksmuseum Kröller-Müller, Otterlo

OPPOSITE
Georges Seurat
Sunday Afternoon on the Island of the Grande Jatte, 1884–86
Oil on canvas, 81⁵/₈ x 121¹/₄in
(207.5 x 308cm)
Art Institute of Chicago

Seurat's imaginative but restrictive extension of Impressionism influenced, at least temporarily, many of his contemporaries, including Vincent, but only Seurat himself remained faithful to the Pointillist method until his early death.

decorative effect ... they heed only the eye, and neglect the mysterious centres of thought.' The fundamental conception and motivation of Vincent van Gogh who, following his own erratic but purposeful way had here and there crossed the Impressionists' trail, found great rewards in them, but the aims of their successors were, nevertheless, entirely different.

Vincent remained open to influence from eclectic sources, and the first artist to leave a mark on his style, evident in the early still lifes he did in Paris, was neither an Impressionist nor a Parisian artist, except briefly. Adolphe Monticelli was not particularly well known in his own time, still less now, though he had some success in Paris before 1871, when he retired to his native Marseille and virtually disappeared from sight (he died within weeks of Vincent's arrival in Paris). Of Italian descent, he was influenced by the Venetians. The flamboyant, almost violent (he has been seen as a forerunner of the Fauves) style of the flower paintings, owing more to 'lyrical ardour ... than botanical knowledge', were painted in rich, glowing, jewel-like colours, laid on thick as pastry crust. Earlier, he was better known for his Provençal landscapes and Romantic scenes of courtly life in medieval Provence.

Theo had come across Monticelli's paintings in the Delarbeyrette Gallery some time earlier, and took his brother there. Vincent was carried away with an enthusiasm that never left him,

OPPOSITE
Fishing in the Spring, Pont de Clichy, 1887
Oil on canvas, 19¼ x 22⅞in (49 x 58cm)
Art Institute of Chicago

and among his own flower paintings ('A branch of white lilies – white, pink, green – against black ... a bunch of orange tiger lilies against a blue background, then a bunch of dahlias, violet against a yellow background, and red gladioli in a blue vase ...', all presumably provided by the 'friends' mentioned by Theo in the letter to their mother), some are almost direct copies of Monticelli. When he first thought about going south, his original purpose was to make for Marseille and, not having heard of Monticelli's declining health, he even dreamed of joining forces with him. He came later to think of himself and Monticelli together, not unreasonably, as independent spirits whose ability was unrecognized and unrewarded by the world at large.

The Eighth Impressionist Exhibition opened in May, a few weeks after Vincent appeared at the Louvre to wait for Theo. It was dominated by Camille Pissarro and the younger artists whom he supported. The older Impressionists – Monet, Renoir, Sisley – had withdrawn in protest against the inclusion of those they considered had strayed too far beyond the Impressionist canon, especially Georges Seurat and Paul Signac. However, the star of the show beyond a doubt was Seurat's great picture, more than six square metres in area, *Sunday Afternoon on the Island of the Grande Jatte* (page 139).

The style practised by Seurat and Signac, artistic allies though opposite personalities, is known as Divisionism (also Pointillism or Neo-Impressionism). Seurat brought to his calling as an artist the devotion of a priest or a research scientist, and aspects of his work suggest the discipline of both those vocations. Beginning, like the Impressionists, with the researches of Chevreul, Seurat conducted an intensive scientific study of colour that took him much farther. Among other things he had become interested in theories regarding the association of colour and music.

This is of special interest to students of van Gogh because, at the time when he was living in Nuenen and giving informal art lessons to several persons, Vincent had applied to the local organist for music lessons, keen to investigate such an association himself. The lessons were not a success; in fact, the very idea of them summons up some comic scenes – Vincent bashing away at the piano with frequent outbursts of frustrated rage, and occasional sudden, delighted and prolonged pauses when he would discourse on the association of the chord he had just played with a particular colour, no doubt to the utter bewilderment of his teacher.

The Neo-Impressionist theory of colour was a more refined and 'scientific', indeed rigid, application of the Impressionist use of complementary colours. Its basis was that brighter secondary colours result if their constituent primary colours, instead of being mixed together on the palette, are applied in small, separate, though intermingled, blobs or dots, what Renoir slightingly called 'the petit point school of painting'. From close up, the viewer sees only a mass

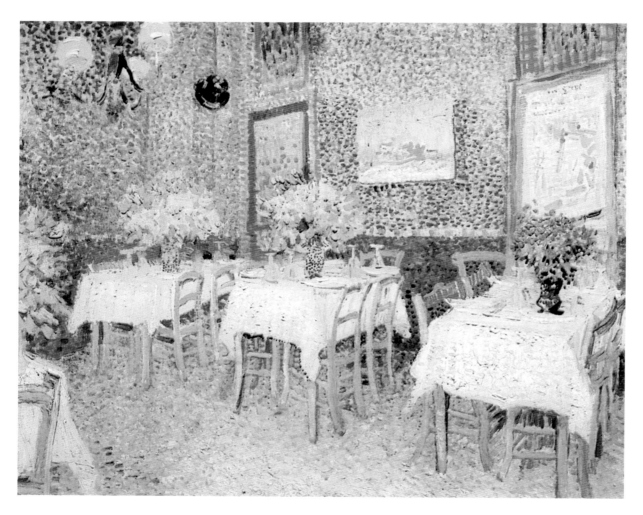

of dots of different colours, say blue and yellow; withdrawing a few feet, he sees only green. The viewer's eye does the mixing instead of the painter's brush, and the result is a cleaner, brighter tone.

In some ways, Divisionism was the very opposite of Impressionism. Far from depending on swift, on-the-spot spontaneity, it demanded endless hours of close and laborious painting in the studio. It is also said to have been, in time, injurious to the eyesight, although that idea seems to have no scientific basis. The Grande Jatte, a favourite Sunday picnic spot for Parisians, was also well frequented by artists, but it is said that when Seurat, an ascetic, aloof man (who died at thirty-two) was working there, he never spoke a word to any of his fellow-painters.

The Divisionists represented one more small but significant step away from naturalism and towards abstraction, something that only becomes evident in hindsight. They took their researches very seriously, and when they discovered to their surprise that Chevreul was still alive, Signac went to visit him in the hope of discovering more about his theory of complementary colours. He had difficulty conveying to Chevreul, who was ninety-eight, exactly what he wanted to know, and in the end the old man could only suggest that he go and ask his good friend Ingres. That left Signac somewhat perplexed since, apart from Ingres having had no particular interest in colour theory, he had been dead for nearly two decades.

OPPOSITE
Interior of a Restaurant, 1887
Oil on canvas, 18 x 22¹/₄in
(45.5 x 56.5cm)
Rijksmuseum Kröller-Müller, Otterlo

Vincent's version of Divisionism (see page 147).

LEFT
The Outskirts of Paris, 1886
Oil on cardboard, 18 x 21¹/₂in
(45.7 x 54.6cm)
Christie's Images, London

Le Moulin de la Galette, 1886
Oil on canvas, 15 x 18¹/₄in (38 x 46.5cm)
Nationalgalerie, Berlin

There are three almost identical paintings
of this scene, all probably done in October
1886. In a letter of 25 October concerning
a possible exchange of pictures with two
other artists, Vincent remarked, 'Right
now I have two views of the Moulin
Galette that I could part with.'

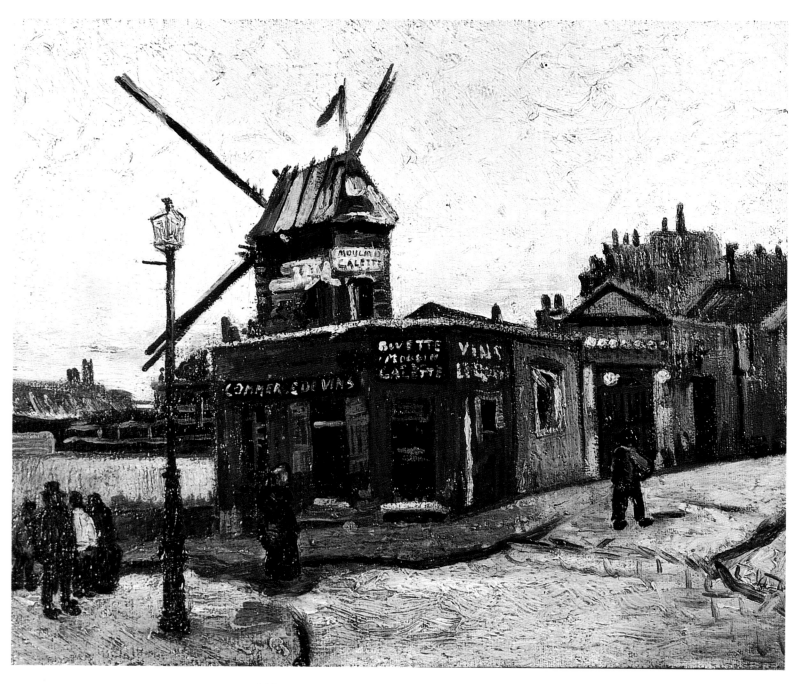

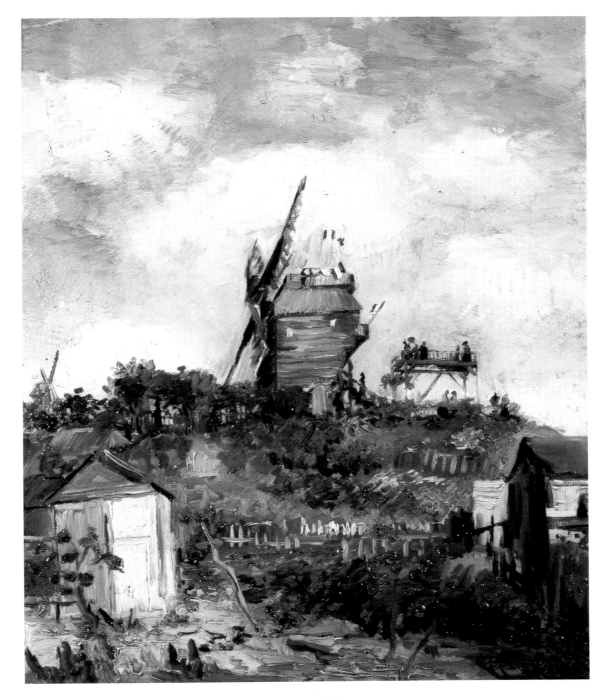

LEFT
Le Moulin de Blute-Fin, 1886
Oil on canvas, 17⁷/₈ x 18⁵/₈in
(45.4 x 47.5cm)
Glasgow Art Gallery and Museum

PAGE 146
Still Life with Mussels and Shrimps, 1886
Oil on canvas, 10³/₈ x 13¹/₂in
(26.5 x 34.5cm)
Rijksmuseum Vincent van Gogh,
Amsterdam

PAGE 147
Bowl with Peonies and Roses, 1886
Oil on canvas, 23¹/₄ x 28in (59 x 71cm)
Rijksmuseum Kröller-Müller, Otterlo

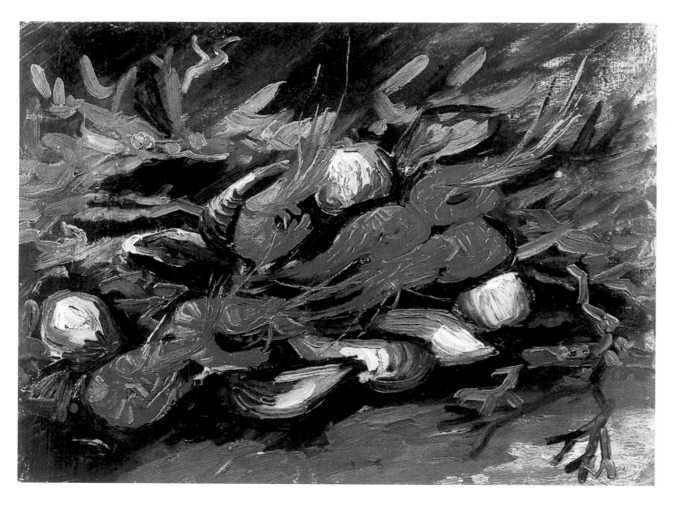

NEW FRIENDS AND NEW SUBJECTS

Camille Pissarro, now fifty-five, was the most genial of the original
Impressionists and also the most open-minded, the most supportive
of aspiring artists and, although in one respect the most faithful (he
was the only artist who exhibited at all the Impressionist
exhibitions), perhaps also the most easily influenced. His quiet
manner lent him a certain gravitas, and he was the most peaceable,
accommodating of men, in spite of his anarchist convictions, who
arbitrated in the numerous quarrels of his fellow artists. Many of the
painters who had grown restive with Impressionism were drawn to at
least experiment with the technique of the Divisionists, but Pissarro,
once a disciple of Corot and Courbet, regarded them as representing
the future and adopted their methods wholeheartedly, although it
proved only a phase as he eventually came to the conclusion that the
technique was inhibiting and 'hinders the development of
spontaneity of sensation'.

Camille Pissarro was a friend of Theo, as was his son Lucien, a
lesser painter in his father's style who eventually settled in London
and became a member of the Camden Town Group. Vincent met
Lucien in Theo's apartment, and later the elder Pissarro when, on
his way to paint at Asnières (a favourite destination), he
encountered him with Lucien in the street. Vincent, completely
ignoring amused passers-by and the convenience of the traffic,

VAN GOGH

proceeded to spread the canvases he was carrying all over the street for Pissarro's inspection.

He also became friendly with Signac, ten years his junior, at first by simply following him and setting up his easel next to him. Far from resenting this and other manifestations of Vincent's odd behaviour, Signac, the most tolerant of men, enjoyed his eccentricities, and they often painted together. He told a story that sounds typical of Vincent, when one day they were on their way to paint together at the same destination. Vincent, said Signac, never stopped talking the whole way and all the while waved his canvases about in emphasis. As they were still wet, he splashed paint liberally over himself as well as several passers-by.

Vincent's version of the Divisionist method generally employed short dashes rather than Seurat's dots or Signac's little 'commas', and he did not necessarily stick to it for every part of a given painting. *Interior of a Restaurant* (page 142) is an example, the method being used for the background but not the furniture.

The best examples occur in paintings of the early summer of 1887, the first masterpieces of his Paris period, such as the two paintings of restaurants at Asnières, *Restaurant de la Sirène at Asnières* (page 151) and *The Restaurant Rispal at Asnières* (page 150), and especially the *Interior*, which is no doubt the inside of one of these. *Interior of a Restaurant* manages to seem lively in spite of

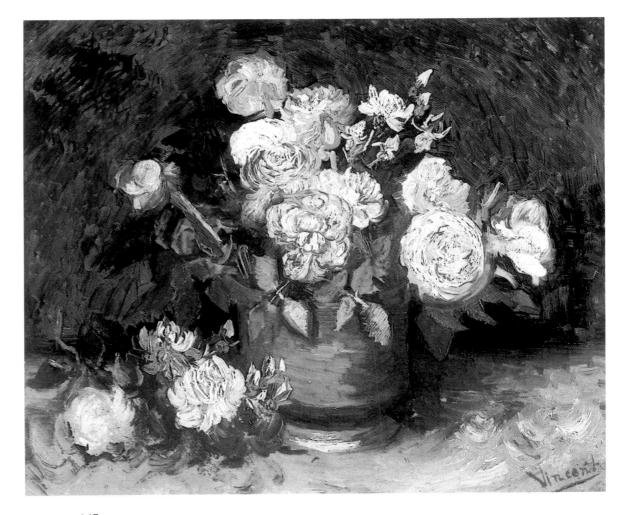

147

RIGHT
The Fourteenth of July Celebration in Paris, 1886
Oil on canvas, 17¹/₃ x 15¹/₃in (44 x 39cm)
Collection L. Jäggli-Hahnloser, Winterthur

OPPOSITE
Vegetable Gardens in Montmartre, 1887
Oil on canvas, 17⁵/₈ x 31⁷/₈in
(44.8 x 81cm)
Rijksmuseum Vincent van Gogh,
Amsterdam

The Moulin de Blute-Fin appears in many
views of Montmartre, including this one.

RIGHT
The Restaurant Rispal at Asnières, 1887
Oil on canvas, 28¹/₃ x 23⁵/₈in (72 x 60cm)
Shanwee Mission, Kansas: Collection
Henry W. Bloch

OPPOSITE
Restaurant de la Sirène at Asnières, 1887
Oil on canvas, 21¹/₂ x 25³/₄in
(54.5 x 65.5cm)
Musée d'Orsay, Paris

*Vincent made many trips into the Paris
suburbs, especially Asnières, home of
Emile Bernard. Another friend, Paul
Signac, described him wearing '... a blue
zinc worker's smock [with] painted
coloured images on the sleeves. Pressed
closely against me, he walked along
shouting and gesticulating, waving his
freshly painted oversize canvas, smearing
paint on himself and the passers-by.'*

the absence of customers or staff (considered as a picture about eating, it is a far cry from *The Potato Eaters*!). Vincent makes the Restaurant de la Sirène a very attractive hostelry in the bright summer sunshine; the painting of it gains vividness from the use of complementary colours (e.g. the red building on the right next to the green creeper, or the use of orange and blue in the walls of the restaurant) and energy from Vincent's use of straight horizontal and vertical strokes of the brush. Similarly, the Restaurant Rispal looks the sort of place one would be glad to enter, although there is nothing particularly attractive about this scene – except the colour.

Because Vincent encountered Impressionism and Divisionism, besides other influences, at the same, rather bewildering time, in 1886, he did not make much distinction between them, but their combined effect on his palette, which grew steadily lighter, and on his subject matter, was swift and striking.

Vincent was not much attracted by the grand monuments of Paris, and he found the atmosphere of Montmartre, bohemian yet villagey (something like New York's Greenwich Village in a later era), more to his liking. When he went beyond Montmartre it was generally to the semi-rural suburbs to the north-west, Clichy and, beyond it, Asnières. Among the subjects he painted were the three windmills that still survived on the Butte of Montmartre, the most famous of them being the Moulin de la Galette (page 144), which

had been converted into a place of entertainment and was commemorated by Corot, by Renoir in a particularly fine painting of 1876, and later by others, including Toulouse-Lautrec.

Among other favoured subjects were the little allotments and gardens of Montmartre; the Paris ramparts and the factories fast encroaching on the fields of Clichy and Asnières; bridges, which sometimes, as in *Bridges across the Seine at Asnières* (page 156) show the influence of Japanese design in their unusual perspective and improbable angles, while *Bridge in the Rain* (also page 156), with peasants scurrying across in their enormous hats to escape the steadily falling rain, is a direct copy of a print by Hiroshige, which Vincent took amazing trouble over, first tracing the outline of the original on tracing paper, then dividing it into squares so that he could increase the total size.

Though he often painted the factories, he did not paint the factory workers, nor the slum district of Montmartre where the impoverished and the inadequate scraped some kind of living together, and Hiroshige's faintly comical, bare-legged peasants are a world away from those of Millet or of Vincent's Brabant. For the time being, at least, his social conscience was overborne by his concern with technique and his fascination with current developments in the artistic avant-garde. Nor did he paint the country scenes that had once been virtually his exclusive interest. If

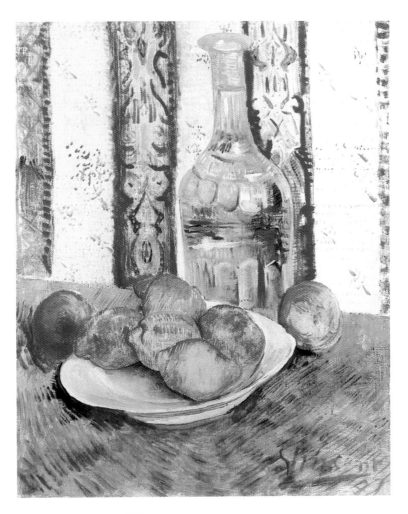

OPPOSITE
Restaurant de la Sirène at Asnières, 1887
Oil on canvas, 20¹/4 x 25¹/4in
(51.5 x 64cm)
Ashmolean Museum, Oxford

Another view of the restaurant at Asnières (see also page 151).

LEFT
A Plate with Lemons and a Carafe, 1887
Oil on canvas, 18¹/4 x 15¹/8in
(46.5 x 38.5cm)
Rijksmuseum Vincent van Gogh, Amsterdam

RIGHT
Still Life with Lemons on a Plate, 1887
Oil on canvas, 8^{1}/$_{4}$ x 10^{3}/$_{8}$in (21 x 26.5cm)
Rijksmuseum Vincent van Gogh,
Amsterdam

OPPOSITE
Fortifications of Paris with Houses, 1887
Pencil, chalk and watercolour,
15^{1}/$_{2}$ x 21in (39.5 x 53.5cm)
Whitworth Art Gallery, The University of
Manchester, England

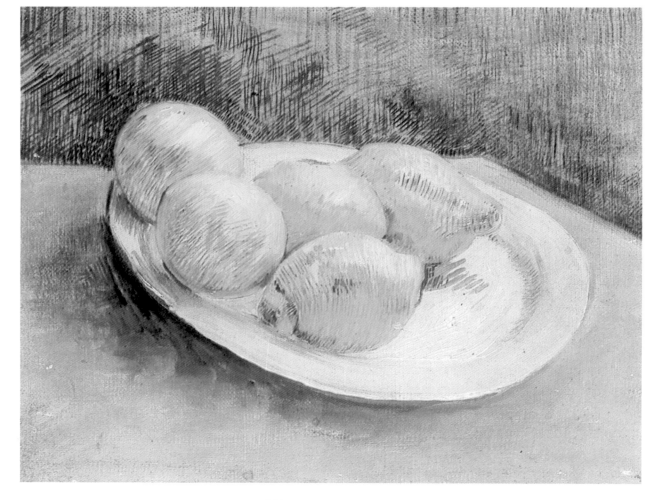

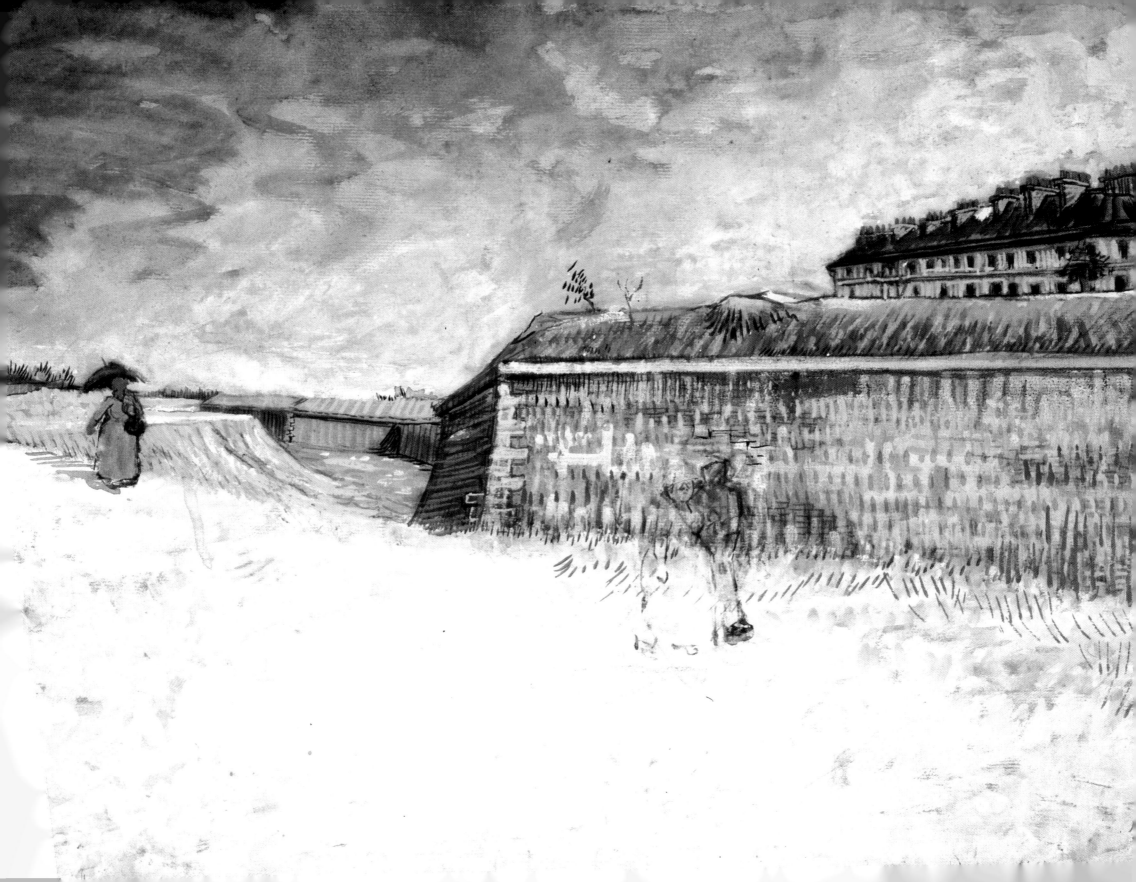

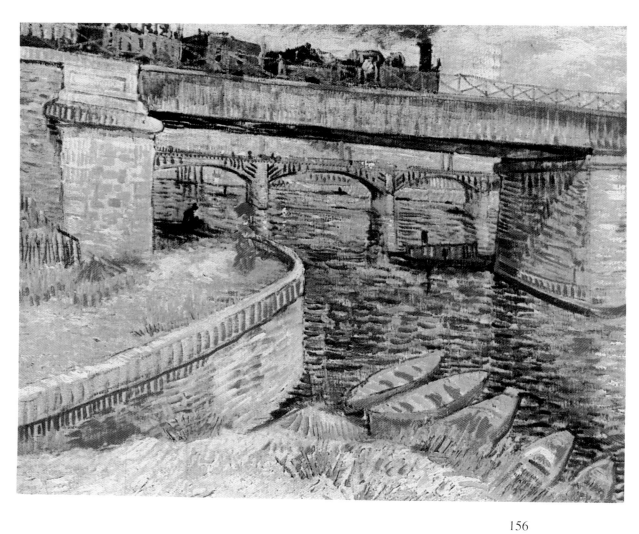

not totally an urban artist, as one might say of Toulouse-Lautrec for instance, he hardly went beyond the suburbs, although there were a few exceptions, such as *Edge of a Wheatfield with Poppies and a Lark* (page 158), the sort of scene usually associated with his Arles period.

Vincent also painted many self-portraits – nearly thirty in two years. He explained that the reason for so many was simply the shortage of models, but that can hardly be the whole explanation since he did have free models available, other than himself, close at hand. It seems strange, for instance, that he never painted a portrait of Theo. The self-portraits are notably different one from another, the variable technique suggesting his changing moods, and it seems possible that they played some function in Vincent's attempts to understand himself, as well as representing changes in technique, some of them mere experiments not followed up, others longer-lasting developments.

Some of the most attractive pictures of this period were portraits, such as that of the elegant, composed young woman, now identified as Léonie Davy-Charbuy, the niece of a friendly art dealer, which is known as *Woman Sitting by a Cradle* (early 1887). The painting gains additional poignancy from our knowledge of Vincent's longing for domesticity. His own portrait was done by several friends and acquaintances from Cormon's studio, including Henri de Toulouse-Lautrec and the underrated Australian John Peter

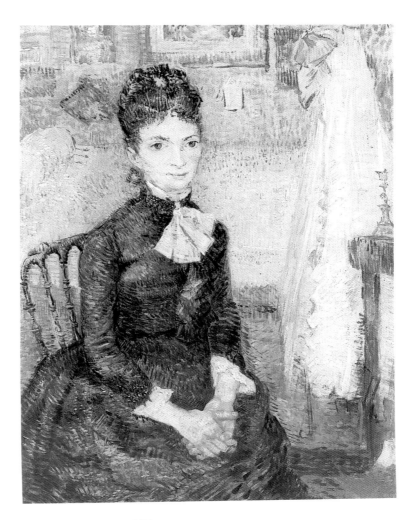

OPPOSITE LEFT
Bridges across the Seine at Asnières, 1887
Oil on canvas, 20¹/₂ x 25¹/₂in (52 x 65cm)
Collection E.G. Bührle, Zurich

OPPOSITE RIGHT
Japonaiserie: Bridge in the Rain (*after Hiroshige*), **1887**
Oil on canvas
Rijksmuseum Vincent van Gogh, Amsterdam

LEFT
Woman Sitting by a Cradle, 1887
Oil on canvas, 24 x 18in (61 x 45.5cm)
Rijksmuseum Vincent van Gogh, Amsterdam

VAN GOGH

Edge of a Wheatfield with Poppies and a Lark, 1887
Oil on canvas, 21¼ x 25⅜in
(54 x 64.5cm)
Rijksmuseum Vincent van Gogh,
Amsterdam

FAR LEFT
Reclining Nude, 1887
Oil on canvas, 9½ x 16⅛in (24 x 41cm)
De Steeg, Netherlands: Collection Mrs.
van Deventer

ABOVE LEFT
Reclining Nude, Seen from the Back,
1887
Oil on canvas, 15 x 24in (38 x 61cm)
Private collection

Certain Antwerp influences lingered in
Paris, including an interest in the figure.
Some of Vincent's paintings of prostitutes
were destroyed after his death.

Russell (also featuring the grey felt hat of several of Vincent's self-portraits). Though very different, Vincent and Russell, who later returned to Australia and died virtually unknown, became friends, and continued to correspond after Vincent had left Paris.

Vincent also drew a series of odd, strangely unattractive nudes, nothing like his near-classical reclining nude (oil on canvas) of about February 1887 but reminiscent of Rembrandt's more grotesque etchings of such a subject, though Vincent's models (or model?) are less offensive. It is far from certain that Vincent's were consciously ugly, and they were probably intended to serve some introspective need. They are not up to much technically, and they may have been little more than idle doodling. He did not, apparently, show them to others, but as he signed at least one of them he was clearly not ashamed of them, either.

DIFFICULT TIMES FOR THEO

Among the advantages of Paris was the presence of a large community of artists among whom, unlike almost all previous acquaintances, were many who sympathized with Vincent and offered encouragement. Pissarro was one, and although he and his family still lived in cruel poverty, in this community he was a leading figure, and he did sell a few paintings, although his adoption of Divisionism had a negative effect on his sales. Vincent met some of the Paris-based artists in Theo's apartment.

RIGHT
Portrait of Alexander Reid, 1887
Oil on cardboard, 16¹/₃ x 13¹/₄in
(41.5 x 33.5cm)
Glasgow Art Gallery and Museum

Reid was a Scottish art dealer of whom
Vincent did two portraits, the other,
slightly earlier, showing him seated in an
armchair.

OPPOSITE
Woods and Undergrowth, 1887
Oil on canvas, 18¹/₈ x 21⁷/₈in
(46 x 55.5cm)
Rijksmuseum Vincent van Gogh,
Amsterdam

This is one of several paintings of
woodland dating from the late summer of
1887.

VAN GOGH

Theo, a man of taste and refinement, used to civilized surroundings, was finding his brother's presence there a considerable strain, and the demanding behaviour of his mistress added to his difficulties. Although Vincent's self-portraits suggest that he had smartened himself up considerably, the neat grey felt hat replacing the drowned-cat fur, Theo complained to their sister Wil of Vincent's dreadful untidiness and dirtiness, and of his strangely split personality; 'It is as if he were two persons: one marvellously gifted, tender and refined, the other egoistic and hard-hearted.'

Theo's Dutch friend Andries Bonger told his family that Theo was looking 'frightfully ill'. Theo would appear in the evening, worn out after working till seven (Gauguin was one who testified that Theo was 'busy from morning until night') as he struggled to persuade reluctant buyers of the virtues of the Impressionists and also to defend them against his doubting superiors. But he found no rest in his apartment. 'The impetuous, violent Vincent,' wrote Johanna Bonger, Theo's future wife and widow (and editor of Vincent's letters), 'would begin to expound his own theories about art and art dealing ... indeed, sometimes he sat down on a chair beside Theo's bed to spin out his last arguments.'

In the summer, Theo took some time off to visit Holland. He was hoping that his uncles might help to set him up in his own gallery, a plan enthusiastically advocated by Vincent, who had no

RIGHT and OPPOSITE
Self-Portrait, 1887
Oil on canvas laid down on panel,
13³/₈ x 10¹/₂in (34 x 26.7cm)
The Detroit Institute of Arts

PAGES 166 and 167
Self-Portrait with Straw Hat, 1887
Oil on canvas, 16¹/₈ x 13in (41 x 33cm)
Rijksmuseum Vincent van Gogh,
Amsterdam

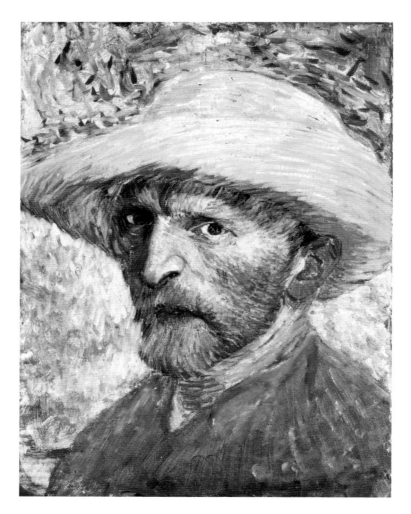

respect for *ces messieurs* ('those gentlemen'), as he called the directors of the firm. This hope was to be disappointed, but Theo also visited Bonger's family, as he was paying suit to his friend's sister. In his absence, Andries moved into the flat to keep Vincent company – or, more likely, to keep an eye on him.

In fact, these two seem to have got on pretty well, perhaps helped by the fact that Andries was not connected with the arts and therefore less liable to be subjected to Vincent's lengthy, exhausting and sometimes combative disquisitions on the subject. They were left to deal with the problem of Theo's mistress, whom Vincent described as 'seriously deranged'. The solution they proposed was that they should try to pass her on to someone else, and Vincent volunteered for this role, asserting that he was ready to take her off his hands, preferably without having to marry her, but if the worst comes to the worst he would even agree to a *mariage de raison*. Bonger told Theo that he thought Vincent's plan impracticable. Obviously worst did not come to worst, although precisely how the problem was resolved we do not know, as no more is heard of this unhappy woman.

AT CORMON'S ATELIER

Ostensibly, one of the chief reasons for Vincent's move to Paris was to attend the *atelier libre* of Fernand Cormon, which he did in the summer of 1886, although he seems not to have attended it for much

longer (he says three to four months, some contemporaries say less) than he had the Antwerp Academy. His motive was the same as in Antwerp: he wanted to improve his drawing with the benefit of free models, otherwise very expensive in Paris, and to get some guidance from a discerning teacher. In spite of his Antwerp experience, his drawing had improved there, and he was now willing to grant that there was some sense even in copying Classical plaster casts. A subsidiary motive was his desire to belong to an artistic community, which came nearer to fulfilment in Paris than anywhere else.

Cormon was a curious mixture. He had built his reputation as a painter of large official commissions and had become an important establishment figure, sitting on the jury of the Salon and holding a professorship in the Ecole des Beaux-Arts. His more recent works tended to be equally large scenes from prehistory, featuring rather Gallic-looking Neanderthals dressed in furs. Yet his mind was not entirely closed to new developments, nor did he object to a reasonable amount of bohemianism, which was just as well given the reputation of Parisian art students for unconventional behaviour. He was said to have been running three mistresses simultaneously, some achievement for a man who was extremely ugly – at least, in the view of Toulouse-Lautrec, who might himself have offered competition in that sphere.

As an artist, Cormon was said to be a master of composition. He

RIGHT and OPPOSITE
RIGHT and OPPOSITE
Self-Portrait with Grey Hat, 1887–88
Oil on canvas, 17¹/₃ x 14³/₄in
(44 x 37.5cm)
Rijksmuseum Vincent van Gogh,
Amsterdam

Vincent's version of Divisionism is at its
height in this picture.

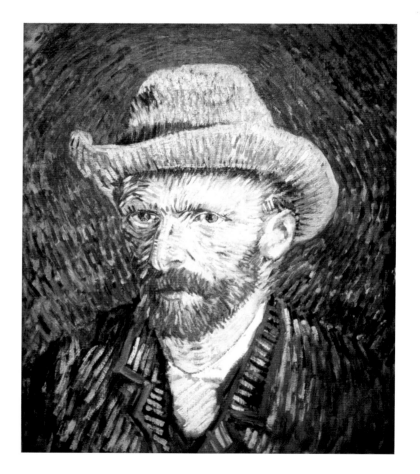

and his work passed into total obscurity long before he died in 1924, but his studio was certainly popular in the 1880s. When Vincent was attending it the pupils included several future internationally famous painters, notably Toulouse-Lautrec himself, and most of his ex-students tended to remember him with gratitude. He seems to have been one of those people who make better teachers than practitioners.

Some studios were open to allcomers (hence the term *atelier libre* – 'free studio'), and tended to attract a lot of young men of no artistic ability who only wanted to leer at naked models, but Cormon was a little more particular, requiring some kind of reference (it would be interesting to know exactly what made him decide to accept Vincent). All the same, among Cormon's sixty-odd pupils, who incidentally provided useful income, there were some unruly characters. One of these was the eighteen-year-old Emile Bernard, who would become a great friend of Vincent. Models at Cormon's classes were posed against a dull, brown backcloth, and students were told to paint just the figure and not to create their own setting, but Bernard decided things ought to be livened up a bit, and so painted the offending backcloth with bold red and green stripes. It was not his first prank, and he had also offended Cormon by his experiments with colour in the manner of Signac. This time Cormon asked his father, a substantial merchant, to remove the boy.

Vincent did not like the brown backcloth any better than Bernard

RIGHT
Portrait of Père Tanguy, 1886–87
Oil on canvas, 18¹/₂ x 15¹/₈in
(47 x 38.5cm)
Ny Carlsberg Glyptotek, Copenhagen

*This is Vincent's earliest portrait of
Tanguy, probably painted around the
beginning of 1887 before he got to know
him well.*

OPPOSITE
The Factory at Asnières, 1887
Oil on canvas, 18¹/₃ x 21¹/₄in
(46.5 x 54cm)
*The Barnes Foundation, Merion,
Pennsylvania*

*Asnières was not all pleasant restaurants
and placid woods, it also had factories, of
which Vincent painted two pictures. But
his intense commitment to the working
poor of the countryside in Brabant was not
translated into an equivalent concern for
industrial workers.*

did, and one of his contemporaries remembers that, one day, painting
a blonde model with honey-coloured skin, he posed her against an
imagined blue curtain, the better to set off her colouring. Cormon,
making his rounds, wisely offered no comment.

Bernard's fall from grace occurred before Vincent arrived at
Cormon's, although he saw Bernard when he came later to say
goodbye. Then, ignoring his father's decree that he should give up
art and go into business, Bernard went off to Pont-Aven in Brittany,
a popular summer resort for artists, where he later joined Gauguin in
developing the style, allied to Symbolism, known as Synthetism or
Cloisonnisme (because it looked like *cloisonné* enamels, in which
fired enamel panels are contained within thin inlaid metal strips).
Meanwhile, after Bernard's return to Paris, Vincent invited him to
his studio, where Bernard was very impressed by the work he saw,
especially *The Potato Eaters*, and they became friends. Bernard's
parents lived in Asnières where he had a studio, and Vincent often
visited the house and worked in the studio. Later he quarrelled
ferociously with Bernard's father over their conflicting ideas of what
Emile should do in life, and he never stepped inside the house again.
However, he continued to be friends with Emile, perhaps the only
painter-friend with whom he never quarrelled.

After Vincent's death, Bernard described his friend with a
painter's eye as he had appeared then: 'Red-haired, with a goatee,

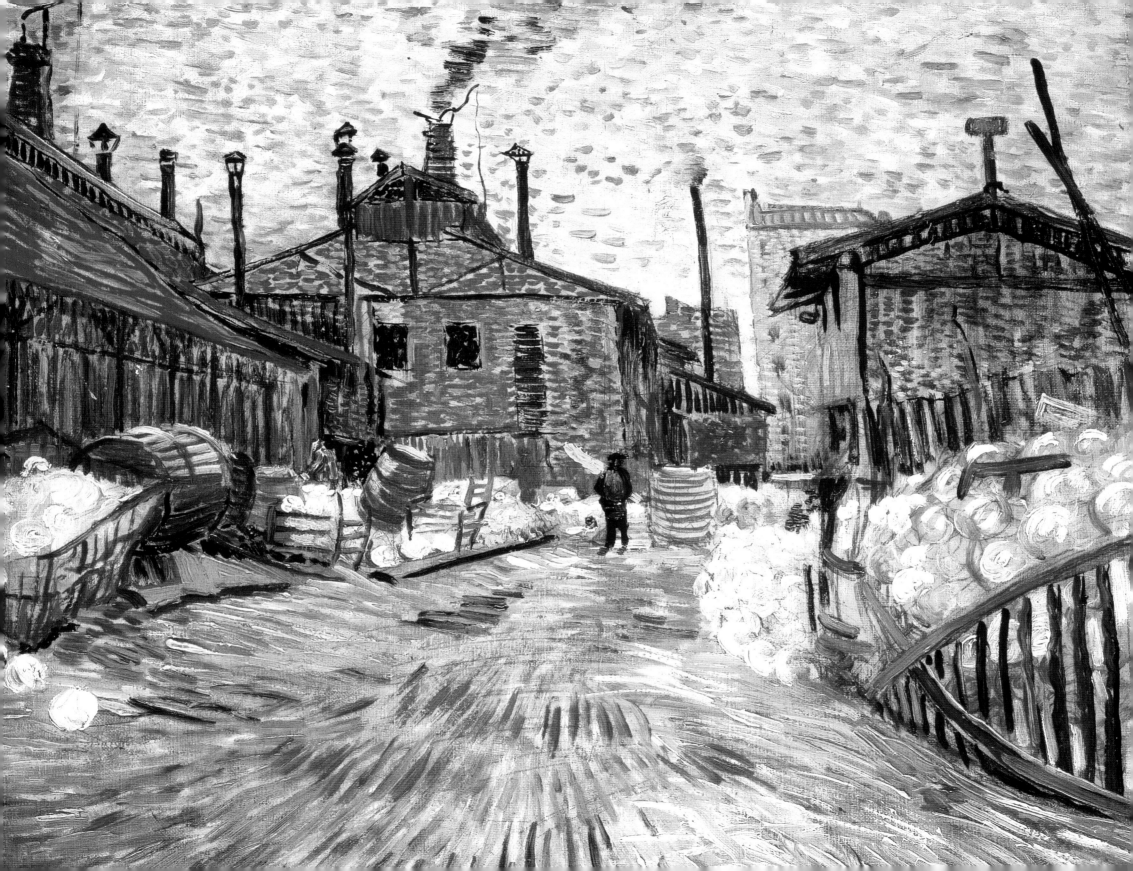

RIGHT and OPPOSITE
Portrait of Père Tanguy, 1887
Oil on canvas, 36¹/₄ x 29¹/₂in (92 x 75cm)
Musée Rodin, Paris

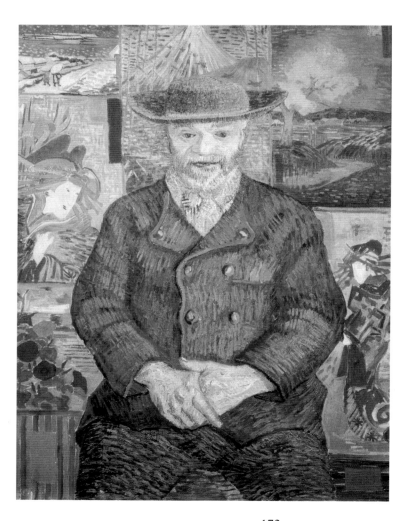

rough moustache, shaven skull, eagle eye, and incisive mouth as if he were about to speak; medium height, stocky without being in the least fat, lively gestures, jerky step, such was van Gogh, with his everlasting pipe, canvas, engraving or sketch. He was vehement in speech, interminable in explaining and developing his ideas, but not very ready to argue. And what dreams he had: gigantic exhibitions, philanthropic communities of artists, colonies to be founded to the south, and the conquest of public media to re-educate the masses ...'.

Cormon had invited further problems by appointing Toulouse-Lautrec as *massier*, more or less 'head boy'. Henri Marie Raymond de Toulouse-Lautrec Montfa, twenty-one years old when Vincent met him, came from an aristocratic family of Albi in the Languedoc, who traced their descent from the medieval counts of Toulouse. As a result of a constitutional deficiency aggravated by the childhood accidents that it provoked, his legs never grew and he was extremely short, barely 5-ft (1.5-m) tall. Characteristically, he tended to choose friends who were abnormally tall, enjoying the incongruity. He was also plain to the point of ugliness, having a large nose, fleshy lips with a speech impediment that made him spray saliva, and no chin to speak of. But he had some notable advantages, including a devoted mother, acerbic intelligence, wit and charm that, when exercised, enabled him, like John Wilkes, to talk away the impression made by his unfortunate appearance in a

couple of minutes. Finally, he had God-given artistic gifts. He did not sell his first painting (as distinct from drawings) until 1889 but thereafter – paradoxically, since his family was relatively wealthy – he had no difficulty selling his pictures in his own lifetime, which occupied the same brief span as Vincent's (and Raphael's).

The art of Toulouse-Lautrec is, even in the context of late-nineteenth-century Paris, *sui generis*. He belonged to no 'school' or 'movement' and had no disciples. Today, through his pictures and posters of Montmartre night life, his art is as familiar to us as that of van Gogh himself.

Although Toulouse-Lautrec took some things from the Impressionists, shared their passion for Japanese prints, and was a great admirer of Degas (especially his informally-posed nudes), he was not interested in landscape, nor in light, and his works are largely devoid of chiaroscuro (light and shade). He worked chiefly in thinned oil paint on cardboard, often incorporating the colour of the untouched cardboard as an element of the painting. His subject matter was narrow, drawn chiefly from the cafés, nightclubs, dance halls and brothels where he spent most of his time. Above all, perhaps, he was a brilliant draughtsman, conveying scene and movement with minimal strokes and working with great speed. In spite of his gift for caricature and the nature of his subject matter, Toulouse-Lautrec makes no moral judgements and expresses no emotions.

LEFT and OPPOSITE
Portrait of Père Tanguy, 1887–88
Oil on canvas, 25¹/₂ x 20in (65 x 51cm)
Private collection

PARIS

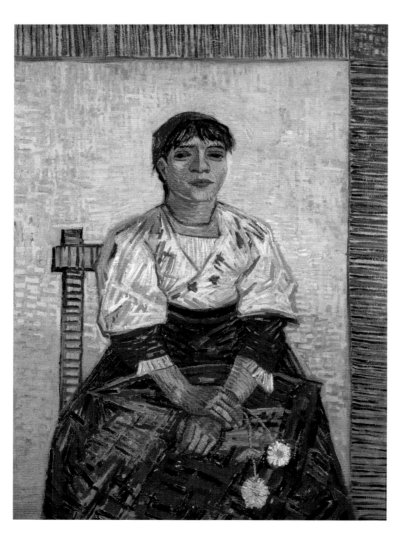

Encountering such artists as van Gogh and Emile Bernard at such an early stage no doubt encouraged Toulouse-Lautrec to pursue his own inclinations, helping to liberate him from the restrictions of academic training and the pressure to adhere to fashionable trends.

His influence on van Gogh, at least socially, was probably less beneficial. One example of Cormon's relatively liberal outlook was that he encouraged his pupils to paint *en plein-air*, but this could be interpreted as freedom to seek inspiration in a convenient bar. Toulouse-Lautrec's portrait of Vincent (1887), in pastel and watercolour, shows him in profile seated at a café table, staring ahead in an abstracted manner suggestive of the effects of absinthe, a glass of which is close at hand. It would have been difficult to be a friend of Toulouse-Lautrec without spending a good deal of time in bars or brothels, and although it would be unreasonable to load all the responsibility on Toulouse-Lautrec, the once-abstemious Vincent was acquiring a taste for the so-called 'Green Fairy'. Whether absinthe had quite such sinister effects as it was blamed for, which led to its being being banned some years later, or whether, being high in alcohol, it simply made one very drunk very easily, is still a matter of argument.

Another student of Cormon to do a portrait of Vincent (though apparently later, from memory) was a young Englishman named Archibald Standish Hartrick, who became a moderately successful

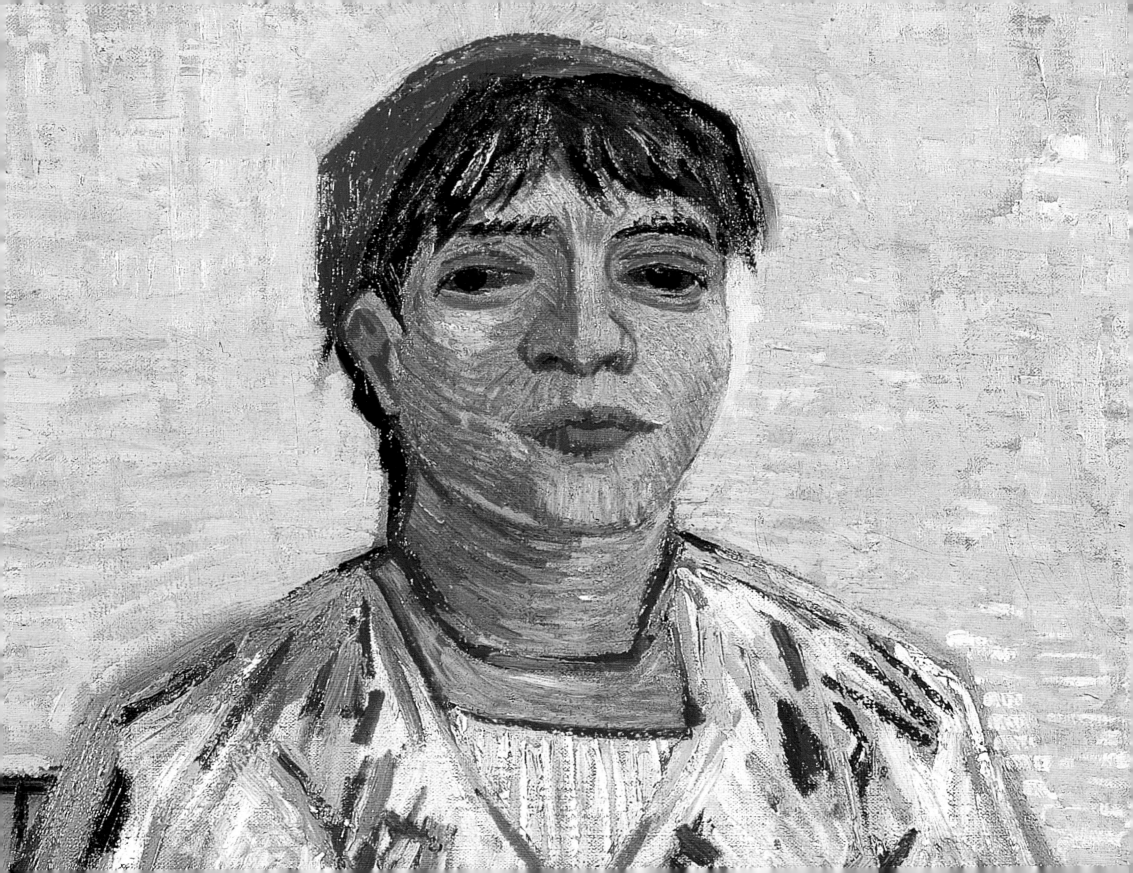

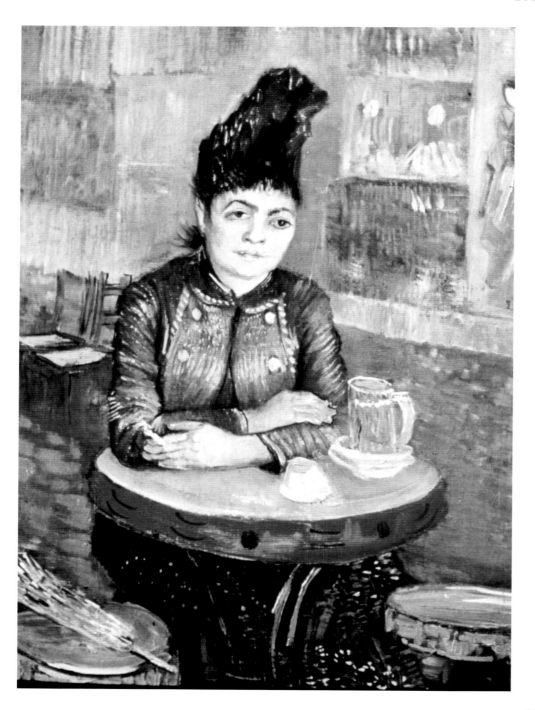

book illustrator in England during the interwar period. His description of Vincent in his memoirs, published in 1939, was less benign than Bernard's: 'a rather weedy little man, with pinched features, red hair and beard, and a light blue eye. He had an extraordinary way of pouring out sentences, if he got started, in Dutch, English, French, then glancing back at you over his shoulder and hissing through his teeth. In fact, when thus excited, he looked more than a little mad...'. Hartrick thought fellow-artists were nice to Vincent because they knew he was the brother of an influential dealer. But, to be fair to this now-forgotten artist, his account of Vincent's aims and motives in painting was perceptively accurate.

Vincent's family would have been surprised by Bernard's remark that he was 'not very ready to argue', and by Hartrick's implication that it was difficult for him to start talking, but his shyness is confirmed by the testimony of that remarkable woman, Suzanne Valadon, an artist's model turned artist, whose work was admired by Degas and influenced by Gauguin and, to a lesser extent, van Gogh.

Valadon lived with her mother and three-year-old son, Maurice Utrillo, the future painter of Montmartre, in the same building as Toulouse-Lautrec, with whom she had an on-and-off affair. She was often to be found, with other artists, in his studio, which

served also as a drinking den, Toulouse-Lautrec serving a particularly fierce concoction of absinthe and cognac. It was there that she first encountered Vincent, who arrived '... carrying a heavy canvas under his arm, which he would place in a well-lit corner, and wait for someone to notice him. No one was in the least interested. He would sit down opposite his work, surveying the others' glances and sharing little of the conversation. Finally wearying, he would leave carrying the latest example of his work.' Next week, the same scene would be repeated. Though one may feel a little sceptical of Suzanne Valadon's description, there is no doubt that, much as he might wish to, Vincent did not mingle easily, even with basically sympathetic company.

AT PERE TANGUY'S

A third rendezvous where painters often met was the shop of the kindly 'Père' Tanguy in the rue Clauzel, described by someone as like 'a little mortuary chapel', which sold artists' materials and acted also as an informal agency, club and commercial gallery. Among others, Vincent first met Cézanne there.

Julien François Tanguy, a Breton then in his sixties, was a famous character in Montmartre. A revolutionary socialist, he had fought for the Commune and spent two years in prison as a result. He was well disposed to avant-garde and (by definition) badly off

PARIS

Parisian Novels: The Yellow Books, 1887

Oil on canvas, 28³/4 x 36¹/4in (73 x 92cm)
Private collection

These are supposed to be Vincent's
favourite French novels, but in fact no
titles are legible. Another version of this,
possibly a study, exists.

painters, whom he considered politically sympathetic, victims of the Establishment and the world of the 'Grands Boulevards'. He helped many of them in various ways, besides letting them exhibit pictures in his window.

Tanguy was especially good to Vincent, letting him pay for colours and canvases with his pictures, which Tanguy knew he had no chance of selling. He was one of the few, all the same, who believed in Vincent's great gifts, and bracketed him with Cézanne, whom he considered the most promising of contemporary painters. Jo van Gogh-Bonger perhaps underrated him when she wrote in her introduction to Vincent's letters that he 'did not understand very much about the pictures on view in his window'. He acquired the bulk of Cézanne's output at this time as Cézanne, like Vincent, could not otherwise afford to purchase his materials. The generosity of Père Tanguy was only curbed by his 'old witch of a wife' (Vincent's frustrated and unfair description), who was less keen on the little family business being turned into a charity for needy artists.

In a letter to Andries Bonger written four years after Vincent's death, Tanguy complains of not selling a single picture in Paris that year, not even the most interesting ones such as the van Goghs, which everyone admired. But for that he had been planning to raise the price of Vincent's paintings, being confident that one day they would be recognized for their true worth. What that would be, of course, Tanguy could not possibly have guessed. For instance, one of Vincent's paintings that Theo deposited with him in 1889, after it had been shown at that year's Salon des Indépendants, was *Irises* which, a hundred years later, was sold at auction in New York for $54 million. Tanguy sold it in 1892 to the critic Octave Mirbeau, an early admirer of van Gogh's work, for 300 francs.

Vincent did at least three portraits of Tanguy, of which the best known dates from late 1887 (page 172). It is now in the Musée Rodin in Paris, having been bought from Tanguy's descendants by the great sculptor Auguste Rodin, and communicates what Vincent himself called Tanguy's Buddha-like quality, as well as incorporating many characteristics of Vincent's Paris period. (See also page 170.)

The old man sits upright, hands clasped, gazing downwards, a pose suggestive of Vincent's portraits at Arles, against a background of brightly coloured Japanese prints, most probably owned by Vincent himself and including *The Courtesan* by Kesai, on which Vincent had based his *Japonaiserie: Oiran* (page 179) about six months earlier, probably after seeing it on a cover of *Paris Illustré*. The sources of the others can also be identified. The emotional energy of Vincent's technique contrasts with the calm stillness of the sitter, but, above all, the painting is a celebration of

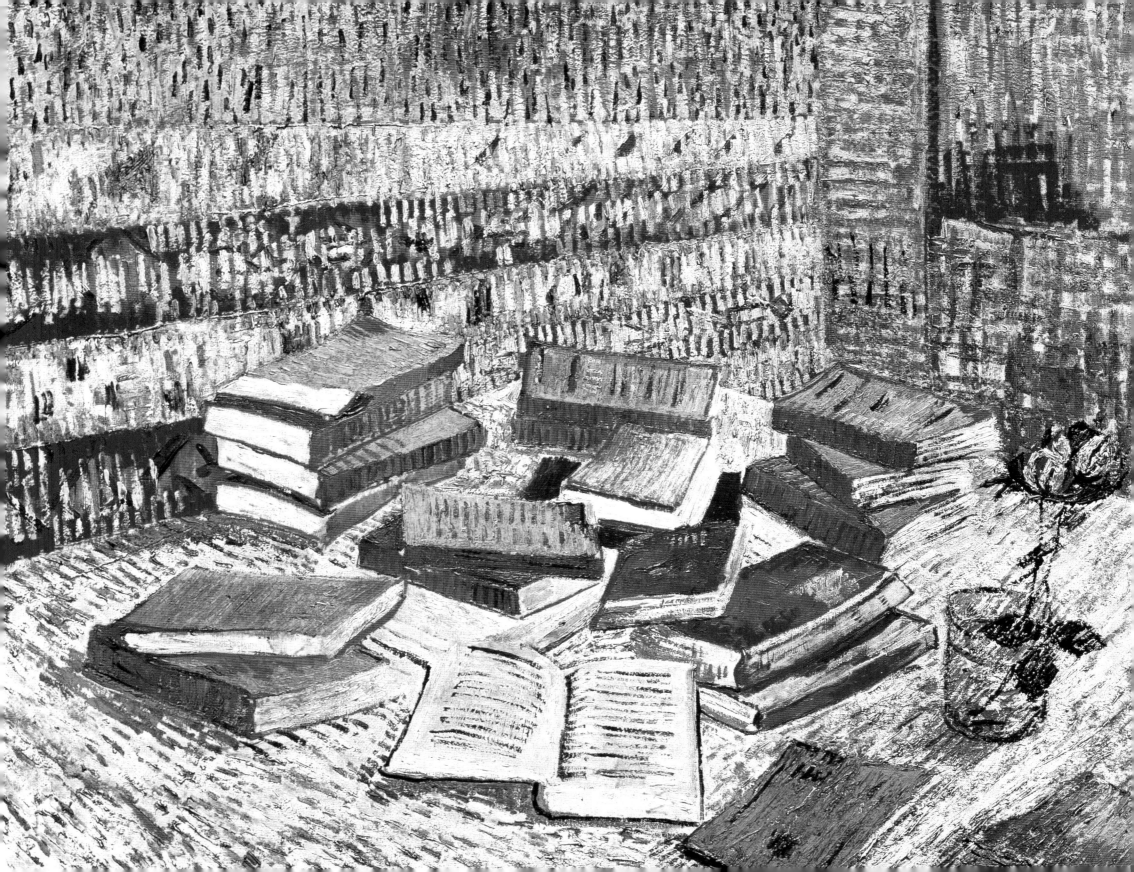

the emotive power of colour, with the bold use of complementary colours, represented in combinations of red and green and in the blue and orange of the sitter's trousers. The great colourist familiar from the paintings of Arles here makes himself known.

When Tanguy was asked to name a price for the portrait, he answered, 'Five hundred francs', and when the would-be purchaser observed that his price seemed very high, he explained that he did not really want to sell it at all.

THE LAST MONTHS IN PARIS

Another of Vincent's finest Paris portraits is *Woman at the Café du Tambourin: La Segatori* (page 178). The Café du Tambourin was in the Boulevard Clichy, and its proprietor, Agostina Segatori, the subject of the portrait, was a lady at this time approaching middle age, who had probably come to Paris from her native southern Italy twenty years or more earlier as a model – such dark-haired, large-eyed, sensual beauties being in great demand for fashionable Eastern or North African settings. La Segatori herself had posed for several famous artists, including Corot and Gérôme.

Clearly, she was more than just another southern beauty, for her restaurant, in which even the chairs and tables echoed the instrument for which it was named, was popular and played successfully on an ethnic theme, the waitresses wearing traditional Neapolitan dress, the food inspired by the cooking of the same

region and, by all accounts, of high quality. When Vincent met her, her looks were long past their best, and her face showed the evidence of the years of hard work, of mixed personal fortunes and of failed love affairs. Had she been still young and beautiful, he would hardly have become involved with her. As it was, they certainly had a close and emotional relationship, and some of Vincent's biographers take it for granted that they were lovers, although there is no proof and not very much evidence. His picture of her, seated pensively at one of her tambourine tables with a glass of beer and a cigarette, manifests warm sympathy and affection.

Agostina may also be the subject of *The Italian Woman* (page 176), although it was painted in the winter of 1887–88, after the break-up of their relationship. It is a very 'flat' picture, again suggesting the influence of the Japanese artists, with a broad border of red and green lines on two sides of the canvas, balanced by the opposing right angle of the blue, streaked chair-back. Its colours, especially the yellow background and the red dress, are positively incandescent.

Certainly Vincent could not have afforded to drink and dine at Le Tambourin, as he frequently did (sometimes with Père Tanguy, to the annoyance of Mme. Tanguy), had he been required to pay cash. Agostina accepted paintings for payment, preferring his still lifes which she thought more likely to sell. Ambroise Vollard, as a

young man, years before he became a famous dealer, happened to drop in at the café and overheard someone asking if 'Vincent' (a name that meant nothing to him then) had been in. The caller was told that he had just left after dropping in to hang some pictures of sunflowers, a subject for ever associated with van Gogh above all others, though chiefly with his Arles period. So slight an anecdote hardly seems worth inventing, but Vollard was not a pedantically accurate person.

Colour is again rampant in the famous celebration of French writers and of Vincent's love of literature, in *Parisian Novels* (also called *The Yellow Books* or *Still Life with Books*), page 181, one of his last paintings in Paris, done in Bernard's studio and exhibited at the Salon des Indépendants in 1888. Japanese influence is evident not only in the colour – orange, yellow and red heightened with touches of complementary green – but also in the perspective, with the objects seen from an elevated viewpoint.

In March, 1887 Vincent was instrumental in promoting an exhibition of Japanese prints at Le Tambourin. It aroused great interest in the group of artists he knew in Montmartre, especially Bernard, who had incorporated Japanese influences in his work in Brittany. Vincent's portrait of La Segatori was probably painted about that time, and she also allowed him to exhibit some of his own pictures in the café, along with those of Bernard, Toulouse-Lautrec and others, but in the summer there was a falling-out,

which merged into a dispute over the ownership of some of Vincent's paintings that she was holding. These appear to have been painted specifically for the café, which had since run into financial trouble.

In a letter to Theo (then visiting the Netherlands), Vincent says that Agostina had been unwell and he (Vincent) suspected she had had an abortion. In this letter he also offers a clue that Paris was beginning to pall on him, as he is thinking of taking himself off somewhere down south, although he had first mentioned this as a long-term objective much earlier, even before his arrival in Paris.

CHAPTER SEVEN
ARLES

Frequent and sudden changes of locale are a feature of Vincent's career. In spite of his paintings of streets, restaurants and factories, he was fundamentally a man – and artist – of the countryside, and his tolerance of city life was relatively short-lived. On the other hand, Paris was no ordinary city, and for a painter who for most of his life suffered from loneliness and always yearned to belong to a community of like-minded artists, Paris offered much greater opportunities than anywhere else. For over a year he had probably been happier in Paris than he had ever been before (or ever was, at least for so long a period, afterwards).

Theo had to a large extent adapted to the difficulties of living with his brother, and had recovered from the illness of 1886 that may have been partly due to Vincent's disruption of his life and household. It helped that Vincent, traipsing around the bars with Toulouse-Lautrec and others, was there less often. Nevertheless, even Vincent may have sometimes thought that their relationship, the solid foundation on which his life rested, worked better when they were not so intimately connected.

He must have been concerned, too, over the progress of Theo's courtship of Andries Bonger's sister, which seemed to be moving towards a formal engagement. Until now, the welfare and support of Vincent had been Theo's first priority. That could hardly continue in the same way if he had a wife and in time, no doubt, children.

Although he seldom displayed much talent for dissembling, Vincent did succeed, at least superficially, in concealing the misgivings he must have felt, and spoke about Theo's prospects with Johanna Bonger favourably and encouragingly. In his *Self-Portrait before His Easel*, one of the last of his Paris paintings and possibly related to Rembrandt's self-portrait of 1660 in similar pose, which Vincent would have seen in the Louvre, he manifests a certain calm, not to say grim, acceptance of life and concentration on his work.

He described this painting in a letter to his sister Wilhemien as '...painted from a mirror ... a pinky grey face with green eyes, ash-grey hair, a wrinkled forehead, and with a bright red beard surrounding the stiff wooden mouth, rather unkempt and sad, but with full lips, a blue coarse linen smock, and a palette of lemon yellow, vermilion, Veronese green, cobalt blue, in fact all the colours on the palette [i.e. as shown in the picture] except the orange beard, the only pure colours.' He does look rather less healthy and, most strikingly, very much older than in the self-portraits of about 18 months earlier.

Vincent was, as everyone who knew him agreed, subject to fits of bad temper and inclined to quarrel with everybody. But he was also a man of strange contradictions, and often even the fiercest quarrels did not penetrate very deeply. A story is told by Willem Wenkenbach, a friend of van Rappard who sent him to Nuenen in the hope of

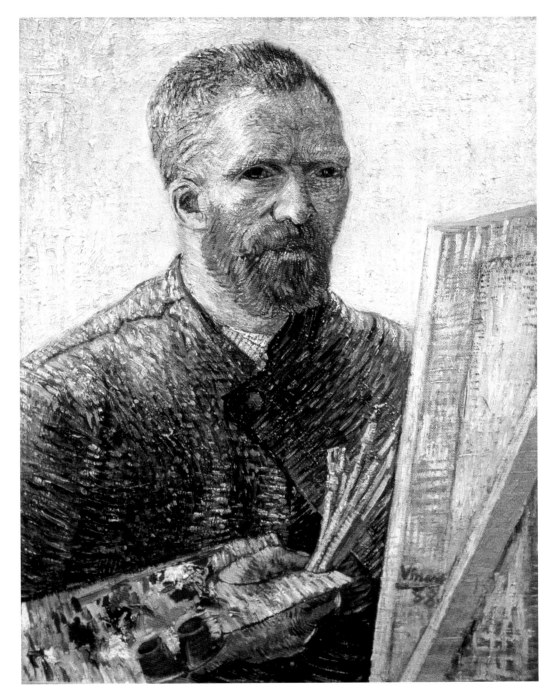
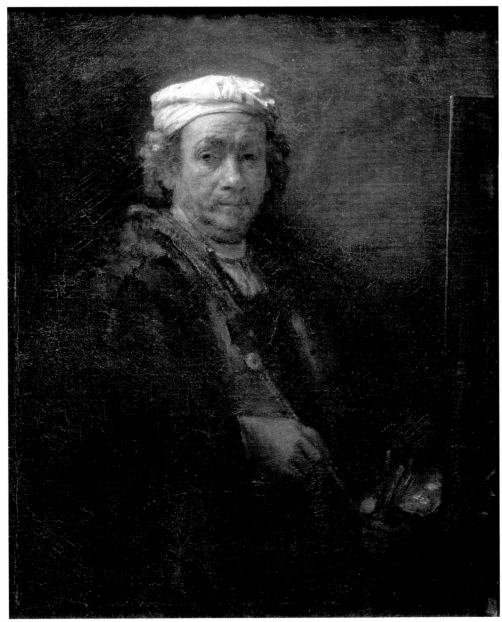

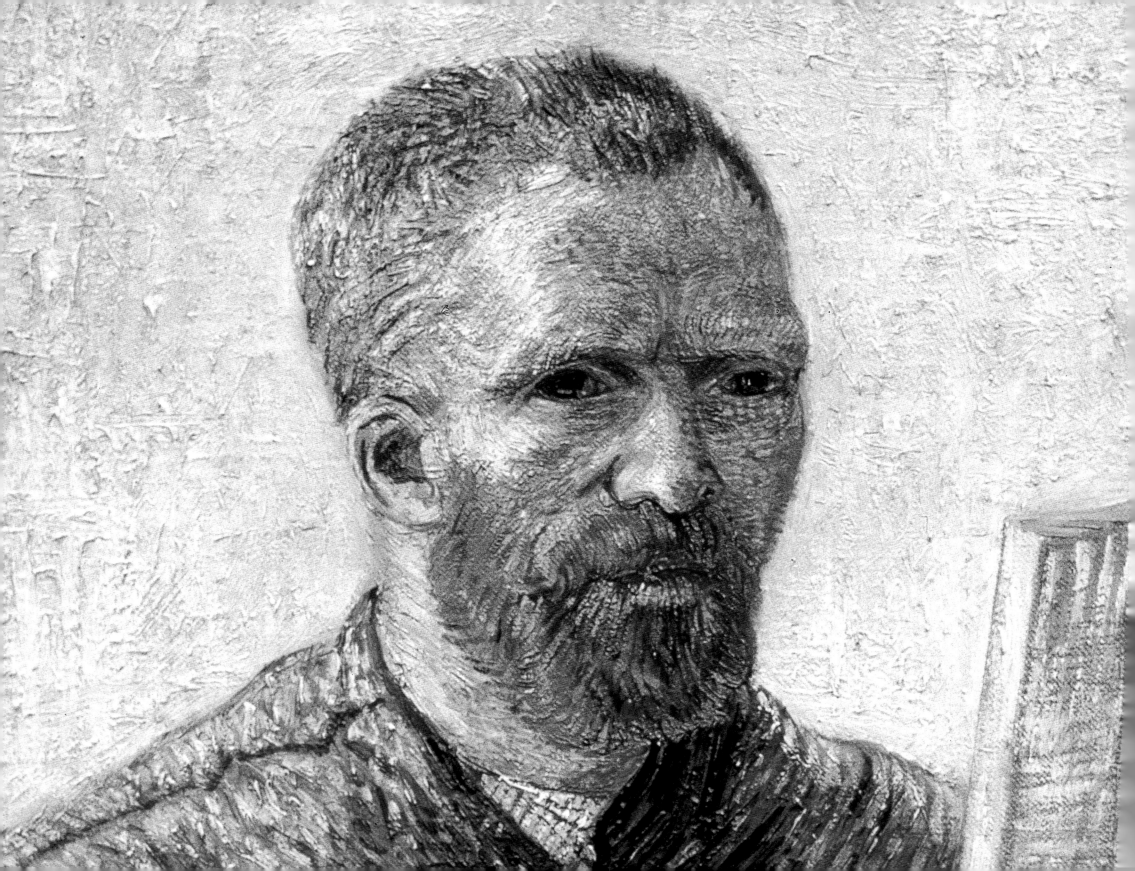

restoring his relations with Vincent after the quarrel over *The Potato Eaters*. They dined at the Kerssemakers, where Vincent, who had already shaken Wenkenbach with a succession of angry outbursts, took umbrage at some idle remark, blew up in a rage, and stalked out of the house in the middle of dinner. Yet next morning, when Wenkenbach went to catch his train, there was Vincent waiting to see him off and saying pleasantly, 'I hope you'll come again soon.'

Behaviour of that kind is certainly not a sensible way to make friends or keep them, but in spite of his peculiar temperament Vincent was not fundamentally an aggressive man. He was usually unwilling to criticize others, especially other artists, and he was easily impressed by talent and equally by anyone of strong character, or anyone whom he took to be a strong character – Gauguin for example.

Although there was good fellowship among the artists he knew in Montmartre, there was also a good deal of bitchiness – the product of various grievances, resentments and rivalries, of too much standing on dignity or riding of high horses, of too many stiff necks and fixed ideas. The exclusivity of the Impressionists is a case in point. Pissarro (a notable exception) might have said 'there are no rules', but if one was seen to be deviating too far from Impressionist principles, many of Pissarro's comrades would refuse to exhibit their work in the same room.

In van Gogh's circle similar animosities developed. The major split was between, on the one hand the Synthetists, represented by Gauguin and Bernard, on the other hand by the Divisionists, Seurat and Signac. An incident, nothing to do with art, that caused great resentment arose when Signac, leaving Paris for a time, told Gauguin that he could use his studio. Unfortunately, he omitted to tell Seurat, who was in charge, and when Gauguin turned up Seurat flatly refused to surrender the keys. When Signac returned, Gauguin refused to speak to him, stalking out of the room when Signac entered and treating a careless slip as a deadly insult.

Their different approaches to painting soon produced more profound disagreements, and later Gauguin and Bernard would themselves fall out over who deserved the credit for creating what is sometimes called the Pont-Aven school.

To Vincent all this was very dispiriting. He more or less straddled the two groups as he was friends with all these men (except perhaps Seurat, rather an unfriendly man), and he had high respect for them as painters. Nor was he alone in reacting against the frustrations and animosities of the Paris art world. It was partly the desire to be free of that atmosphere that sent Bernard and Gauguin to Brittany as well as, later, Vincent to Arles.

PAUL GAUGUIN

Of all these artists, it was Paul Gauguin, forceful, experienced and apparently self-confident, who made the strongest impact on Vincent.

Paul Gauguin was born in 1848 and was thus the oldest of the group, five years older than Vincent and fifteen years older than

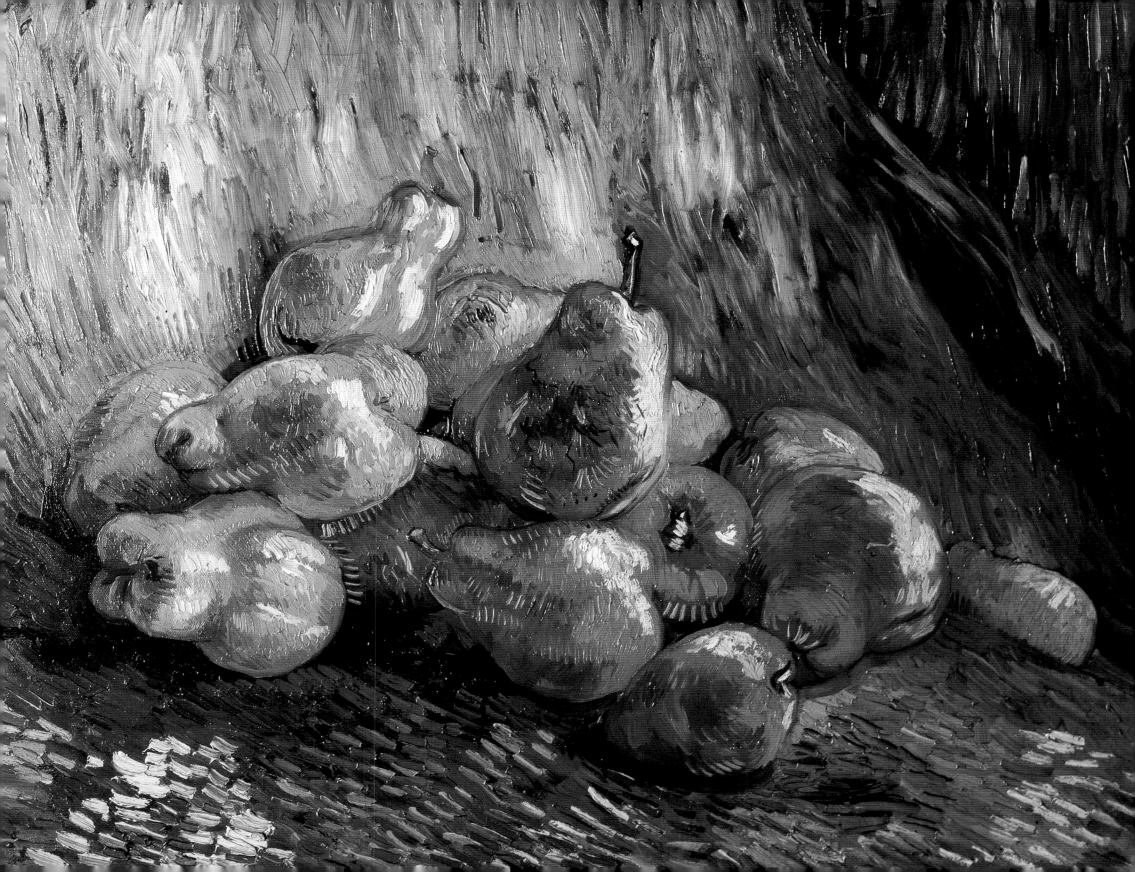

VAN GOGH

Bernard. When he was a baby, his father had taken his young family to Peru, but died on the voyage out. His widow with her two small children did not return to France until 1855.

Paul joined the merchant navy at 17, making several voyages to South America. In 1871 he entered a merchant bank in Paris, where he did rather well. Two years later he married a Danish girl and, about the same time, started to paint. Like Vincent, he was a very late starter. The hobby rapidly grew more important than his profession and, with Emile Schuffenecker, a fellow employee turned painter, he attended an *atelier libre*, with the result that in 1876 a landscape by Gauguin was accepted by the Salon. Soon after that, he met Pissarro, who became his mentor, and gradually adopted Impressionist methods.

In the Sixth Impressionist Exhibition of 1881 Gauguin's *Study of a Nude* elicited strong praise and for the first time he began to think of himself seriously as a painter. He gave up his job, but found no market for his paintings and, as their money ran out, his wife retreated to Denmark to take up a teaching post. Thus, family and material comfort were sacrificed to art for, as Gauguin announced, 'I am a great artist and know it.'

Growing disillusionment with Western civilization and a craving for a more 'primitive' and exotic culture was strengthened, first, by a spell in Brittany – comparatively backward, deeply religious, steeped in ancient tradition – and further by several months in the Caribbean island of Martinique in 1887, where he and a companion, Charles

Laval, lived in primitive conditions in a native hut, eating fish and fruit and painting the local people and scenery, before they were forced by poverty and illness to return to France. This period saw the beginning of Gauguin's rejection of Impressionism as, in the tropical sunlight, he moved towards simpler forms and bolder colours. Vincent, for one, recognized his paintings from Martinique as something new and important; he was equally impressed by Gauguin's trenchant opinions and colourful stories.

Gauguin had met both Vincent and Emile Bernard on earlier occasions, and in 1888 Bernard joined him in Pont-Aven, where between them they developed Synthetism.

Gauguin, Bernard and van Gogh had much in common, including their attitude to art, which to them was a vocation like religion, demanding sacrifice and extreme dedication. They had all rejected Impressionism and Neo-Impressionism (Gauguin, like Vincent, had flirted with Divisionism, though more briefly) and they shared an enthusiasm for Japanese woodcuts, especially their flat, strong colours, and also for 'popular', or 'primitive', art forms. A wide range of these could be seen in 1889 at the Paris World's Fair, where Gauguin, Bernard and others succeeded in displaying their works in the Café Volpini, inside the grounds, under the title 'Groupe Impressioniste et Synthétiste' (the exhibition is now seen as an early proclamation of Symbolism), but they failed to attract a single buyer.

The three men also shared an admiration for that uniquely

independent artist Puvis de Chavannes, whose enormous canvases in flat, pale colours with stylistically simplified drawing seemed more closely related to the fresco painters of Renaissance Florence (though of course Puvis painted in oils) than to any contemporary movement; they all needed to escape from the sophisticated art world of Paris in order for their individual styles to evolve.

However, their styles evolved differently. What 'Synthetism' meant for Gauguin was (in the unVincentian words of Diane Kelder), 'a selective and simplified arrangement of colours and shapes as well as a distillation of images that would succinctly convey meaning or emotion'. Gauguin had more or less given up painting in the open air, so vital to Vincent. 'Art', he said, 'is an abstraction; derive this abstraction from nature while dreaming before it, but think more of creating the actual result.' Whereas Vincent 'required direct contact with nature to stimulate his creative impulses, [Gauguin came] to rely primarily on the imagination and memory'.

TO THE WARM SOUTH

Vincent's health was poor towards the end of 1887, and his deteriorating condition aggravated his antisocial tendencies. There were several awkward scenes. Though being, as Andries Bonger said, 'such a desperately pig-headed fellow', he eventually succumbed to Bonger's urging that he should consult an

OPPOSITE
The Corner of the Park (Garden with Weeping Tree), 1888
Ink and pencil on paper, 12^{1}/$_{2}$ x 9^{3}/$_{8}$in
(31.7 x 24cm)
Private collection

LEFT
Flowering Garden with Path, 1888
Oil on canvas, 28^{1}/$_{3}$ x 35^{7}/$_{8}$in (72 x 91cm)
Gemeentemuseum, The Hague

RIGHT

The Caravans: Gypsy Encampment near
Arles, 1888

Oil on canvas, 17³/4 x 20in (45 x 51cm)
Musée d'Orsay, Paris

OPPOSITE

Flowerpiece and Fruit, 1888

Oil on panel, 21⁵/8 x 18¹/8in (55 x 46cm)
The Barnes Foundation, Merion,
Pennsylvania

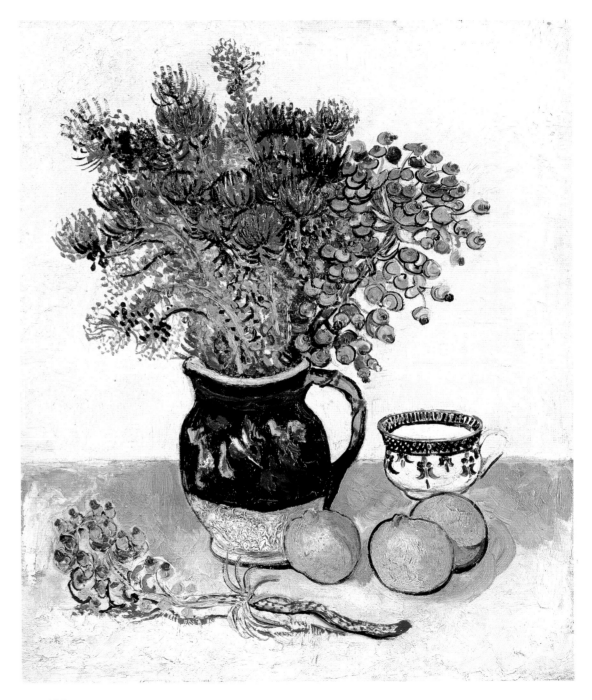

unconventional physician, Dr. David Gruby, who lived in the same street and had a reputation for advocating very strange cures that nevertheless often seemed to work. Gruby seems to have diagnosed the root of Vincent's problem as too much whoring and drinking. and told him to take things easy. Vincent obeyed, spending his time in his studio making his own versions of Japanese prints and demonstrating the evidence of his poor condition in a succession of generally gloomy self-portraits.

By the beginning of 1888 his health and temper had improved, but he no longer found the society of other artists so stimulating. The chief topic seemed to be money, in particular its scarcity, and when the talk turned to painting fierce arguments generally ensued. Gauguin's insistence on asserting himself as the leader of the Pont-Aven school irritated Bernard, but when Gauguin left again for Brittany, Vincent found he missed his stimulating presence. He listened more eagerly to Toulouse-Lautrec's descriptions of Provence, where Toulouse-Lautrec had spent his childhood, and was attracted by the idea of exchanging the chill and damp of the northern winter for the warm and sunny South.

Another friend, John Peter Russell, described the old town of Arles invitingly. Russell had a friend, the American artist Dodge MacKnight, who was living in the nearby village of Fontvieille, and it occurred to Vincent that he might go to Arles before moving on to Marseille and seeking out Monticelli. Living would be cheaper

RIGHT and OPPOSITE
Portrait of Armand Roulin, 1888
Oil on canvas, 25$\frac{1}{2}$ x 21$\frac{1}{4}$in (65 x 54cm)
Museum Folkwang, Essen

The 17-year-old Armand Roulin was an apprentice blacksmith when Vincent painted this attractively frank and relaxed portrait, which was bought from the Roulin family by Ambroise Vollard in 1895. Vincent painted Armand a second time in more introspective mood, in the same hat with a matching dark coat.

RIGHT and OPPOSITE
Man Smoking, 1888
Oil on canvas, 24³/₈ x 18¹/₂in (62 x 47cm)
The Barnes Foundation, Merion,
Pennsylvania

there, or so he assumed and, as Bernard described, he had grand dreams of attracting others, for instance Gauguin, to join him in forming an artistic co-operative, which would be financially beneficial as well as socially desirable, as it would cut out the percentage-hungry middlemen, the dealers.

Vincent left Paris on 20 February 1888, almost on the spur of the moment, as usual, although he did call on Bernard to say goodbye, leaving everything as if he were soon to return – his pictures spread all over the walls of the apartment to compensate for the absence of his person. And Theo, though he must have felt some relief, also discovered that he missed his brother once he had gone.

THE FIRST WEEKS IN ARLES

When Vincent arrived in Arles, after a train journey of sixteen hours, it was snowing. So much for the warm and sunny south as described by Toulouse-Lautrec!

Arles was a small city: Vincent reckoned it was about the size of Breda or Mons, with not much more than 20,000 inhabitants. It had once been much grander. Julius Caesar brought it under Roman rule ain bout 46 BC, and it developed into one of the greatest centres of the Western Roman Empire, as is still evident from the amphitheatre (part ruined but still usable) and the remains of other Roman buildings, including the palace of Constantine, who presided over the first synod of Christian bishops here in 314. The bishopric had

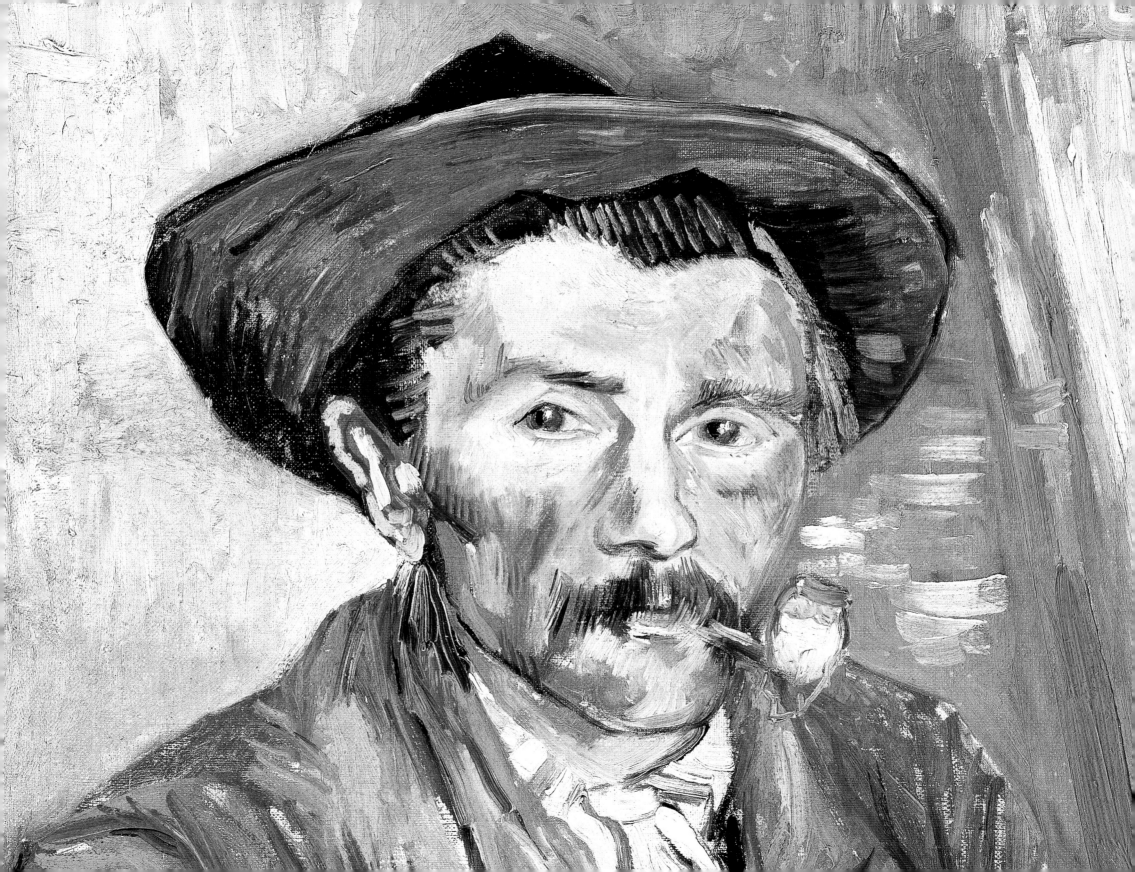

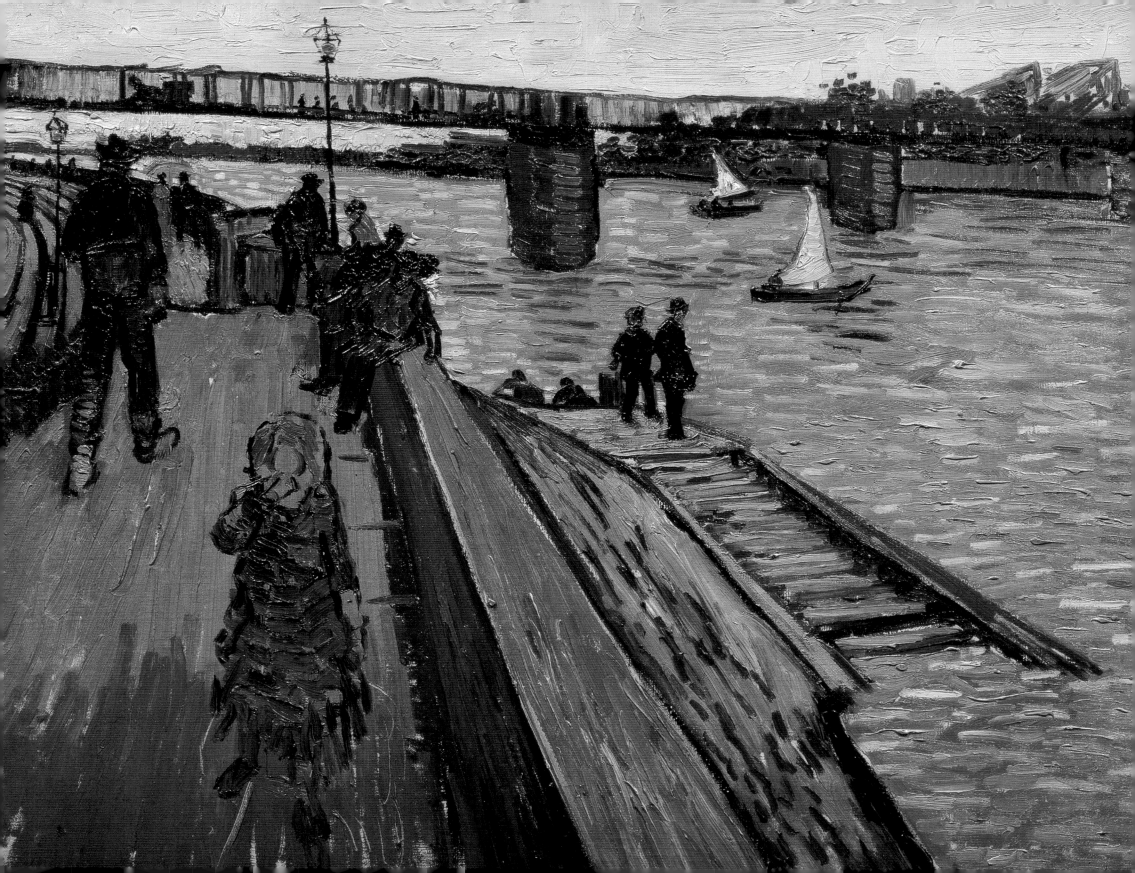

VAN GOGH

'cruel' (Vincent called the style 'Gothic', an indication of his lack of sympathy with medieval art in general). The rule of the Visigoths and the attacks of the Moors brought decline, but by the twelfth century medieval Arles revived, becoming the capital of a small kingdom and later an independent city-republic, before it was absorbed into Provence in the thirteenth century.

Arles never regained its ancient eminence, but in Vincent's time it was not just a sleepy little market town. The railway had reached it comparatively early, and although the old town remained little changed in the 1880s, from a distance the church towers were already outnumbered by factory chimneys. A bridge had been built across the Rhône, which at Arles, near the mouths of its delta, is a mighty river. Perhaps the main change in the century following was the arrival of the tourists (many of them attracted by the connection with Vincent van Gogh).

When Vincent lived in Arles there were no tourists, and while one might think that a pleasant prospect, the lack of them meant that such tourist-oriented services as decent lodgings and restaurants were also absent. Other amusements, no longer so evident, were provided. The *maisons de tolérance*, or brothels, were located near the old city walls and were capable of servicing a large clientele, boosted in Vincent's time by the presence of Italian immigrant workers as well as a regiment of Zouaves, the colourfully uniformed

been founded in the first century by Saint-Trophime and lasted until the French Revolution.

The tower of the old cathedral, dedicated to Saint-Trophime, still dominates the town. It is famous for its magnificent Romanesque sculpture, although Vincent did not think much of it; the great Romanesque porch seemed to him, though admirable, also rather

OPPOSITE
Le Pont de Trinquetaille, Arles, 1888
Oil on canvas, 25^1/$_4$ x 31^1/$_2$in (64 x 80cm)
Private collection

LEFT
The Gleize Bridge over the Vigueirat Canal, 1888
Oil on canvas, 18^1/$_8$ x 19^1/$_4$in (46 x 49cm)
Private collection

RIGHT
Garden with Flowers, 1888
Reed pen and ink, 24 x 19^1/$_4$in (61 x 49cm)
Private collection

FAR RIGHT and OPPOSITE
Self-Portrait, 1888
Oil on canvas
Private collection

Though some assign this painting, with clean-shaven face, to the previous year, it was probably painted in late January 1889. The injured ear had healed fast and is here hidden from view.

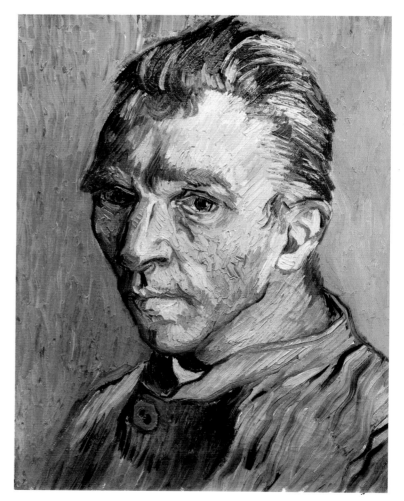

ARLES

OPPOSITE
Sunny Lawn in a Public Park, 1888
Oil on canvas, 23⅞ x 29in (60.5 x 73.5cm)
Kunsthaus, Zurich

troops of North African origin, which was stationed in Arles after recent service in Indochina.

Soon after his arrival, Vincent had witnessed a riot, sparked off by the alleged murder of two Zouaves by Italians, shattering the image of a quiet old country town. He was no stranger to brothels himself, and became as regular a client as his paltry means allowed. He described these visits as hygienic, thus, sadly, equating sexual intercourse with regular bowel movements. He did establish some kind of relationship with one girl, but it did not extend beyond the doors of the brothel. Outside the professional ranks, however, the women of Arles had a reputation for beauty, which Vincent confirmed.

He found lodgings in almost the first place he came to from the station, in an attic room of the Hotel-Restaurant Carrel on the rue de la Cavalerie (the building survived until the Second World War).

Though he admitted to being travel-weary, he seems to have started painting within a day of his arrival. He discovered two places, a grocer and a bookshop, where he could buy paints and canvas, though neither could supply everything he needed and he was always worried about the quality of the paint. In Eindhoven he had been plagued with whites that 'ran', and he experienced similar difficulties here, for quality was still variable even in pigments supplied in tubes.

Before long, he was sending a large order for Theo to get filled in Paris ('15 Malachite green, double tubes, 10 chrome yellow, 3 Vermilion, 6 Crimson lake ...' etc.,) with a note against the reds 'Newly pounded, if they are greasy I'll send them back', and a suggestion that if the Paris supplier would give him a 20 per cent discount he would place a regular order. He named two possible suppliers (not Tanguy, with whom there had been a – temporary – falling-out) and noted that among the colours ordered, 'hardly one of them is to be found on the Dutch palette ... They are only to be found in Delacroix'.

All this, he reckoned, would save money, an important consideration as he found to his disappointment that Arles was not appreciably cheaper than Paris. In any case, Theo paid this bill, besides sending 100 francs, on top of 200 francs the previous month. He also paid for a crate of paintings to be shipped to Paris, being instructed by Vincent to keep three of them until the day when they would be worth 500 francs each. One day they would be worth several million dollars, but unfortunately, at the time, they were not worth a bean.

In Antwerp and Paris Vincent had started out by painting a few typical views of the place, and he went through the same process, compared by David Sweetman in his 1990 biography of Vincent with a cat marking out its boundaries, in Arles. He did three pictures, one of the beautiful young Arlésiennes, one of a snowy landscape and a third painted from the Carrel restaurant, looking through the

RIGHT
The Olive Trees, c. 1889
Ink on paper
Musée des Beaux-Arts, Tournai

Olive trees became almost as powerful a symbol of Provence as cypresses, but they are mostly associated with the Saint-Rémy period.

OPPOSITE
Pink Peach Trees in Blossom (Souvenir de Mauve), 1888
Oil on canvass, 28³/4 x 23³/8in
(73 x 59.5cm)
Rijksmuseum Kröller-Müller, Otterlo

Vincent later believed that he had done this attractive painting specifically as a tribute to Anton Mauve, though in fact it was done before he heard of Mauve's death.

window across the street to a charcuterie. This picture, painted on canvas on cardboard, was painted in the same colours as he was using in Paris, but differed in being finished on the spot, not in the studio.

Vincent had, he said, a thousand reasons for travelling to the Midi, though the chief motive was his desire, one could say his need, for its light and colour (these were not immediately evident, as it continued to snow). He gained something else too, as he was quick to notice: a greater freedom. Removal from Paris freed him not only from the drink-fuelled bickering of the Montmartre nightspots, but also from the fiercely advocated theories of fellow-artists and the constant pressure of different styles, different schools. Vincent was always open to influence, as his work demonstrates, but ultimately he needed to express himself in his own uniquely self-expressive way. At Arles, Vincent van Gogh and his art were finally united.

Arles straddles the Rhône, but most of it, including the old city, is to the east of the river. Immediately north of the city the Rhône divides into its two main branches, the Petit and Grand Rhône, which roughly form the borders of the Ile de la Camargue, a marshy wilderness with flamingos and wild horses, now carefully preserved but then truly wild. East of Le Grand Rhône is the plain of La Crau, part marshy, part rocky, and even now thinly inhabited, although

Almond Branch in a Glass, 1888
Oil on canvas 9³/8 x 7¹/2in (24 x 19cm)
Rijksmuseum Vincent van Gogh, Amsterdam

irrigation had already turned much of it into good agricultural land (Vincent remarked that it produced 'excellent wine').

He went also to the little port of Les Saintes-Maries, where Monticelli had painted, on the Golfe du Lion, and sometimes to the relatively bleak landscape of La Crau. To the west, the road to Mausanne les Alpilles passes by the ancient complex of the deserted abbey of Montmajour, a national monument under restoration even in Vincent's time, and through the village of Fontvielle, current residence of the American MacKnight, with, in the distance, the remarkably rugged though not very high chain of Les Alpilles.

BLOSSOMING COLOUR

Spring comes early in Provence, and its herald is the lovely almond, which flowers in February. Vincent broke off a small sprig and took it home to paint (*Almond Branch in a Glass*, now in Amsterdam), making a second version to which he added a book. He told his sister Wil that he was keeping this picture for her, and it was eventually delivered by Theo. By March, the orchards were in full flower, and the mass of brilliant blossom encouraged Vincent to pursue a fantastic work rate: 'I am working like a madman because the trees are in blossom and I want to make a Provençal orchard of astounding gaiety ...'. He was to sustain that rate for most of the rest of his life.

La Crau from Montmajour, 1888
Pen and ink and chalk, 19¼ x 24in
(49 x 61cm)
British Museum, London

This was actually done a short distance to the west of the abbey of Montmajour. In another drawing, done about the same time and bearing the same title, the abbey walls are immediately behind the artist.

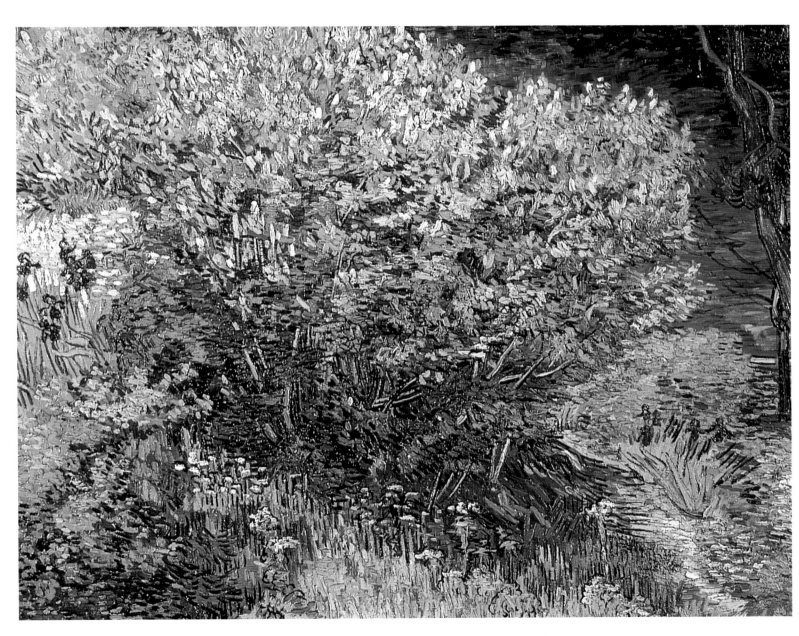

OPPOSITE
The Rocks, 1888
Oil on canvas, 21⁵/₈ x 25⁷/₈in
(54.9 x 65.7cm)
Museum of Fine Arts, Houston

LEFT
The Lilac Bush, 1889
Oil on canvas, 28¹/₃ x 36¹/₄ (72 x 92cm)
Hermitage Museum, St. Petersburg

RIGHT

Drawbridge with Carriage (Le Pont de Langlois), 1888

Oil on canvas, 21¹/₄ x 25¹/₂in (54 x 65cm)

Rijksmuseum Kröller-Müller, Otterlo

FAR RIGHT

Drawbridge with Carriage (Le Pont de Langlois), 1888

Oil on canvas, 23⁵/₈ x 25¹/₂in (60 x 65cm)

Private collection

OPPOSITE

Le Pont de Langlois, 1888

Oil on canvas, 23⁵/₈ x 25¹/₂in (60 x 65cm)

Rijksmuseum Vincent van Gogh, Amsterdam

(See page 213 et seq.)

He apparently gained access to a nearby orchard that contained many different kinds of fruit trees and, aware that the spring blossom is short-lived, in less than four weeks and in defiance of the mistral that forced him to secure his easel with stout poles driven into the ground, produced a marvellous series of fifteen 'portraits' of flowering trees (not counting drawings or watercolours nor the odd failure – a cherry tree 'spoiled', a group of apricot trees 'completely ruined'). One canvas was devoted to each kind – it seems unlikely that he found them all in the same orchard – and he employed a range of different techniques, whatever struck him as most appropriate. He told Bernard. 'At the moment I am completely preoccupied with flowering fruit trees: pink peach trees, yellowish- white pear trees. There is no system in my efforts. I dab the canvas with irregular strokes and leave the result as it is. Sometimes I apply thick layers of paint; sometimes I leave parts of the canvas unpainted, and there are corners which I do not finish. I repeat myself, and sometimes I do very daring things. I

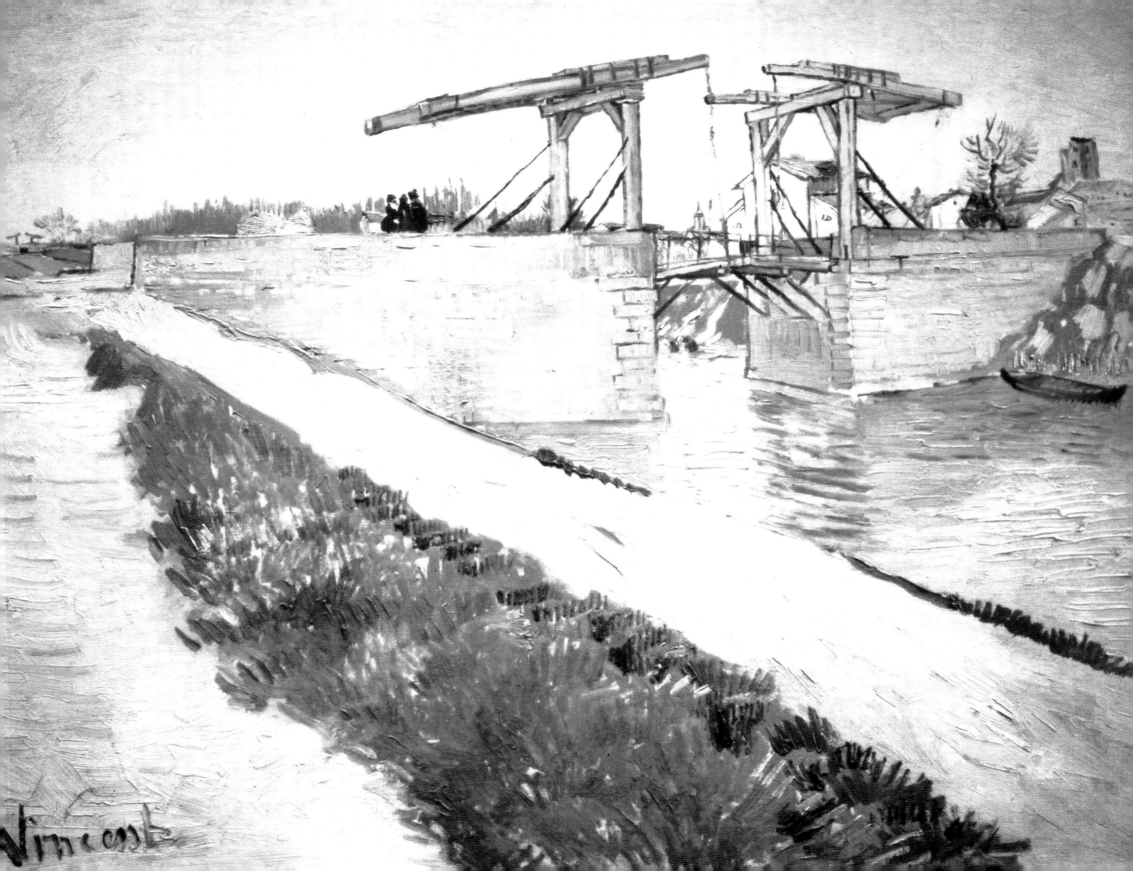

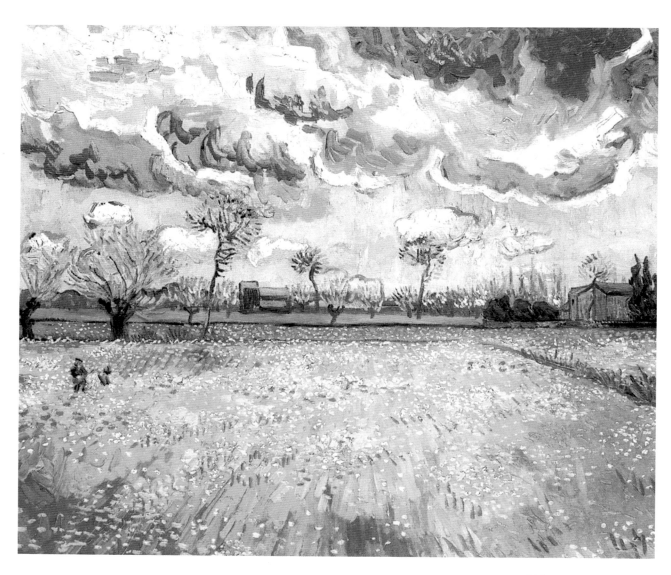

believe the final result is quite disquieting and challenging ...'.

It was not unusual for Vincent to concentrate for a period of time on a particular subject to the virtual exclusion of others; the fruit trees of Provence recall the floral still lifes he did in his early months in Paris, or before that, the series of studies of Brabant peasants. Of his total commitment to the Provençal orchards, Vincent assured Theo, 'You know I am changeable in my work and this craze for painting orchards will not last for ever.' Only as long, obviously, as the blossom.

One of this series, which he described as 'probably the best landscape I've done', was of two wonderfully effervescent peach trees, whose pink-and-white blossom seems to merge with the small, fluffy clouds in a pale blue sky sparkling with sunlight. On the day he painted it he received a letter from Wil enclosing a cutting of an obituary of Anton Mauve, who had died on 8 February.

In spite of their quarrel, Vincent always felt grateful to Mauve, the man who had persuaded him to venture into colour, and he sent the peach trees, inscribed *Souvenir de Mauve* (page 206), to Mauve's widow, Jet. He told Wil, 'I wanted to use a tender and gay subject to remember Mauve by', and he said he had signed it 'Van Gogh & Theo', although the painting (now at Otterlo) bears only his accustomed signature, 'Vincent'. Probably Theo persuaded him that the original inscription would look rather odd, notwithstanding Vincent's insistence that Theo was equally responsible for all his work. A few weeks later Vincent remarked to Theo that Mauve's death had been 'a terrible blow to me. You will see that the pink peach

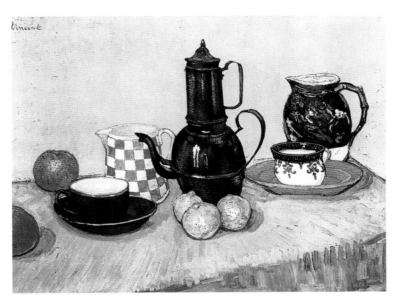

trees were painted with a sort of passion'. He forgot that news of Mauve's death reached him only after he had done the painting.

It is always unsafe to link the 'mood' of a painting with the mood of its painter, but it is difficult to resist the notion that in the early months at Arles, the joyful panache of Vincent's masterly pictures of trees in blossom reflected feelings of contentment, satisfaction, even happiness, this disposition in turn stemming chiefly from his feeling that he had now, at last, 'found' himself as an artist, and that all the failures and frustrations of the earlier years were behind him.

He soon ventured farther afield. South of Arles a canal runs parallel to the Rhône, skirting the plain of La Crau. Exploring in this direction soon after his arrival in Arles, Vincent was confronted, to his astonishment and delight, by something that carried him straight back to Drenthe, a wooden two-way drawbridge of exactly the same design as those on the Dutch canals. It was one of a series of about a dozen such bridges, which were in fact built by a Dutch engineer, and this one was known after its keeper as the Pont de Langlois (sometimes misheard as the 'Pont de l'Anglais'). It became the subject of several versions of *Drawbridge with Carriage* (page 210), one of the most popular of all van Gogh's subjects.

A painter acquainted with Vincent once told Marc Edo Tralbaut, 'Vincent thought Provence was very colourful. It isn't. But as he was a

OPPOSITE

Meadows with Flowers under a Stormy Sky, 1888
Oil on canvas, 23⅝ x 28¾in (60 x 73cm)
Fondation Socindec, Vaduz

FAR LEFT

Farmhouse in a Wheatfield, 1888
Oil on canvas, 17¾ x 19⅝in (45 x 50cm)
Rijksmuseum Vincent van Gogh, Amsterdam

There is also a drawing of this subject, with the tree less prominent, done a short time earlier and which is no doubt a study.

ABOVE LEFT

Still Life: Blue Enamel Coffeepot, Earthenware and Fruit, 1888
Oil on canvas, 25½ x 31⅞in (65 x 81cm)
Collection Basil P. and Elise Goulandris

RIGHT and OPPOSITE
Portrait of Eugène Boch, 1888
Oil on canvas, 23⅝ x 17¾in (60 x 45cm)
Musée d'Orsay, Paris

Vincent saw Boch as a poet and placed him against a starry sky.

VAN GOGH

genius, he was right.' Certainly, no one could disagree that the colours of Provence are less vivid than Vincent painted them. The painting of the Pont de Langlois is a gorgeous assemblage of colour, drawing its vitality from the featherlight gleam of the spring sunlight, which derives from the trees in blossom, and sparkling like champagne.

Vincent described his picture in a letter to Theo, 'I brought back a size 15 canvas today. It is a drawbridge with a little cart going over it, outlined against a blue sky – the river blue as well, [and what blue!] the banks orange coloured with green grass and a group of women washing linen in smocks and multicoloured bonnets.' In Vincent's landscapes, even a token human presence is not common and such a scene of human activity – for these bonneted women are energetically employed dipping, scrubbing, wringing out and stretching their laundry – is rare. In the pictures of flowering trees, for example, no human being appears, the only sign of human activity being the occasional abandoned ladder. When Vincent painted the Pont de Langlois again a few months later, he omitted both the women doing their washing and the two-wheeled cart crossing the bridge, and the result is a less attractive picture.

There are several other versions of this picture (though not quite as many as once appeared, before the fakes were unmasked) although, as is usually the case, the copies are inferior to the original. One was a straightforward copy that he sent to Theo, and one (referred to above,

and now in the Wallraf-Richarz Museum in Cologne) done from a different perspective, in which a woman in black with a parasol is crossing the bridge on foot; instead of the poplars to the right there is a pair of cypresses beside the road to the left of the bridge, probably added for the sake of a more harmonious composition. In addition, there are two or three drawings and a watercolour.

The painting of the Langlois drawbridge proclaims Vincent's current happy contentment with the world. 'Art', he once said, 'is only to be found in what is healthy', not perhaps an indisputable statement but certainly relevant to the wonderful paintings of this year. Art should be 'something peaceful and agreeable, realistic and yet painted from the heart, something brief, synthetic, simplified and concentrated, full of serenity and pure harmony, consoling as music'.

A PRODIGIOUS OUTPUT

Vincent's carelessness of his own personal welfare ensured that he would not be put off by the terrific workload he imposed on himself in Provence, in spite of his own fragile condition. He confessed to sometimes feeling weak, and he had some kind of persistent stomach trouble. He thought, rather oddly, that the basic problem was poor circulation, and he expected this to improve rapidly under the influence of a warm sun.

His cramped finances, aggravated by his hefty consumption of

RIGHT and OPPOSITE
The Yellow House, 1888
Oil on canvas, 28¹/₃ x 36in (72 x 91.5cm)
Rijksmuseum Vincent van Gogh,
Amsterdam

Vincent wrote to Theo, 'The subject is
frightfully difficult, but that is just why I
want to conquer it. It's terrific, these
houses, yellow in the sun, and the
incomparable freshness of the blue. And
everywhere the ground is yellow too.'

PAGES 220 and 221
The Dance Hall in Arles, 1888
Oil on canvas, 25¹/₂ x 31⁷/₈in (65 x 81cm)
Musée d'Orsay, Paris

This makes an obvious pair with Spectators
in the Arena. *Both were painted from*
memory and, curiously, neither is
mentioned in Vincent's letters.

PAGES 222 and 223
The Café Terrace on the Place du Forum,
Arles, 1888
Oil on canvas, 31⁷/₈ x 25³/₄in
(81 x 65.5cm)
Rijksmuseum Kröller-Müller, Otterlo

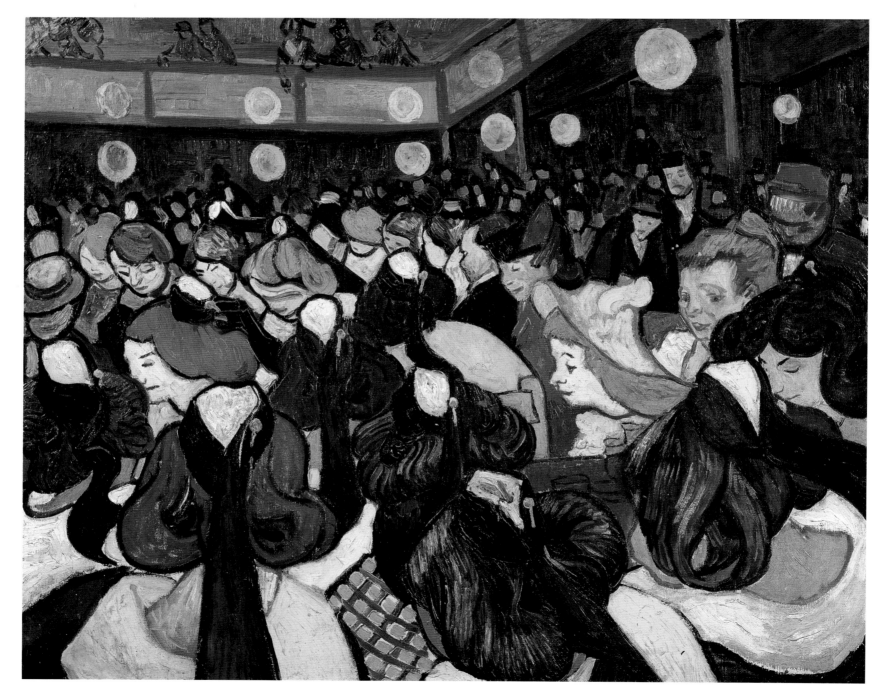

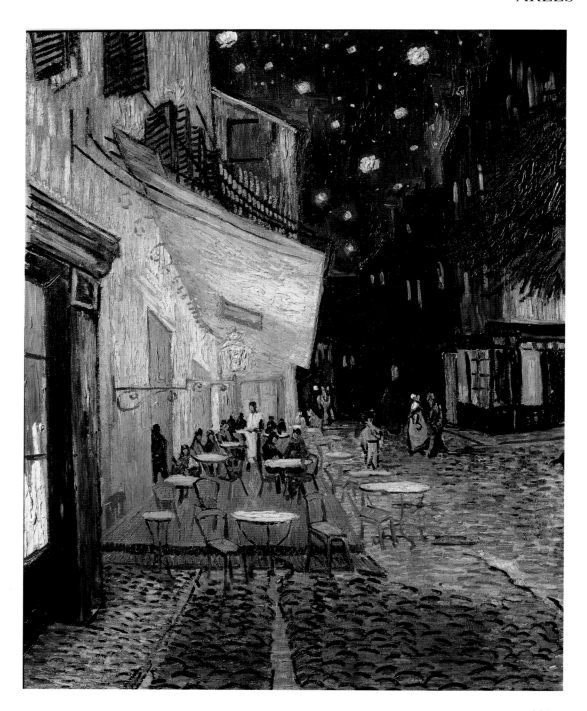

paints and canvas, did not make him revert immediately to a diet of bread and cheese. He had two eggs for breakfast and ate his evening meal in the café. However, Vincent, hardly a man to make a fuss about his food, was very dissatisfied with the food at the Carrel, where he also felt he was being overcharged: '... it's preposterous, but I never can get what I ask for, even in simplest things, from these people here. And it's the same everywhere in these little restaurants. But is it not so hard to bake potatoes? Impossible. Then rice, or macaroni? None left, or else it is all messed up in grease, or else they aren't cooking it today, and they'll explain that it's tomorrow's dish, there's no room on the stove, and so on. It's absurd, but that is the real reason why my health is low.'

He soothed his stomach with a better class of red wine and, whereas in Paris he admitted having been a virtual alcoholic, after a few abstemious weeks in Arles he protested that 'one small glass of brandy makes me tipsy here'.

Unfortunately, this sensible regime was not to be maintained permanently. The sheer pressure of work, and the intense tension imposed by the act of creation, would eventually drive him back to the bottle; but in the meantime his general health did improve. In March he told Theo, 'If I take it easy, my body doesn't refuse to function.' The psychological uplift no doubt also helped his recovery: 'Old boy, you know, I feel as though I were in Japan,' said

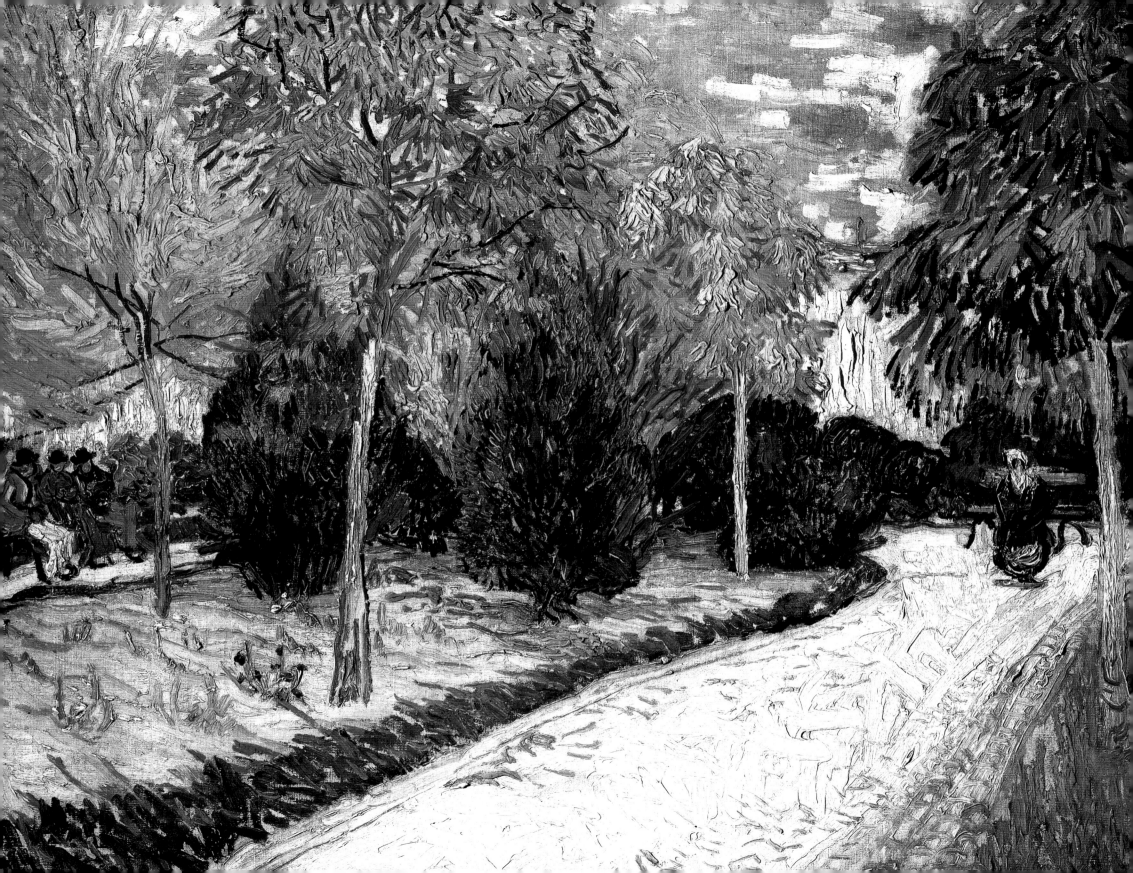

Vincent, for whom that unseen country represented a kind of Eden.

Of course, he was lonely. He knew no one in Arles, and the local people were not very outgoing, tending to retreat into Provençal in front of strangers. He felt out of it: '...the Zouaves, the brothels, the adorable little Arlésiennes going to the first Communion, the priest in his surplice, who looks like a dangerous rhinoceros, the people drinking absinthe, all seem to me creatures from another world.' And Vincent himself was not a particularly prepossessing acquaintance. Learning that an artist from Paris was in their midst, one or two amateur painters called on him, but they did not call twice, probably put off by Vincent's work if not by his personality.

His room in the café overlooked the arena, and within a few weeks he had been to see the bullfights at least twice, once with the Belgian painter Eugène Boch (page 214). One involved the contest of matador versus bull, the other the more 'popular' or less artistic form of harassment in which several bulls are pursued by nimble-footed young men who endeavour to pluck cockades from their horns. 'Yesterday I saw another bullfight, where five men played the bull with darts and cockades. One toreador crushed one of his balls jumping the barricade. He was a fair man with grey eyes, plenty of sang-froid; people said he'll be ill long enough. He was dressed in sky blue and gold, just like the little horseman in our Monticelli ... The arenas are a fine sight when there's sunshine and a crowd.'

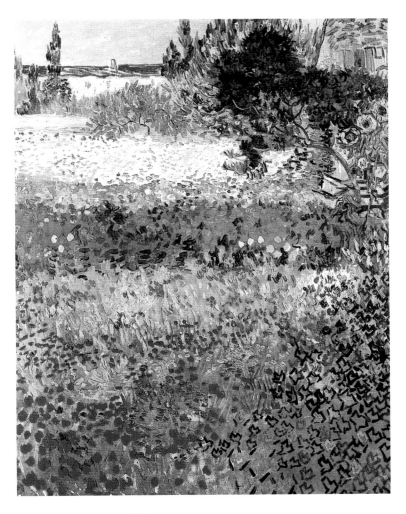

OPPOSITE
Path in the Park at Arles, 1888
Oil on canvas, 28^{1}/$_{3}$ x 36^{5}/$_{8}$in (72 x 93cm)
Private collection

LEFT
Flowering Garden, 1888
Oil on canvas, 36^{1}/$_{4}$ x 28^{3}/$_{4}$in (92 x 73cm)
Metropolitan Museum of Art, New York

RIGHT and OPPOSITE
Boy with a Cap, 1888
Oil on canvas, 18¹/₂ x 15¹/₃in (47 x 39cm)
Private collection

The sitter is unknown.

Vincent does not seem to have been particularly attracted by the spectacle itself, but he was fascinated by the great throng of people, reporting on another occasion to Emile Bernard that 'the crowd was magnificent, those great colourful multitudes piled up one above the other on two or three galleries ...', and he saw this as a promising future subject. The excited throng that took part in the riot against the Italians had a similar effect on him. The eventual result was *Spectators in the Arena* (page 216) and *The Dance Hall* (page 220), both done in December, 1888. The subject matter may be that of Toulouse-Lautrec, but the style is certainly not. It reflects Synthetist or cloisonné influences, no doubt the result of Gauguin's presence in Arles.

Loneliness made him all the more eager to attract fellow artists to Arles. He told Bernard that it might be an advantage to many artists who loved colour to settle in the south, and he was particularly hopeful of Gauguin, although he also approached, of all people, Toulouse-Lautrec, the ultimate artist of the city, whom it is impossible to imagine setting off in the morning sunshine to paint an orchard or a field of wheat.

Gauguin did not reject the idea of a move to Arles, while remaining for the time being noncommittal. He, too, was lonely. In Pont-Aven he was surrounded by many far younger, unsympathetic and, in his view, not very talented artists, while at the same time he was increasingly dissatisfied with his own work, which seemed to be

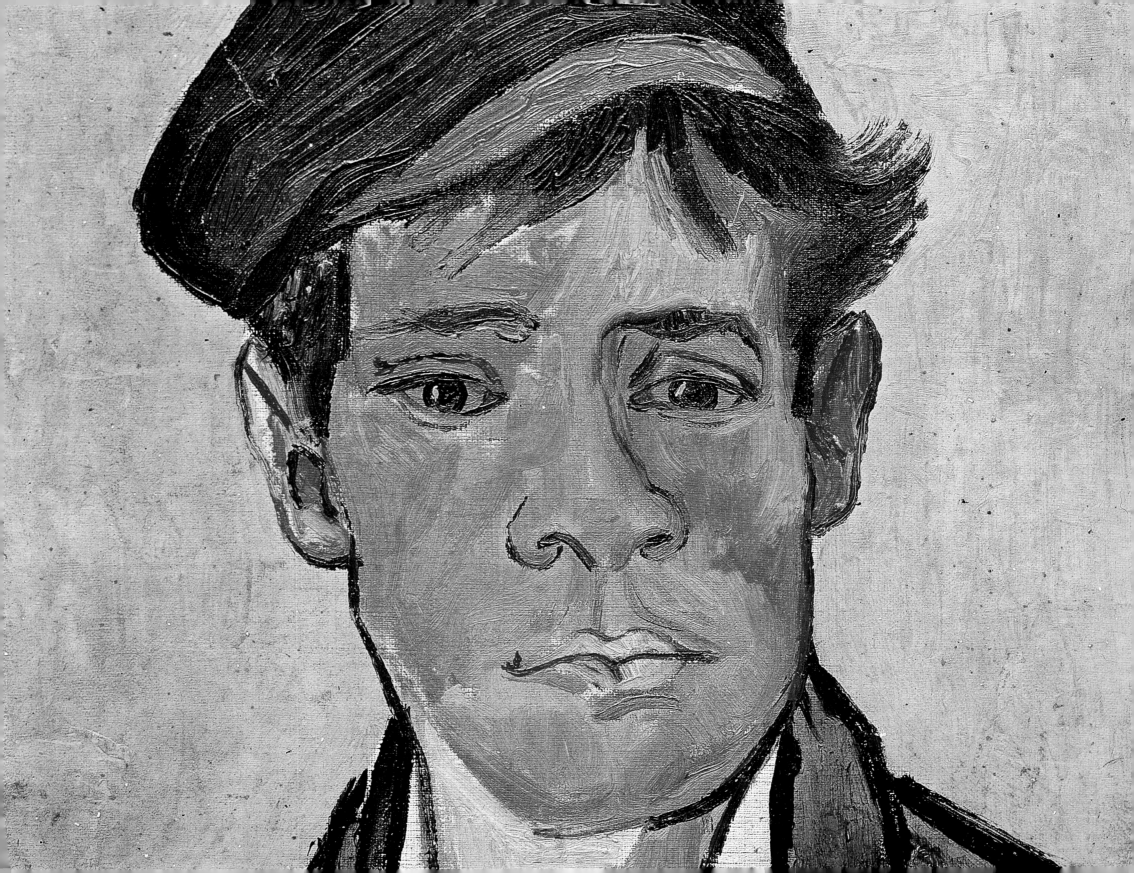

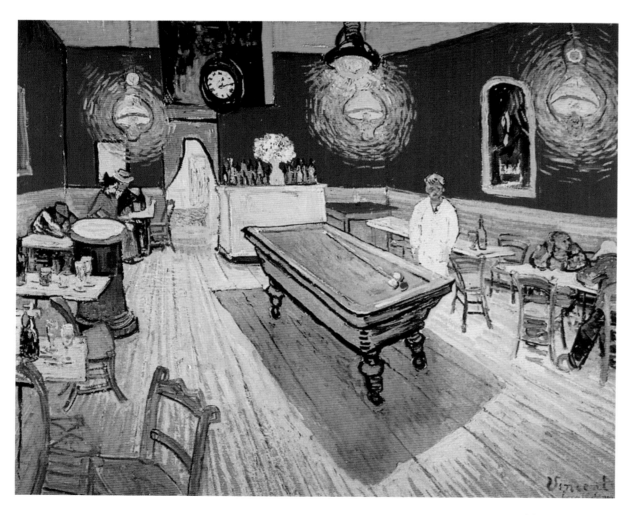

going nowhere. And for Gauguin, who never lost his sense of business, the van Gogh brothers might be useful. He had already written to Vincent in order to make use of his influence with Theo, and Vincent, always sympathetic to Gauguin's difficulties, besides interceding with Theo on his behalf, had made efforts to persuade his friend John Peter Russell to buy one of Gauguin's paintings.

Vincent did make the acquaintance of one genuine artist early in March, a young Dane called Christian Mourier Petersen, who was furthering his education in the South and intended to go to Paris for the Salon before touring the Dutch museums. He was still under the spell of Northern realists, and his work, Vincent considered, was 'dry, correct and timid, but I do not object to that when the painter is young and intelligent'. Petersen's saving grace was that he had 'a genuine desire to do very different work from what he is actually producing now'. They had little in common, but found more to share when discussing literature (Vincent mentions Zola, Maupassant and the Goncourts), and they seem to have spent a good deal of time together. It is clear that Vincent contemplated Petersen's forthcoming departure (he left in May) with regret. After Vincent's death, it was Petersen who seems to have been largely responsible for the early favour accorded to Vincent's works in Denmark.

Another acquaintance was Dodge MacKnight, the friend of Russell. Vincent did not take to the 'Yankee', but assumed from his

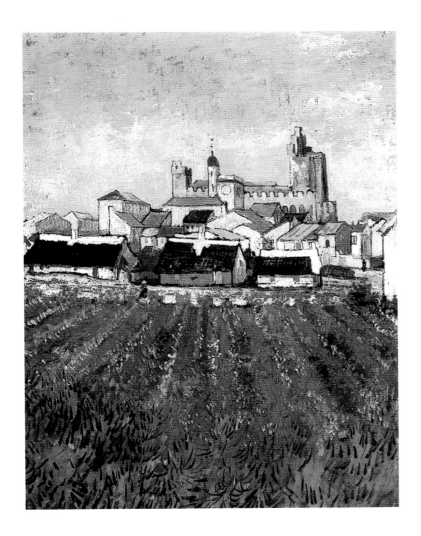

nationality that he had money and therefore might help in creating the artists' commune he hoped to create. Visiting him, 'a dry sort of person and not too sympathetic either', in Fontvieille, Vincent was disappointed by his work, a collection of uninspiring watercolours, and although they met again, they failed to establish bonds of fellowship.

From his first week in Arles Vincent had mentioned the desirability of having his own establishment, and in May he became the proprietor of the famous Yellow House (page 218), so named for obvious reasons. It was a two-up, two-down dwelling, one of an adjoining pair, whose twin pedimented facades, on a corner off the Place Lamartine just outside the city walls, faced one of the medieval gates. The old gate was largely destroyed in the fighting of 1944, and so was the Yellow House, though the taller structure with a red roof that appears behind it in Vincent's painting is still there. Although the other half of the building was apparently in good order, with a grocer's shop on the ground floor, Vincent's house was a shambles, without even a lavatory – he had to use the one in the building behind, which was also owned by his landlord.

He described the house in a letter to his sister Wil in September: 'My house here is painted the yellow colour of fresh butter on the outside with glaringly green shutters; it stands in the full sunlight in a square which has a green garden with plane trees, oleanders and

RIGHT and OPPOSITE
Self-Portrait, 1888
Oil on canvas, 18¹/₈ x 15¹/₃in (46 x 39cm)
Private collection

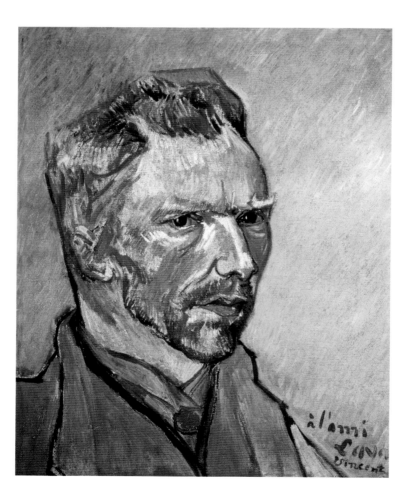

acacias. And it is completely whitewashed inside, and the floor is made of red bricks. And over it there is the intensely blue sky. In this I can live and breathe, meditate and paint.'

His idea was to use the house as a studio and store while making one room fit to sleep in. He spoke already of showing his friends' paintings there and later of persuading them to come and stay. One of his arguments was that all his painter friends liked and had been influenced by Japanese painting and, short of actually going to Japan, the South was the ideal stand-in. He had written in February, 'This country seems to be as beautiful as Japan as far as the limpidity of the atmosphere and the gay colours are concerned.'

Although his dream of an artists' community was one motive, Vincent's move was expedited by his dissatisfaction with his present circumstances in the Carrel. Not only did he have no proper studio, he believed that, in addition to the grudging service of which he complained, he was being overcharged. That this was not just a touch of paranoia is confirmed by the decision of the magistrates' court to whom Vincent took the dispute after he had been forced to pay the full demand in order to get possession of his sequestered luggage. The court ordered about half the sum in dispute to be returned to him.

The rent for the Yellow House was 15 francs a month, a lot less than the four francs a day he paid to the Carrel, although of course he had other expenses. In the meantime he moved into the Café de la

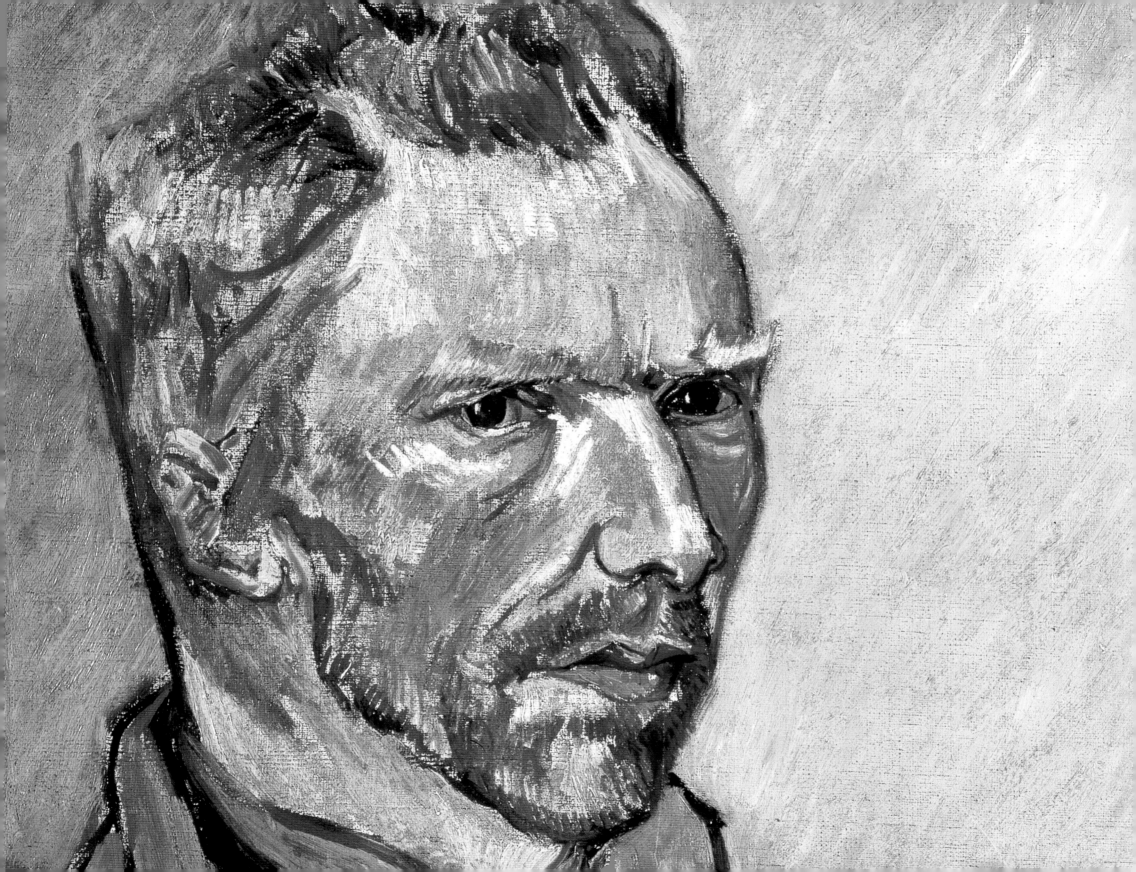

OPPOSITE
Street in Saintes-Maries, 1888
Oil on canvas, 15 x 18¹/₈in (38.3 x 46.1cm)
Christie's Images, London

The squat cottages of the little fishing village reminded Vincent of the North.

LEFT
Fishing Boats on the Beach at Saintes-Maries, 1888
Oil on canvas, 25¹/₂ x 32in (65 x 81.5cm)
Rijksmuseum Vincent van Gogh, Amsterdam

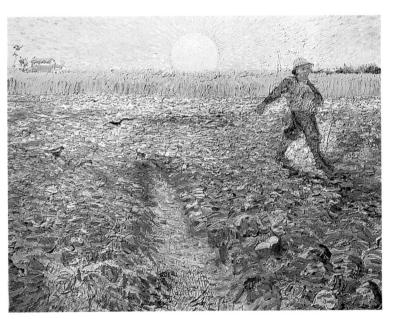

OPPOSITE
OPPOSITE
Fishing Boats at Sea, 1888
Oil on canvas, 17¹/₃ x 28⁷/₈in (44 x 53cm)
Pushkin Museum, Moscow

Vincent did two marvellous seascapes at
Saintes-Maries of which this is the smaller,
but the artist himself liked it better and
later made no less than three drawings of
it – one for Theo, one for Emile Bernard,
and one for John Russell.

FAR LEFT
Sower with Setting Sun, 1888
Oil on burlap on canvas, 29 x 36⁵/₈in
(73.5 x 93cm)
Foundation Collection E.G. Bührle

Millet's Sower *was an icon to which*
Vincent returned time and time again. This
is perhaps his most evocative version.

ABOVE LEFT
The Sower, 1888
Oil on canvas, 25¹/₄ x 31⁵/₈in
(64 x 80.5cm)
Rijksmuseum Kröller-Müller, Otterlo

Gare, one of the numerous unpretentious, open-all-hours drinking dens around the Place Lamartine, their character well conveyed in two famous paintings, *Café Terrace on the Place du Forum* (now at Otterlo) and *The Night Café*, both painted in August–September 1888 (pages 222 and 228). The Café de la Gare was hardly more attractive than the Carrel, with the important exception that the proprietors, Joséph and Marie Ginoux, were a kindly couple who not only treated him generously but became his friends. He got his meals in a nearby restaurant where he was also well treated and could eat a good meal for a franc or two.

INSPIRED BY THE SEA

At the end of May Vincent took time off from furnishing his house – he had found the money to buy a coffee pot and some china, of which he promptly made a cheery painting – to catch the early-morning coach from Arles to Les Saintes-Maries-de-la-Mer on the coast,

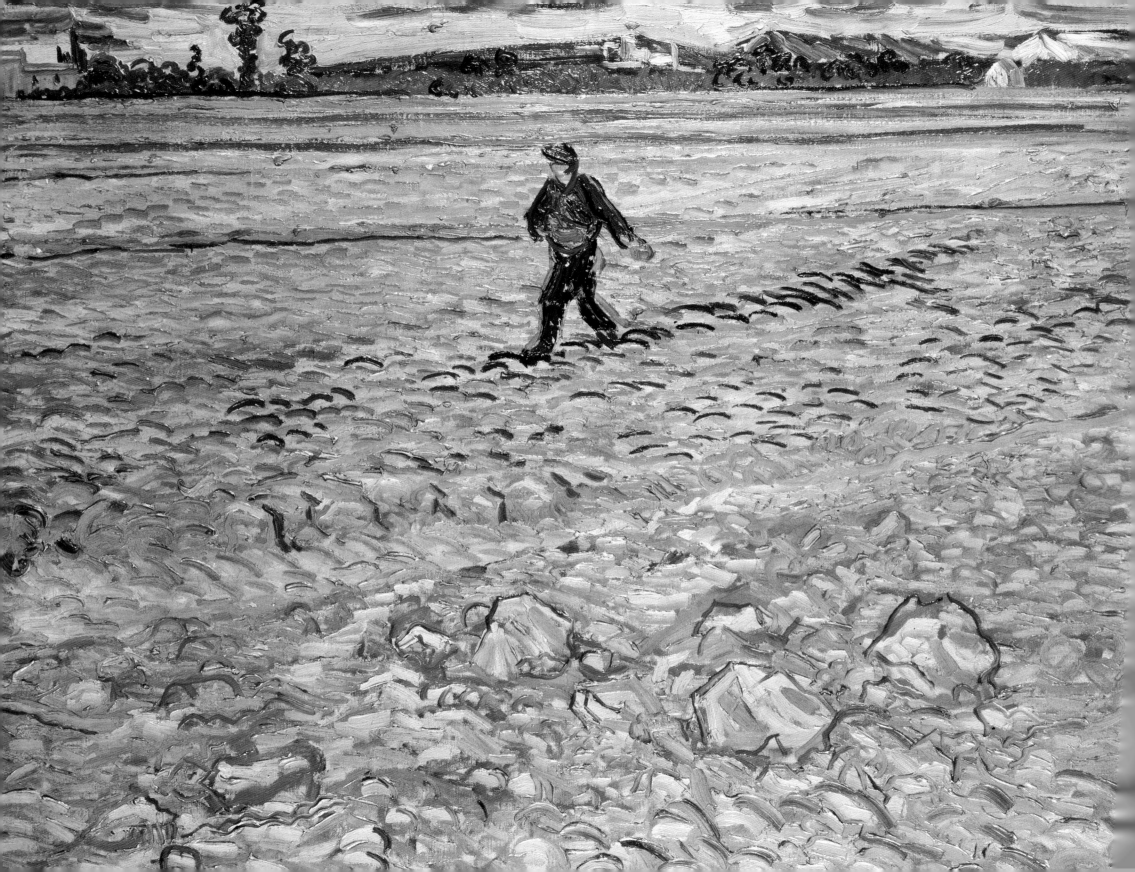

OPPOSITE
The Sower, 1888
Oil on canvas, 28¹/3 x 36in (72 x 91.5cm)
Private collection

The scene is the Crau, with the remains of the abbey of Montmajour in the background.

LEFT
The Sower, 1888
Oil on canvas, 13 x 15³/4in (33 x 40cm)
Christie's Images, London

RIGHT

Harvest on La Crau, with Montmajour in the Background, 1888

Oil on canvas, 28³/4 x 36¹/4in (73 x 92cm) Rijksmuseum Vincent van Gogh, Amsterdam

FAR RIGHT

Haystacks near a Farm, 1888

Oil on canvas, 28³/4 x 36³/8in (73 x 92.5cm) Rijksmuseum Kröller-Müller, Otterlo

Vincent painted or drew this farmhouse, sometimes including the gigantic haystacks (even he admitted that their appearance in another painting was 'bizarre'), several times just before he made his trip to the seaside.

OPPOSITE

Harvest in Provence, 1888

Oil on canvas, 19⁵/8 x 23⁵/8in (50 x 60cm) The Israel Museum, Jerusalem

was just the sea that brought him to his nephew's mind. Recent visitors to the beach of Saintes-Maries might be surprised at Vincent's remark that the following month would begin the season for bathing when 'the number of bathers varies from 20 to 50'! He found lodgings, for the same price he had paid at the Carrel, and stayed three or four days.

There was nothing much to the village, where the fishermen's

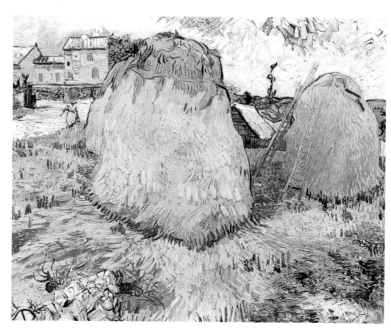

travelling through the wilds of the marshy Camargue with its roaming white horses, fighting bulls and flamingos. The fare was reduced because it was the time of pilgrimage to this little harbour-less port (nowadays one would expect fares to rise at such a time), which was allegedly the place of disembarkation of the three saints, all called Mary, who had converted Provence to Christianity a decade after the Resurrection.

Monticelli had painted at Saintes-Maries and there was also some connection with Vincent's Uncle Jan, the admiral (now dead), unless it

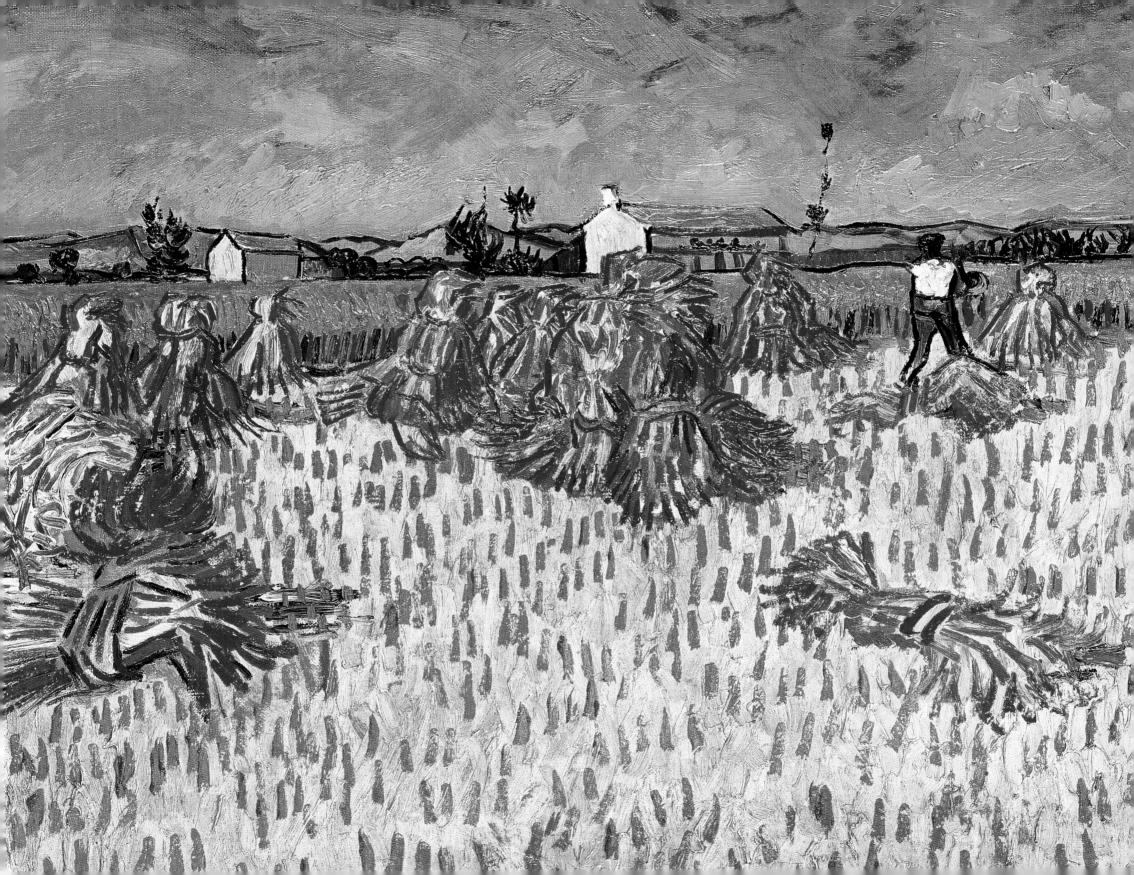

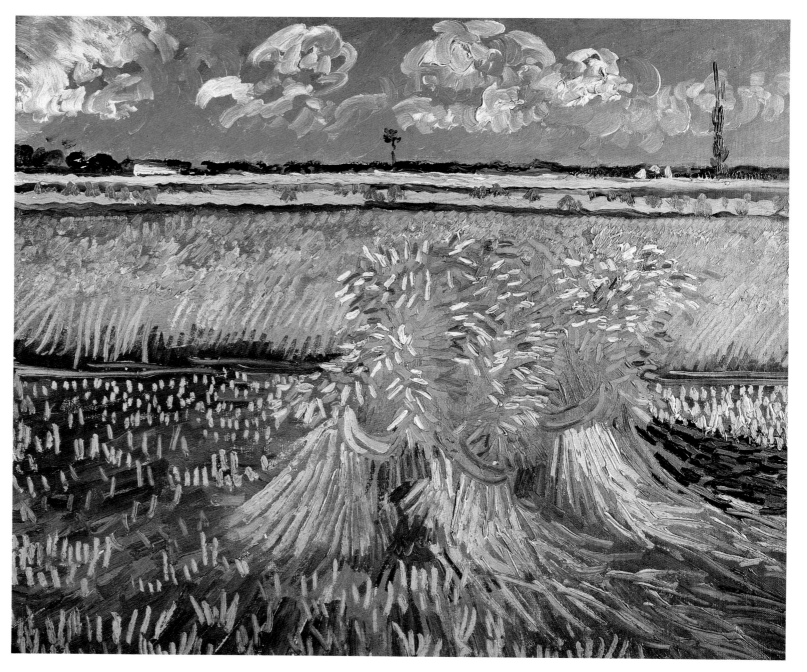

RIGHT
Wheatfield near Arles, 1888
Oil on canvas, 20⁷/₈ x 25¹/₄in (53 x 64cm)
Honolulu Academy of Arts, Hawaii

OPPOSITE
Wheatfield with Sheaves and Arles in the Background, 1888
Oil on canvas, 28³/₄ x 21¹/₄in (73 x 54cm)
Musée Rodin, Paris

In most of the wheatfields of June 1888 the painter has his back to the town, but in this case he was facing the other way and Arles appears in the background.

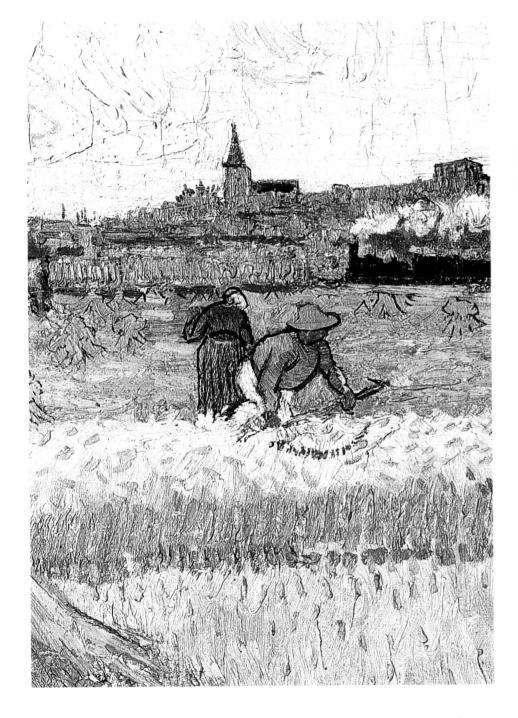

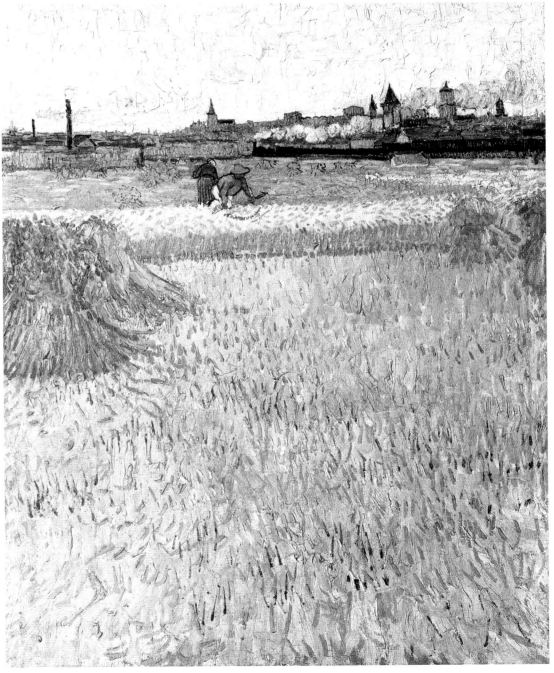

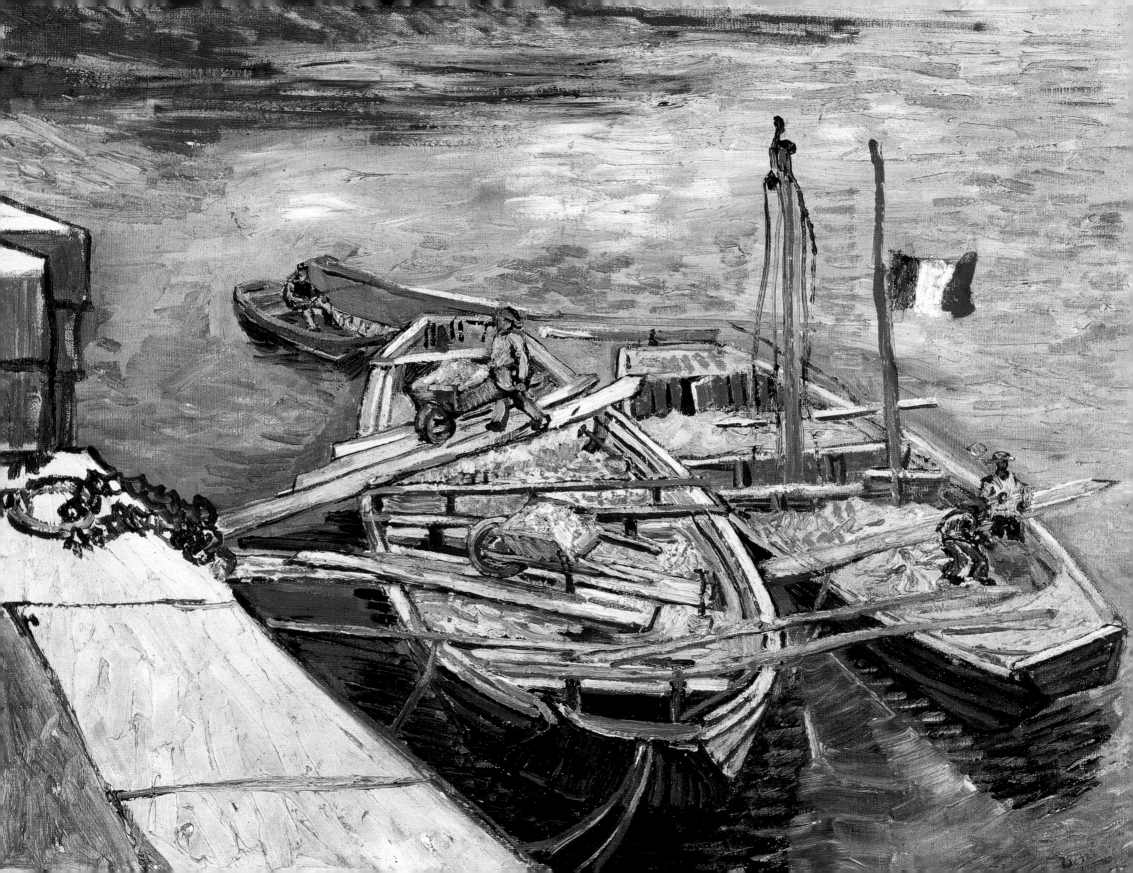

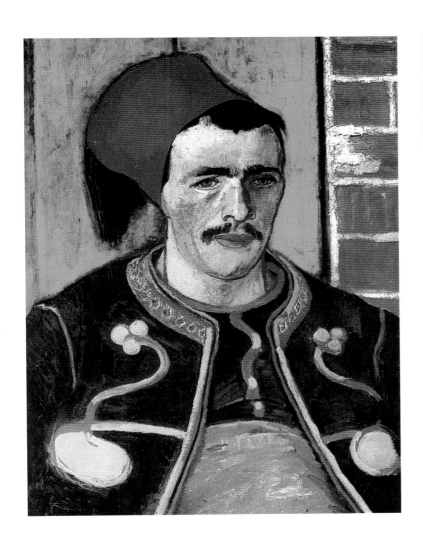

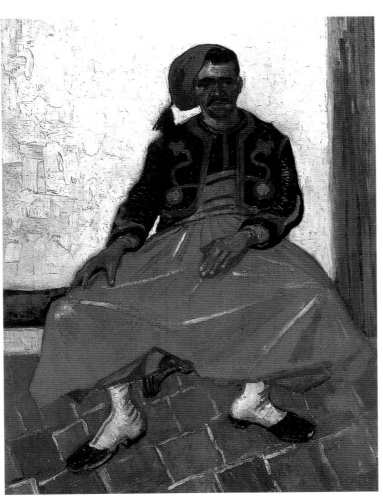

OPPOSITE
Quay with Men Unloading Barges, 1888
Oil on canvas, 21⁵/₈ x 26in (55.1 x 66.2cm)
Museum Folkwang, Essen

FAR LEFT
The Zouave, 1888
Oil on canvas, 25¹/₂ x 21¹/₄in (65 x 54cm)
Rijksmuseum Vincent van Gogh,
Amsterdam

LEFT
The Seated Zouave, Arles, 1888
Oil on canvas, 31⁷/₈ x 25¹/₂in (81 x 65cm)
Private collection

Vincent made three portraits of this
subject, whom he described as 'a boy with
a small face, a bull neck and the eye of a
tiger' and remarked that 'it seemed very
harsh, but all the same I'd like always to
be working on vulgar, even loud portraits
like this'.

cottages sprawled close to the ground like the peasants' cottages in Drenthe, except an impressive citadel of fortress-like church and castle, forming a powerful stone monument somehow out of character with the wider environment, and painted by Vincent from the landward side, across a field of lavender. *View of Saintes-Maries* (page 229) is now in Otterlo; there are, as so often, several versions, painted later in Vincent's studio. This is as fine a painting as the two, perhaps better-known, seascapes, *Fishing Boats on the Beach* (page 233) and *Fishing Boats at Sea* (page 234), that Vincent completed in a crowded three days of work – one masterpiece per day!

The first, *Fishing Boats on the Beach*, has four picturesque little craft drawn up on the sand, their varicoloured masts and spars forming a seductive interlacing pattern against a pale and cloudy sky, the whole reflecting strong Japanese influence. These little boats had a single, small lateen sail and a steering oar, with a crew of one. They would not put out in rough weather, nor venture far from shore, for a squall may blow up fast in the Mediterranean. As we see in *Fishing Boats at Sea*, the boats, confined to the top left quarter of the picture, are trying hard to regain the safety of the beach amid the turbulent, thickly painted sea that occupies the rest of the canvas.

'The Mediterranean', Vincent wrote, 'has the colours of mackerel, changeable I mean. You don't always know if it is green or violet, you can't even say it's blue, because the next moment the

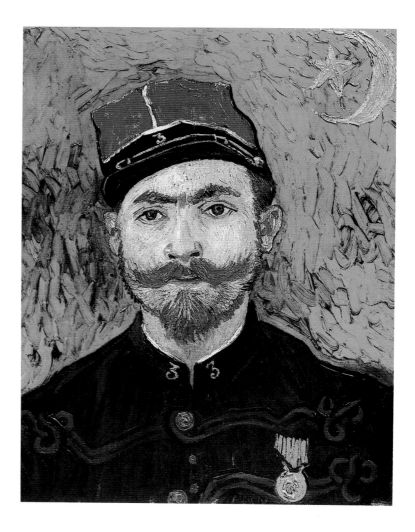

changing light has taken on a tinge of pink or grey.'

Vincent's love affair, passion rather, for colour, and especially for that Provençal blue, most subjective of colours, that he had dreamed of in Paris before he had ever seen it, leaps out again from his description of a walk late in the evening along the shore. 'It was not gay, but neither was it sad – it was beautiful. The deep blue sky was flecked with clouds of a blue deeper than the fundamental blue of intense cobalt, and others of a clearer blue, like the blue whiteness of the Milky Way. In the blue depth the stars were sparkling, greenish, yellow, white, pink, more brilliant, more sparklingly gemlike than at home – even in Paris: opals you might call them, emeralds, lapis lazuli, rubies, sapphires. The sea was very deep utramarine – the shore a sort of violet and faint russet as I saw it, and on the dunes (they are about seventeen feet high) some bushes Prussian blue.' (In that paragraph, the word 'blue' has to do for six different colours, an indication of the hopelessness of describing works of art in mere words!)

Of course colour was not his only interest. Besides the three oils, he also did a watercolour and several drawings – a particularly striking one of the boats at sea. He had said not long before that he was trying to develop a more individual, more striking style in his drawings, which are an important, though often neglected, aspect of his art. He had found the reeds along the canal in La Crau made

even more effective pens than those of the North, and drawings had several advantages, being cheaper to produce and easier to transport: he had to leave his paintings at Saintes-Maries because the paint was not dry enough to travel. The drawings are more often than not of the same subjects as the paintings, as were the drawings at Saintes-Maries, and have often been taken as studies for the paintings. A few certainly were, but more often they were conceived as separate works.

SUMMER LANDSCAPES

By June, the blooming orchards were long forgotten, as the haymaking and harvesting season arrived. Although these are dominant in his landscapes of the summer of 1888, he also painted, perhaps slightly out of season, *Sower with Setting Sun* (page 235 left), one of his thirty-odd versions of Millet's *The Sower*, a perfect symphony of yellow and purplish blue with the great golden globe of the setting sun positioned on the horizon at the Vanishing Point (where receding parallels appear to meet) of the perspective. The importance of the themes of the sower and the sheaf in Vincent's art is hard to exaggerate; as he was aware, they represented a 'longing for the infinite'.

The landscapes of the spring and summer of 1888 are the clearest, the most colourful and the most confidently painted of Vincent's career. The many harvesting scenes around Arles are more

RIGHT and OPPOSITE

Portrait of the Postman Joséph Roulin, 1889

Oil on canvas, 25¹/₄ x 21¹/₂in
(64 x 54.5cm)
Museum of Modern Art, New York

Vincent painted his friend Roulin more often than any other model in Arles. He was clearly a rather stiff sitter, but Vincent did not let that discourage him. This is the last portrait of him, possibly as late as April 1889, when Roulin was visiting Arles from his new job in Marseille.

loosely painted than the – very accurate – *View of Saintes-Maries*, but similar in mood. Some show strong signs of Divisionist influence, for example *The Crau with Peach Trees in Bloom* in the Courtauld Galleries, London, which was painted in April, with a flowering orchard behind a picket fence, Les Alpilles in the background and between them scattered houses. These buildings are familiar from other paintings, including *Harvest on La Crau* of June 1888 (page 238) that is one of the most attractive pictures of this series, in fact one of Vincent's finest landscapes ('one of the best works in the Amsterdam collection' in the view of Hans Bronkhorst). It also includes the same farm cart, which here is central and draws the eye on into the depth of the painting, beautifully conveyed with the colours almost imperceptibly fading as distance increases.

As in the Pont de Langlois paintings, there is often something Dutch in the detail of some of these landscapes, although nothing Dutch about the colours. Human beings are generally rather insignificant or altogether absent, although sometimes they are needed, as in *Wheatfield with Sheaves and Arles in the Background* (page 241), where they provide a point of focus and interest, helped by the train puffing along in the distance. In another painting of haymaking, *Haystacks near a Farm* (page 238), the foreground is dominated by a very large and unruly haystack, whose suggestion of life and movement is rather sinister, as if it is about to

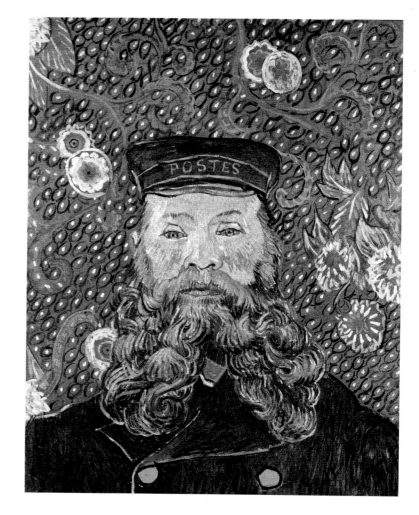

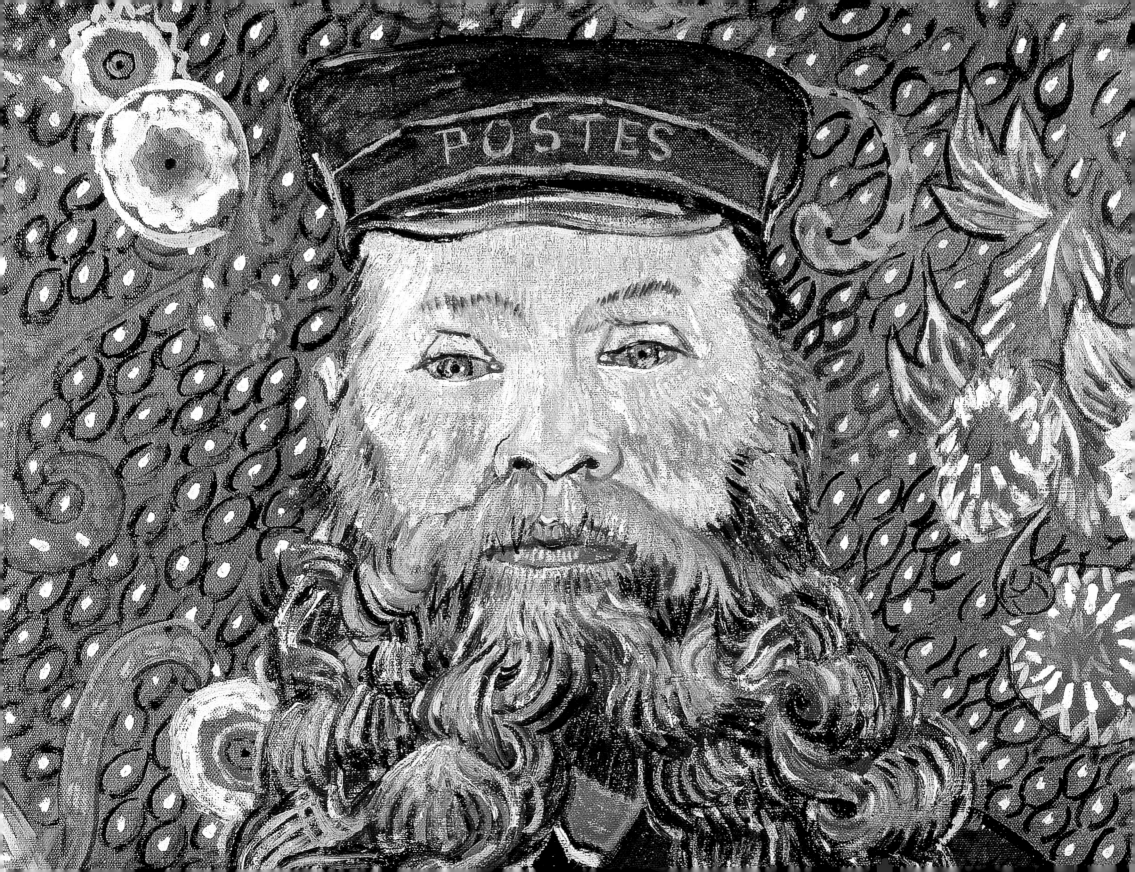

RIGHT

Madame Roulin and Her Baby, 1888

Oil on canvas, 25 x 20in (63.5 x 51cm)

Metropolitan Museum of Art, New York

This was one of the series of the Roulin family painted in November–December 1888. The frenetic treatment, showing evidence of palette knife as well as brush, may have been the result of the need to complete it quickly before its main subject became too obstreperous!

FAR RIGHT and OPPOSITE

Portrait of Postman Roulin, 1888

Oil on canvas, 25¼ x 18⅞in (64.1 x 48cm)

Detroit Institute of Arts

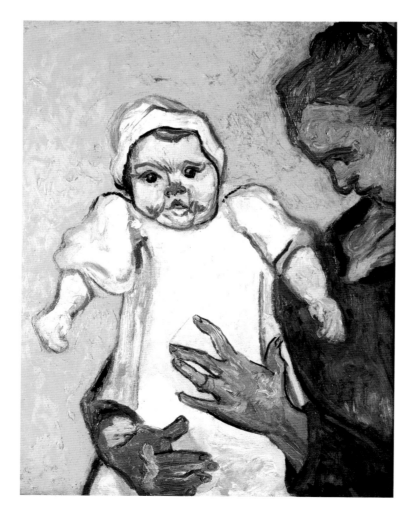

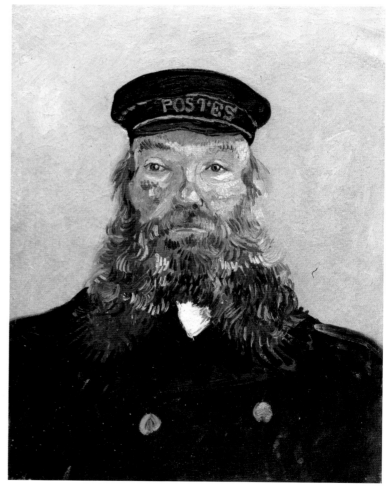

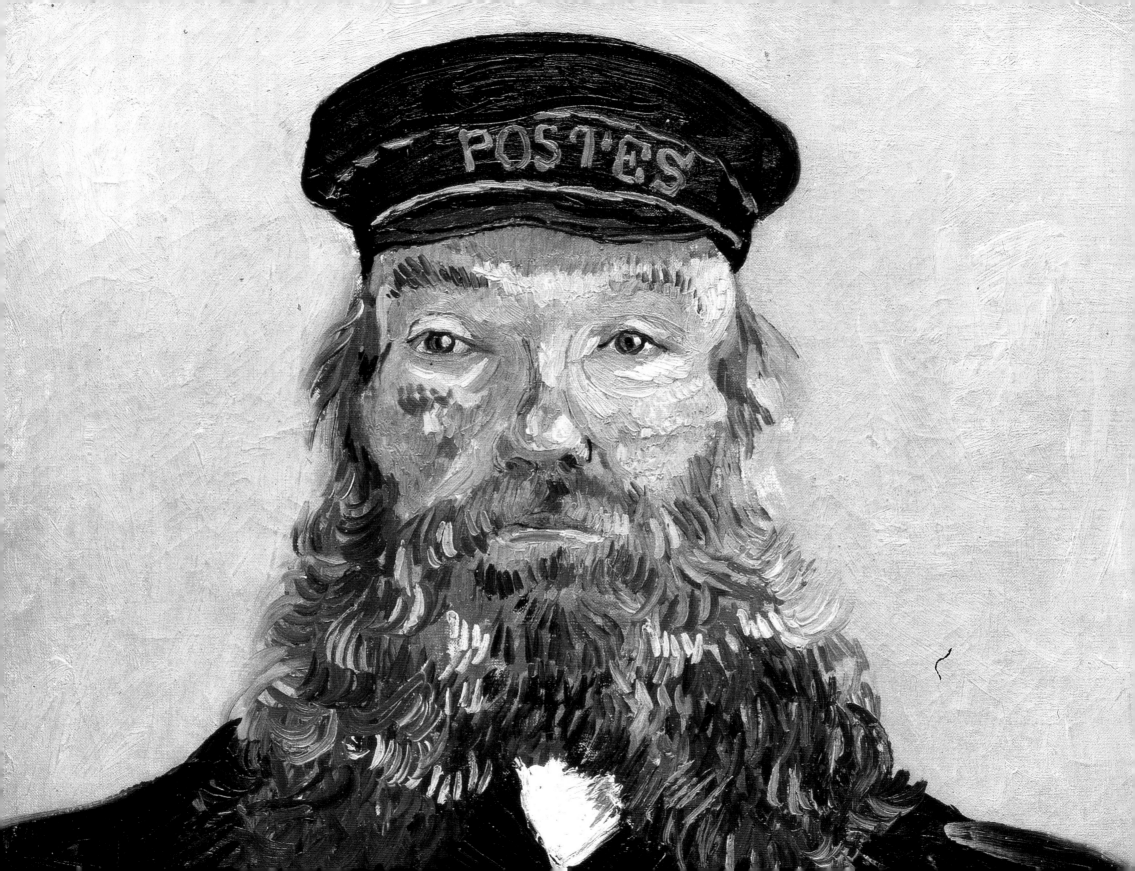

The Old Peasant Patience Escalier with a Walking Stick, 1888
Oil on canvas, 27³/4 x 22⁷/8in
(70.5 x 58cm)
Christie's Images, London

After their prominence in Vincent's early career, peasants, of whom, as he said, there were as many in Provence as there were in Brabant, do not figure much in his work. But he was struck with the old Camargue ex-herdsman and must have exercised some charm to overcome his reluctance to model. He painted him twice in August 1888, at about the time as he was doing his series of Sunflowers. As he said, the colours suggested 'the blazing air of harvest time right at midday'.

overwhelm the neat little farmhouse and the peaceful woman with a basket in the background, while in *Wheatfield near Arles* (page 240), painted about the same time as *Wheatfield with Sheaves*, the interest lies in the paint itself, applied in exuberant impasto.

Scenes of human activity, as in *Drawbridge with Carriage* (page 210), remain comparatively scarce, but one exception in this sensational summer is *Quay with Men Unloading Barges* (page 242), a rather precarious activity if Vincent's rendering is precise. The Rhône is painted a brilliant green, the boats predominantly reds and yellow – their cargo is builder's sand. A sketch exists for this painting which is considerably less lively. In the sketch there is only one barge and the little boat behind it with an eternally expectant fisherman holding his rod is not present. Also, the French flag is at the top of the mast whereas, in the painting, it is at half mast. There may be some undeciphered symbolism here, but close inspection of the painting suggests that Vincent decided at a late stage to lengthen the mast, to balance the one next to it, but did not bother, or forgot, to move the flag up as well.

ARLESIAN PORTRAITS

Landscape was Vincent's subject in the early summer, and he did few portraits as long as the weather was fine. Also, he had few potential models, although as he acquired a few real friends, like the

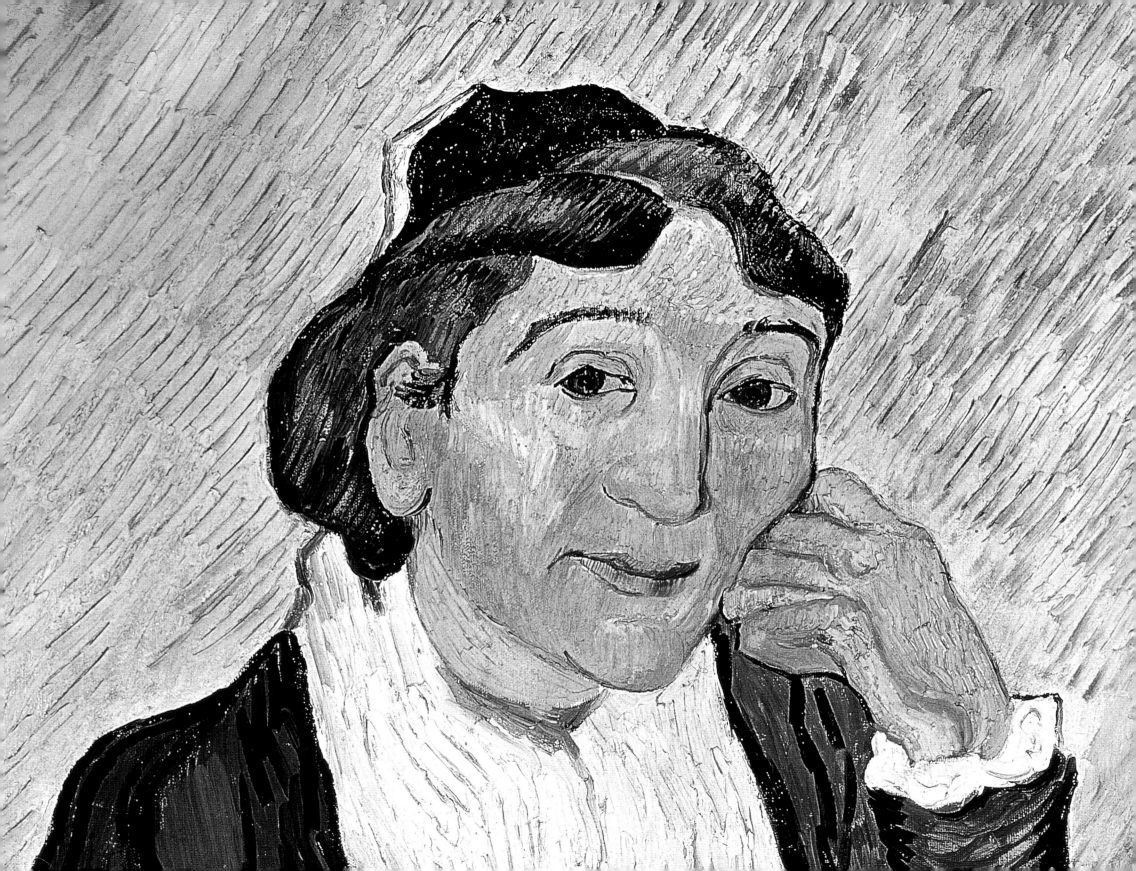

RIGHT and OPPOSITE
L'Arlésienne, 1890
Oil on canvas, 25¹/₂ x 21¹/₄in (65 x 54cm)
Museu de Arte, São Paulo

Ginoux and Roulin families, more opportunities appeared. The model for the Zouave of June, 1888, a painting that Vincent admitted was 'strident' but rewarding, was probably provided through the good offices of Paul-Eugène Milliet, an officer in the Third Regiment and himself the subject of the portrait by Vincent done three months later (page 244). It was perhaps delayed because, although he would have been, Vincent thought, a good model for a painting of a lover, he could not sit still.

Rather unusually for a handsome young army officer, Milliet was also a keen amateur painter, and Vincent, always ready to encourage the tyro, tried to help him. They went out sketching together, and spent a day exploring the long-abandoned monastery of Montmajour. When he went on leave in the north, Milliet carried a batch of Vincent's paintings to Theo in Paris, and brought back a parcel of Japanese prints and illustrated magazines. Vincent privately thought Milliet's talent a modest one, and Milliet did not admire Vincent's painting. He drew very well, said Milliet years later, and could be a charming companion when he wanted to be but he became a different man when he picked up his brushes, and then, rather than risk provoking a furious tantrum by saying what he felt, Milliet left him alone. 'Sometimes he was a real savage.'

The much-admired portrait of Patience Escalier with his walking stick (page 252, but see also page 245), represents a return to former

subject matter – the weary, work-worn peasantry. Though the style, with powerful complementary colours, and the light (one feels the intense heat of Provence in August) are quite different, the artist's sympathy for the rural working class is still evident. Escalier was then employed as a gardener somewhere in La Crau, after spending most of his working life as a stockman in the Camargue.

Vincent appears to have painted practically every member of the Roulin family (25 paintings altogether, according to the estimate of the vangoghgallery website), who lived a few doors away, several times in the six months from July 1888. The portraits of 'the Postman Roulin' (see page 246 et seq.), as the subject is usually called although he did not actually deliver the post but was a postal official at the railway station called, more imposingly, a *brigadier-chargeur*, are among Vincent's best. He painted his friend Joséph Roulin, with his powerful build, patriarchal beard and 'head like Socrates', several times in his postal uniform. The portrait called *The Postman Roulin* at Otterlo was described by Maurice de Vlaminck, one of the best of the Fauves who rightly claimed Vincent as progenitor, to be a work 'of such great and vital interest, [it] is a sure manifestation of genius'.

Vincent was frequenting the bars more often and found Roulin a congenial drinking companion. In some respects he was a kind of Provençal substitute for Père Tanguy, whose fierce republican views he shared, but being 'a man of the people' he was relatively uneducated and had no cultural pretensions. Their conversation must have been quite unlike the kind heard in the bars of Montmartre or in Tanguy's shop, yet Roulin seems to have genuinely admired Vincent's work. More important, he proved a loyal friend – in bad times as in good.

The famous portraits known as *La Berceuse* (page 254) are of Joséph Roulin's considerably younger wife, Augustine, whom Vincent painted on several different occasions, as well as making four copies. In one painting she appears with her baby, Marcelle (page 250), who was also the subject of an individual portrait. The loop of cord that Mme. Roulin is holding in the Berceuse or Lullabye pictures is attached to the baby's cradle to enable her to rock it. Painted in 1889 they betray the legacy of Gauguin's visit, not only in style but also in mood, for there is something gloomy about them in spite of the strong colours, which are heightened by the fierce complementaries red and green. There is an affinity with *Portrait of Dr. Rey* (page 298), done about the same time. The spectacular 'wallpaper' here lacks the jollity and lightness of the similar background in the portraits of her husband.

Besides M. and Mme. Roulin and their baby daughter, Vincent also painted their sons, again more than once, the handsome young Armand Roulin, who was 17 (page 194), and his younger brother Camille, aged 12. The family must have found it hard to get by, as Joséph's pay was only 135 francs a month, slightly less than Vincent received from Theo.

ARLES

Perhaps the friend in Arles of whom Vincent was most fond was Mme. Ginoux, a fellow depressive who, with her husband, ran the Café de la Gare, where Vincent stayed before moving into the Yellow House in September. Her strong, intelligent and attractive face is that of *L'Arlésienne*, of which there are two versions, painted in November 1888 (besides other later versions). Dressed in traditional black against a yellow background, she leans on a table which in one version (Metropolitan Museum, New York, page 256) has books on it, in the other (Musée d'Orsay, Paris, page 258) gloves and a parasol.

Vincent is said to have remarked, more presciently than he knew, 'Madame Ginoux, one day your portrait will hang in the Louvre.' He claimed to have done the second of these portraits in forty-five minutes. Perhaps that was an exaggeration, but he was a notoriously fast worker, especially at this time, and resembling the Impressionists, he actually needed to work fast, not to capture the Impressionist moment but to realize his feelings.

Gauguin also painted Mme. Ginoux as L'Arlésienne (page 295), and at Saint-Rémy, when he could not see her in person, Vincent did several portraits based on Gauguin's version (see pages 258 et seq.).

In July, Vincent painted the picture of a young girl (she has never been identified) called *La Mousmé* (page 263), the French version of the Japanese word for 'girl', in predominantly red and blue. He

described the painting, now in the National Gallery in Washington, D.C., to Bernard: 'a portrait of a girl of twelve, brown eyes, black hair and eyebrows, grey-yellow flesh ..., an oleander flower in the charming little hand'. She is sitting in the same cane chair as Roulin in *Joséph Roulin in a Cane Chair*, painted in the following month. This chair, interestingly, was the one item of furniture which Vincent did not want sold from the Yellow House (it eventually passed into the possession of the Ginoux family). Marc Edo Tralbault says that Picasso once told him that the Fauves thought the picture represented a daring experiment by van Gogh in 'enlargement of form' which, looking at the painting, one can understand, but which is in fact totally realistic; the Fauves merely forgot to allow for the fact that the sitter was a rather small person!

Another friend whose portrait Vincent painted in the late summer of 1888 was the Belgian landscape painter, Eugène Boch. A couple of years younger than Vincent, he was staying in Fontvieille with Dodge MacKnight, who brought him to call on Vincent in Arles. Vincent liked him better than he liked MacKnight (who left Provence in August) and was at least not openly offended by his sub-Impressionist paintings; in fact he thought they showed promise.

Of independent means, Boch had a strangely thin, horsey face and reminded Vincent of a Flemish gentleman in the time of the Revolt of the Netherlands. Another point about him that aroused

VAN GOGH

Vincent's interest was that his home was on the fringe of the Borinage. Vincent urged him to go back there, assuring him that he would find more inspiration in that land of the sulphurous sun than he would under the blue skies of Provence. Whether or not Vincent's advice was decisive, Boch did return to the Borinage, where his work appears to have improved markedly.

Vincent's portrait of him (page 214), sometimes called *The Poet* (Boch also wrote poetry), he later hung on his bedroom wall alongside the portrait of Lieutenant Milliet, as revealed by his painting, *Van Gogh's Bedroom* (though not all versions). Vincent was pleased with it. It was done, he told Theo, to express his appreciation, the love he had for him, and was painted as faithfully as possible (other images of Boch, including a portrait by Bernard, suggest that this is true), but he admitted manipulating the colours, exaggerating the fairness of the hair for example, while behind the head, instead of the wall of his studio, he painted a background of intense blue, suggesting infinity, so that overall he achieves 'a mysterious effect, like a star in the depths of an azure sky.'

By this time Vincent had taken to painting at night at. 'It often seems to me that the night is still more richly coloured than the day, having hues of the most intense violets, blues and greens. If only you pay attention to it you will see that certain stars are citron-yellow, others have a pink glow, or a green, blue and forget-me-not brilliance. And without expatiating on this theme it will be clear that putting little white dots on a blue-black surface is not enough.'

Some older accounts say that he used to attach lighted candles to his hat so that he could see to work outside, for instance in his nocturnal painting, *The Yellow House* (page 218). Such behaviour would have been likely to have encouraged the suspicion, even distaste, of the respectable folk of Arles; but the story is probably a myth. Vincent told Theo that *The Yellow House* was done by gaslight. At least this habit kept him out of the bars for a time, and in fact it produced several outstanding paintings, including *Café Terrace on the Place du Forum* (page 222), one of his best loved paintings, though it does not have the cheerful high spirits of a similar scene by Renoir; *The Night Café* (page 228), an indoor scene; and *The Starry Night* (page 266), with the lights from houses reflected in the broad waters of the Rhône (the painting is sometimes called *Starry Night over the Rhône* to avoid confusion with the later, equally famous *Starry Night* done in Saint-Rémy, page 268). 'Looking at the stars makes me dream, as simply as I dream over the black dots representing towns and villages on a map. Why ... shouldn't [the stars] be as accessible as the black dots on the map of France?'

CHAPTER EIGHT
GAUGUIN

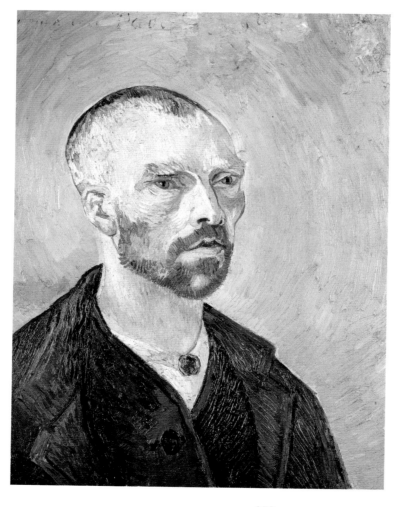

Vincent had been keen to attract Paul Gauguin to Arles since the spring of 1888. As we have seen, he had always yearned to belong to an artistic community, perhaps one like the associations of artists in Japan, failing which, almost any associate would have done for a start. At one time he had hopes of Bernard, who would probably have been a more suitable companion than Gauguin, but Bernard was soon to go off on military service which would put him temporarily out of the picture. And Gauguin was, in a way, a bigger catch.

Why did Vincent particularly want Gauguin to join him in Arles? Gauguin was of course older (by five years), more experienced and more self-confident. Vincent may have seen him as some kind of fatherly, guiding figure. He certainly respected him inordinately, and the eager tone of his entreaties, whether to Gauguin directly or via Theo, is almost embarrassing, given that his eagerness was unreciprocated. Gauguin was a fluent talker with a well-developed sense of irony, talents that Vincent lacked. Vincent admired Gauguin's art, believed he could learn from him, and never recognized the substantial gulf between them. He thought that the warmth and colour of Provence would have a similarly rehabilitating effect on Gauguin that it had had on him. One thing they did have in common was dissatisfaction with Impressionism and a strong desire to find a way forward, although perhaps it should have been evident that their routes had already separated.

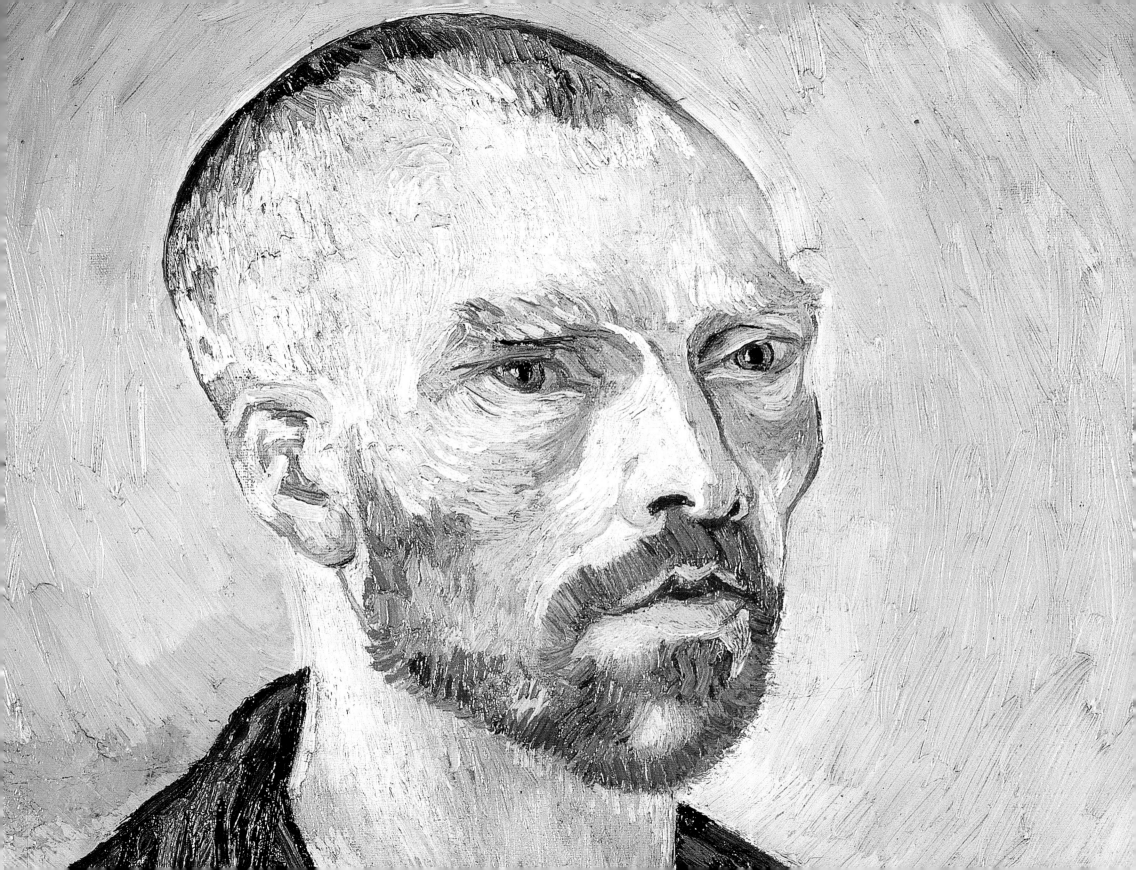

Pollarded Willows and Setting Sun, 1888
Oil on card, 12³/₈ x 13¹/₂in (31.5 x 34.5cm)
Rijksmuseum Kröller-Müller, Otterlo

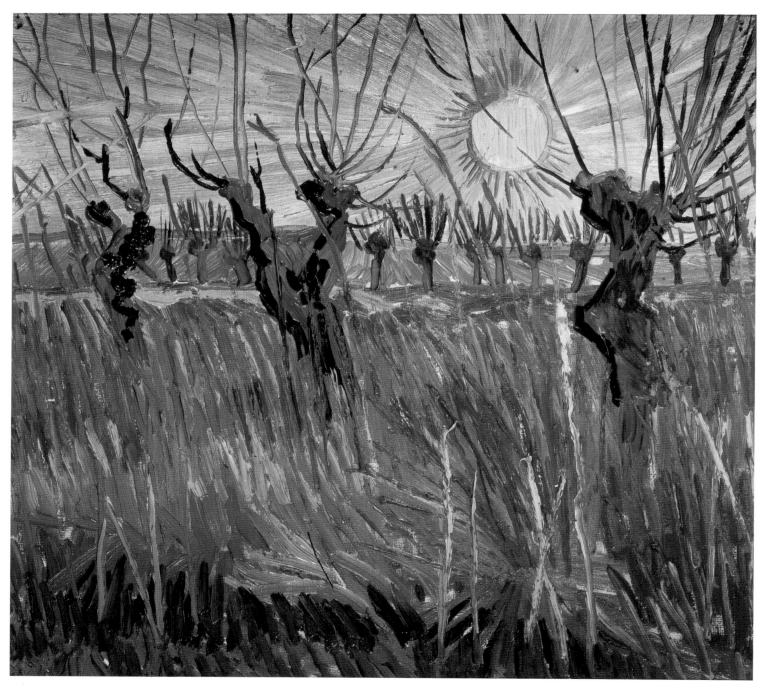

VAN GOGH

Vincent was all the more eager for company since he was spending so much time alone in Arles. Milliet had left the area, though temporarily, and Boch was about to leave, as advised by Vincent, for the Borinage. Old Joséph Roulin was a faithful drinking partner, but there was hardly anyone with whom Vincent could exchange views on art and literature.

A larger question is: why did Gauguin want to go? Or did he want to go? Gauguin did not have much respect for Vincent. When Vincent, years after his death, gained recognition as a genius, Gauguin was full of his praise, but he felt differently when Vincent was alive. Unlike Vincent's, his view of his contemporaries' work was generally severe, although he was occasionally prepared to borrow their ideas and later take the credit, and he does not seem to have thought that Vincent was more than moderately gifted. He probably, and erroneously, assumed that his comparative lack of articulacy reflected lack of intelligence, and he regarded Vincent's subservience to him as merely appropriate. It was not out of any artistic interest or common feeling for Vincent that Gauguin went to Arles, it was for what Vincent's brother could do for him.

In the summer of 1888, Gauguin was in Pont-Aven feeling very low. He was alone, out of sympathy with other resident artists, feeling unwell, and he had run out of inspiration. On top of that, his most immediate problem was that he was deep in debt, from which he saw

no prospect of escape. He was living on increasingly fragile credit.

Vincent, in response to Gauguin's pleading, had already used his influence with Theo to try and sell Gauguin's paintings, and now it appeared that Theo was prepared to subsidize Gauguin if he decided to accept Vincent's invitation. His reply was therefore encouraging, although he declined to make a firm commitment. Soon afterwards, things began to look up for him. Charles Laval, his companion in Martinique, appeared at Pont-Aven. Now he had a friend, and a disciple as much in awe of him as Vincent was. Then Bernard turned up. Recent relations had not been good, but the amiable Bernard was prepared to make himself agreeable – and to play second fiddle to 'the Master'.

It was Bernard, however, who had ideas, and this was the period when, together, they developed Synthetism (or Cloisonnisme). The most famous work of these few weeks is Gauguin's *The Vision after the Sermon* (*Jacob Wrestling with the Angel*), page 279. It is regarded as the masterwork of Synthetism, but it derived from Bernard's earlier *Breton Women in a Field*. Bernard was accompanied by members of his family, including his pretty, eighteen-year-old sister. Gauguin, old enough to be her father but an inveterate womanizer, immediately fell for her. (He must have been shocked when, later, he learned that he had been beaten to it by his unassuming follower, Laval!)

One way or another, Gauguin was feeling much better and less

Entrance to the Public Gardens in Arles, 1888
Oil on canvas, 28¹/₂ x 35³/₄in
(72.3 x 90.8cm)
Phillips Collection, Washington, D.C.

OPPOSITE
Couple in the Park, Arles, 1888
Oil on canvas, 28³/₄ x 36¹/₄in (73 x 92cm)
Private collection

Vincent described this picture, accompanied by a rough sketch of it, in a letter to Theo in October 1888: 'Imagine an immense pine tree of greenish blue, spreading its branches horizontally over a bright green lawn, and gravel splashed with light and shade. Two lovers in the shade of the great tree ...' It belongs to a sequence, the Poet's Garden, apparently painted to decorate Gauguin's bedroom in the Yellow House.

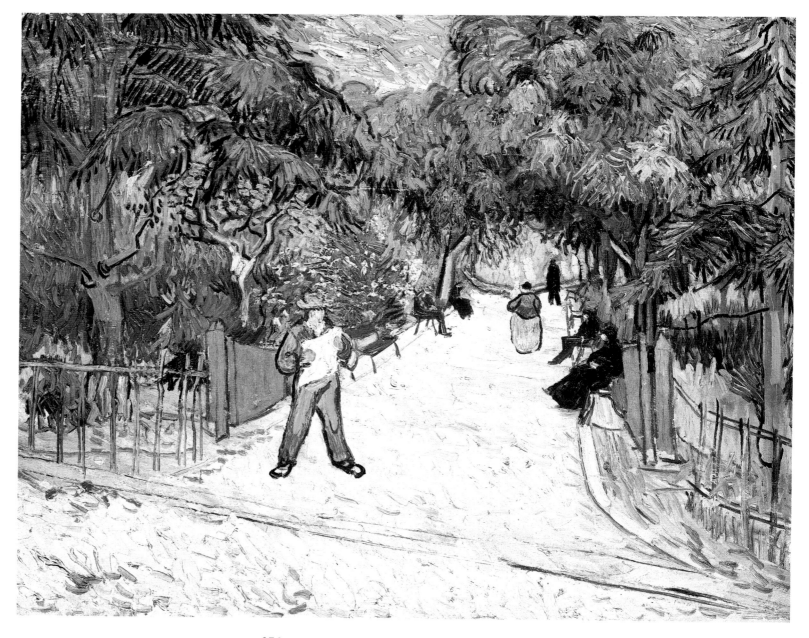

GAUGUIN

inclined to take himself off to Arles in sheer desperation. However, Theo had sold few of his paintings, and his financial situation was little better.

Theo's salary was not large and his brother was getting nearly a quarter of it. He could hardly afford to support two indigent painters, let alone a community of them as Gauguin blithely suggested (with himself as its head of course), but in July his resources received a boost when Uncle Cent died, leaving him a legacy. Uncle Cent left nothing to Vincent, but Theo concluded that this extra money ought to be devoted to Vincent's project. Accordingly, he promised Gauguin 150 francs a month, the same as he regularly sent to Vincent. It was supposed to be an advance on paintings but, although Theo managed to sell one or two in November, for a total of 300 francs, it was, in effect, a salary. That Gauguin should fulfil his promise to join Vincent in Arles, where Theo's two dependants could live in the same house and keep expenses to a minimum, was not made an actual condition of the arrangement, but Gauguin would have needed an even thicker skin than nature had given him not to have gone.

The news that Gauguin was finally coming prompted Vincent to move into the Yellow House in September; hitherto he had been staying in the Ginoux café. Furniture, linen and a kitchen stove were required, and Theo provided the cash. Vincent began to paint

throughout the hours of daylight and into the night as well, because he was anxious for his work to make an impression on Gauguin, although he believed 'his coming will alter my manner of painting and I shall gain by it'.

He was painting, he told Theo, with the passion of a citizen of Marseille eating bouillabaisse. He painted decorative canvases – notably a series of dynamic sunflowers whose brilliant yellow tone he is said to have achieved by overstimulating himself with coffee – to hang on the walls of the studio. One of the best of these is *Vase with Fifteen Sunflowers* (page 284) in the National Gallery, London. Another was sold in 1987 for $40 million to a private collector in Japan, where Vincent's affection for Japanese art is appropriately reciprocated.

Vincent and Gauguin also exchanged self-portraits. The original plan, in imitation of a Japanese custom, was that Gauguin, Bernard and Vincent should make portraits of each other, but Bernard found Gauguin as a subject too much for him. Gauguin's self-portrait was inscribed *Les Misérables*, a reference to Victor Hugo's novel suggesting, as Gauguin explained, the theme of an artist persecuted by society. In a letter to a friend he described it as 'one of my best things: absolutely incomprehensible (upon my word) so abstract it is'.

Vincent's slit-eyed, shaven-headed self-portrait (page 272) was

RIGHT
Two Cut Sunflowers, 1887
Oil on canvas, 8¹/₄ x 10⁵/₈in (21 x 27cm)
Rijksmuseum Vincent van Gogh,
Amsterdam

OPPOSITE
Two Cut Sunflowers, 1887
Oil on canvas, 19⁵/₈ x 23⁵/₈in (50 x 60cm)
Kunstmuseum, Bern

VAN GOGH'S SUNFLOWERS
(Van Gogh's Sunflowers have attracted the forgers, but the following are generally undisputed)

Paris, late summer 1887

Four Cut Sunflowers	Otterlo
Two Cut Sunflowers	Amsterdam
Two Cut Sunflowers	Kunstmuseum, Bern
Two Cut Sunflowers	Metropolitan Museum, New York

Arles, August 1888

Vase with Five Sunflowers	Destroyed by fire 1945
Vase with Fifteen Suflowers	National Gallery, London
Vase with Twelve Sunflowers	Neue Pinakothek, Munich
Vase with Three Sunflowers	Private collection

Arles, January 1889

Vase with Fifteen Sunflowers	Museum of Fine Art, Tokyo
Vase with Fifteen Sunflowers	Amsterdam
Vase with Twelve Sunflowers	Philadelphia Museum of Art

even stranger. It was, he said, almost colourless. 'The ashen-gray colour is the result of mixing malachite green with an orange hue on pale malachite ground, all in harmony, with the reddish-brown clothes. But as I also exaggerate my personality, I have in the first place aimed at the character of a simple bonze worshipping the Eternal Buddha.' Someone remarked that he looks more like the mad axeman, and it is not a picture, one would have thought, to have encouraged visitors, though no doubt Gauguin thought the Eternal Buddha stood for himself.

GAUGUIN

RIGHT
Two Cut Sunflowers, 1887
Oil on canvas, 17 x 24in (43 x 61cm)
Metropolitan Museum of Art, New York

OPPOSITE
Four Cut Sunflowers, 1887
Oil on canvas, 23⁵/₈ x 39¹/₃in (60 x 100cm)
Rijksmuseum Kröller-Müller, Otterlo

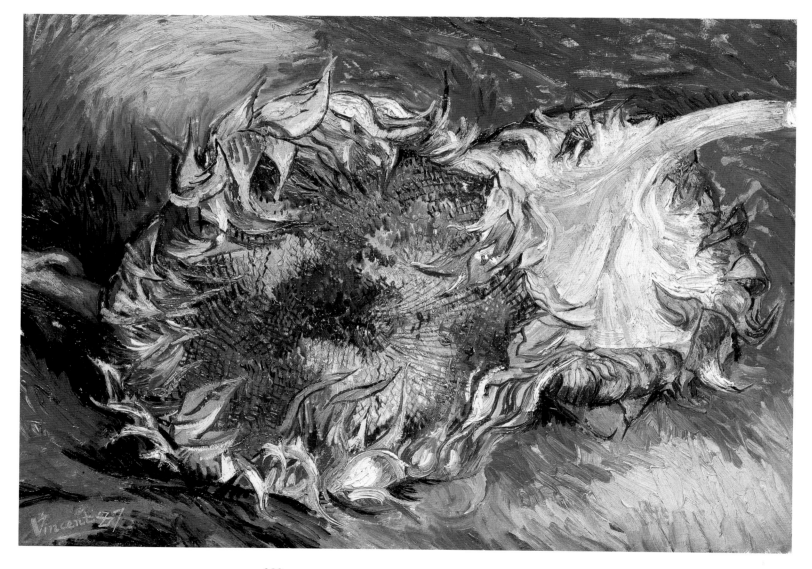

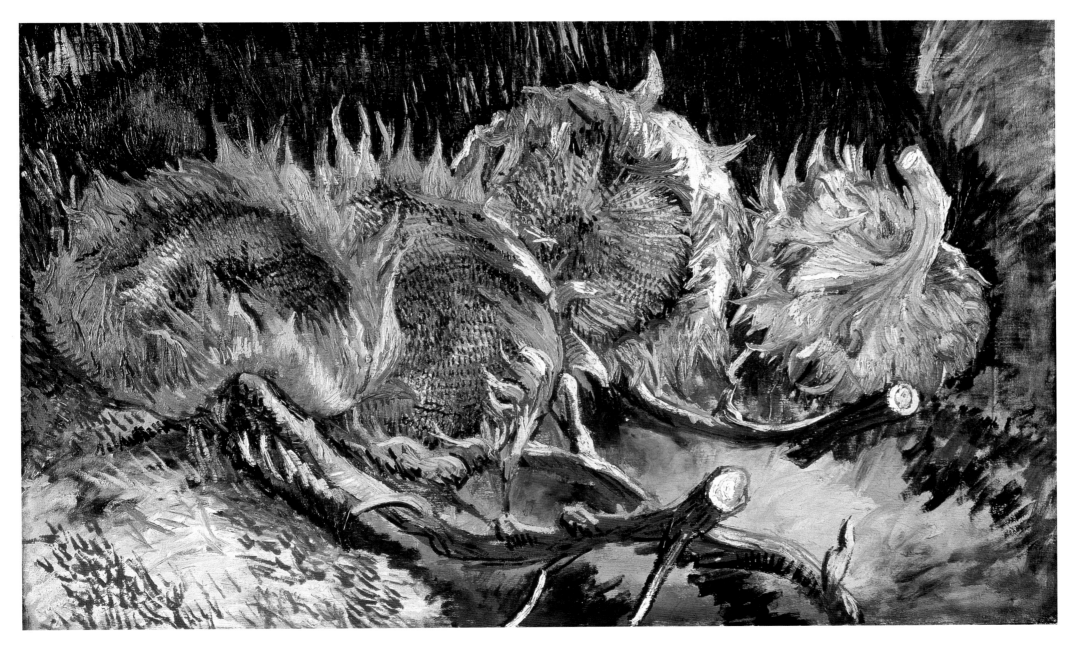

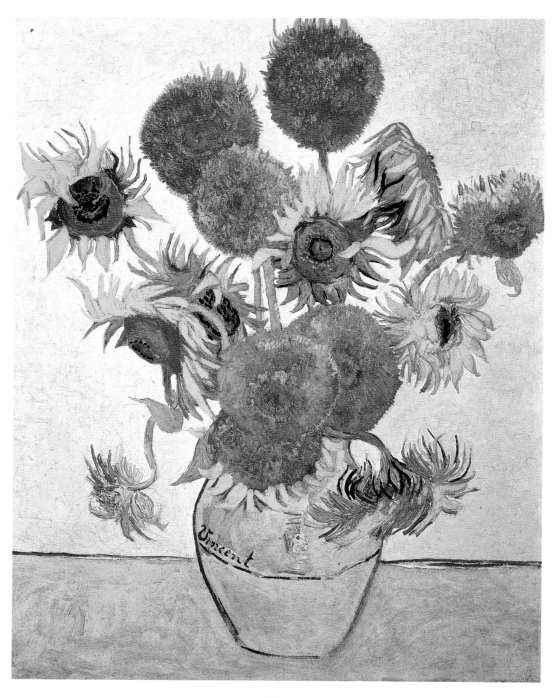

ABOVE

Still Life: Vase with Five Sunflowers, 1888

Oil on canvas, 38^1/$_2$ x 27^1/$_8$in (98 x 69cm)
Destroyed by fire during the Second World War.

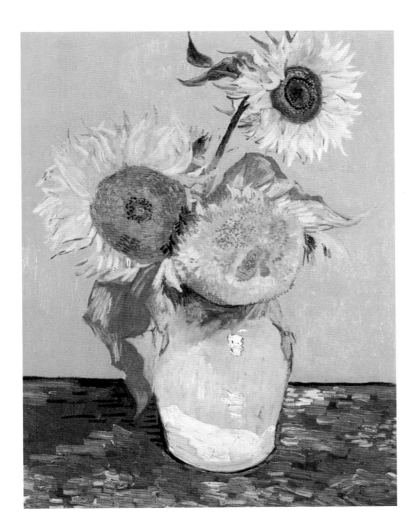

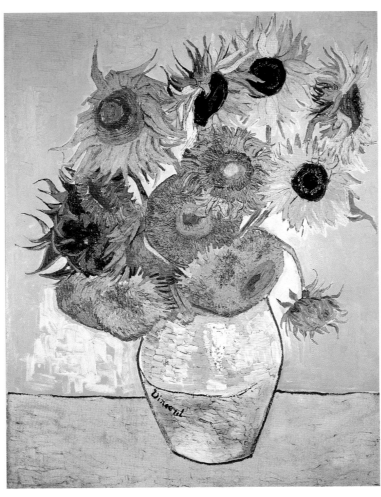

OPPOSITE RIGHT
Still Life: Vase with Fifteen Sunflowers,
1888
Oil on canvas, 36⁵/8 x 28³/4in (93 x 73cm)
National Gallery, London

FAR LEFT
Still Life: Vase with Three Sunflowers,
1888
Oil on canvas, 28³/4 x 22⁷/8in (73 x 58cm)
Private collection

LEFT and PAGE 286
Still Life: Vase with Twelve Sunflowers,
1888
Oil on canvas, 35⁷/8 x 28¹/3in (91 x 72cm)
Neue Pinakothek, Munich

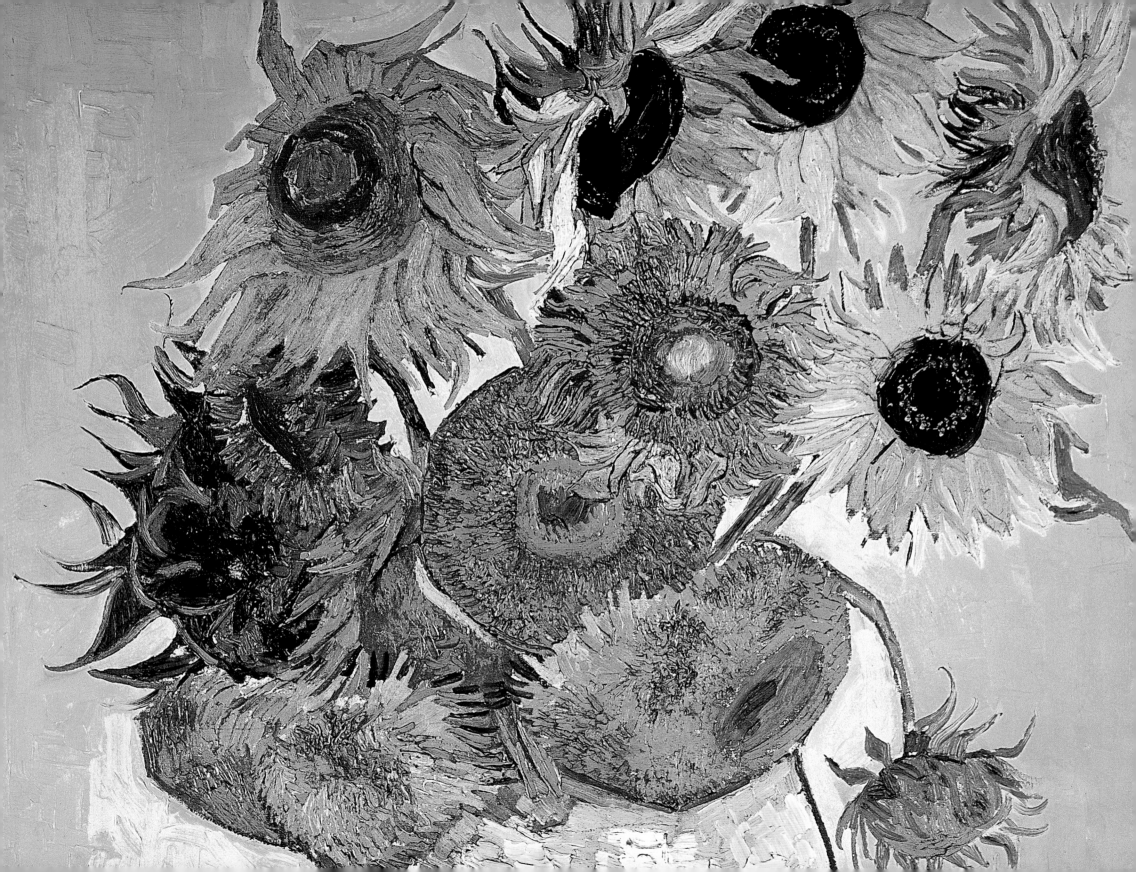

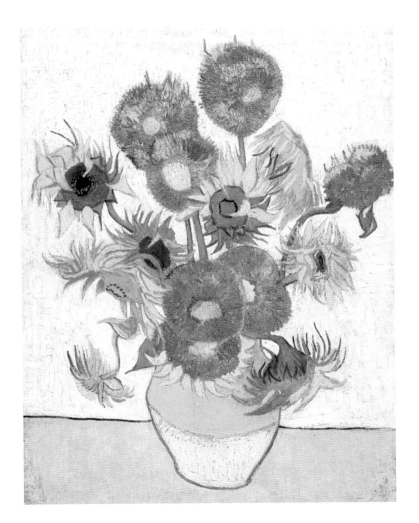

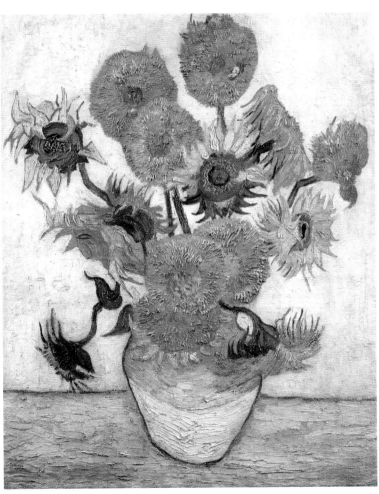

ABOVE
Still Life: Vase with Twelve Sunflowers, 1889
Oil on canvas, $36^{1}/_{4}$ x $28^{1}/_{2}$in
(92 x 72.5cm)
The Philadelphia Museum of Art

FAR LEFT
Still Life: Vase with Fifteen Sunflowers, 1888
Oil on canvas, $36^{5}/_{8}$ x $28^{3}/_{4}$in (93 x 73cm)
Rijksmuseum Vincent van Gogh, Amsterdam

LEFT
Still Life: Vase with Fourteen Sunflowers, 1889
Oil on canvas, $39^{1}/_{2}$ x $30^{1}/_{8}$in
(100.5 x 76.5cm)
Private collection

Orchard in Blossom, 1888
Oil on canvas, 29³/4 x 36¹/4in
(75.5 x 92cm)
Rijksmuseum Vincent van Gogh,
Amsterdam

The Alyscamps, Falling Autumn Leaves, Arles, 1888
Oil on canvas, 28³/4 x 36¹/4 (73 x 92cm)
Rijksmuseum Kröller-Müller, Otterlo

Vincent painted three views of the Alyscamps, with its lines of trees, in November 1888. This one is on extra-thick canvas, bought by Gauguin with the proceeds from his painting of Breton women, which Theo had recently sold.

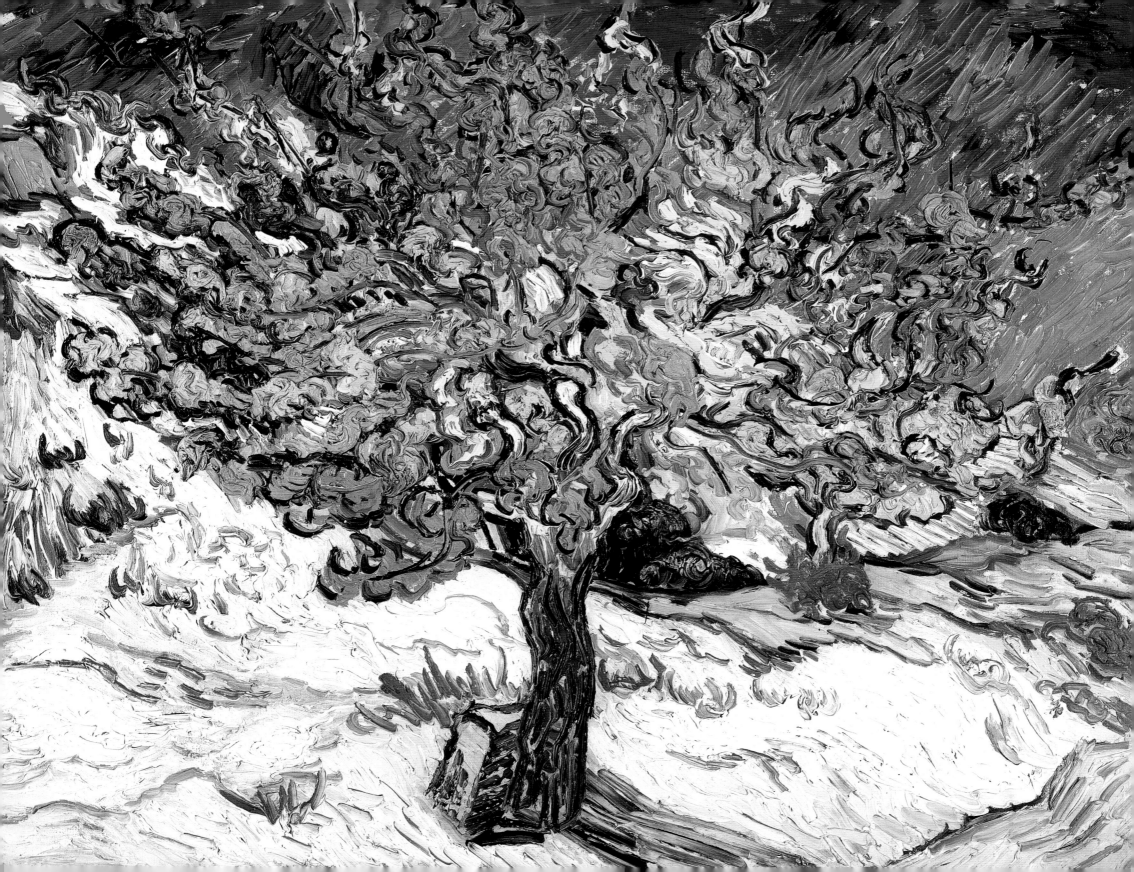

VAN GOGH

In a fever of excitement, Vincent was working too hard, drinking too much and not eating enough. He suffered several fainting fits. His state might also be reflected in his strangely desolate picture, *The Night Café* (page 228), which he stayed up to paint for three nights. The few customers are mostly tramps or old drunks sleeping it off with head on table. 'The room is a blood-red colour', he told Theo, 'with dark yellow and green billiard table in the middle, four lemon yellow lamps with a glow of orange and green. Everywhere there is a contrast between the most desperate shades of red and green... for example, the blood-red and yellow-green colours of the billiard table contrast with the soft tender...green of the bar.' He also did a watercolour of the scene, in which the colours are almost as strong as oils.

But before surrendering to the temptation to find the artist's state of mind expressed in the work, we should consider another 'night café' painted in the same month, *Café Terrace on the Place du Forum* (page 222), under an exuberantly starry sky said to have been inspired by a description in Maupassant's novel, *Bel Ami*. The atmosphere is cheerful, almost festive; one would like to stop off for a nightcap oneself. As Vincent described it, 'This is a night painting without black, with only beautiful blue, violet or green, and in these surroundings the illuminated square takes on the colour of a pale sulphur or lemon yellow. I really enjoy painting the square in situ. In

the past, you would first do a drawing (in situ) and then do the painting in the daytime, based on the drawing. But it suits me very well to paint this sort of thing directly.'

Another picture that contradicted the foreboding of *The Night Café* was *Van Gogh's Bedroom*, page 265 (he did a later version at Saint-Rémy the following summer, of which he made two copies). This picture was intended to be 'restful'; he wanted 'to create an impression of rest, or sleep in general' and, as he said, 'it all depends on the colours' (it usually did!). 'There is nothing special in this room with its closed shutters. The thick lines of the furniture also express intangible peace ...' He added that the frame of the picture ought to be white, as there was no white in the painting. We may wonder, incidentally, if the room was actually so neat and clean as it appears in the painting, this – an orderly domestic life – being one area of Vincent's life in which aspiration was never matched by achievement. Gauguin, however, would clear up the mess.

Restful was not the word for Vincent's state of mind as the day of Gauguin's arrival approached.

GAUGUIN TAKES OVER
Paul Gauguin arrived in Arles on 23 October 1888 at five in the morning after two exhausting nights on the train. He was cold and stiff, there was no one at the station, and he did not know where

VAN GOGH

Vincent lived. Fortunately, the Café de la Gare was open and he stumbled in. M. Ginoux was behind the bar. He took a long look at the stranger and his face broke into a grin. 'You're his pal.' he said.

Vincent, in his anxiety about his friend's arrival, and not knowing what train he would be on, had taken Gauguin's self-portrait down to the café and asked Joséph to keep an eye out for him. He was able to direct him to the Yellow House. As it was so early, Gauguin hung about for a time, probably not very long, before banging on the door and rousing Vincent from sleep.

In retrospect, it seems painfully obvious that the association of Paul Gauguin and Vincent van Gogh would end unhappily. The fullest account of their brief period of co-existence comes from Gauguin himself. He was not a man with a modest view of himself, and one would have expected the effect of his version of events to have swung public opinion in his favour, but the reverse is the case.

In this respect (among others), Gauguin was his own worst enemy. His account was written over a decade after Vincent's death, at a time when people tended to blame him for the disastrous events in Arles, if not directly for Vincent's breakdown. While the incidents he describes may well have happened more or less as he says, and other sources, where they exist. broadly support him, Gauguin's picture of his own impeccable virtue and model behaviour in the face of Vincent's aggression and irrationality, is little short of absurd. His efforts at self-justification only strengthened feeling against him,

and perhaps also encouraged the idea that his influence had had a deleterious effect on Vincent's art. That belief is hard to accept in the context of Vincent's career. He was always open to influence (whether 'good' or 'bad') up to a point, but while it might contribute, it never diverted him seriously from his own uniquely personal voyage of discovery.

The most serious weakness in this infant artists' colony was divided attitudes – the neurotic but utterly committed zeal of Vincent against the sceptical coolness of Gauguin. It became evident that Gauguin's idea of an artists' colony was not Vincent's. In his view, a better location would have been somewhere in the tropics, and he regarded his sojourn in Arles as temporary, a matter of a few months at most. Thus, from the first, additional strain was put on Vincent by the fear that Gauguin would soon leave again.

Vincent was all the more anxious that Gauguin should approve of everything – his house, his art, the town of Arles, the beauty of the girls, the light and colour of Provence, and so on. Gauguin's reactions, though not entirely negative, could hardly measure up to Vincent's enthusiasm. The house, for a start, was a shambles. Les Arlésiennes did not measure up to their reputation. Provence was not, alas, the tropics. Vincent's paintings ... that heavy impasto, those violent complementaries ... well, best say nothing. To Vincent, Gauguin's reticence on this subject was unnerving.

Besides all the other things Vincent admired about Gauguin, he

RIGHT
Vincent's Chair with His Pipe, 1888
Oil on canvas, 36⁵/₈ x 29in (93 x 73.5cm)
National Gallery, London

FAR RIGHT
Paul Gauguin's Armchair, Arles, 1888
Oil on canvas, 35⁵/₈ x 28¹/₂in
(90.5 x 72.5cm)
Rijksmuseum Vincent van Gogh,
Amsterdam

The symbolism of this pair of paintings is obvious: Van Gogh's chair – daylight (yellow); Gauguin's chair – night (red and green). The pipe and tobacco strongly suggest Vincent's presence; the candle Gauguin's (impending?) absence. Vincent reported in November that he had just completed these paintings at great speed, but he seems to have worked further on them in January 1889, when first released from hospital.

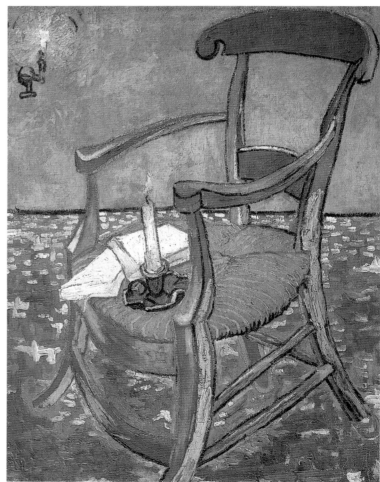

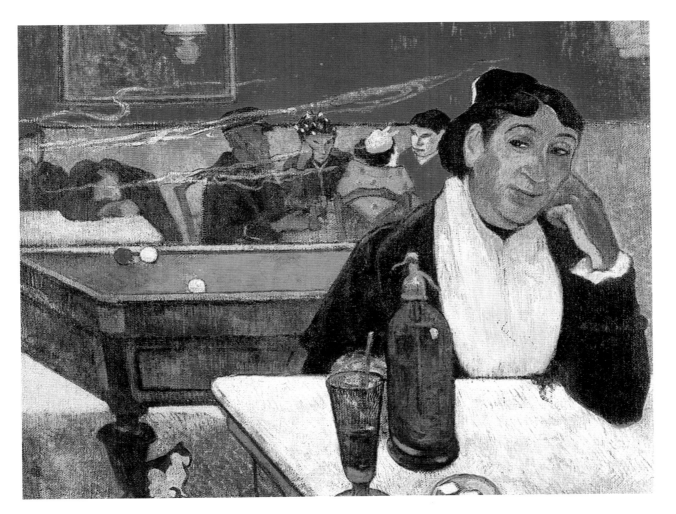

Paul Gauguin
The Night Café, 1888
Oil on canvas, 28³/4 x 36¹/4in (73 x 92cm)
Pushkin Museum, Moscow

*Gauguin wrote to Bernard in November:
'I have also done [a painting of] a café
which Vincent likes a lot and myself less.
Actually it's not my subject and the vulgar
local colours don't suit me ... the figure in
the foreground is far too orthodox. But
still ...'*

GAUGUIN

turned out to have domestic skills undreamt-of by his host. The house was tidied up, and Gauguin suggested that instead of eating out at restaurants they should save money by eating in. Since Vincent could not cook (his home-made soup made Gauguin wonder if he mixed the ingredients as he mixed his paints, which suggests a similar view of both his cooking and his painting), Gauguin would therefore cook and Vincent would do the shopping. He instituted a budget, with money kept in a box along with a list of spending priorities and a record of cash spent. Whatever his doubts, Gauguin was clearly making a positive effort to co-operate.

At the head of the list of items of expenditure was 'hygiene' – the brothel in other words (the very last item was 'rent', no doubt a sensible ordering of priorities). Here, at least, was something of which Gauguin heartily approved. They visited one his first night, and frequently thereafter – too often, perhaps, for Vincent, whose sexual drive was probably diminished by poor health and the legacy of disease. Whether or not hygiene remained within budget, Gauguin's accounting had other weaknesses, as Vincent noted. For three or four days they would stick to the plan, but then Gauguin would decide to go on a great drinking binge, and the accounts could go hang. This habit, too, probably disagreed with Vincent who, although he certainly drank too much, was not a 'binge drinker'.

In spite of the underlying tension, for the first few weeks everything went rather well. We should not forget that, whatever Gauguin's faults in this respect, he was no less a social outcast than Vincent and subject to much the same pressures. Moreover, Vincent

was a very difficult person to live with – even his devoted brother had found him exasperating at times. But now he was on his best behaviour, eager to please, willing to agree with all, or almost all, Gauguin's suggestions. Gauguin was a good raconteur, and Vincent listened with becoming eagerness to tales of his adventures abroad.

They went out together painting, something of a concession to Vincent, and when the weather was bad they painted together in the studio or sometimes, taking their cue from Toulouse-Lautrec, in the brothel. Often they painted the same subjects, such as the Alyscamps (i.e. Champs Elysées, or Elysian Fields), the ancient cemetery in Arles, where Vincent found another opportunity to express his liking for a series of strong verticals, typically a line of trees, in the foreground. *The Alyscamps* (page 289) is done from a high viewpoint, Vincent having taken advantage of the raised bank of a canal.

The two artists ventured farther afield, to the Museum of Montpellier, for instance, where Gauguin concealed his indifference to Monticelli but was able to see Courbet's *Bonjour, Monsieur Courbet*, the inspiration for his later painting *Bonjour, Monsieur Gauguin* (page 292). In spite of his allegedly decisive influence on van Gogh, Gauguin's early pictures in Arles show the effect of Vincent's work on him. One of his first paintings was a portrait of Mme. Ginoux which might almost have been done by Vincent. Not only did he paint Vincent's subjects, he even employed those powerful complementary colours, red and green, for which on another occasion he had professed profound dislike.

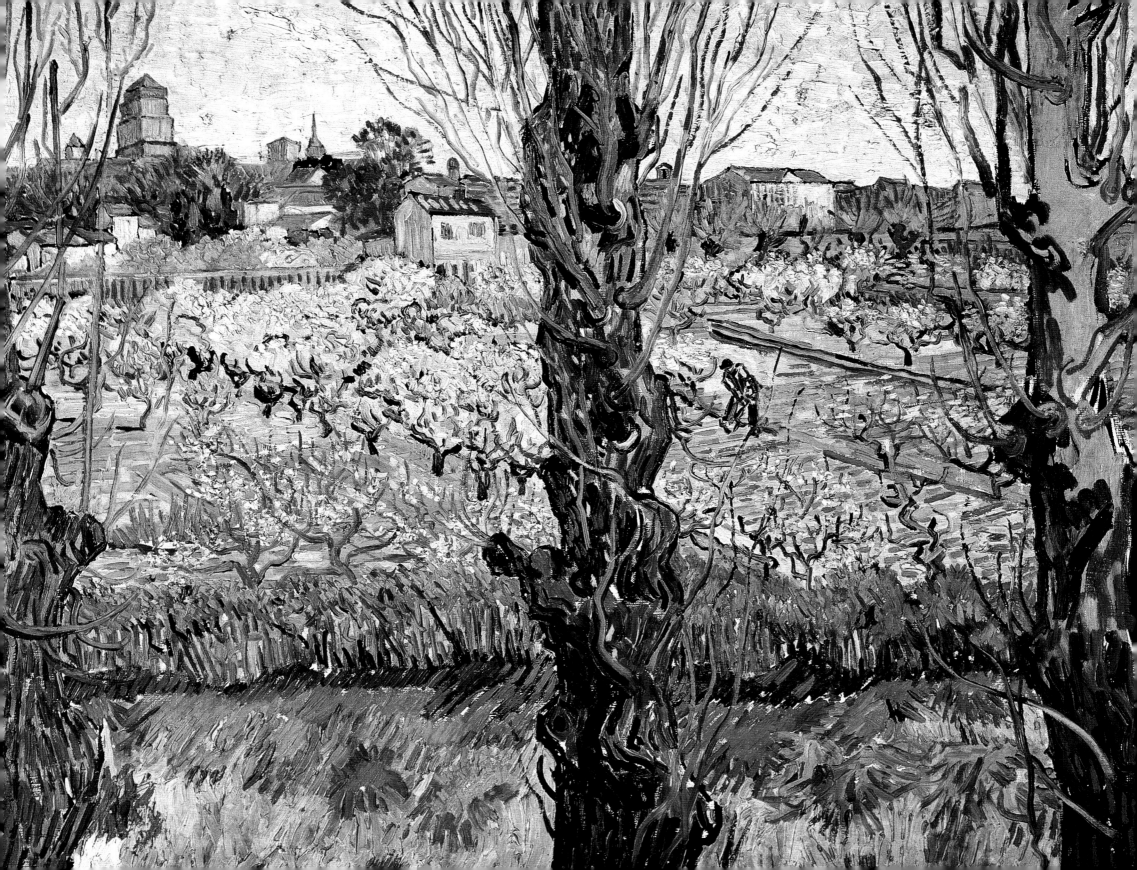

RIGHT
Self-Portrait with Bandaged Ear and Pipe, 1889
Oil on canvas, 20 x 17³/₄in (51 x 45cm)
Private collection

FAR RIGHT and OPPOSITE
Portrait of Dr. Félix Rey, 1889
Oil on canvas, 25¹/₄ x 20⁷/₈in (64 x 53cm)
Pushkin Museum, Moscow

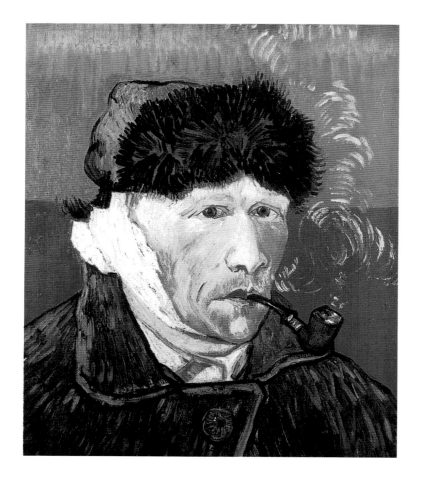
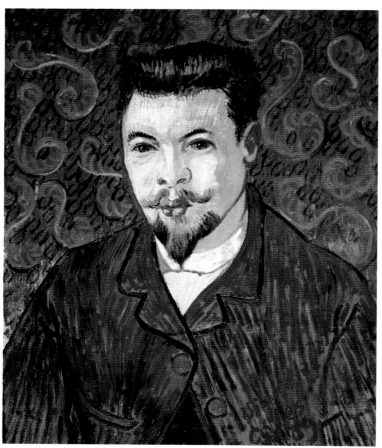

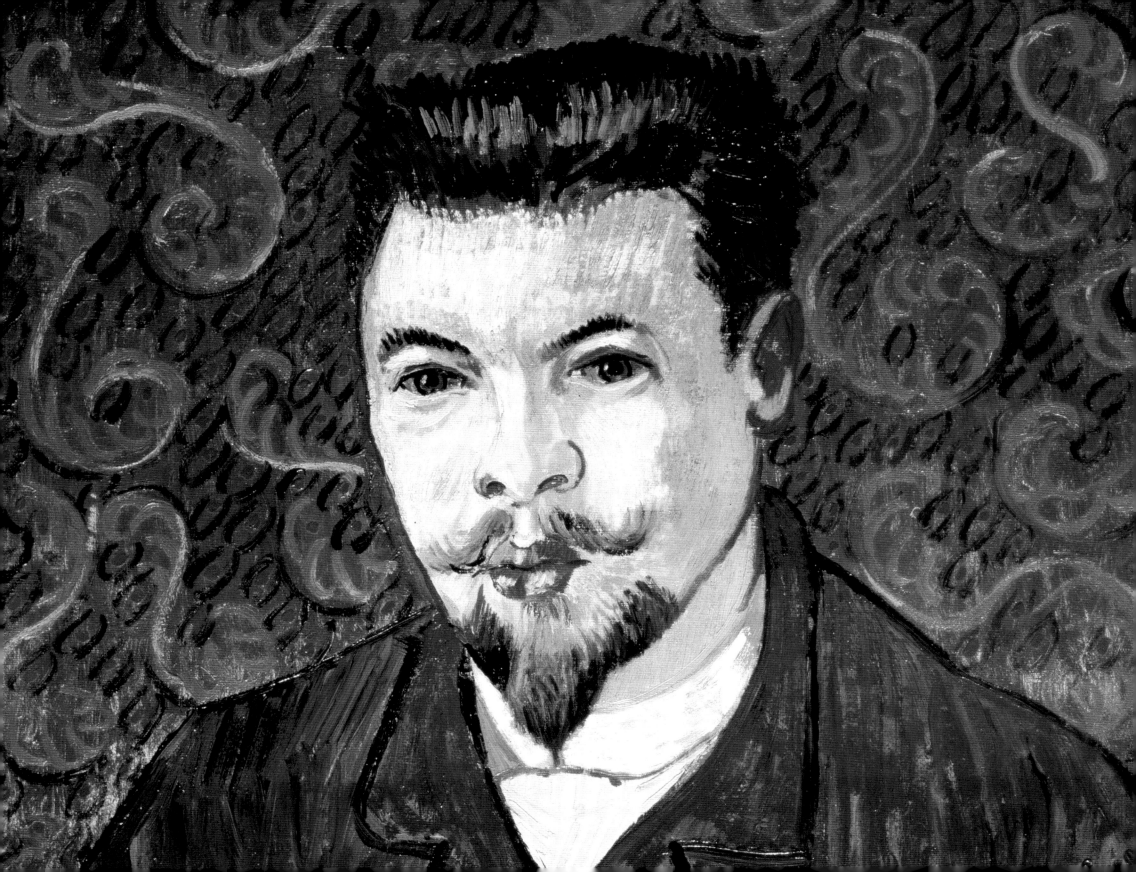

RIGHT and OPPOSITE
Self-Portrait with Bandaged Ear, 1889
Oil on canvas, 23⁷/₈ x 19⁵/₈in
(60.5 x 50cm)
Courtauld Institute Galleries, London

*Much discussion has been provoked by the
two self-portraits with bandaged ear.
Which was painted first? Are they both
actually by van Gogh? etc. What is
notable is that neither of them shows any
deleterious effect of his breakdown on his
art. As he wrote in late March: 'You will
see that the canvases I have done in the
intervals [i.e. intervals of normality] are
steady and not inferior to the others.'*

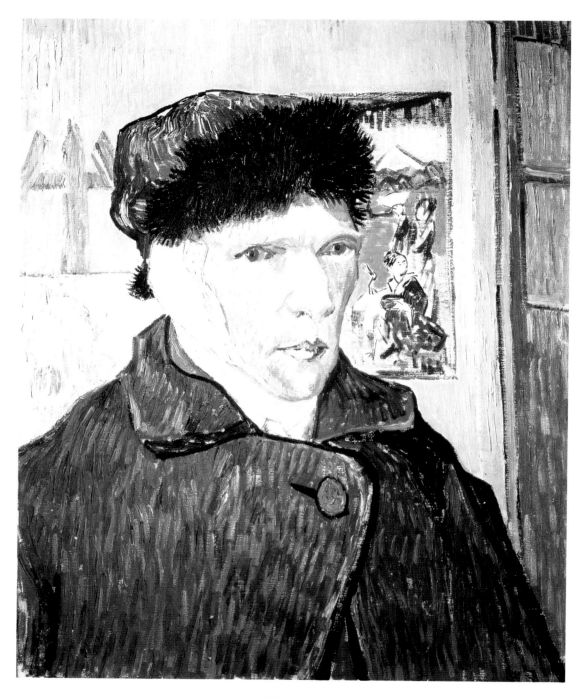

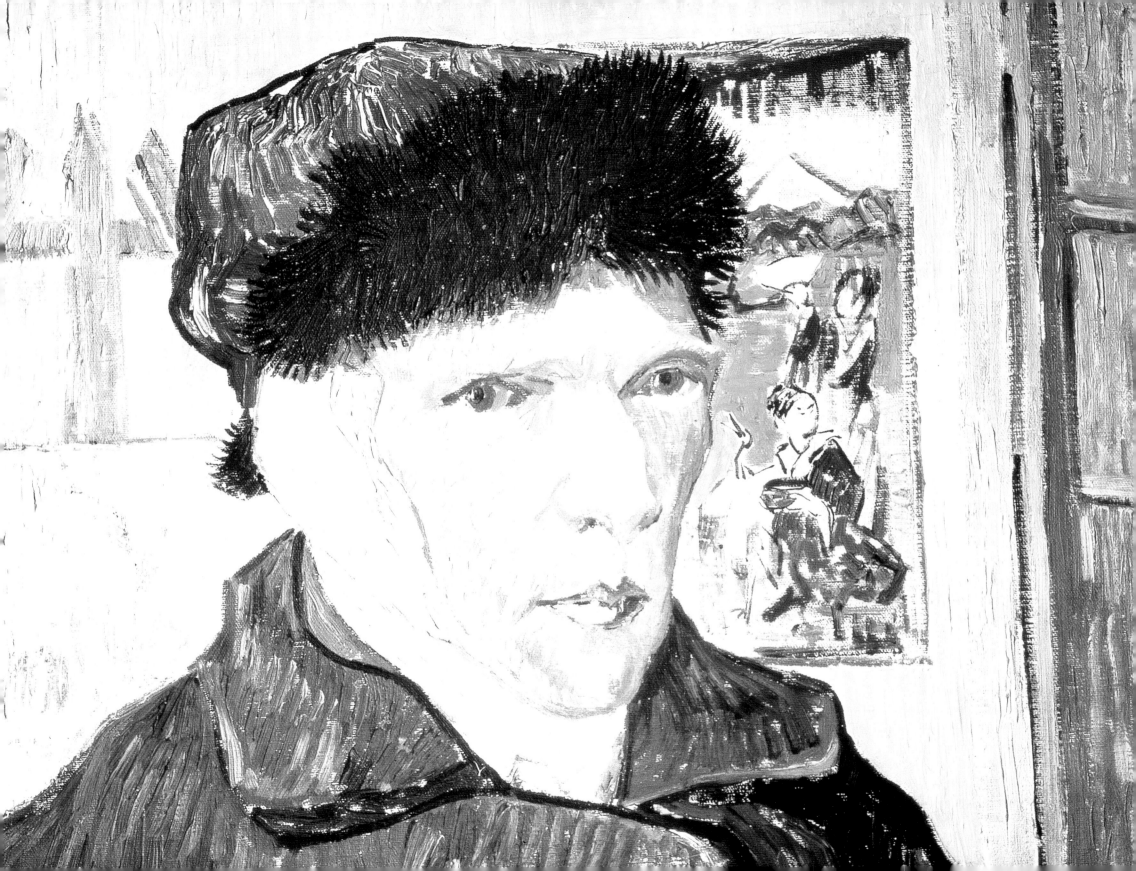

GAUGUIN

Although their artistic heritage was generally similar, the taste and temperament of the two men were mutually antagonistic. Gauguin himself, prejudice notwithstanding, put this well. 'Vincent and I are in general very little in agreement, above all with regard to painting. He admires Daumier, Daubigny ... and the great Rousseau, whom I cannot stand. And on the other hand he detests Ingres, Raphael, Degas and all those whom I admire.' (Still, there were some artists they both admired, Puvis de Chavannes for one, if for different reasons.) 'He likes my paintings very much but when I have finished them, he always finds that I have made a mistake here, or there. He is a romantic, while I am rather inclined towards a primitive state. When it comes to colour, he is interested in the accidents of the pigment, as with Monticelli, whereas I detest this messing about with the medium.'

Gauguin was a decorative painter; shapes are simple, colours are flat, the brushwork is scarcely evident. Vincent remained fundamentally a naturalist, who needed to be looking at his subject. He often made copies of his own paintings, but seldom painted from memory alone. Perhaps Gauguin did nudge him slightly towards abstraction, although that was a direction in which he was already moving.

The influence of Synthetism, perhaps derived from Bernard as much as Gauguin, appears in several pictures of this period,

notably, as we have seen in the previous chapter, *Spectators in the Arena* and *The Dance Hall*. They provide a good illustration of Vincent's willingness to experiment with the ideas of other artists and either to incorporate them into his own distinctive style or simply to discard them. He continued to follow his own naturalistic style in, for instance, the portraits of the Roulin family painted at the same time, and there were no more cloisonné effects after Gauguin left.

The most notable result of Vincent's attempt to follow Gauguin's advice by painting from memory and imagination is *Memories of the Garden at Etten* (page 59), which was influenced by Gauguin's deliberately strange and mysterious painting of the garden in the hospital in Arles. It shows two women, whom Vincent identified as his mother and his sister Wil, although it has been suggested that the younger woman may have been his cousin Kee. In the end, Vincent decided that this richly coloured painting, compared by Tralbaut with stained glass (also descriptive of Bernard's Cloisonnisme), and in one way suggestive – though no doubt irrelevantly – of Gustav Klimt, was a failure. Although it is impossible to agree with that judgement, certainly the language of mystery and dark symbolism was not his. The picture remains something of a one-off.

Symbolism of a less exotic kind inhabits the well-known pair of paintings, now unfortunately divided between Amsterdam and London, *Vincent's Chair* and *Paul Gauguin's Armchair* (page 294), of which the latter was probably painted after Gauguin had announced his intention to return to Paris. As David Sweetman remarked, the two paintings could be interpreted as 'day' and 'night'. Vincent's is a familiar, simple, cane-seated chair in yellow, like the pair in his bedroom, perhaps one of them. It stands on reddish-russet tiles and the wall behind is a light green. On the chair is his pipe and open tobacco pouch, and the name 'Vincent' appears in bold letters on a box in the background. Clearly, he will be back in a moment. The picture is light and cheery.

Gauguin's chair is a more elaborate piece, made of some dark hardwood, with curved arms, sabre legs and an upholstered seat. Either the perspective has gone awry, or it is slightly misshapen. (The chair appears in other paintings, for instance *La Berceuse*, where its form is obscured by the sitter's ample dimensions.) On the seat are a couple of books and a lighted candle in a candlestick, suggesting that Gauguin is perhaps not here. The colours are those of *The Night Café*, dominated by those disturbing complementaries, dark red and dark green. The image of 'the empty chair' was well known, and Vincent, besides remembering his father's empty chair in 1885, had been much struck by an English print of Charles

OPPOSITE
Rembrandt
The Anatomy Lesson of Dr. Nicolaes Tulp, 1632
Oil on canvas, 66³/4 x 85in (169.5 x 216cm)
Mauritshuis, The Hague

As he was recovering from the injury to his ear, Vincent asked his brother Theo to get a print of this painting for Dr. Rey, who had shown him much kindness and consideration.

RIGHT
Women Picking Olives, 1889
Oil on canvas, 28³/4 x 36¹/4in
(73 x 92cm)
National Gallery of Art, Washington, D.C.

OPPOSITE
Women Picking Olives, 1889
Oil on canvas, 28³/4 x 35in (73 x 89cm)
Private collection

Vincent spent much time in the olive groves in November–December 1889, producing at least ten paintings and several drawings.

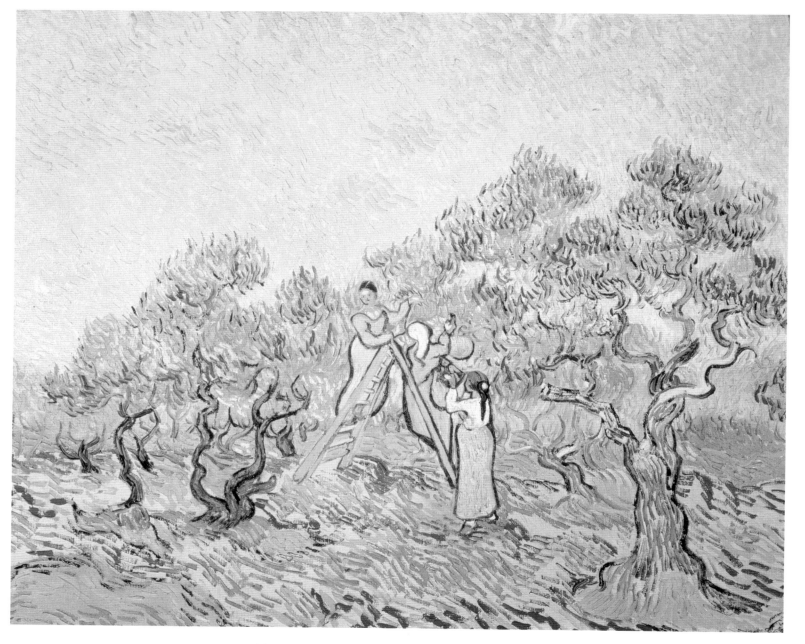

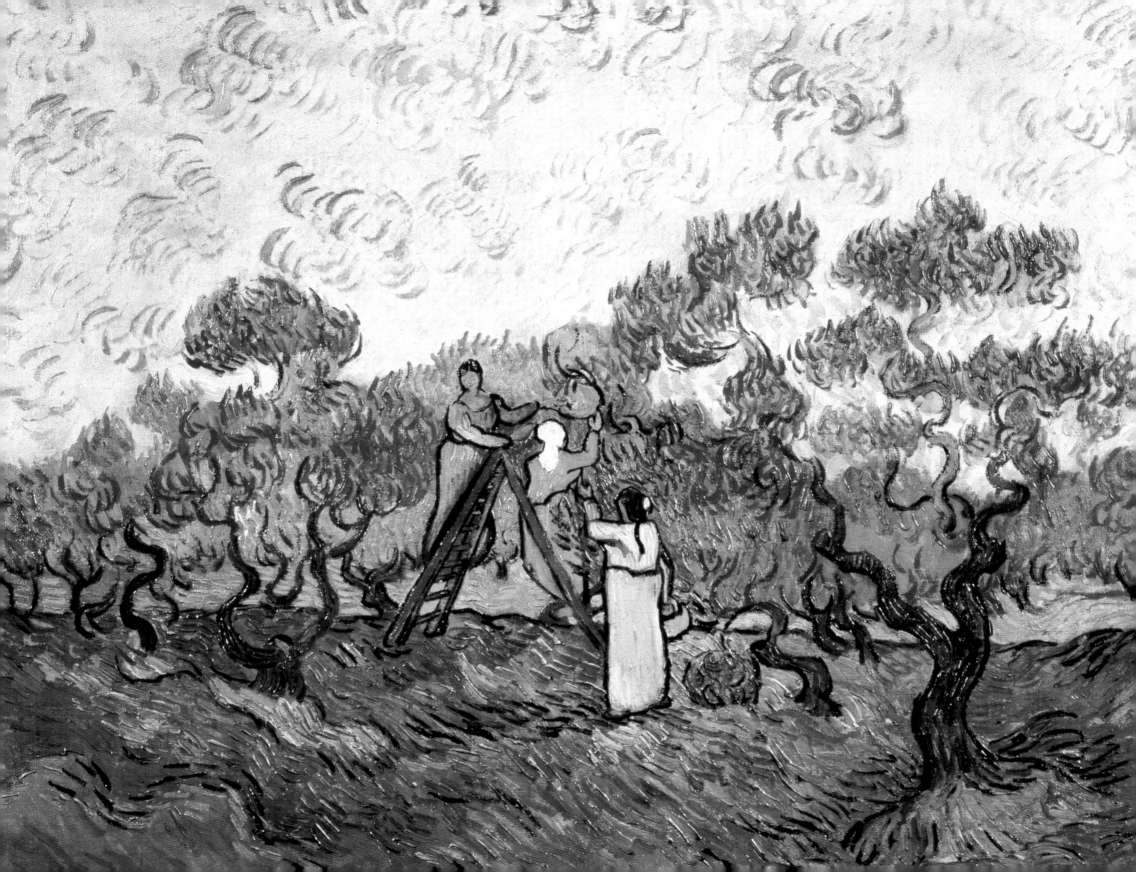

Dickens's study after his death, which employed this device.

DISASTROUS END TO AN ARTISTIC EXPERIMENT

As Vincent and Gauguin became more familiar, guards were lowered, with the result that they argued more fiercely. Neither man, but Vincent especially, was capable of such intercourse without passions rising to dangerous levels, especially when they were fuelled by absinthe or brandy – or both. After their visit to Montpellier, Vincent reported, their discussion, which centred on Delacroix and Rembrandt, became 'charged with enormous electric tension', and they did not stop until their heads were as drained as an exhausted electric battery.

They were together too much, twenty-four hours a day and seven days a week. Although they saw Vincent's few friends (Milliet left with his regiment in November) and drank with old Roulin, there was no third party to act as mediator or referee in their arguments about art or other matters; more equable temperaments than theirs would have been strained. An additional aggravation was the weather. It rained continually in December and they could not escape from the small studio of the Yellow House, except to continue their argument in one of the bars in the Place Lamartine, or the brothel.

Worried by Gauguin's occasionally expressed desire to move on,

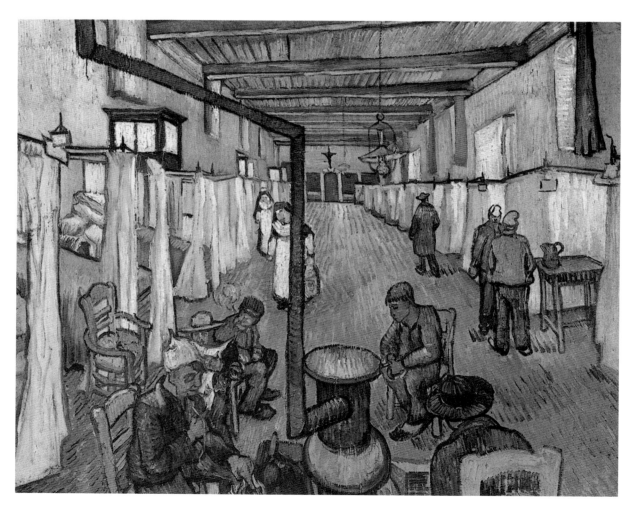

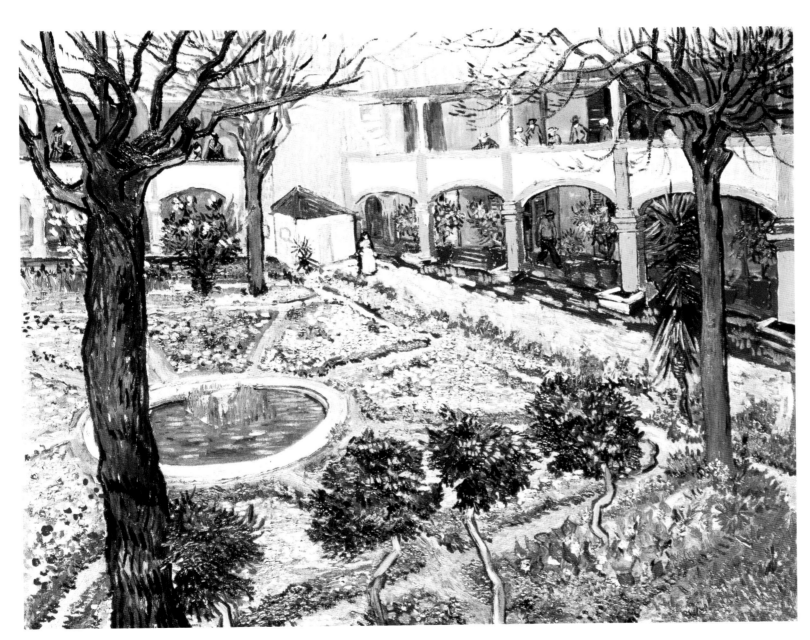

OPPOSITE
Dormitory in the Hospital at Arles, 1889
Oil on canvas, 29^{1}/$_{8}$ x 36^{1}/$_{4}$in (74 x 92cm)
Oskar Reinhart Collection, Winterthur

LEFT and PAGE 308
Courtyard of the Hospital at Arles, 1889
Oil on canvas, 28^{3}/$_{4}$ x 36^{1}/$_{4}$in (73 x 92cm)
Oskar Reinhart Collection, Winterthur

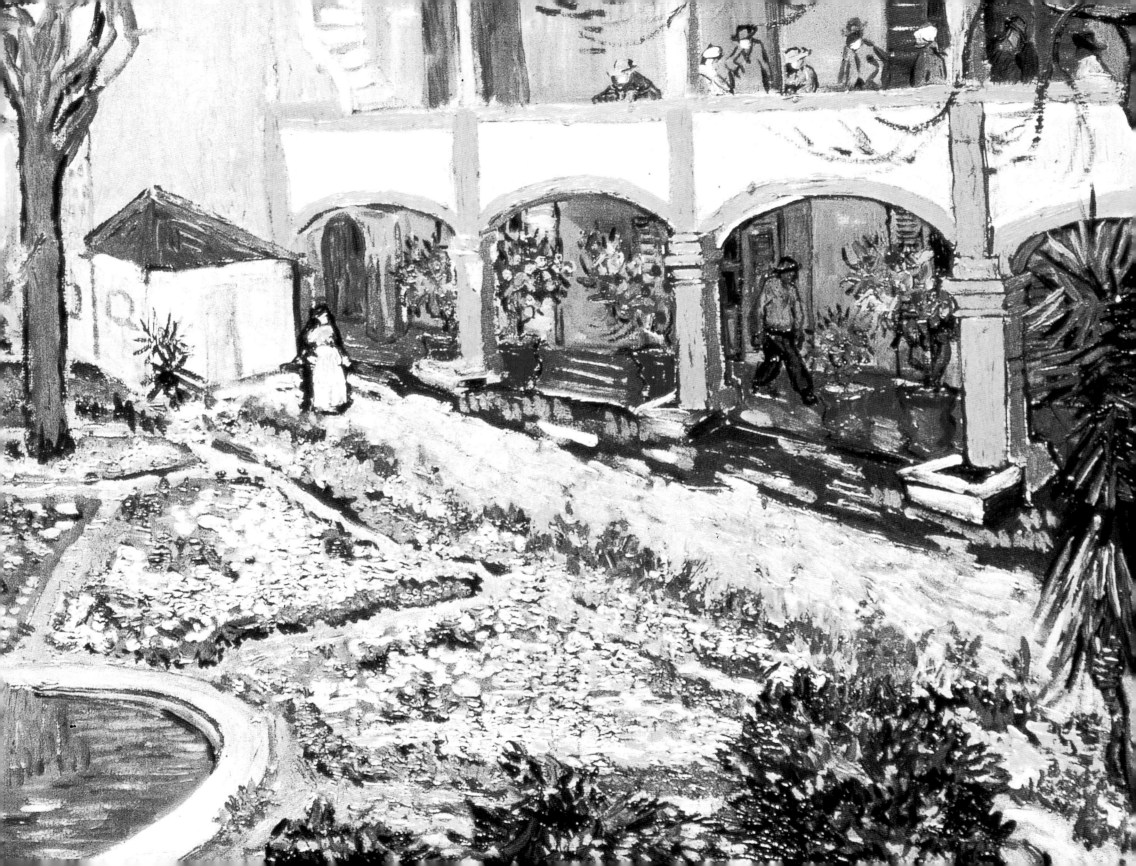

preferably to some tropical, primitive culture, Vincent was living on his nerves. His behaviour was sometimes odd, but then it always had been. According to Gauguin, he woke up more than once in the night to find Vincent standing over him. When he asked him what the matter was, he turned and went back to his bed without speaking.

To be fair to Gauguin, he was aware of Vincent's problems and, so far as he was capable, tried to assuage them. To a friend he admitted that he owed a great deal to both the van Gogh brothers, and 'in spite of some discord' he could not be angry with 'an excellent fellow who is sick, who suffers, and who asks for me'. He tried to reassure Vincent that he would stay, although he admitted that he might feel bound to leave, which sounds like emotional blackmail, but it was in fact only honest.

They painted each other's portrait, Gauguin's picture of Vincent painting sunflowers being, to say the least, unflattering. When Vincent saw it he said, 'It is certainly me, but it's me gone mad.'

That evening, Gauguin recalled, they went to a café where Vincent ordered an absinthe, and suddenly flung the glass and its contents at Gauguin's head.' Gauguin dodged and, so he says, picked Vincent up bodily and carried him back to the Yellow House. It was not far away, but the imagination boggles. No doubt he was propelling him rather than actually carrying him.

Next morning Vincent made some kind of apology, which Gauguin accepted though he added that should such an incident occur again, he might be unable to stop himself from retaliating, and

therefore he would write to Theo and request approval for his return to Paris. He wrote the letter and posted it but later, taking pity on Vincent, announced that he had changed his mind and would be staying after all. Vincent was not much reassured, and his state of mind would not have been eased by the knowledge that Theo was about to become engaged to Johanna Bonger, sister of his great friend Andries.

On 23 December it was still raining. The atmosphere in the Yellow House hummed with tension as Vincent worked on a painting of Mme. Roulin with her baby. A mother-and-child subject always upset Vincent, remembering Sien and little Willem. They had supper, and afterwards Gauguin went off for a walk by himself to escape the oppressive atmosphere of the house. He was crossing the Place Victor Hugo when he heard footsteps coming up rapidly behind him. As he turned, Vincent rushed towards him brandishing a cut-throat razor. Gauguin, so he tells us, stood his ground and glared, which made Vincent stop and, dropping his head, he set off at a run in the direction he had come. Gauguin went straight to a hotel and booked in for the night, though he did not get much sleep.

Van Gogh's movements are not entirely clear. It seems that he ran back to the Yellow House and then, or possibly later in the evening after a bout of heavy drinking, sliced off the lower part of his left ear with the razor. At 11.30 he appeared at the Maison de Tolérance No. 1 and asked for a girl called Rachel. She was presumably the prostitute with whom he had established some kind

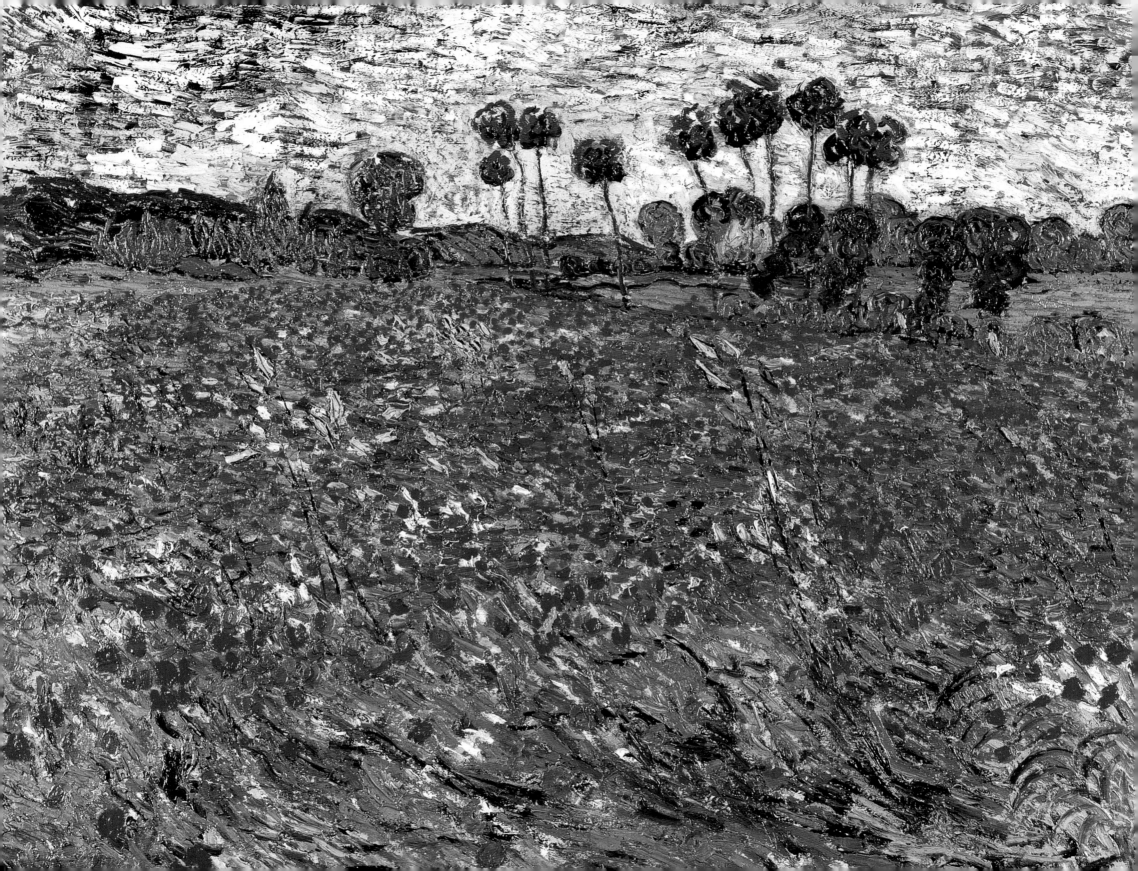

of a relationship, although that seems to have been no more than any regular customer might have expected. He presented her with his ear, wrapped in newspaper, and disappeared. Rachel's reaction may be imagined. The police were called, the ear was taken into custody, and having established the identity of its owner, the police arrived at the Yellow House early the next morning, Christmas Eve. They found bloody towels all over the floor and upstairs, a body unmoving in a bed with blood all over the bedclothes.

At about that point Gauguin arrived. Seeing a crowd around the house, he hurried forward, to be confronted by a police officer. 'What have you done to your comrade, monsieur?' It was soon ascertained that Vincent was not dead but merely sleeping or unconscious, and having convinced the police that he had had nothing to do with it, Gauguin was allowed to leave. He asked them to tell Vincent, when he awoke, that he had left for Paris, as he was afraid the mere sight of himself might be enough to kill him. Then he went to telegraph Theo.

IN HOSPITAL

Vincent was taken off to the public hospital, where his injury was dressed and judged not to be dangerous. His mental state was another matter. He was placed in the care of Dr. Félix Rey. Although he looked older in his neat goatee beard and frock coat, Rey was only twenty-three years old, he was not yet fully qualified, and he had no special knowledge of mental illness (he later became an expert on lung disease). Yet his care for Vincent was not only wise, it exceeded the duty of a physician. He allowed his patient unlimited access to himself, even, once, when he was shaving. Vincent tried to grab the

razor but Rey, and following the same tactics as Gauguin in a similar situation, told him roughly to clear off, with the same satisfactory result.

Dr. Rey was not the only person celebrated by posterity by the chance fact of Vincent becoming a world-famous artist. When Theo arrived – in a terrible state, poor man – he sought help from the local Protestant minister, Frédéric Salles, who fortunately lived nearby. As no one knew how long Vincent would remain in his present state – perhaps forever? – there was nothing Theo could do in Arles, and on Boxing Day he returned to Paris, accompanied by Gauguin, still badly shaken. Dr. Salles agreed to visit Vincent regularly and keep Theo informed. Like Rey, he proved a kind and considerate friend.

Good old Roulin was an early visitor, and was shocked to the core at Vincent's state. He reported to Theo, 'I am sorry to say I think he is lost. Not only is his mind affected, but he is very weak and downhearted.' He had learned that Dr. Rey was thinking of sending him to a mental hospital.

But within a few days, Vincent began to show marked signs of improvement. Clearly, he was not a hopeless lunatic; it appeared, rather, that he had suffered some kind of attack. Dr. Rey speculated that it was epilepsy, a diagnosis that has been often dismissed although, while obviously not the whole story, was quite probably correct. One sign of recovery was Vincent's request to Theo to get a print of Rembrandt's painting *The Anatomy Lesson of Dr. Nicolaes Tulp* (page 302) for Rey, who had heard of it but never seen it.

Once Vincent began to reconnect with the outside world, his improvement was rapid, and Roulin wrote to Theo to retract the

OPPOSITE
Field with Poppies, 1890
Oil on canvas, 28³/4 x 36in (73 x 91.5cm)
Gemeentemuseum, The Hague

Painted near Auvers, in the last month of Vincent's life.

gloomy prognosis of his first letter. Salles, also making daily visits, reported Dr. Rey's feeling that he ought to be allowed some liberty, and Roulin went with him to the Yellow House, where the sight of his own paintings put new spirit into him. But Vincent would soon be deprived of this loyal friend, as Roulin had been promoted to a post in Marseille and left soon afterwards, although his family remained in Arles for a month or two longer.

A week after the breakdown, Vincent wrote a note to Gauguin on the back of a letter to Theo, the first of several apologetic messages, assuring him of his deep and sincere friendship. Others have blamed Gauguin for at least contributing to Vincent's illness, but Vincent himself never did. To the end of his days he regarded Gauguin as a great friend.

On 7 January Vincent was released. He was obliged to visit the hospital every day, and Dr. Rey kept a close eye on him. He and others on the hospital staff called at the Yellow House, where they were taken aback by Vincent's paintings; but they listened patiently while he explained the theory of complementary colours which, Vincent naively reported to Theo, they were quick to understand.

In early February Vincent visited the brothel to apologize to Rachel, who came up trumps, pooh-poohing the incident as just one of those things that happen in brothels, nothing for him to worry about.

Vincent was soon painting again, one of his first pictures being *Self-Portrait with Bandaged Ear*. In fact he painted two of this subject (pages 298 and 300), each showing him in a fur-trimmed hat and green coat with the right ear bandaged. Of course it was his left ear that he had sliced, but as in all self-portraits, what we see is what Vincent saw, a mirror image. The two paintings are otherwise very different, reflecting his vacillating mental state. Both paintings show a calm assurance in the handling and a total absence of self-pity that is almost disconcerting in the circumstances.

In the first painting, he is smoking his pipe against a plain background divided into two bands of red and orange, respectively complementary colours to the green of the jacket and the blue of the hat. Now in a private collection in Chicago, it is simpler and more immediate than the second version, and was regarded by A.M. Hammacher as superior on grounds of its greater rigour, austerity and impact. The second portrait, in the Courtauld Galleries, London, is more considered, more of an 'interior', with a Japanese print on the wall behind and part of his easel visible. The facial expression is less stark, more withdrawn.

He continued working on his pictures of the Roulin family and also persuaded Dr. Félix Rey to sit for him (page 298). The sitter looks intelligent and composed, in spite of the luridly patterned background, which is similar to the floral backgrounds in the Roulin portraits except that the pattern is not of flowers but abstract swirls. Against the background of the Doctor's dark-blue coat, Vincent has signed his name with rather disturbing

prominence in large red letters. He gave the picture, now regarded as among the best of his portraits, to its subject, and Rey passed it on to his mother, who stored it in the attic until it came in handy to mend a chicken coop. It was rescued in 1901 by an alert Marseille art dealer.

RECOVERY, RELAPSE AND THE ASYLUM

Vincent's fear of a relapse, which continued until the end of his days, was shared by friends and carers. His behaviour was often strange and he suffered from delusions, including the not uncommon one that he was somehow being poisoned. His strange behaviour was reported to the police, who put a watch on the Yellow House and rapidly concluded that its inhabitant was insane and therefore probably dangerous. He was arrested and taken back to the hospital where he was placed in isolation. The minister Salles hurried over, demanded that a fire be lit in the cold room, and got in touch with Theo.

Again, he seemed to recover, but unfortunately the civil powers, less understanding than the medical authorities, were now involved. However, it was agreed that Vincent should be allowed to return to the Yellow House provided he returned to the hospital for his meals and slept there. For the time being, this seemed an ideal arrangement from every point of view, but some of his neighbours set up a clamour to get him removed from the area altogether. Young men, apparently encouraged by their elders, pursued him in the street, throwing refuse at him and shouting abuse.

One of these youths, talking to Marc Edo Tralbaut when he was an old man, remembered this harassment with shame. 'He never made any scandal, except when he had been drinking, which happened often. We only became afraid of him after he had maimed himself because then we realized that he really was mad! I have often thought about him. He was really a gentle person, a creature who would probably have liked us to like him.'

A petition signed by about 30 citizens reached the office of the mayor, and the police took evidence from some of the complainants. Even where embroidery of the facts may have been reasonably suspected, the evidence hardly added up to anything more than occasionally indecorous behaviour. Nevertheless, without medical consultation, Vincent was shut up again in the hospital and forbidden to read, paint or even smoke his pipe.

Salles, Rey and the hospital authorities protested and the conditions of confinement were eased. But what was to be done with Vincent? There was talk of settling him in another part of town, and installing him in a small apartment owned by Dr. Rey's mother. Vincent wrote to Theo on 22 March: 'So far as I can tell myself, I am not really insane.' He cited the pictures he had been painting, which were 'calm and in no way inferior to the others'. They included two well-known pictures of the hospital and its pleasant courtyard garden.

The first was *Dormitory in the Hospital at Arles* (page 306), a

OPPOSITE
Olive Trees: Bright Blue Sky, 1889
Oil on canvas, 19¹/₄ x 24⁷/₈in (49 x 63cm)
National Gallery of Scotland

long room lined with white-curtained beds, which in perspective might almost be an academic exercise. Two nuns (nurses) are checking the beds, and in the foreground a group of convalescents sit smoking or reading a newspaper around a stove, whose steeply angled chimney rising to the roof almost bisects the canvas. This is no doubt the picture that Vincent offered to Rey as a gift. Remembering his mother's view of Vincent's work, Rey politely refused it, but buttonholed a passing pharmacist to accept it who also declined. Finally, the hospital administrator agreed to have it, chiefly no doubt as a kindness to Vincent. Years later it made him a small fortune.

The picture of the hospital ward was painted from a slightly raised viewpoint, perhaps a dais. The *Courtyard of the Hospital at Arles* (page 307) was clearly painted from a position overlooking the garden from the second storey. The garden is laid out in the formal French manner, with a pond at the centre and trees at each corner. The opposite side of the building is an open arcade, like the cloisters of a monastery. A solitary nun walks along the path in the distance.

Towards the end of March Vincent's old friend Paul Signac, visiting the area and advised by Theo of recent events, called to see him. Vincent took him to the Yellow House, which had been boarded up by the police. At first they were refused entry but the police backed down when Signac demanded to know by what legal right they barred a man from his own house. They had a long and

eventful day, for Vincent was both physically and mentally exhausted, and by evening had begun to show signs of stress. He suddenly grabbed a bottle of turpentine and would have drunk it had Signac not prevented him.

It was clear that Vincent could not be left to his own devices, equally that he no longer had any wish to be left alone and understood that it was now impossible. That seems to have been the reason why he did not take up the offer of Rey's mother's accommodation. He also wanted to get away from Arles, and even dreamed of joining the Foreign Legion. In the course of a long, intimate conversation with the sympathetic Salles, he said he felt quite different from the person he was before the first attack, and unable to look after himself. He agreed that he would be best off in some private home where he would be supervised.

Salles reported all this to Theo, and included with his letter a prospectus he had obtained from a private asylum, of which he had previously heard good reports, at Saint-Rémy-de-Provence, about 14 miles (23 kilometres) north-east of Arles on the other side of the Alpilles.

On 8 May 1889, escorted by Salles, Vincent entered the asylum of Saint-Paul-de-Mausole, a remodelled monastery just outside Saint-Rémy.

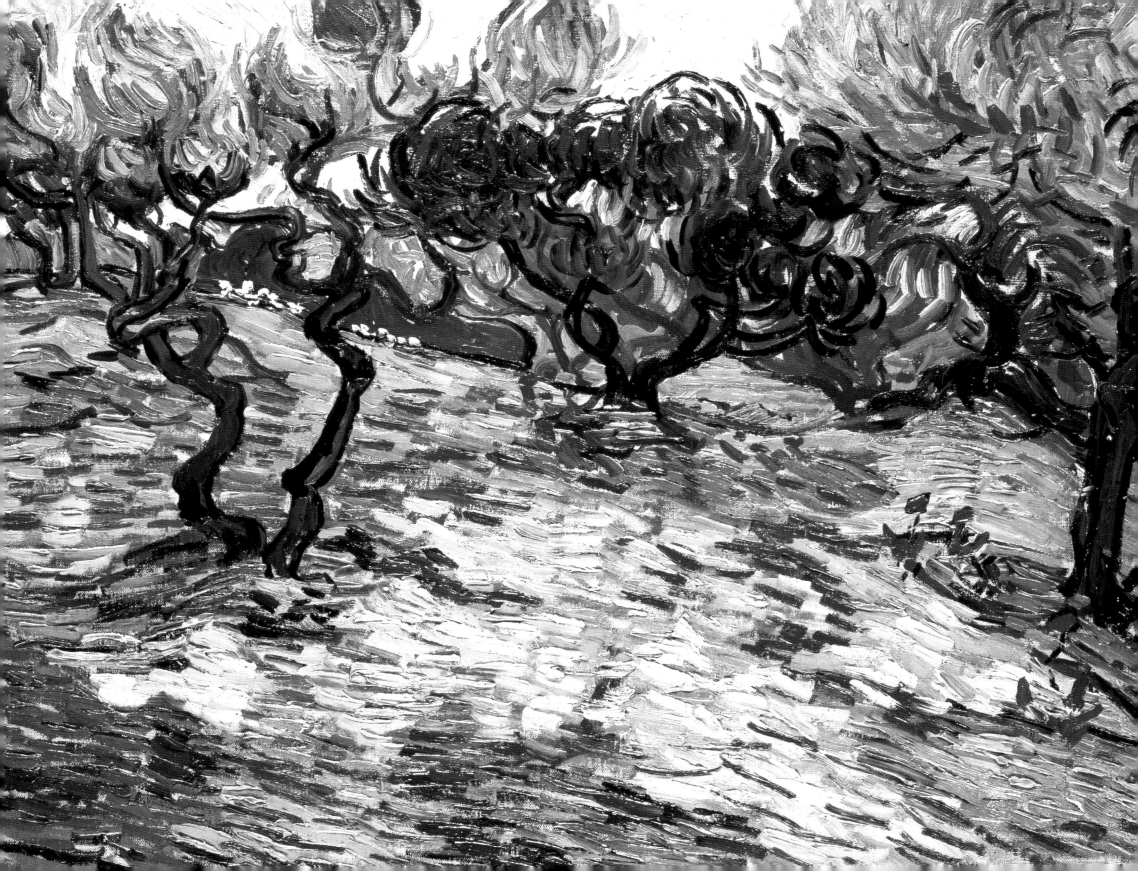

CHAPTER NINE
SAINT-REMY-DE-PROVENCE

The head of the asylum of Saint-Paul-de Mausole at Saint-Rémy-de-Provence was Dr. Théophile Peyron, a man of about fifty who had specialized in mental illness while practising in Marseille. In the context of the time, it was a kindly establishment and well-run, if also slightly run down, and was less than half full. Dr. Peyron, 'a gouty little man' in Vincent's description, and a widower for some years, appears in the painting *Pine Tree with Figure in the Garden of Saint-Paul Hospital* (page 318), although Vincent, who puts himself in the doorway in the background, does not give him any features and is characteristically more interested in the trunk of the pine tree, an interest that reappears in a series of pictures, such as *Field of Grass with Dandelions and Tree Trunks*. From what we know of him, the proprietor of the asylum does not emerge as someone of strong personality, though one can never tell, and his diagnosis of Vincent's condition did not differ essentially from that of Dr. Rey, including the supposition that he was suffering from epilepsy. He noted that one of Vincent's maternal aunts was also an epileptic.

Treatment was at least comparatively harmless, including the giving of bromides and other sedatives, opiates for the most disturbed, and the preservation, as far as possible, of a calm and peaceful environment. Dr. Peyron was keen on hydrotherapy, and Vincent had to take a bath twice a week, remaining immersed for two hours at a time. Theo asked for two concessions on behalf of his

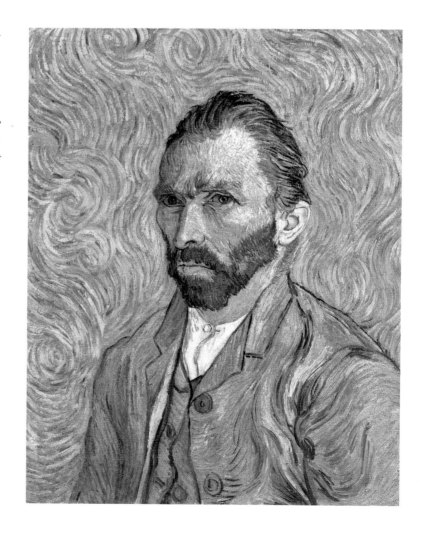

316

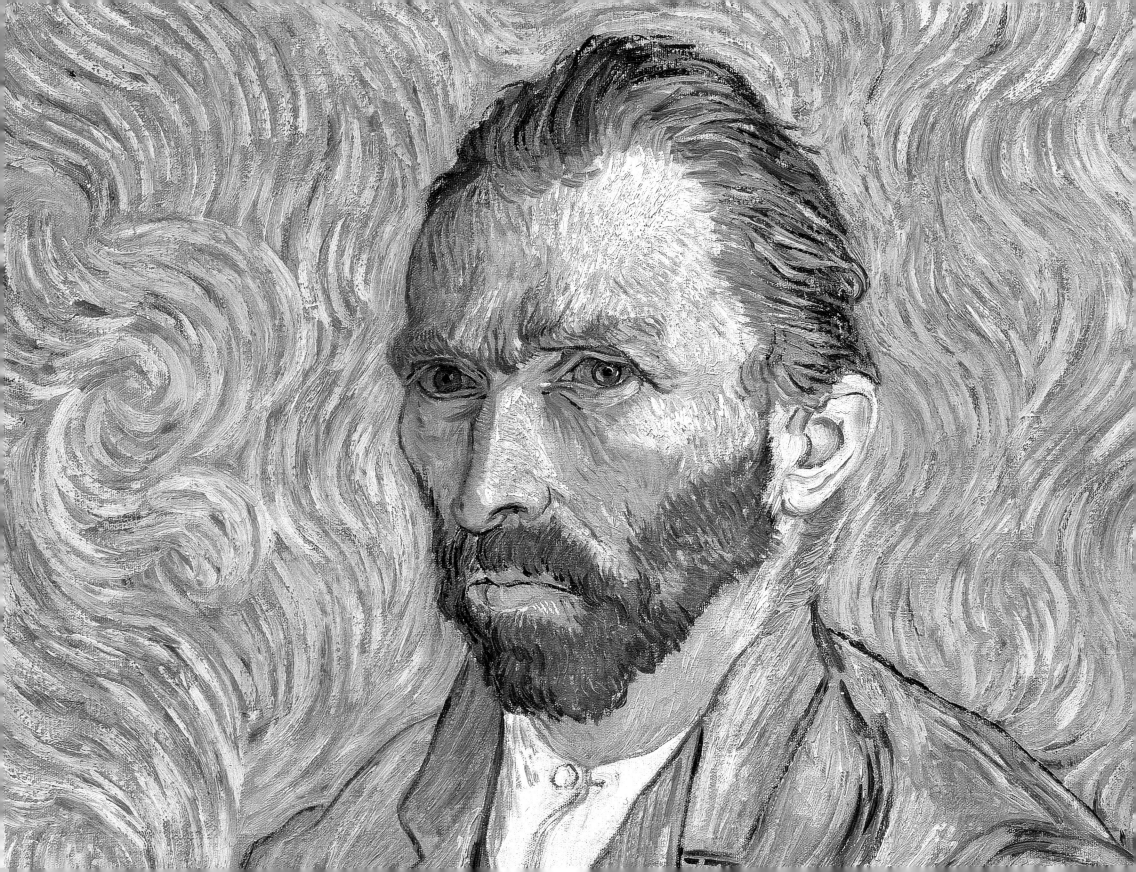

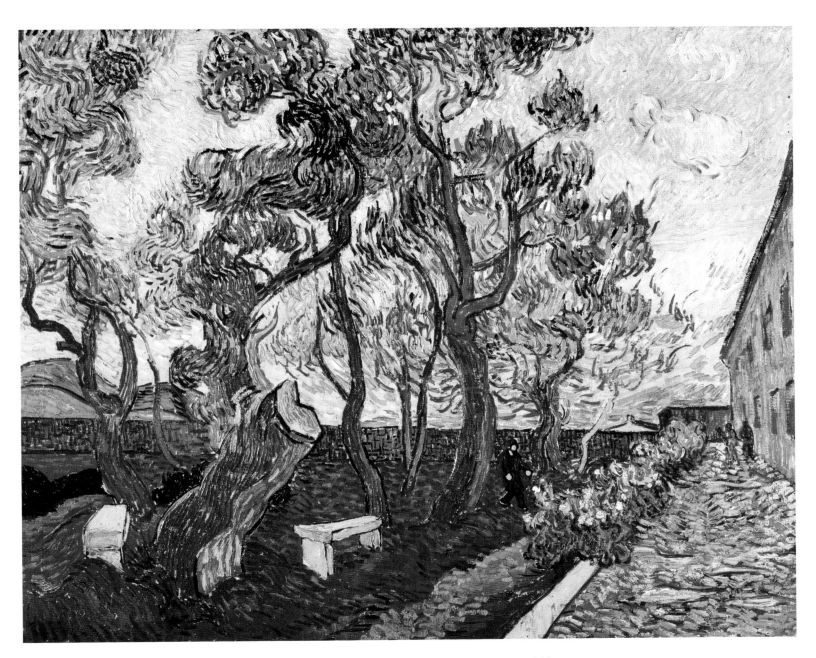

OPPOSITE LEFT and detail PAGE 320
Pine Tree with Figure in the Garden of
Saint-Paul Hospital, 1889
Oil on canvas, 22⁷/₈ x 17³/₄in (58 x 45cm)
Musée d'Orsay, Paris

OPPOSITE RIGHT and detail PAGE 321
Portrait of Trabuc, an Attendant at Saint-
Paul Hospital, 1889
Oil on canvas, 24 x 18¹/₈in (61 x 46cm)
Kunstmuseum, Solothurn

LEFT
The Garden of Saint-Paul Hospital,
Saint-Remy, 1889
Oil on canvas, 29 x 36¹/₄in (73.5 x 92cm)
Museum Folkwang, Essen

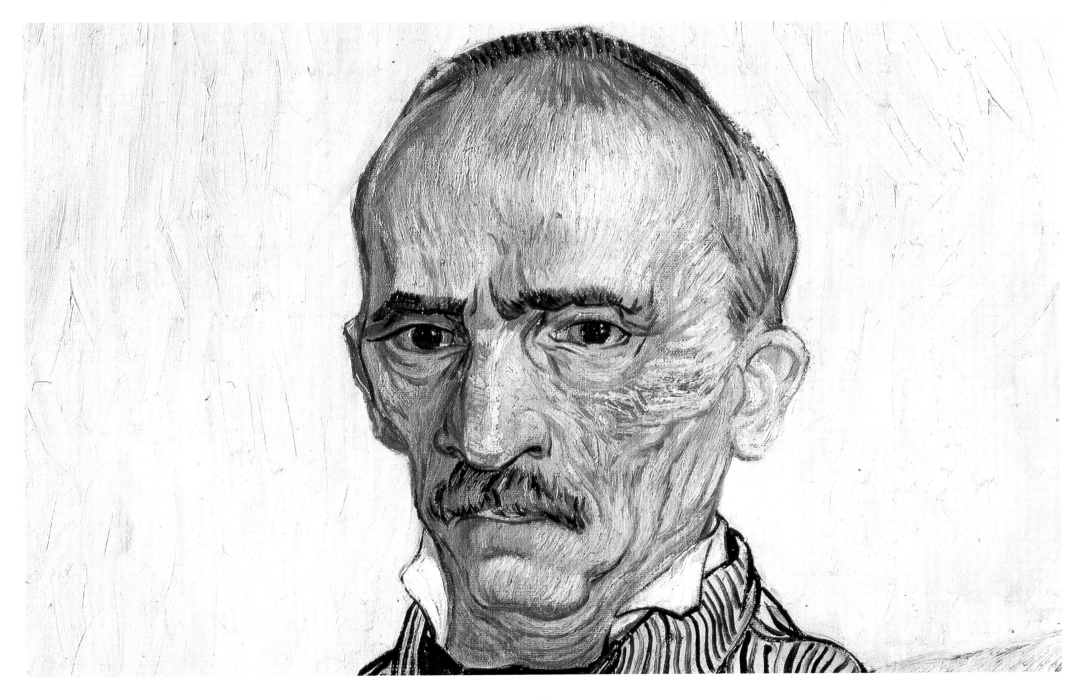

RIGHT
Roadmenders in a Lane with Plane Trees, 1889
Oil on canvas, 29 x 36¹/₂in (73.6 x 92.7cm)
The Phillips Collection, Washington, D.C.

OPPOSITE
The Garden of Saint-Paul Hospital, Saint-Rémy, 1889
Oil on canvas, 25³/₈ x 19¹/₄in (64.5 x 49cm)
Private collection

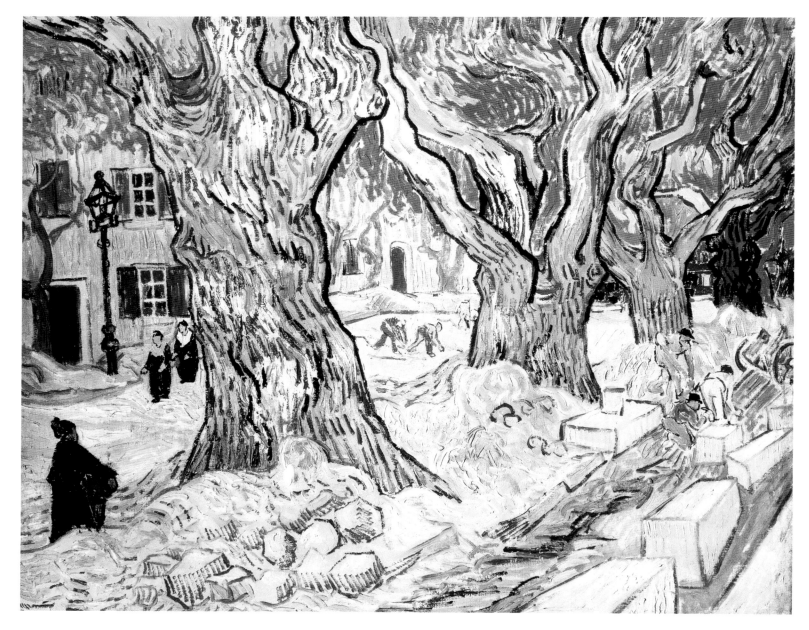

brother, the freedom to paint outside the grounds and 'at least half a litre of wine with his meals'. By paying extra he also secured him two rooms, a bedroom and another room that he could use as a studio.

These 'rooms', on the upper storey, were more like cells, with a heavy metal door and bars covering the windows, though none of Vincent's paintings of the splendid views from his window shows the intervening bars. The asylum was clearly not a bad place to be, given the general standard of such institutions, but it had seen better days, having been founded early in the century with well-to-do patients in mind. Vincent was used to roughing it, and his description of his bedroom is not unattractive – 'a little room with greenish-grey paper, sea-green curtains with very pale roses and touches of blood-red'; the curtains were scruffy and the single armchair well worn but colourful, reminding him of Monticelli. The food did not please him, consisting largely of lentils and tasting, according to Vincent, rather mouldy, 'like a cockroach-infested restaurant in Paris'.

Some of the patients had been there for years and Vincent considered that, since they did 'absolutely nothing' all day, their main problem was enervation, and hoped his work would preserve him from this fate. 'For me ... it is a relief to paint a picture, and without it I should be more miserable than I am.' One result of

living among people with more or less severe mental illness was that it reduced his fear of madness, which Dr. Rey had thought was the likely cause of Vincent's relapses. When he was painting outside, the other patients would come to look; they showed much better manners, he said, than the people of Arles. Although at night 'you continually hear terrible cries and howls like beasts in a menagerie', Vincent was consoled by learning of the experience of others. There was a spirit of sympathy and co-operation among the patients, some of whom, like himself, were not permanently insane but merely subject to unpredictable attacks.

He began painting almost immediately after his arrival. For a few days he was nervous of going outside, even into the garden, but from his window he could see several different views by changing the angle of observation. He painted all he could see, in the early-morning light and in the evening, in fine sunshine and in pouring rain. In one of these, *Mountain Landscape seen across the Walls* (right), he exaggerates the slope of the hill to give extra drama to the confining wall marking the asylum's boundary. During his Saint-Rémy period we receive more frequent reminders, as here, of the link between van Gogh and Expressionism and its French equivalent, Fauvism.

One of his earliest paintings in the garden was *Irises,* page 326 (his favourite flower after sunflowers), done in May, 1889, but after

OPPOSITE
Trees in the Garden of Saint-Paul Hospital, 1889
Oil on canvas, 35¹/₂ x 28⁷/₈in (90.2 x 73.3cm)
Armand Hammer Foundation, Los Angeles

FAR LEFT
Mountain Landscape Seen across the Walls, 1889
Oil on canvas, 23¹/₄ x 28¹/₃in (59 x 72cm)
Rijksmuseum Kröller-Müller, Otterlo

LEFT
Enclosed Field with Rising Sun, 1889
Oil on canvas, 28 x 35⁵/₈in (71 x 90.5cm)
Private collection

PAGE 326
Irises, 1889
Oil on canvas, 28 x 36⁵/₈in (71 x 93cm)
J. Paul Getty Museum, Los Angeles

a few weeks he was allowed beyond the grounds, providing he was accompanied by an attendant. This was a genial young man named Jean-François Poulet, who knew the district well. Their expeditions were a success, and they ventured as far as the ravine of Les Peyroulets, several miles from the asylum. The first time they ventured into Saint-Rémy itself, although it was a smaller and quieter town than Arles, Vincent became stressed by the proximity of so many people and they beat a quick retreat. Later, they did

penetrate the town, as Vincent's lively *Roadmenders in a Lane with Plane Trees* (page 322), painted in the Boulevard Mirabeau, bears witness. In the foreground, again lending depth to the scene, the dynamic, slightly distorted trunks of the plane trees are characteristic.

On another occasion, after they had returned to the asylum and were going up the staircase to Vincent's room, Vincent suddenly turned and kicked the young attendant in the stomach. Poulet made nothing of it, and the next day Vincent offered an idiosyncratic

apology. 'Please forgive me, I had the Arles police after me.' Clearly his hallucinations had not been banished entirely.

Poulet left the asylum about the same time as Vincent and became a roadmender. He lived into his nineties, and used to sit on a bench in the Plateau des Antiques (boasting a grand Roman tomb and Triumphal Arch), across the road from the asylum. 'Vincent was a good fellow', he recalled, 'though he was strange and silent. When he was painting he forgot his sufferings and scorned all the rest.'

TOWARDS AN 'EXPRESSIONISTIC' STYLE

Vincent's paintings and drawings of the asylum in the early months of his confinement suggest that he was not displeased with his situation. In fact, he tended to make the place look more attractive than other evidence suggests it really was, and some of his exteriors of the building with its gardens suggest a country estate rather than a mental hospital. Today, no longer a hospital, there is certainly something of that feel about it. Indoors, even the long, institutional corridors, which must actually have been a rather depressing prospect, appear, with their ochre walls, vaulted ceilings, blue-grey arches and pilasters, and rather mysterious light source, a pleasant place to stroll. In *The Vestibule of Saint-Paul Hospital* (right), the doors are flung open to admit the late-summer sunlight and frame a fountain playing in a small round pond. As in nearly all his landscapes, Vincent demonstrates a remarkable fidelity to the actual scene, however unexpected the result.

In the early months at Saint-Rémy Vincent's style manifested changes that have been linked, perhaps too easily, with his disturbed mentality: the swirling, flame-like cypress trees (he told Theo he was 'astonished' that no one else had painted them as he saw them), the gnarled and contorted olives, the billowing waves of cloud, the vast, hurtling heavenly bodies of that astounding work, *The Starry Night* of June, 1889.

The Starry Night (page 268), now in the New York Museum of Modern Art, is the most famous work of this period and just the kind of painting that once convinced people that Vincent was a madman. It cannot be reconciled with his general principles, being imaginative rather than naturalistic, and it is really a thoroughly Expressionist work. More particularly perhaps, it anticipates the work of Edvard Munch, who was only ten years Vincent's junior. The sky itself fits the description 'Surrealist' and to some people has suggested the Biblical Apocalypse, or the concept of infinity. The generally realistic village cannot be identified, and the spire of the church seems to belong more to the North than the Midi, while the mountains do not bear much resemblance to Les Alpilles. The dark cypress tree in the left foreground serves the purpose of adding depth to the picture, a device that recurs in many other paintings and may

***The Vestibule of Saint-Paul Hospital,
1889***
*Black chalk and gouache, 24 x 18³/₄in
(61 x 47.5cm)
Rijksmuseum Vincent van Gogh,
Amsterdam*

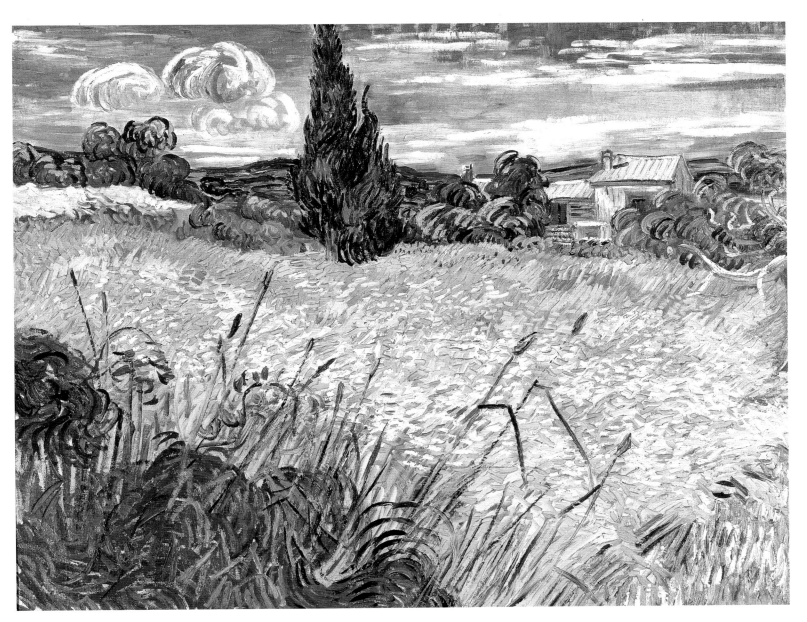

OPPOSITE LEFT
Cypresses, 1889
Oil on canvas, 36³/4 x 29¹/8in
(93.3 x 74cm)
Metropolitan Museum of Art, New York

OPPOSITE RIGHT
Cypresses, 1889
Reed pen, graphite, quill and brown and
black ink on paper, 24¹/2 x 18³/8in
(62.3 x 46.8cm)
Brooklyn Museum of Art, New York

LEFT
Green Wheatfield with Cypress, 1889
Oil on canvas, 29 x 36⁷/8in (73.5 x
92.5cm)
Národni Gallery, Prague

RIGHT
Wheatfield with Cypresses, 1889
Black chalk and pen, 18^1/$_2$ x 24^3/$_8$in
(47 x 62cm)
Rijksmuseum Vincent van Gogh,
Amsterdam

OPPOSITE
Wheatfield with Cypresses, 1889
Oil on canvas, 28^1/$_3$ x 35^7/$_8$in
(72 x 91cm)
National Gallery, London

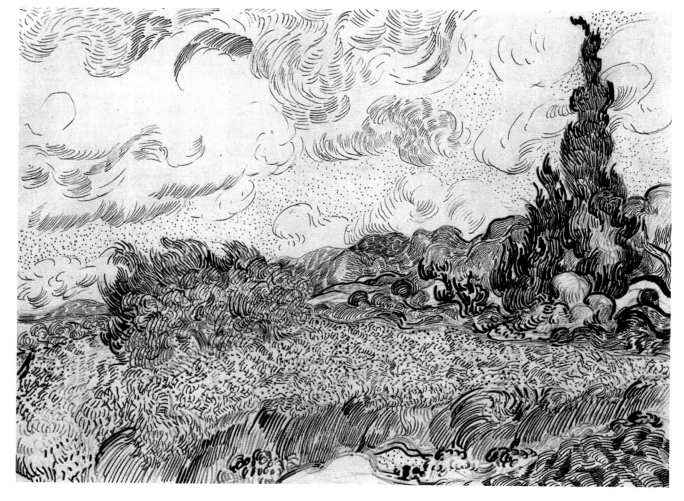

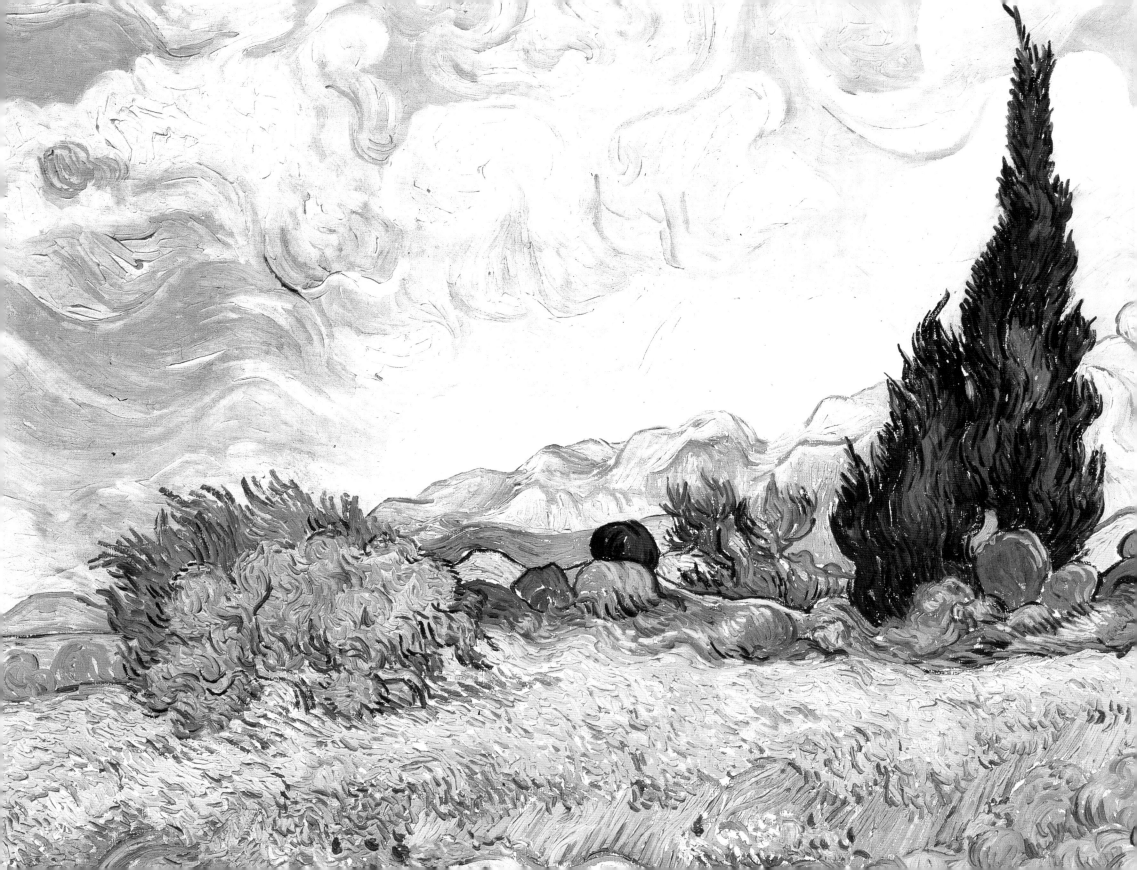

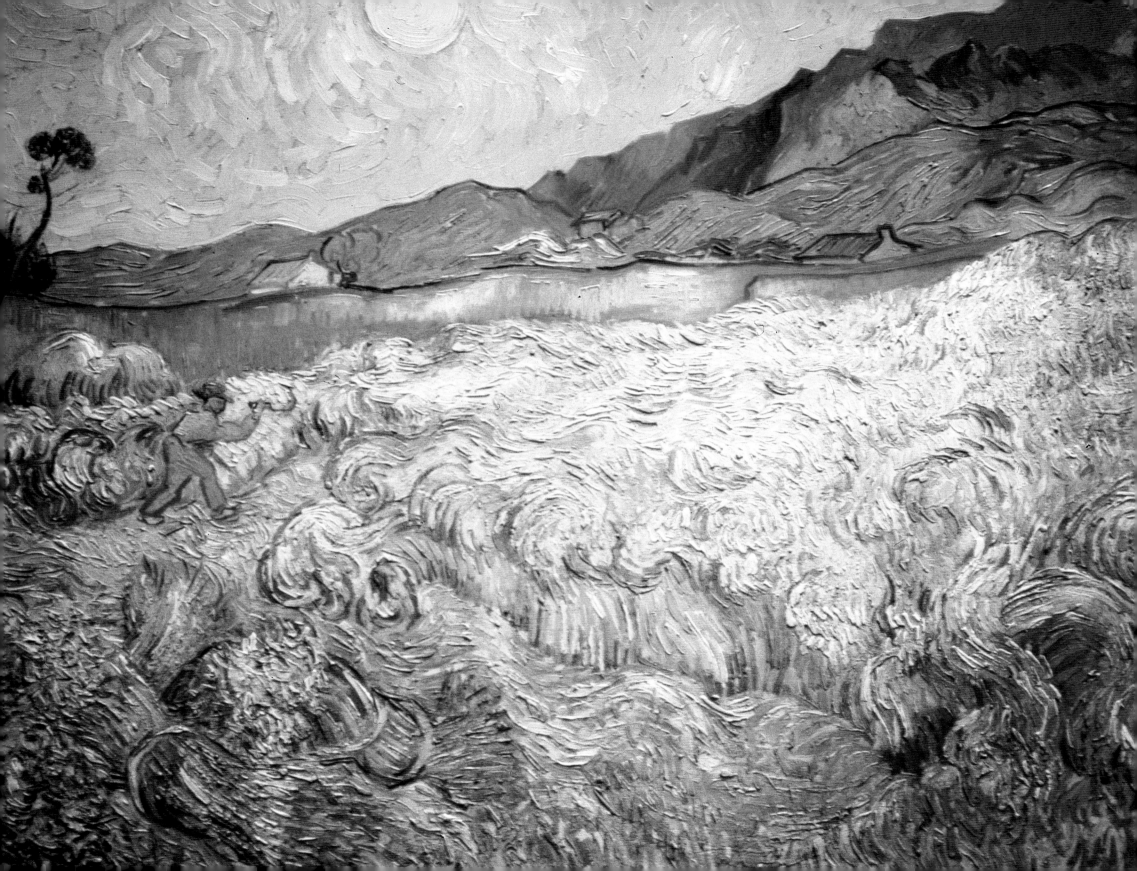

OPPOSITE
Wheatfield with Reaper at Sunrise, 1889
Oil on canvas, 28¹/₃ x 36¹/₄in (72 x 92cm)
Rijksmuseum Vincent van Gogh,
Amsterdam

FAR LEFT
Evening Landscape with Rising Moon,
1889
Oil on canvas, 28¹/₃ x 36¹/₄in (72 x 92cm)
Rijksmuseum Kröller-Müller, Otterlo

LEFT
Cypresses with Two Female Figures,
1889
Oil on canvas, 36¹/₄ x 28³/₄in (92 x 73cm)
Rijksmuseum Kröller-Müller, Otterlo

have derived, ultimately, from the perspective of Japanese prints. In his 1990 book, *Vincent van Gogh: Christianity versus Nature*, the Japanese scholar Tsukasa Kodera saw the picture as an expression of the conflict stated in his subtitle, and drew attention to its similarities with a description of a character's hallucination in Zola's *La Faute de l'Abbé Mouret*.

Cypress trees, so typical of the scenery of Provence, Vincent conceded, 'are always occupying my thoughts. I would like to make something of them like the canvases of the sunflowers ... [The

RIGHT
Landscape in the Rain, 1889
Oil on canvas, 28³/4 x 36¹/4in (73 x 92cm)
Museum of Art, Philadelphia. (See also page 410.)

OPPOSITE LEFT
Acacia in Flower, 1890
Oil on canvas, 13 x 9³/8in (33 x 24cm)
Nationalmuseum, Stockholm

This was done at Auvers in May 1890, probably on the same day as Vincent's second portrait of Dr. Gachet (see pages 380–383), the acacia being in the doctor's garden.

OPPOSITE RIGHT
Wild Flowers and Thistles in a Vase, 1890
Paper over canvas, 26 x 17³/4in (66 x 45cm)
Christie's Images

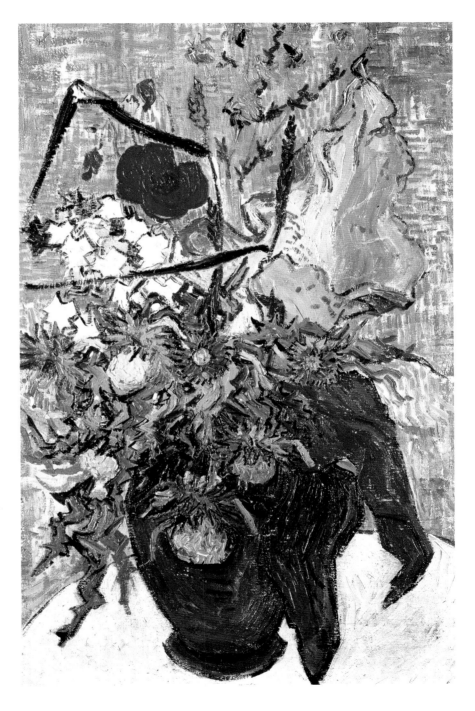

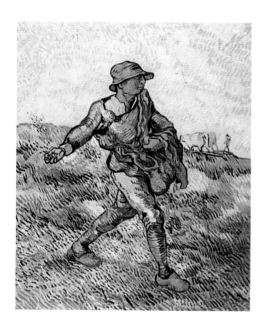

ABOVE
The Sower (after Millet), **1889**
Oil on canvas, 25^{1}/$_{4}$ x 21^{5}/$_{8}$in (64 x 55cm)
Rijksmuseum Kröller-Müller, Otterlo

RIGHT and detail PAGE 338
**Japanese Vase with Roses and Anemones,
1890**
Oil on canvas, 20^{3}/$_{8}$ x 20^{1}/$_{2}$in
(51.7 x 52cm)
Musée d'Orsay, Paris

OPPOSITE and detail PAGE 339
The Midday Rest (after Millet), **1890**
Oil on canvas, 28^{3}/$_{4}$ x 35^{7}/$_{8}$in (73 x 91cm)
Jeu de Paume, Paris

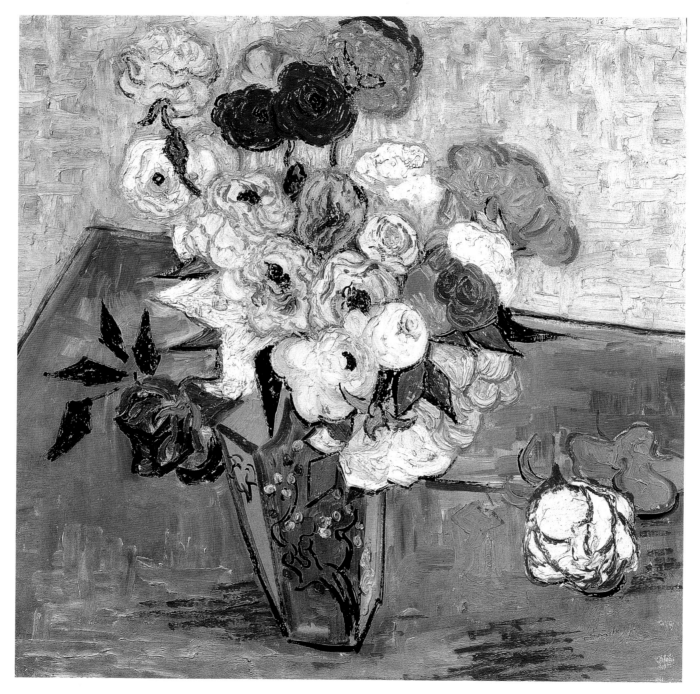

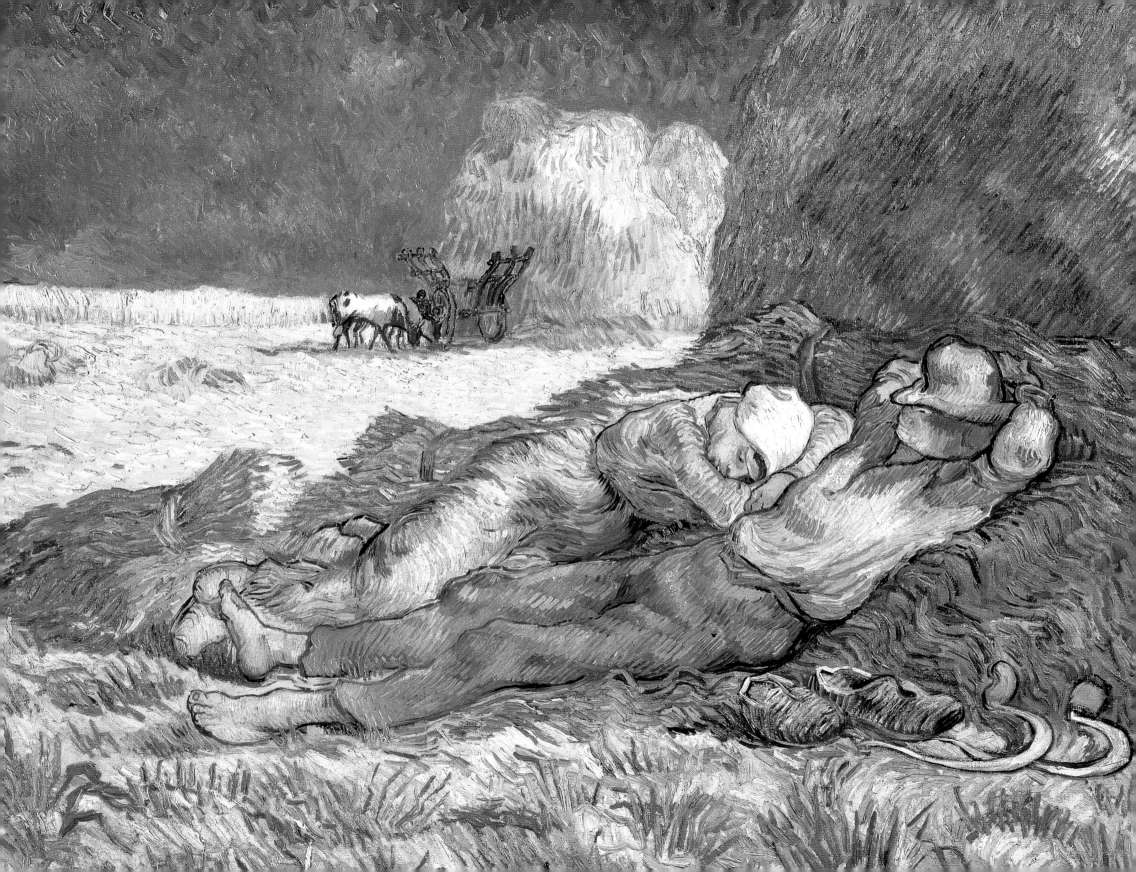

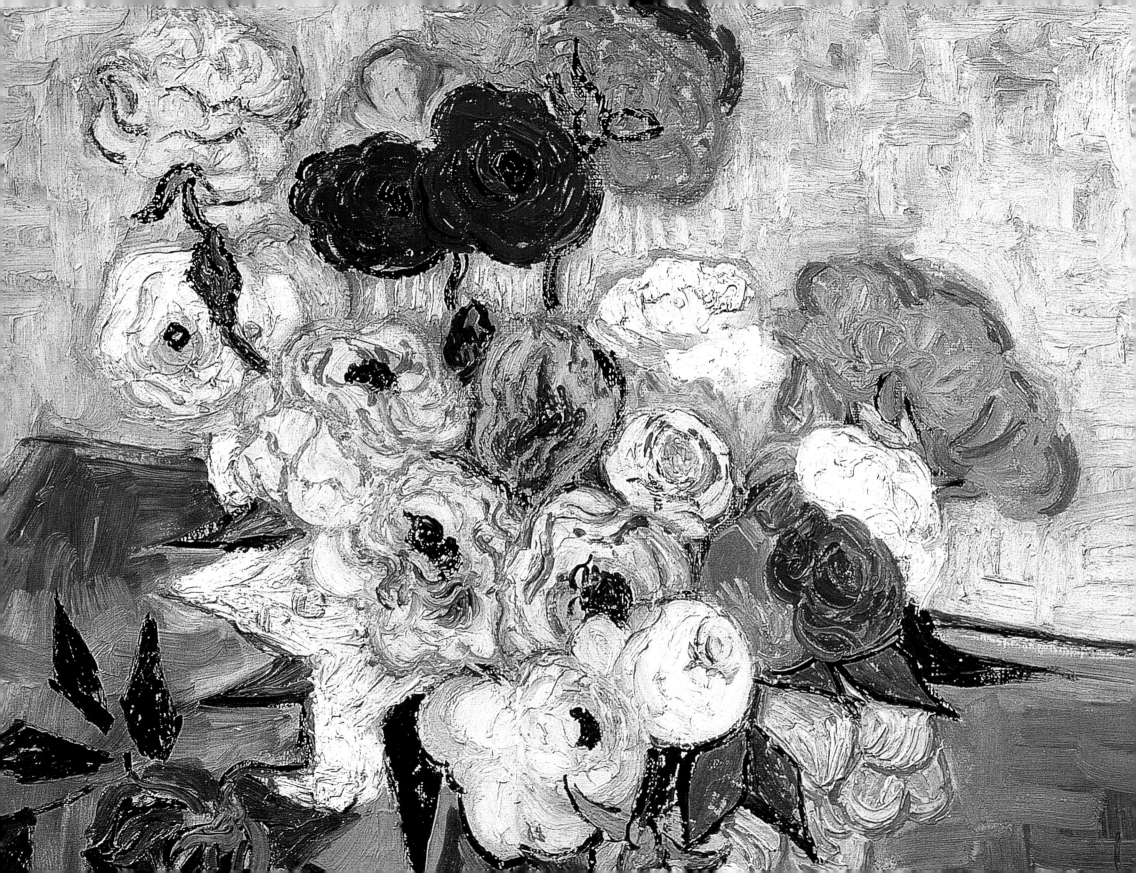

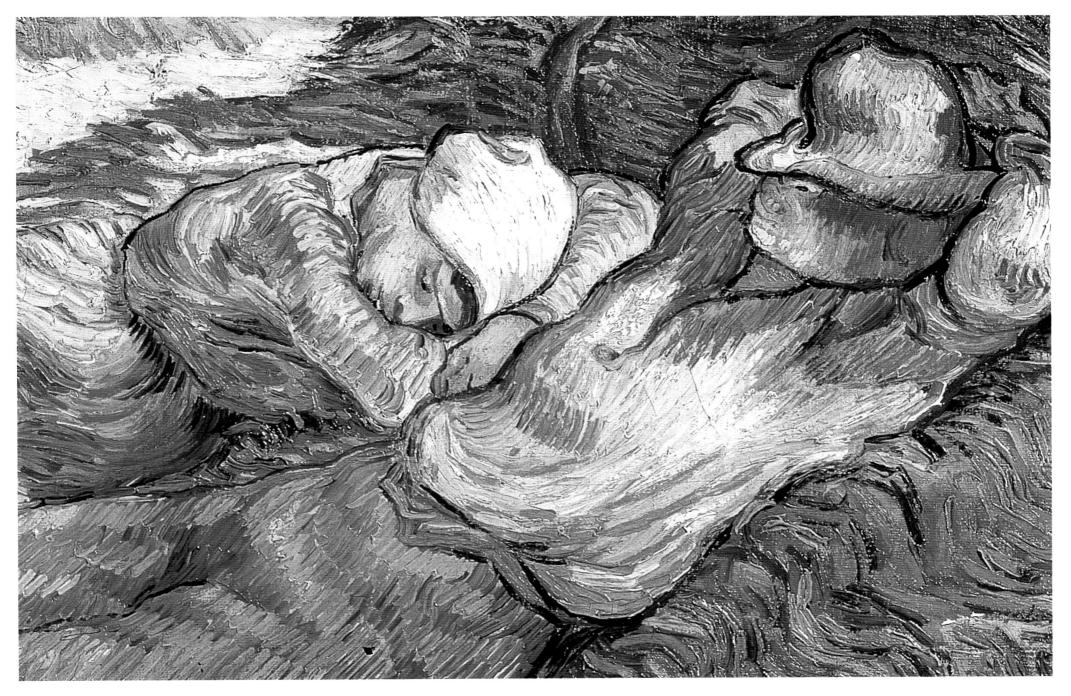

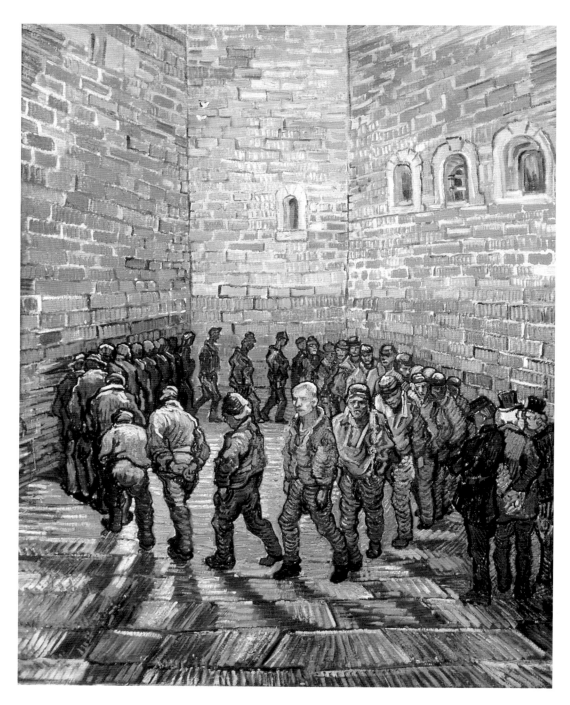

cypress] is as beautiful in line and proportion as an Egyptian obelisk. And the green has a quality of such distinction. It is a splash of black in a sunny landscape, but it is one of the most interesting black notes, and the most difficult to hit off exactly that I can imagine.'

The connection of Vincent's 'disturbed' style with his illness seems obvious, and if all the paintings of this period were in that style it would be hard to contradict. But they were not. For he was also at this time also making copies of earlier paintings in exactly the same style as the originals. Besides, many watercolours and drawings, as well as some paintings (for instance, of the interior of the asylum), betray little or no sign of his allegedly 'disturbed' style and therefore throw doubt on the notion that it was the product of his mental state. If it had been, surely all his work would have been similarly affected.

There was also a change in his palette. From this time onward, the fierce effects of complementary colours are forgone, and instead of intense reds and greens we get milder blues and greens. Impasto is, in general, less evident.

In a sense Vincent was regressing, returning to the colours of the north which he had abandoned on arrival in Arles, and this is explained by another of those compulsions towards a change in his environment, in particular from city to country and, in this case, sunny South to temperate North. In a word, he was homesick. There

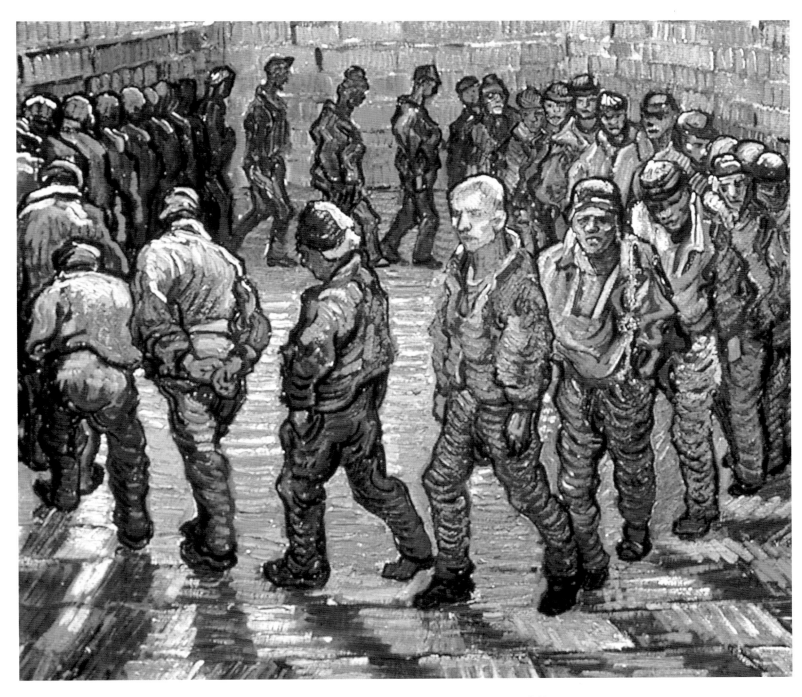

OPPOSITE and LEFT
The Prisoners' Round *(after Gustave Doré*), 1890*
Oil on canvas, 31^1/$_2$ x 25^1/$_4$in (80 x 64cm)
Pushkin Museum, Moscow

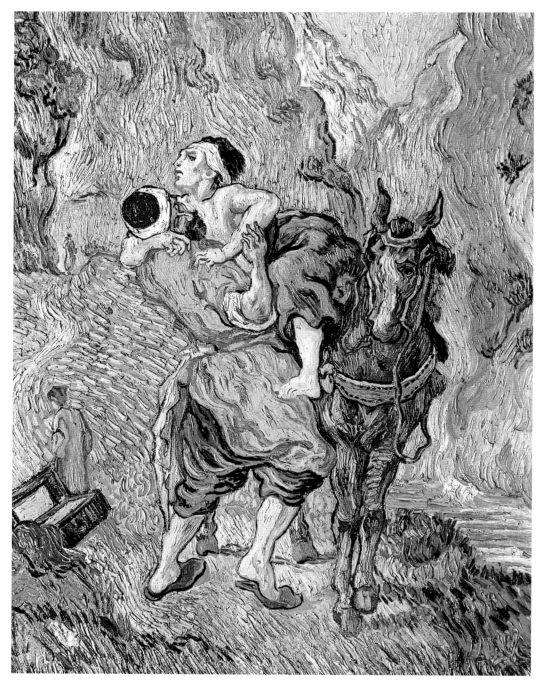

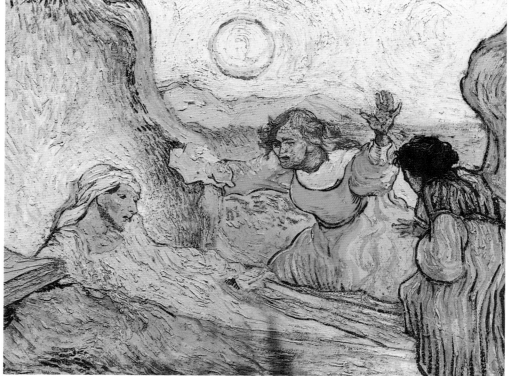

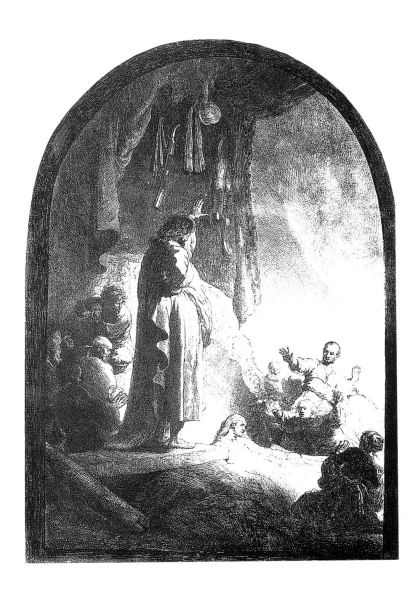

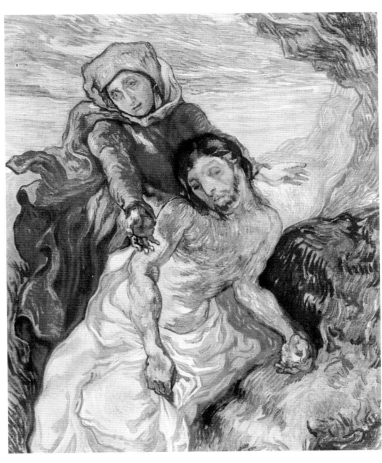

OPPOSITE LEFT
The Good Samaritan (after Delacroix),
1890
*Oil on canvas, 28³/4 x 23⁵/8in (73 x 60cm)
Rijksmuseum Kröller-Müller, Otterlo*

OPPOSITE RIGHT
The Raising of Lazarus (after
Rembrandt)**, 1890**
*Oil on paper, 19 x 24⁷/8in (48.5 x 63cm)
Rijksmuseum Vincent van Gogh,
Amsterdam*

FAR LEFT
Rembrandt
The Raising of Lazarus, c. 1632
*Etching, 14³/8 x 10¹/8in (36.7 x 25.7cm)
Rijksmuseum, Amsterdam*

LEFT
Pietà (after Delacroix)**, 1889**
*Oil on canvas, 28³/4 x 23⁷/8in
(73 x 60.5cm)
Rijksmuseum Vincent van Gogh,
Amsterdam*

VAN GOGH

is a small drawing of a landscape from Saint-Rémy that includes both the ubiquitous cypress trees and a peasant's cottage, only the cottage is thatched – hardly characteristic of Provence where the risk of fire makes a thatched roof impracticable as well as too warm, but, unlike the cypress, it is common enough in Brabant! It reappears in several works of this period.

Vincent was going through a period of depression following another mental attack when he did the series of small works called Reminiscences of the North, most of them drawings. This harking back to earlier times to some degree affected the style of all his late paintings in Saint-Rémy, for although his disillusion with the South was due chiefly to his terrifying breakdown in Arles and the hostility of the local people, caught up with all that was a rejection of the very things that, little more than a year ago, had driven him there – sunshine, warmth, light and colour. The hot, glaring, southern Sun, it seemed, was one cause of his troubles.

ANOTHER ATTACK

Vincent suffered several attacks while at the asylum, but they seemed quite arbitrary: it was difficult to see what had provoked them. For instance, he was allowed to go to Arles to collect some of his belongings, although his carers considered it was risky. For that reason he was accompanied by the superintendent of the asylum, a grizzled veteran called Trabuc, who played the kind of role in

Vincent's existence that had been filled by Tanguy in Paris and Roulin in Arles. (Vincent later expressed his appreciation with affectionate portraits of Trabuc and his wife, although these works were soon lost and only Vincent's copies survive, see page 318.) The trip passed without untoward incident, in spite of the foreboding. Nor did Vincent seem in the least dismayed by the news that Theo and his wife Johanna were expecting a baby. On the contrary, he was pleased for them.

But early in July, while out painting in the fields with Poulet, he felt another attack threatening, and by the time they got back to the asylum he was in a desperate condition. Later, he managed to swallow some of his paints and had to be dosed with a powerful emetic.

He began to recover in less than a week, but the incident with the paints had convinced Peyron that his obsession with painting lay at the root of his problems. He was therefore forbidden to paint. As he began to improve, and after intercession from Theo, this ban was rescinded, though weeks passed before Vincent felt able to leave the sanctuary of the asylum.

VINCENT'S 'REPRODUCTIONS'

Up in his room, Vincent had only the views he had painted so often and perhaps that was why he returned to self-portraits. He painted three at this time, the last portraits we have of him. One, probably

OPPOSITE
Woman on a Road among Trees, 1889
Oil on canvas, 12³/₄ x 16in (32.5 x 40.5cm)
Private collection

This picture belongs to a group of minor landscapes done around Saint-Rémy probably in about December 1889.

the last, was a present for his mother, and he appears younger and less care-worn than the others show him to have been. In the first of these, he paints himself as an artist, with smock and easel (page 184), and the predominant colour is a slightly sickly green. In the third and best known, now in Paris, the predominant colour is a lightish blue, the same tone being used for the swirling background and for Vincent's coat and waistcoat. In this sea of blue his head, in the centre of the canvas, with craggy brow, orange beard and piercing but haunted eyes, stands out like an icon. It is one of his best self-portraits (see page 316).

Vincent was notoriously hostile to photography, which no doubt explains why no photograph of him as an adult exists (bar a distant back view with Emile Bernard in Asnières). 'Photographs are always dreadful, I don't want to have any, especially of people I know and love,' he told his sister Wil. But it was not only photographic portraits to which he objected. Bernard sent him some photographs of paintings he had been doing in Brittany, and although his reprimand was couched in joshing terms, Vincent was clearly outraged, especially as he was now convinced that the School of Pont-Aven was on the wrong track altogether ('... abstraction, my boy,' he told Bernard 'is enchanted ground, and you soon find yourself up against a stone wall.').

His objection to Bernard's photographs was a little inconsistent

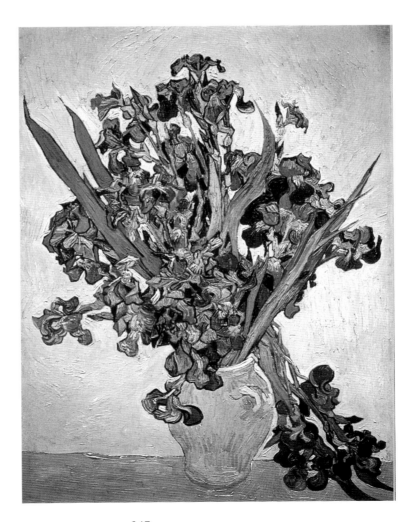

LEFT *and* OPPOSITE
Still Life: Vase with Irises against a Yellow Background, 1890
Oil on canvas, 36¼ x 29in (92 x 73.5cm)
Rijksmuseum Vincent van Gogh, Amsterdam

The great Van Gogh scholar Jan Hulsker worked out that in a maximum of eighteen days up to 16 May 1890, Vincent completed eleven paintings, including Biblical scenes, gardens and landscapes, and still lifes. One of the latter was this lovely vase of irises.

The Green Vineyard, 1888
Oil on canvas, 28¹/₃ x 36¹/₄in (72 x 92cm)
Rijksmuseum Kröller-Müller, Otterlo

During the autumn of 1888 Vincent painted his two scenes of a vineyard near Arles at different stages of the harvest. These are among his most famous landscapes (See page 358.)

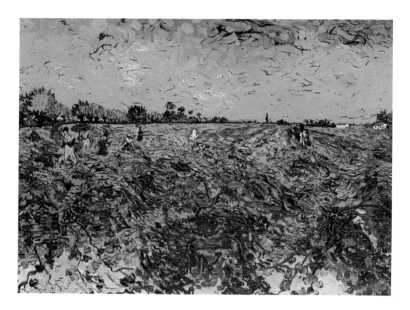

because a major preoccupation at this time, perhaps encouraged by his disinclination to leave the building (and another sign of his reversion to earlier loyalties), was making paintings from black-and-white prints of old favourites such as Millet and Daumier. This hardly seems to be working from nature, but Vincent, never the most logical of men, managed to convince himself that it was, the image being no less 'real' than, say, a living tree.

Among the best results of this enterprise were yet another Sower, *The Midday Rest* (page 337), after Millet's picture of a

peasant couple taking a nap under a haystack, in which the colours are stronger than in Millet's pastel original; and – one of his best-known paintings – *The Prisoners' Round* (page 340). This one was after Gustave Doré's almost equally well-known wood engraving of convicts tramping around in a circle within a small exercise yard enclosed by limitless walls. The subject obviously commended itself to Vincent as he was effectively a prisoner himself, but that he included himself among the prisoners appears to be a fantasy.

There were nearly forty of these 'reproductions' altogether, including half-a-dozen drawings, with twenty from Millet and others from, besides those mentioned, Delacroix and Rembrandt. His painting of Delacroix's *Pietà* (page 343) was made to replace a treasured lithograph which had been accidentally destroyed. Like most of his Dutch predecessors, it was rare for Vincent to adopt religious subjects, especially the figure of Christ. It is said that the figure here is a self-portrait, which seems doubtful, and the figure of Mary is a likeness of the Mother Superior in charge of the female patients. When Vincent had wanted to paint her portrait, she declined, but found herself immortalized here as the Mother of God.

The Raising of Lazarus (page 342), from a Rembrandt etching, was another subject with which Vincent may have felt some personal affinity. He made significant changes in his version of Rembrandt's original, possibly intended to neutralize its religious significance,

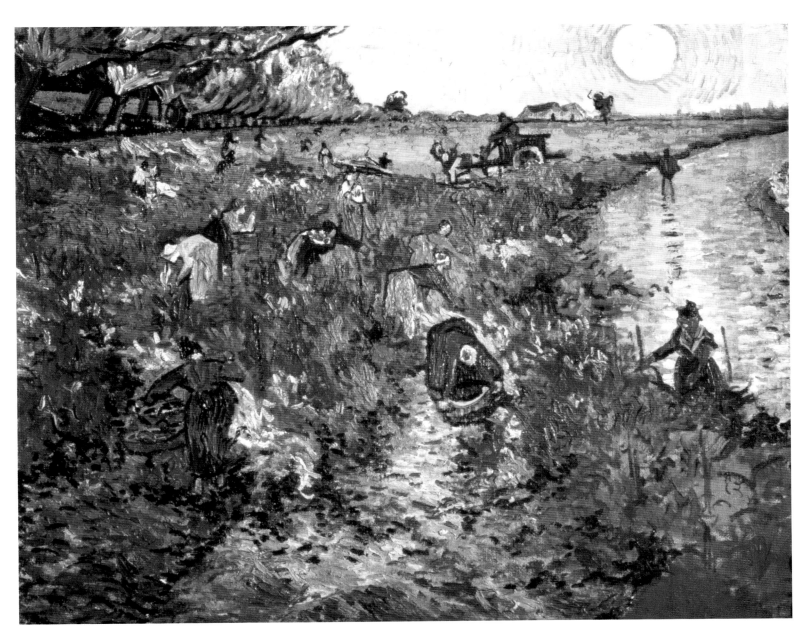

The Red Vineyard, 1888
Oil on canvas, 29^{1}/$_{2}$ x 36^{5}/$_{8}$in (75 x 93cm)
Pushkin Museum, Moscow

This was almost certainly the painting sold as a result of the exhibition of Les XX, once thought to be the only work sold in Vincent's lifetime.

RIGHT and PAGE 352
Still Life: Vase of Roses, 1890
Oil on canvas, 36¹/₂ x 29in (92.6 x 73.7cm)
Private collection

FAR RIGHT and PAGE 353
Still Life with Thistles, 1890
Oil on canvas, 16 x 14in (40.4 x 35.5cm)
Private collection

OPPOSITE
Wheatfield with Reaper at Sunrise, 1890
Oil on canvas 23³/₈ x 28³/₄in (59.5 x 73cm)
Museum Folkwang, Essen
(See also page 332.)

PAGE 354
First Steps *(after Millet)*, **1890**
Oil on canvas, 28¹/₂ x 36in (72.4 x 91.2cm)
Metropolitan Museum of Art, New York

PAGE 355
Meadow with Butterflies, 1890
Oil on canvas, 25³/₈ x 31³/₄in (64.5 x 80.7cm)

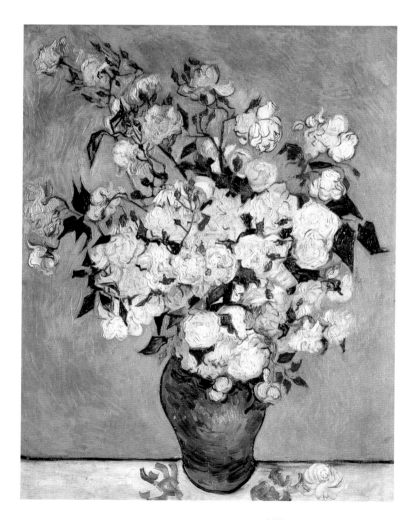

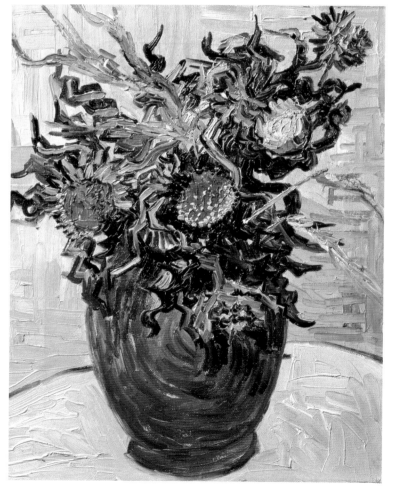

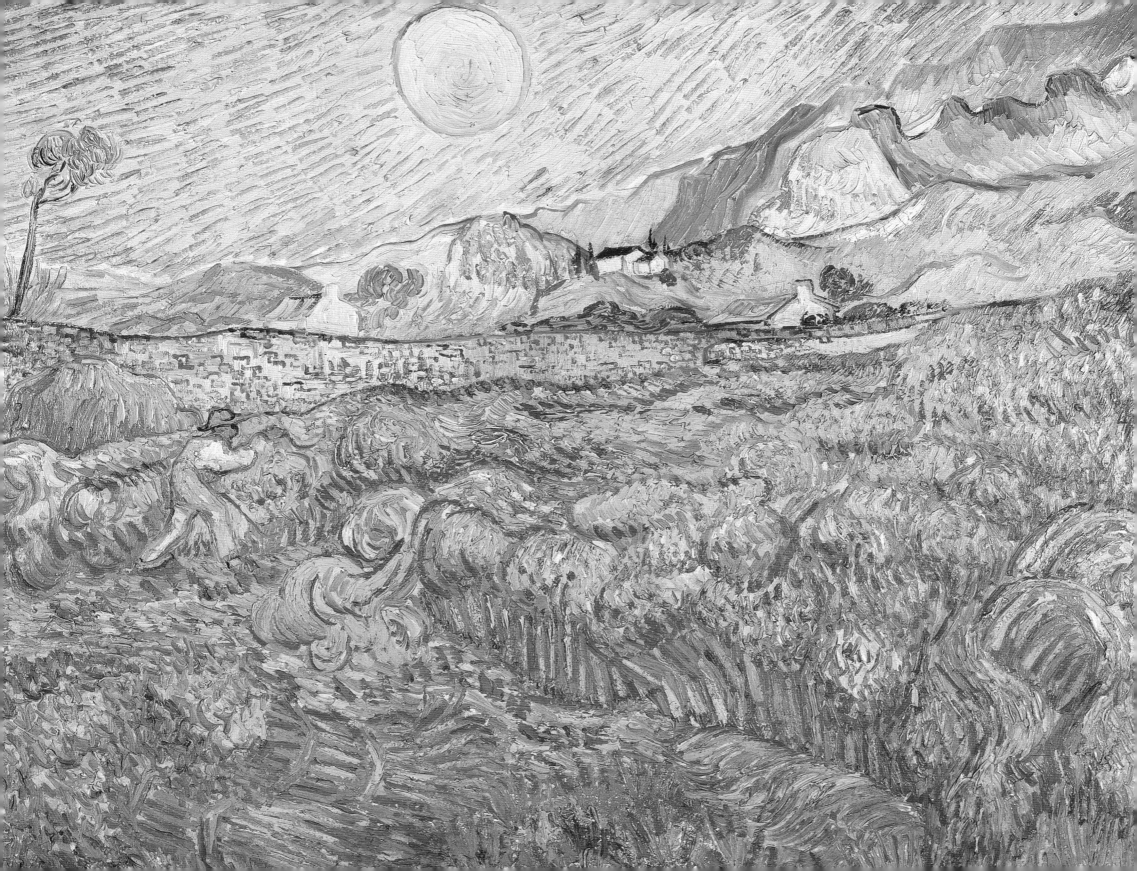

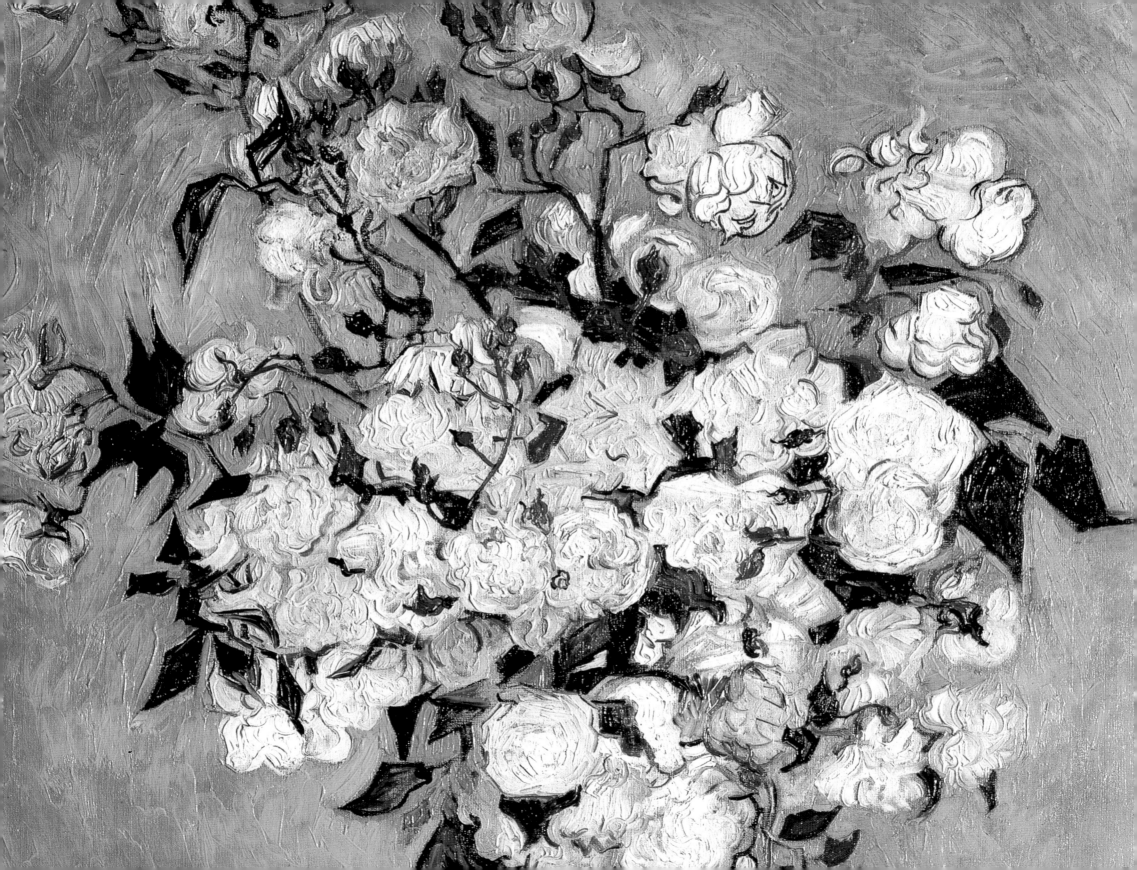

since the male figures have been removed and, instead, a great hot sun looms above the scene. One of the many exotic theories about Vincent's beliefs put forward at various times was that he replaced the Christian god with the Sun god in his personal mythology. He enclosed a sketch after this painting in a letter to Theo not long before he left Saint-Rémy.

Vincent's attitude to the paintings based on other artists is not easily pinned down. In the first place, they can clearly be seen, and were partly intended, as acts of fealty. He did not, however, see them simply as copies, such as one sees being made by students (or others) at their easels in any large modern gallery. But neither did he consider them his own creations in the same way as works done from nature. He once described his function as equivalent to that of a musician who plays music written by someone else, but imparts his own interpretation. In the case of the two works discussed here, it is hard to feel confident of the approval of either Delacroix or Rembrandt in Vincent's reworking.

On 23 December Vincent wrote a letter to his sister Wil. He reminded her that it was exactly a year since his first attack in Arles. That same evening he suffered another relapse. Coincidence? Who can say?

Again, he recovered comparatively quickly. When Dr. Salles came to visit him soon after New Year, he was more or less back to

normal. He complained a good deal about the asylum, which he was growing tired of, but his complaints, if some were a little unreasonable, were not wholly irrational. Unfortunately, during this attack he had repeated his attempt to swallow a lethal dose of paint, and painting was again forbidden, which aggravated his restlessness. Increasingly he thought of leaving Saint-Rémy. But where would he go?

A PAINTING SOLD AT LAST

At long last, Vincent was becoming known beyond his own small circle of friends and acquaintances. Theo reported increasing interest in his work among those who saw it in his apartment (a new and larger one, since Jo was expecting a baby), and he had entered two of Vincent's paintings, *Irises*, a theme that had occupied much of his time during the early weeks at Saint-Rémy, and *The Starry Night* (*over the Rhône*), in the Salon des Indépendants of 1889. That resulted in an invitation to Vincent, relayed via Theo, from Octave Maus, founder of an avant-garde group in Brussels known as Les XX or Les Vingt, to take part in their next exhibition, early in 1890. Les XX occupied a position in Belgium analogous to the Salon des Indépendants in France, as a radical alternative to the official, conservative, Brussels Salon, but it had prospered greatly, and its annual show had expanded into a seasonal festival of the avant-garde in all the arts.

Vincent had again been lamenting his failure to earn any money by his work, and he yearned for recognition as much as financial reward. Several people who knew him at this time remarked how keen he was to sell his paintings. Poulet said that to sell a picture, even at an insignificant price, was his greatest ambition. Arguably, he might have sold many if he had been prepared to compromise his artistic integrity, but there was never the remotest chance of that.

Vincent took full advantage of the liberal policy of Les XX towards their invited artists regarding the choice of the paintings to be exhibited and how they should be hung, asking for more space so that he could group his paintings as he wished, and giving precise directions on how this was to be done – the nature of the frames, the colour of the background, and so on. Vincent was not some simple genius toiling away at his unsaleable canvases out in the sticks miles adrift from the artistic mainstream; he was a former metropolitan art dealer with a sophisticated knowledge of marketing and a sharp awareness of the importance of details that may have seemed merely pedantic.

The Les XX exhibition opened in January 1890. It usually caused a bit of a stir, and this year there was a major row, comparable with that following the First Impressionist Exhibition in 1874. It included many controversial artists who could not find much of a market, including Cézanne and Pissarro, but the main cause of the uproar and the focus of the conservatives' abuse was the

RIGHT and OPPOSITE
Old Man in Sorrow (At Eternity's Gate), 1890
Oil on canvas, 31⁷/₈ x 25¹/₂in (81 x 65cm)
Rijksmuseum Kröller-Müller, Otterlo

This painting was based on an early lithograph (see also page 10).

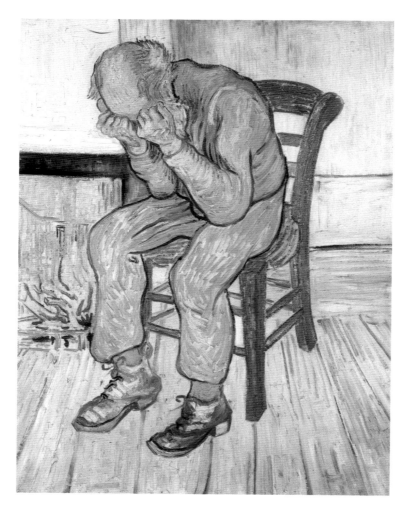

frightful, hitherto unheard-of Dutch barbarian, van Gogh! The critics were outraged, and a well-known Belgian artist, Henri Groux, withdrew his works rather than have them displayed in the same room as 'the execrable vase of sunflowers from Monsieur Vincent'. At the pre-exhibition dinner Groux turned up in pugnacious mood and took on Vincent's friends. He insulted Signac, nearly had to fight a duel with Toulouse-Lautrec, and was asked to resign his membership.

At least Vincent had made a name for himself, even if it was not the kind of name that he or any artist would have preferred. Moreover, he sold a picture, probably *The Red Vineyard*, page 349 (now in Moscow). This painting was later owned by Anna Boch, herself a painter and sister of Eugène, Vincent's friend currently working in the Borinage (the Bochs were related to Octave Maus, and Eugène may have been influential in the invitation to Vincent). It is not certain whether she bought it now or acquired it later, but there is no doubt that Vincent did sell a painting from the exhibition, most probably this one, for 400 Belgian francs.

The Red Vineyard was one of a distinguished pair painted near Arles in the autumn of 1888, when vineyards were for a time a popular theme for Vincent, succeeding a series of wheatfields and olive trees (second only to cypresses in Vincent's fascination for trees). *The Green Vineyard* (page 348), as one might guess, was the

OPPOSITE

Blossoming Chestnut Branches, 1890
Oil on canvas, 28¹/₃ x 35⁷/₈in (72 x 91cm)
Buhrle Collection, Zurich

This painting was done at Auvers, where Vincent did several paintings of the chestnuts, which were in full flower when he arrived in May.

earlier, painted in late September. He described its colours as 'green, dark purple and yellow with purple bunches of grapes hanging on black and orange vines. On the horizon there are several greyish-blue willows, and in the far distance the wine press with its red roof, and far away, the lilac silhouette of the town. In the vineyard there are figures of ladies with red parasols and other figures of grape pickers with their cart'.

In *The Red Vineyard*, apparently the same place painted a month or more later and from a slightly different position, the vintage is in full swing and the vines are even more riotous. Above the high horizon a pale sun shines in a golden sky, the colour reflected in a stream to the right, which warms the rich crimson of the vines. Among them a dozen or so women pickers are energetically at work – no room here for ladies with parasols out for a stroll – while a horse and cart waits to carry the grapes to the wine press in the distance.

It used to be said that *The Red Vineyard* was the only work that Vincent sold in his lifetime. That was never precisely true, even if we discount works bartered for food since, for example, his Uncle Cor had bought some drawings of city views from him, no doubt out of charity, when he was in The Hague (although it is uncertain whether he ever paid up). More recently, the industrious Marc Edo Tralbaut found a letter from Theo to a London art dealer, dated October 1888, acknowledging payment for two paintings he had supplied, a Corot landscape and 'a self-portrait by V. van Gogh'. It is strange that there

is no mention of this among Vincent's letters. Perhaps the relevant letter was lost. Just possibly, Theo withheld the news temporarily from Vincent because he was unsure how he would react to the sale of a self-portrait, and the crack-up with Gauguin, occurring soon afterwards, put other matters out of his mind.

Coinciding with the exhibition, and perhaps more important in bringing Vincent to wider notice, an article about his work was published in the *Mercure de France* and reprinted a week or two later in a Belgian left-wing arts journal to coincide with the exhibition. The author, Albert Aurier, was a student, and not even an art student – he was studying law – but with ambitions to be a critic. He was a friend of Emile Bernard and first heard of Vincent through him, later becoming acquainted with his work through a visit to Theo's flat and to Tanguy's shop, where many paintings were stored and one of Vincent's Sunflowers was displayed in the window. In the circumstances, his article, *Les Isolés* (The Isolated) was remarkably perceptive, especially in relating Vincent to the emerging Modern Movement of which Aurier was a militant adherent, although it was also responsible for creating the image, one that proved hard to shake off, of Vincent as a wild man, a lonely, unknown, misinterpreted genius, toiling away on pictures that ranged from the wonderful to the dreadful.

The article contained much that Vincent could hardly agree with, and he was upset by Aurier's disparagement of the venerable history

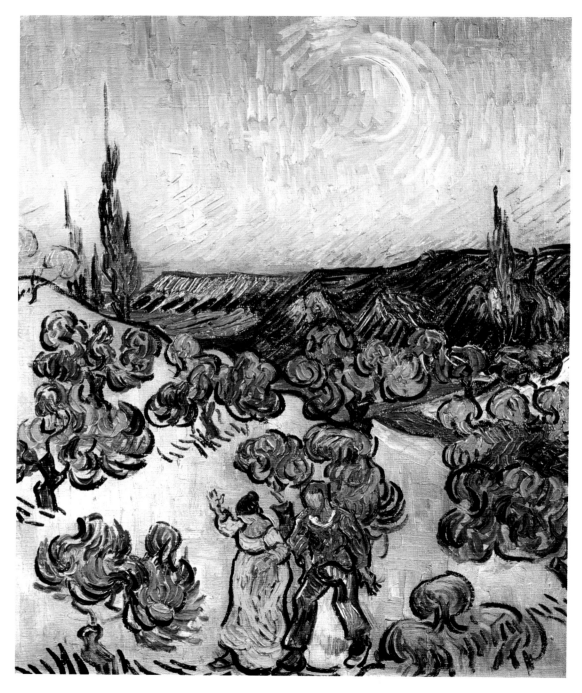

RIGHT and OPPOSITE
Moonlit Landscape (The Evening Walk),
1889
Oil on canvas, 19½ x 18in (49.5 x
45.5cm)
Museu de Arte, São Paulo
(See page 372.)

RIGHT and OPPOSITE

Cottages and Setting Sun with Figure, 1890

Oil on canvas, 19⅝ x 15⅓in
(50 x 39cm)
The Barnes Foundation, Merion,
Pennsylvania

In spite of the southern sun, this is another of Vincent's sad Reminiscences of the North in Saint-Rémy (see pages 345 and 356).

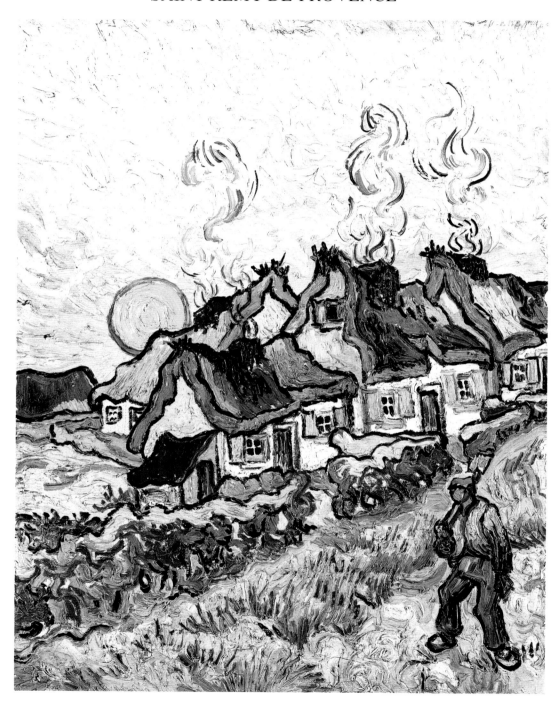

Field of Spring Wheat at Sunrise, 1889
Oil on canvas, 28¹/₃ x 36¹/₄in (72 x 92cm)
Rijksmuseum Kröller-Müller, Otterlo

There are many views similar to these,
which were painted from Vincent's room in
the asylum. He omitted the bars across the
window.

FAR RIGHT
Olive Trees in Mountain Landscape,
1889
Oil on canvas, 28¹/₂ x 36¹/₄in
(72.5 x 92cm)
Private collection

OPPOSITE
Field with Poppies, 1889
Oil on canvas, 28 x 35⁷/₈in (71 x 91cm)
Kunsthalle, Bremen

painter Jean-Louis Meissonier, whom Vincent admired; but he received the piece, forwarded by Theo, approvingly. He set about composing a long letter to its author, endeavouring modestly to divert Aurier's praise of himself to others, suggesting that Aurier's admiration for his colours ought to be directed to Monticelli and the 'tropical' colours of Gauguin. However, while far from swept off his feet, Vincent could not but feel flattered to be suddenly placed, by this up-and-coming young writer, at the cutting edge of the avant-garde. It is interesting to note that Aurier was one of the first people to buy

pictures from Vincent's time in North Brabant, so very different from the pictures that had first engaged his enthusiasm.

FAMILY HAPPINESS AND PERSONAL DESPAIR

Vincent had had another attack shortly before this. It began a day or two after he had visited Arles to see Mme. Ginoux, who had been suffering from another of her periodic bouts of acute depression. He was better in a week, and one happy outcome was that Dr. Peyron

was now convinced that his attacks were provoked by trips away from the asylum, rather than by the act of painting, so he was allowed to paint again.

A letter from Theo told him that he was now an uncle, Jo having given birth to a baby boy whom they named after Vincent. He said he would have preferred the child to be named after his father, Pastor Theodorus, but set to work to make a picture for him, a delightful painting of almond blossom against a blue sky, rather similar to the painting of an almond branch that was one of his first works in Arles.

It was no doubt the birth of Theo's son, too, that prompted Vincent's painting, *First Steps* (page 354), in which a peasant crouching beside his wheelbarrow and spade, opens his arms to encourage a small child, supported by its mother, to walk towards him. Theo seems to have assumed that this was a wholly original work, but such a sentimental subject was most untypical of Vincent and this is, in fact, another painting after Millet.

It is commonly supposed that Theo's acquisition of, first a wife, then a child, must have been a source of grave worry to Vincent, since Theo's new status was likely to threaten his financial support of his brother. This seems to be little more than supposition, although it was apparently shared by some contemporaries: Dr. Peyron withheld the news of the birth from him until he was sure Vincent had recovered from the latest attack. Although there is little

RIGHT and OPPOSITE
Road with Men Walking, Carriage,
Cypress, Star and Crescent Moon, 1890
Oil on canvas, 36¹/₄ x 28³/₄in (92 x 73cm)
Rijksmuseum Kröller-Müller, Otterlo
(See page 373.)

to prove the notion false, there is no real evidence that, apart from a certain disquiet when Theo became engaged, Vincent ever felt serious misgivings about his brother's acquisition of a family, and attempts to link dates of breakdowns with such developments affecting his relationship with Theo seem rather contrived.

On the contrary, he pronounced himself delighted at the arrival of little Vincent, and to his mother, who with Wil had been staying with Jo during her confinement, he wrote how relieved he was that all had gone smoothly. To the happy father, Vincent wrote: 'This has done me more good and given me more pleasure than I can put into words, Bravo!'

Another aspect of Vincent's reversion to former days, besides his versions of old favourites like Millet, was his reworking of his own early works. At Etten in 1881 he had made an affecting drawing of 'an old, sick farmer sitting on a chair near the hearth, his head in his hands and his elbows on his knees'. He did another version of this subject the following year at The Hague, which was based on a print. It became the basis for the painting, after the original lithograph called *At Eternity's Gate*, titled *Old Man in Sorrow* (page 358). The style as well as the subject of this painting belong to an earlier period. Perhaps Vincent identified with the old man's despair.

As a fellow depressive, Vincent sympathized strongly with Mme. Ginoux, and she must have been on his mind in February

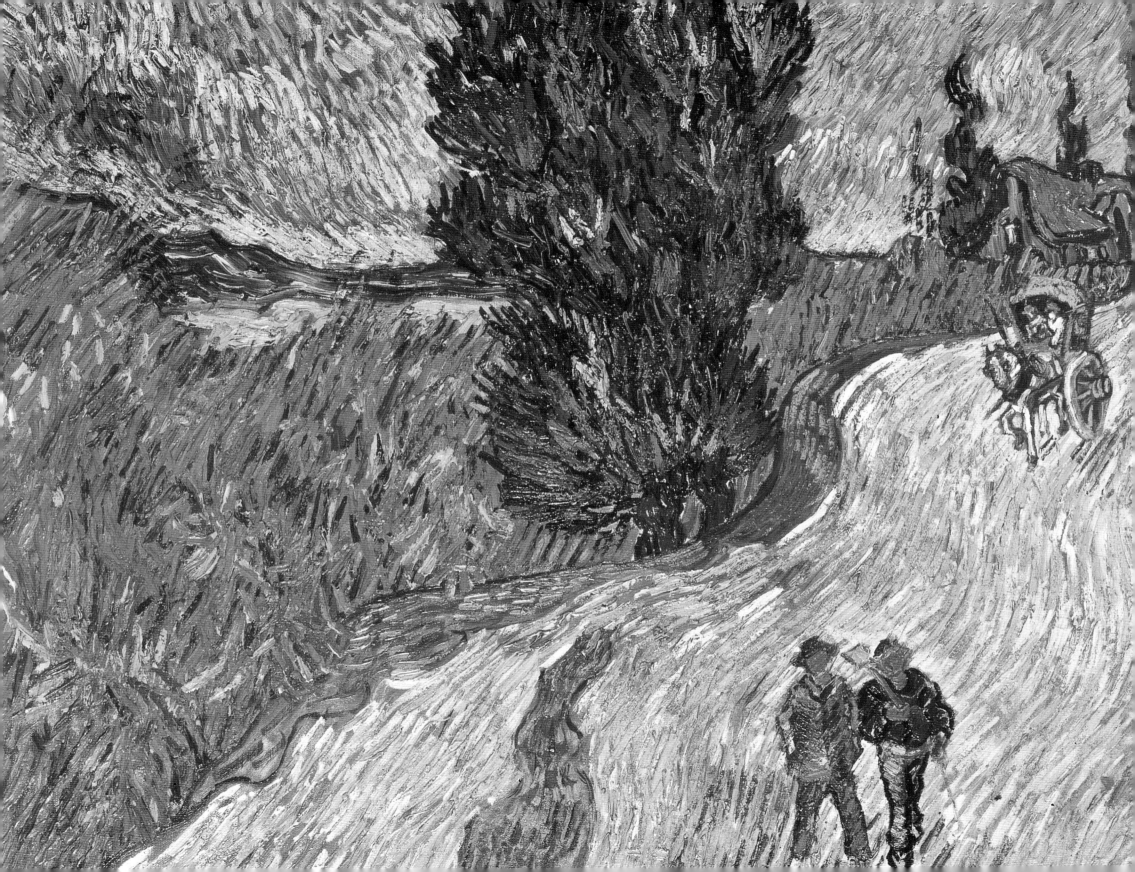

because he painted another portrait of her. Having no other source, he based it on a portrait by Gauguin, left behind after his hurried withdrawal, in which she wears the traditional dress of an Arlésienne. A week or two later he set off to take it to her. He never arrived, but when he failed to reappear at the asylum everyone supposed he was spending the night in Arles. He turned up there next day, out of his mind, and had to be brought back in a carriage. No one, including Vincent, knew where he had been, nor what had happened to Marie Ginoux's portrait.

After this attack, Vincent did not recover as quickly as before. For about two months he remained sunk in semi-irrational gloom, mumbling to himself and harbouring paranoid delusions amid periods of perfect lucidity. His depression was exacerbated by his awareness that, overall, he was not getting better and also by his increasing despondency at being confined to Saint-Rémy. Peace and quiet were no doubt desirable, but they tended to subside into enervating ennui, something which Vincent had quickly noticed in other patients and which now affected him.

Still, he was not entirely idle, even when ill. He was doing his little Reminiscences of the North, including a memory of Brabant: 'hovels with moss-covered roofs and beech hedges on an autumn evening with a stormy sky, the sun setting ...'. (This must be the painting sometimes called *Cottages and Setting Sun with Figure*, page 364). He even thought about 'doing the picture of the Peasants at Dinner [i.e. *The Potato Eaters*], with the lamplight effect. That canvas must be quite black now, perhaps I could do it again altogether from memory'.

Though not without interest, on the whole these small works, often of Brabant peasant life, bear out Vincent's belief that he could (and should) paint from nature, not memory. He was once again reading a lot, mainly old favourites like Shakespeare's history plays.

Vincent was eager to leave the asylum of Saint-Paul-de-Mausole, but neither he nor anyone else knew where he could go. He

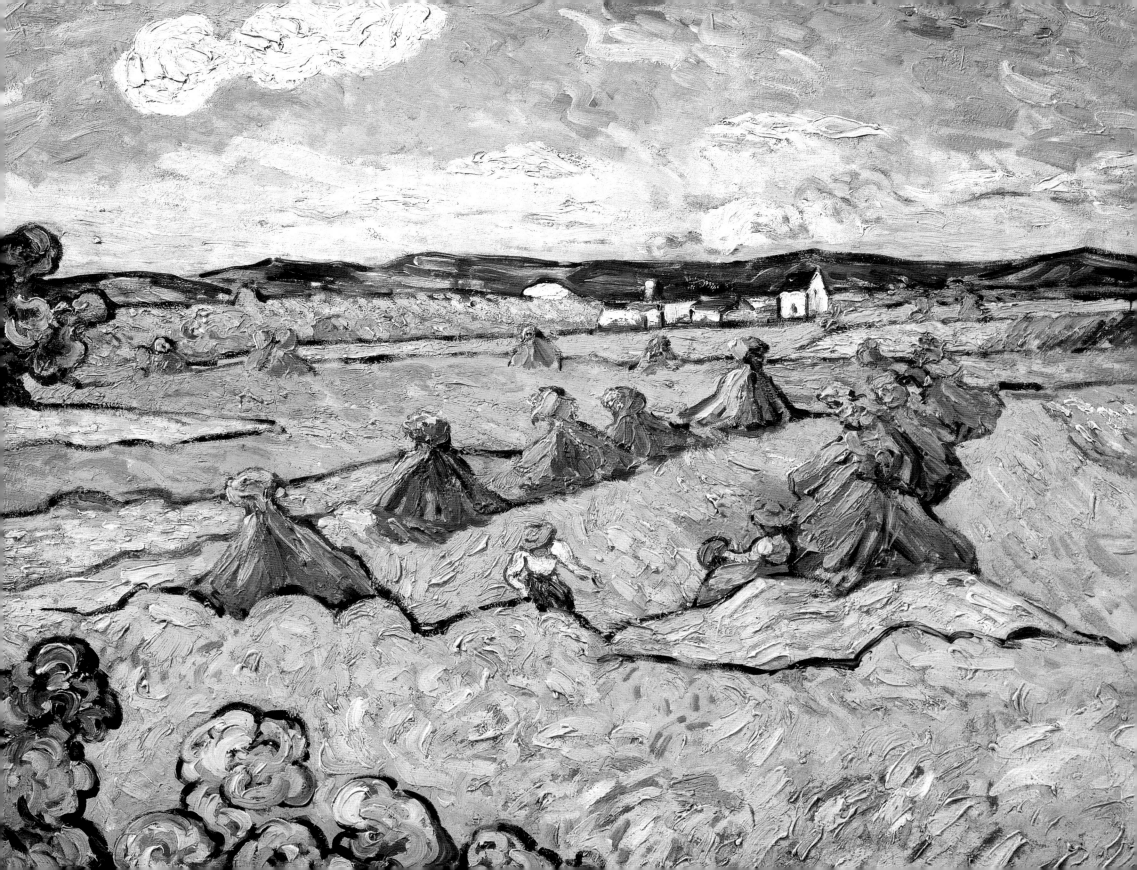

wondered whether he could go to another asylum. One in Avignon had been mentioned although he would have preferred one in the north. Anyway, should he be in an asylum at all, since for most of the time he was perfectly sane? He told Theo that he was in despair about himself, but thought he might make a complete recovery 'in the country'. It seemed that Dr. Peyron was not unwilling to discharge him, for although he was short of patients, the failure to cure Vincent, as promised, was becoming embarrassing.

Another possible solution that attracted Vincent was that Pissarro might take him in. Now in his sixtieth year and troubled by problems with his eyesight, Pissarro in the past had taken in Cézanne and looked after or otherwise supported several other younger artists, including Gauguin. Theo therefore approached him, but this time the long-suffering Mme. Pissarro put her foot down and, regretfully, he had to decline.

Nevertheless, it was Pissarro who came up with the eventual solution. He told Theo about a friend of his, a doctor named Gachet, also an art collector and admirer of the Impressionists, who after taking his doctorate at Montpellier had specialized in nervous diseases and had treated several artists with success. He had an office in Paris but lived in the peaceful and pretty village of Auvers-sur-Oise, about an hour's journey from the centre of the city. Theo went to see him in Paris and gave him an account of Vincent's symptoms since the original breakdown at Christmas 1888. Dr Gachet's reaction was reassuring. He considered that Vincent's

symptoms were not those of lunacy and, whatever the trouble was, it was surely curable.

THE LAST WEEKS IN PROVENCE

In his letter to Albert Aurier, Vincent had said that the emotions that gripped him in front of nature could cause him to lose consciousness, which would be followed by a wasted fortnight when he was incapable of work. But, he added, 'before leaving here I feel sure I shall return to the charge and attack the cypresses'.

Vincent tended to be especially productive in the wake of an attack, and in his last months at Saint-Rémy he was working at full stretch, as if determined to capture aspects of Provence that still eluded him. Trees featured prominently, cypresses especially, but also less common subjects were used in paintings such as *Horse Chestnut Tree in Blossom* and *Field of Grass with Dandelions and Tree Trunks* (both at Otterlo).

Landscapes are generally turbulent, expressing some indecipherable emotive force that is probably connected with the artist's state of mind. In *Moonlit Landscape (The Evening Walk)*, page 362, the trees appear to be mobile, not rooted, and although they are oddly shrunken, they seem to threaten the strolling couple, who are treading warily in the dim light. The woman wears a dress that is a strikingly rich orange against the dark landscape, reflecting the last glow of the vanished sun beyond the blue-black hills, while the man is in blue working clothes, and his red hair and beard

suggest the artist himself, although there is no detail in the faces of either. In *Olive Trees in Mountain Landscape* (page 366 right), it is the hills themselves that appear threatening, great masses of blue and white like huge waves about to overwhelm the countryside beyond the asylum.

The suggestion of hostility in features of the landscape may also perhaps be explained by Vincent's mental state. A.M. Hammacher suggested that the countryside, which had once brought Vincent such joy, became frightening to him after the onset of his illness. 'From the time of his mental breakdown, the landscape around him [which formerly had in a way compensated for his lack of family and reconciled him to his lonely existence] served simply to accentuate his solitude.' Nevertheless, the suggestion of threat is not common to all the landscapes done at Saint-Rémy and later at Auvers, not even to the majority of them, so this generalization, like others, is subject to reservations.

The quality of Vincent's work from the beginning of 1889 became even more variable than it always was, and a certain failure of critical acuteness has been put forward to explain the fluctuations of his final 18 months. Whatever the truth of that, what is indisputable is that, besides a number of relatively unsatisfactory paintings, he continued to produce, up to the end, others that are undisputed masterpieces.

The best-known work of May 1890, and possibly the last painting from Saint-Rémy, is of a road at dusk. The fullest description of it is *Road with Men Walking, Carriage, Cypress, Star and Crescent Moon* (page 368), which includes the major ingredients except for the bank of yellow reeds that resemble the most frequent companion of his cypress trees, ripening cornfields. Vincent himself said of it, 'It is very romantic, but I believe that this is the real Provence.' It is not quite the real Provence, nevertheless, because the building in the background, described by Vincent as 'an old inn', is the same Dutch thatched cottage as featured in his Reminiscences of the North.

Vincent was anxious to leave Saint-Rémy as soon as possible, partly because experience showed that he usually enjoyed a period of normality after every attack and he was anxious to take advantage of this. Theo consulted with Dr. Gachet and they arrived at what seemed a satisfactory arrangement. Vincent would lodge at an inn at Auvers which was near Gachet's house, so that he could visit him whenever he wanted. Although Gachet was in Paris three days a week, he always returned home in the evenings. This arrangement seemed good to Vincent who was, he said, anxious to remain in the care of a doctor to avoid being arrested and forcibly incarcerated by the police as he had been in Arles.

Vincent left the asylum of Saint-Paul-de-Mausole on 16 May, just over a year after he arrived. Dr. Peyron brought his case notes up to date before closing the file. His last entry read simply, 'Cured'.

CHAPTER TEN
AUVERS-SUR-OISE

Some discussion had taken place concerning Vincent's journey from Saint-Rémy to Paris, whether he should be escorted to Tarascon, where it was necessary to change trains, and met there by Theo or his representative. In the end, Vincent made the journey entirely on his own, and apparently without any misgivings. He slept pretty well on the train, whereas poor Theo tossed and turned all night in his comfortable bed in the Cité Pigalle wondering whether his brother was all right. Next morning, 17 May, he left in plenty of time to meet Vincent's train at the Gare de Lyon.

It was the first time that Theo's wife Johanna had met her brother-in-law. 'I had expected a sick man,' she wrote, 'but here was a sturdy, broad-shouldered man, with a healthy colour, a smile on his face, and a very resolute appearance.' Looking at the two men together, she thought how much stronger Vincent looked than his brother. Indeed, Theo's health had been giving concern for some time. There was a fear that he was afflicted by the vague complaints, perhaps largely neurasthenic in origin, that ran in the van Gogh family.

Vincent's appearance of rude good health could be largely explained by his state of mind. He was happy to be out of the asylum, happy to be back in the north, happy to be in good health, happy to see Theo and his wife, who seemed as devoted to his welfare as Theo himself, and happy to see his little nephew and namesake. Theo could not wait to show him the sleeping child, and Jo noticed that as they bent over the cot both men had tears in their eyes.

Far from suffering ill effects from his long journey, Vincent seemed to have been stimulated to just the right amount. Theo was aware that Vincent might be dangerously over-stimulated by his reintroduction to Paris, to old haunts and old friends. Therefore he restricted the number of callers at the apartment. After all, when he left, Vincent would not be going far away. There would be other opportunities to meet old friends.

Vincent was up early next morning to examine his old pictures, which not only covered every wall but were stashed, Jo said, 'under the bed, under the sofa, under the cupboards in the little spare room ... to the great despair of our femme de ménage'.

The brothers then went round to Père Tanguy's, to see the rest of Vincent's unsold paintings, which were stored in an attic for which Theo paid rent. Vincent was, as always, keen to visit all the galleries, but Theo allowed only one visit, to the Salon du Champ-de-Mars, another independent group, though less radical than the Salon des Indépendants. There they saw the painting, a smaller version of the mural in the Musée des Beaux-Arts in Rouen, *Inter Artes et Naturam* ('Between Art and Nature'), by Puvis de Chavannes, whom Vincent had admired in Paris three years earlier. Puvis was now a senior figure in the art world, an artist hard to categorize but with the

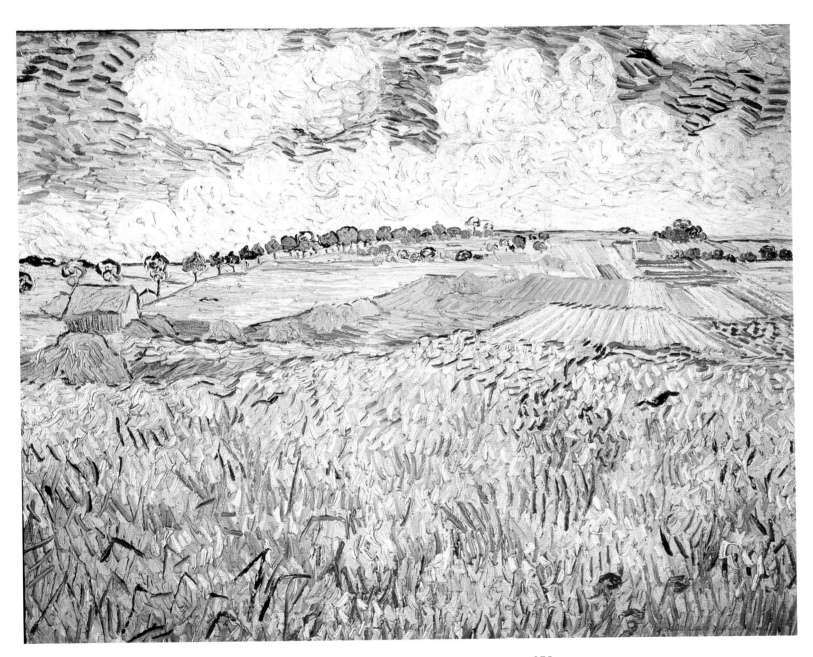

Plain near Auvers with Rainclouds, 1890
Oil on canvas, 29 x 36^1/$_4$in (73.5 x 92cm)
Neue Pinakothek, Munich

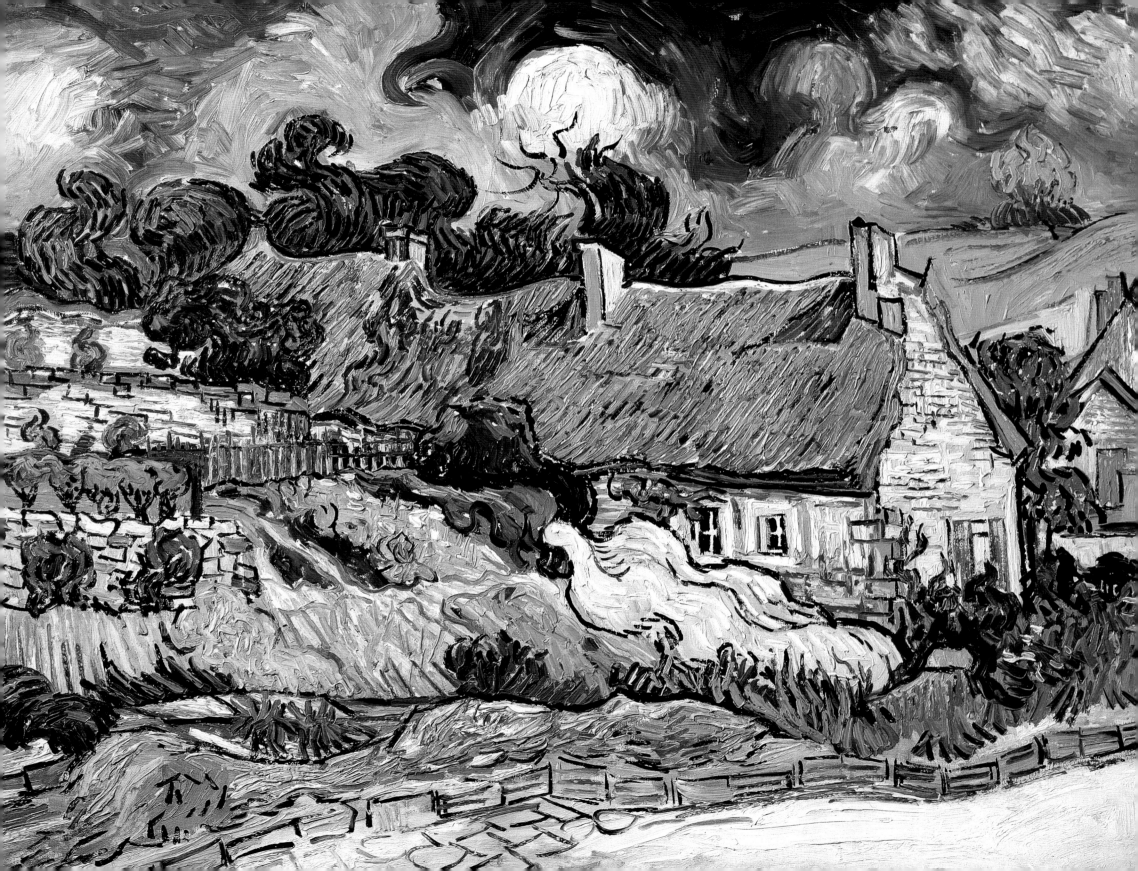

VAN GOGH

unique distinction of being admired by everyone except the most blinkered conservatives. *Between Art and Nature* could be seen as a plea for progress without rupture, a warning against those who would break entirely with the Western classical tradition. It was the showpiece of the exhibition and had considerable influence on artists generally. Vincent was deeply impressed.

The original plan was for Vincent to stay a week in Paris before meeting Dr. Gachet in his clinic. In fact, he stayed only three days before leaving on 20 May for Auvers-sur-Oise, where he could meet Gachet at his home. It seems to have been his own decision. According to Jo, 'Vincent soon perceived that the bustle of Paris did him no good, and he longed to set to work again.' Painting was his all-powerful obsession, what kept him going.

Before his arrival he had expressed some fear of being in Paris again and clearly things did not go as well as all concerned would have hoped. In a letter of a week or two later Vincent seemed rather aggrieved about various minor matters, and reading between the lines some have detected an indication of friction, perhaps with Jo, though if there was any it had no lasting effect. Vincent could not only be difficult, he was also very demanding. For instance, he complained vigorously to Theo that the Ginoux had failed to send on his luggage, despite two requests. He said that if necessary he would goad them into action by sending them money for the cost of carriage, but it seems rather presumptuous to expect his friends to go to all the trouble of packing up his not very valuable possessions and paying for them to be transported to him in Auvers. Moreover, soon afterwards he received an apologetic letter from Mme. Ginoux explaining that Joséph had been injured (gored by a bull, in fact) and was at present incapable of doing the packing.

'BEAUTIFUL' AUVERS

Fortunately, Vincent's first impression of the little town of Auvers was favourable; it was 'very beautiful, among other things a lot of old thatched roofs', which he was painting within a couple of days, with a sense of relief at being back at his easel. 'I am still afraid of the noise and the bustle of Paris,' he told Wil, 'and I immediately went off into the country – to an old village. Here there are moss-covered thatched roofs which are superb ...'. *Thatched Cottages at Cordeville* (opposite), shown in the lea of a green hill, now in the Musée d'Orsay, was one of the results of this enthusiasm.

He walked through the streets, passing the house of the landscape painter, Daubigny, now dead, who had had close links with the Barbizon School and was greatly admired by Vincent. Since Daubigny had moved there, building his house and setting up his studio on a boat that he kept on the River Oise, Auvers had gained a reputation as an artists' colony, like Barbizon or Pont-Aven. It

Thatched Cottages at Cordeville, 1890
Oil on canvas, 28³/4 x 36¹/4in (73 x 92cm)
Musée d'Orsay, Paris

377

AUVERS-SUR-OISE

RIGHT
Houses in Auvers, 1890
Oil on canvas, 29³/4 x 24³/8in
(75.6 x 61.9cm)
Museum of Fine Arts, Boston, Mass.

OPPOSITE
Street in Auvers-sur-Oise, 1890
Oil on canvas, 28³/4 x 36¹/4in (73 x 92cm)
Museum of Finnish Art, Helsinki

PAGE 380 LEFT
Man with a Pipe (Portrait of Doctor Paul Gachet), 1890
Etching, 7 x 5³/4in (18 x 14.7cm)
Bibliothèque Nationale, Paris

PAGES 380 RIGHT and 381
Portrait of Doctor Gachet, 1890
Oil on canvas, 26³/4 x 22³/8in (68 x 57cm)
Private collection

remained 'quiet like a Puvis de Chavannes', according to Vincent, 'no factories, but lovely, well-kept greenery ...'. Corot and Daumier had followed Daubigny; their students and admirers had followed them; later, several of Vincent's contemporaries, including Cézanne, Pissarro and Gauguin, had stayed there at various times.

Dr. Gachet had arrived in Daubigny's time and he himself became an attraction for other artists, Vincent above all. Vincent therefore made his way directly to Gachet's house.

Paul Gachet was an eccentric kind of physician. He was really an artist manqué, and was still a keen amateur painter and etcher, who submitted works to the Salon des Indépendants under the name Paul van Ryssel, (i.e. 'of Lille', his birthplace). He had introduced Pissarro to etching, with excellent results, and he endeavoured to interest Vincent also. Vincent was always open to new techniques, and was fascinated by Gachet's printing press. But he only ever made one etching. Appropriately, it was a portrait of Gachet (page 380).

Gachet's doctorate had been awarded by the University of Montpellier, which had a school of medicine renowned since the Middle Ages (Dr. Rey also received his doctorate there, many years later). All too significantly, Gachet's doctoral thesis was entitled 'A Study of Melancholy', for he was another sufferer from what Winston Churchill used to call 'the black dog'. As a student he had shown himself to be temperamentally unsuited to certain basic medical

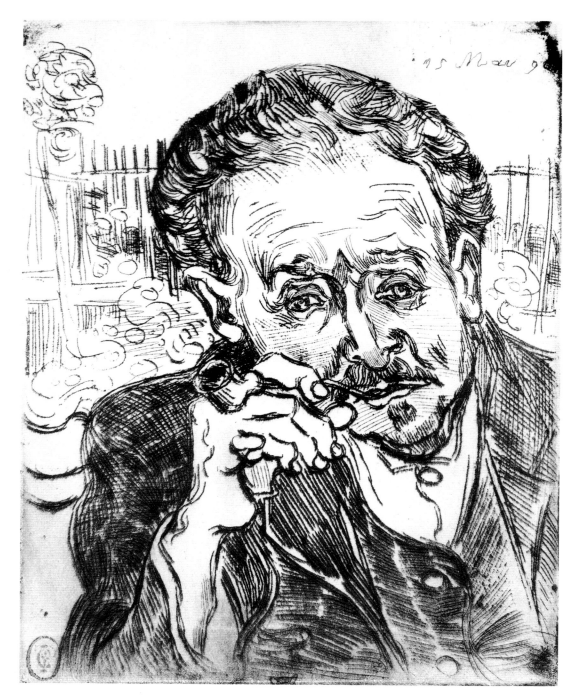

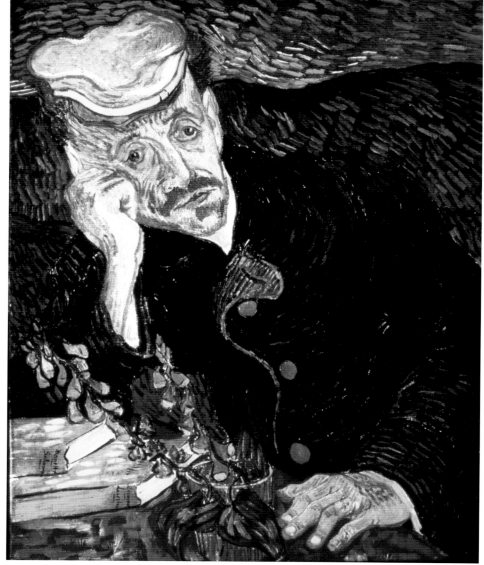

Portrait of Doctor Paul Gachet, 1890
Oil on canvas, 26³/₄ x 22³/₈in (68 x 57cm)
Musée d'Orsay, Paris

This is the second version, retaining the foxglove but without the books (see page 396). Dr. Gachet asked Vincent to do his portrait in the style of his last self-portrait at Saint-Rémy, hence the blue background and the strange absence of an apparent light source. The portrait of Dr. Gachet, however, with its diagonal of the figure and abandonment of traditional perspective, is a much more revolutionary work.

practices, being distinctly squeamish about dissection, and as a result strongly averse to surgery. He had specialized in diseases of the mind. Interested also in aspects of what would now be called 'alternative medicine', he was in some ways – for instance in his belief in the therapeutic properties of electricity – ahead of his time, although in others all too typical of it.

Gachet was now sixty-one years old and a widower. He had a daughter, Marguérite, who was about twenty, and a son, also Paul, sixteen. They lived in a large, plain house on a slope above the village, with fine views of the valley of the Oise. The walls were lined with Impressionists – Renoir, Monet, Pissarro, Cézanne, Guillaumin and others – but apart from the brightness they brought to the place, the house, crammed with gloomy antiques, curios and potted plants, struck Vincent as 'black, black, black ...'.

Besides being tolerant, experienced and sympathetic, Gachet had much in common with Vincent, not least the ability to speak Dutch (or Flemish) as well as he spoke French, and they should have got on well. So they did, eventually, but at first Vincent was doubtful of how much help the doctor would be. 'I have seen Dr. Gachet,' he reported to Theo, 'who gives me the impression of being rather eccentric, but his experience as a doctor must keep him balanced enough to combat the nervous trouble from which he certainly seems to me to be suffering at least as seriously as I.' A week or so later, however, he told Theo they were already great friends.

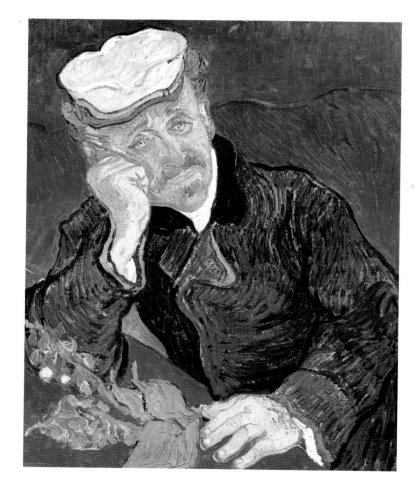

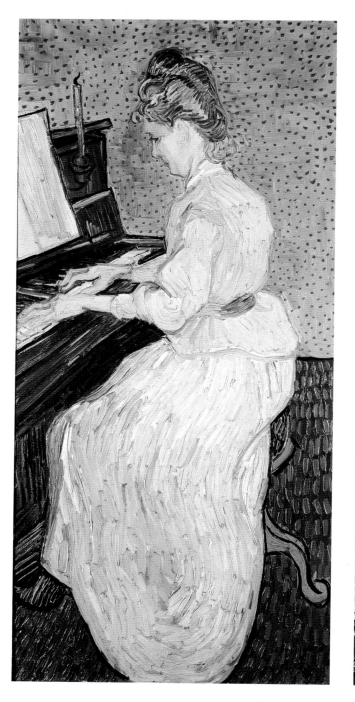

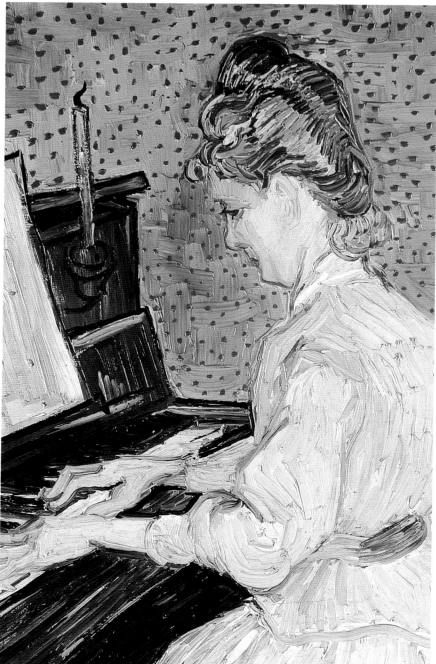

RIGHT
Marguérite Gachet at the Piano, 1890
Oil on canvas, 40^1/$_3$ x 19^5/$_8$in
(102.5 x 50cm)
Kunstsammlung, Basel

In this remarkable portrait, one of his
best, the vigour and confidence of
Vincent's brushstrokes are breathtaking.

OPPOSITE
Cottages at Auvers-sur-Oise, 1890
Oil on canvas, 23^5/$_8$ x 28^3/$_4$ (60 x 73cm)
Hermitage, St. Petersburg

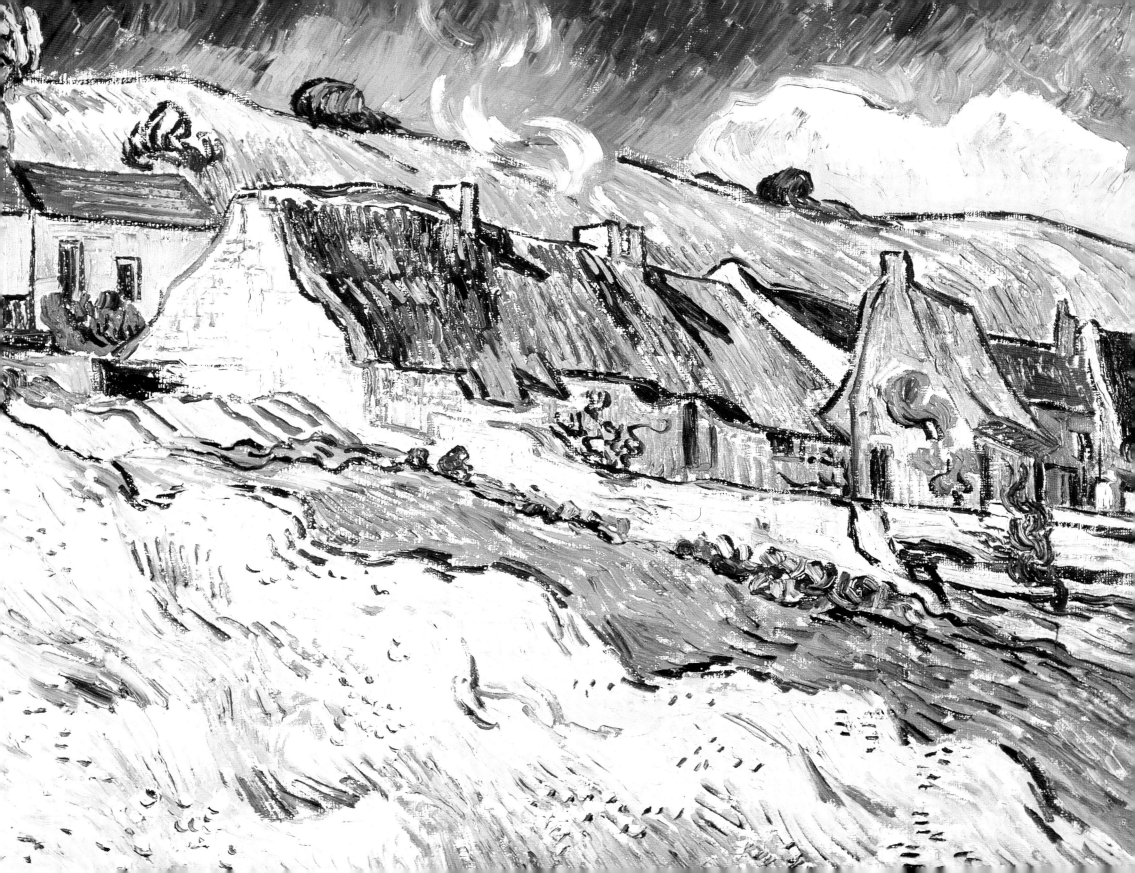

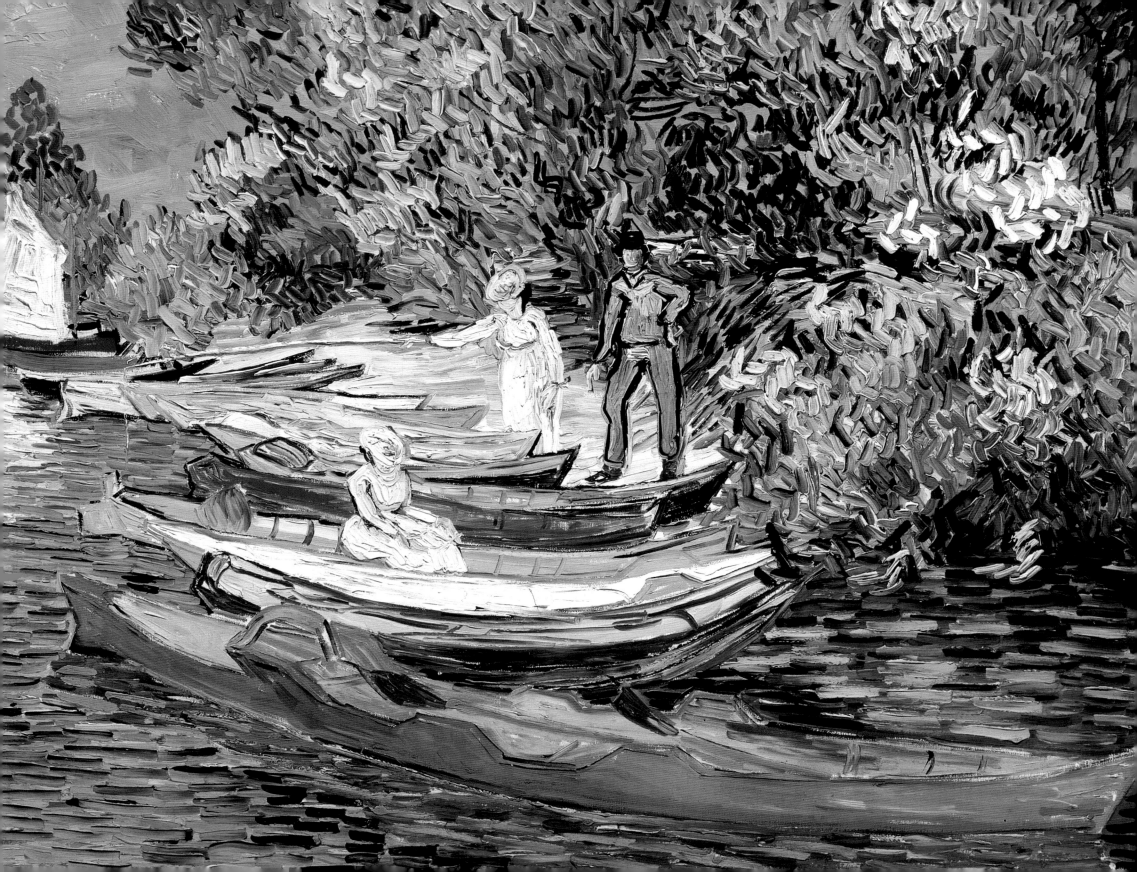

VAN GOGH

In due course, Gachet led him to the inn, but when he learned that a room would cost 6 francs a day, Vincent would have nothing to do with it. He eventually found a more modest establishment, more of a boarding house, combined with a café. It stood opposite the town hall – subject of a cheerful painting decked with bunting for the 14 July festival and therefore painted on or very close to that day. There he was able to rent a room for only F3.50, including board.

Vincent's was a small and ill-favoured room, little more attractive than his room in the asylum, but the place had other advantages. The proprietors, M. and Mme. Ravoux, were accustomed to putting up artists and they had another room which was used as an artist's studio. They did not become close friends, like Joséph and Marie Ginoux in Arles, but they seemed to like Vincent well enough, although, surprisingly in view of his general popularity in the neighbourhood, they apparently did not much care for Dr. Gachet.

The café itself was cosy and had a billiard table, like the room Vincent depicted in *The Night Café*. Whether it would have been possible to stay up half the night drinking absinthe, as he did in Arles, is unlikely, but in any case Vincent had long given up drinking anything stronger than wine, and in Auvers he was apparently not even drinking wine. Of course, he had been under close supervision in the asylum in Saint-Rémy, but if he was tempted to resume his old habits when he regained his freedom, he resisted successfully.

Vincent was certainly not under close supervision in Auvers. From what he told Theo before he had seen Vincent, Gachet seems to have underestimated the seriousness of Vincent's trouble. That impression would have been confirmed when Vincent arrived at his house in Auvers, looking well and behaving quite normally, as Jo had reported. There was no apparent need to keep a close watch on him, which in any case Gachet had not promised to do. Nor could he, since he was away in the city for half the week. He showed great interest in Vincent, but as an artist, not a patient. It is not certain he knew that, since the original breakdown at Christmas 1888, Vincent had experienced a succession of attacks, at irregular intervals but numbering at least seven in eighteen months. Although there were sometimes warning signs, they came upon him quite rapidly and often involved attempts to do himself serious harm, typically by eating his paints. However, while he appeared so well, it was difficult, especially for those who had never known him in that condition, to see him as a potentially suicidal maniac.

We may think that Vincent was left dangerously unsupervised, but what was the alternative? Really, there was none except confinement in another institution of some sort, which he would have rejected. Theo may have been conscious that Vincent's situation in Auvers was not ideal, but no other arrangement was feasible, and, whatever the drawbacks, Gachet seemed to have been an ideal man to have had at hand.

OPPOSITE
Bank of the Oise at Auvers, 1890
Oil on canvas, 28⅞ x 36⅞in
(73.4 x 93.7cm)
Detroit Institute of Arts

RIGHT

The Garden of Doctor Gachet at Auvers-sur-Oise, 1890

Oil on canvas, 28³/₄ x 20³/₈in (73 x 52cm)
Musée d'Orsay, Paris

OPPOSITE

Mademoiselle Gachet in her Garden at Auvers-sur-Oise, 1890

Oil on canvas, 18¹/₈ x 21⁷/₈in
(46 x 55.5cm)
Musée d'Orsay, Paris

AUVERS-SUR-OISE

Fields at Auvers, 1890
Oil on canvas, 19⁵/₈ x 25¹/₂in (50 x 65cm)
Private collection

Vincent painted these wheatfields about twelve times in the final month of his life.

SEVENTY DAYS AND SEVENTY PAINTINGS

Gachet would occasionally visit Vincent while he was working. He encouraged him to work to occupy his mind, and shared his opinion that the return to the north would alone effect a cure. Vincent himself, in a letter to the Ginoux, said he had left the asylum at Saint-Rémy because he had become 'infected' by the other patients.

On Sundays Vincent would go to the Gachets for lunch, a slap-up meal of four or five courses, which, according to Vincent, 'is as dreadful for him as for me – for he certainly hasn't a strong digestion'. There is certainly something slightly comical about these great meals that were uncongenial to host and guest alike, but Vincent may not have disliked them as much as he said. He admitted to Theo that one reason why he uttered no protest was that these occasions reminded him of the family meals of old.

Vincent was in Auvers for seventy days and in that time he completed over seventy works, the vast majority of them paintings, and a handful of those among his finest. It seems almost inconceivable, but most of the works exist to prove it.

He would go off to paint in the fields soon after dawn, returning to the café at midday for a meal and a short nap. Then he would continue painting until it was time for supper or the light was failing. He went to bed at about nine o'clock. Such a schedule is frightening, but of course there were some days when he did not paint at all, or at least not all day, which makes his productivity all the more astonishing.

He painted mainly landscapes, beginning, as he usually did after a change of environment, with the immediate vicinity. Several still lifes of flowers also belong to the first week or two at Auvers. One of the first landscapes was a 'study of old thatched roofs with a field of peas in flower in the foreground ...'. But he found, too, that 'the modern villas and the bourgeois country houses [are] almost as pretty as the old thatched cottages which are falling into ruin', describing these villas later as 'very radiant and sunny and covered with flowers'. One difference in his style was his even bolder brushwork and the return of short dashes of colour, most prominent when he was under the influence of the Divisionists in Paris but virtually absent from his paintings in Provence. He felt that 'it did me good to go South, the better to see the North', and marvelled again at the extent and variety of remembered violet hues.

Later, Vincent moved farther into the countryside and, as he wrote in his last letter to his mother, became 'quite absorbed in the immense plain with wheatfields against the hills, boundless as a sea, delicate yellow, delicate soft green, the delicate violet of a dug-up and weeded piece of soil, checkered at regular intervals with the green of flowering potato plants, everything under a sky of delicate blue, white, pink, violet tones'. Later, the panorama of the fields led

VAN GOGH

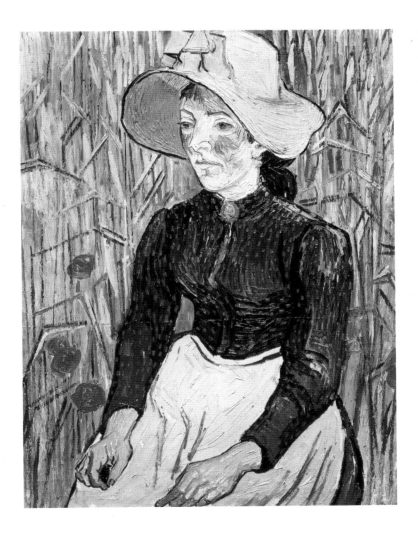

him to join two canvases together to produce an area twice as wide as it was high, as in *Landscape with the Château of Auvers at Sunset*, and the famous last pair of wheatfields under thunderous skies, all about 20 x 40in (50 x 100cm). It is often said, no doubt correctly, that this approach was inspired by the murals of Puvis de Chavannes, and in particular the painting (after the mural in Rouen), *Inter Artes et Naturam*, that he had seen in Paris.

Besides landscapes, most of Vincent's paintings at Auvers were portraits. As Cynthia Saltzman put it, 'To van Gogh's mind, portrait painting was his highest calling – an assignment with a moral purpose. At their finest, portraits conveyed the inexplicable, intangible, subjective being – what he called "something of the eternal".'

One of the best, certainly the most famous, portrait at Auvers was also the first, the *Portrait of Dr. Gachet*, page 380 right, (probably started on 1 June and the subject of Ms. Saltzman's fascinating book, *Portrait of Dr. Gachet*, New York, 1998). Vincent described the work in progress to Theo in his usual fashion. 'I am working at [Gachet's] portrait, the head with a white cap, very fair, very light, the hands also a light flesh tint, a blue frock coat and a cobalt blue background, leaning on a red table, on which are a yellow book and a foxglove plant with purple flowers.' Complementary colours are employed, though less aggressively, for instance in the orange hair against a blue background (Gachet was,

LEFT and OPPOSITE
Young Peasant Girl, 1890
Oil on canvas, 36¼ x 28¾in (92 x 73cm)
Private collection

Vincent painted this girl twice against the same background of wheat. In the second picture, she is standing and wears a white dress.

RIGHT and OPPOSITE
RIGHT and OPPOSITE
Portrait of Adeline Ravoux, 1890
Oil on canvas, 29 x 21¹/₂in (73.7 x 54.7cm)
Christie's Images, London

*There are three surviving portraits of
Adeline Ravoux. Around 24 June Vincent
wrote, 'This week I made a portrait of a
girl of about sixteen [in fact she was
thirteen], in blue against a blue
background, the daughter of the people at
whose place I am living.' He gave her the
portrait, which according to Adeline long
afterwards, her father sold for a footling
sum.*

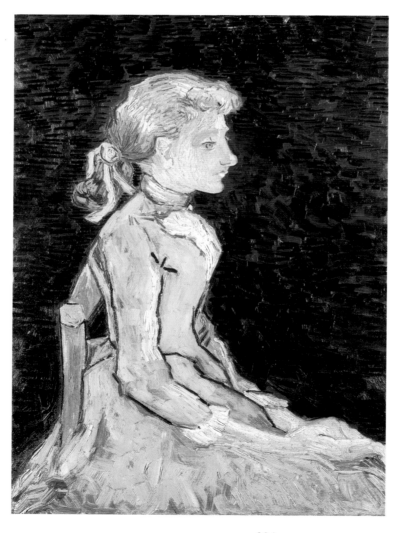

like Vincent, a red-head, though his was said to be dyed – not
unlikely since red hair usually, though not invariably, fades much
earlier than the age Gachet had reached).

Like Mme. Ginoux in *L'Arlésienne*, Gachet is leaning on his
elbow, the traditional pose of Melancholy, which the picture strongly
evokes. In an unfinished letter to Gauguin found among his
possessions after his death, Vincent referred to the portrait of Dr.
Gachet 'with the heart-broken expression of our time'. Vincent also
wrote about the picture to Wil, saying he had given his sitter a
melancholy expression 'which sometimes looks like a grimace when
you look at it. And yet this is what you must paint. Because in this
way you realize that in comparison with the old calm portraits, there
is an expression and passion in the faces, as we paint them now, and
a sense of longing and a crying out. Sad, but soft, clear and
intelligent. Many portraits should be done like this'.

Such thinking once more emphasizes that Vincent was a
scrupulous professional, not just an instinctive painter. As always,
colour was a crucial factor. 'I would like to do portraits that would
seem like apparitions to people in a hundred years' time. I am not
aiming for a photographic likeness, but I explore the possibilities of
expressing the passions. I would like to heighten the expression of
character by means of our modern knowledge and feeling for colour.'

'M. Gachet is absolutely fanatical about [his] portrait,' Vincent
told Theo, 'and wants me to do one for him, if I can, exactly like it.'

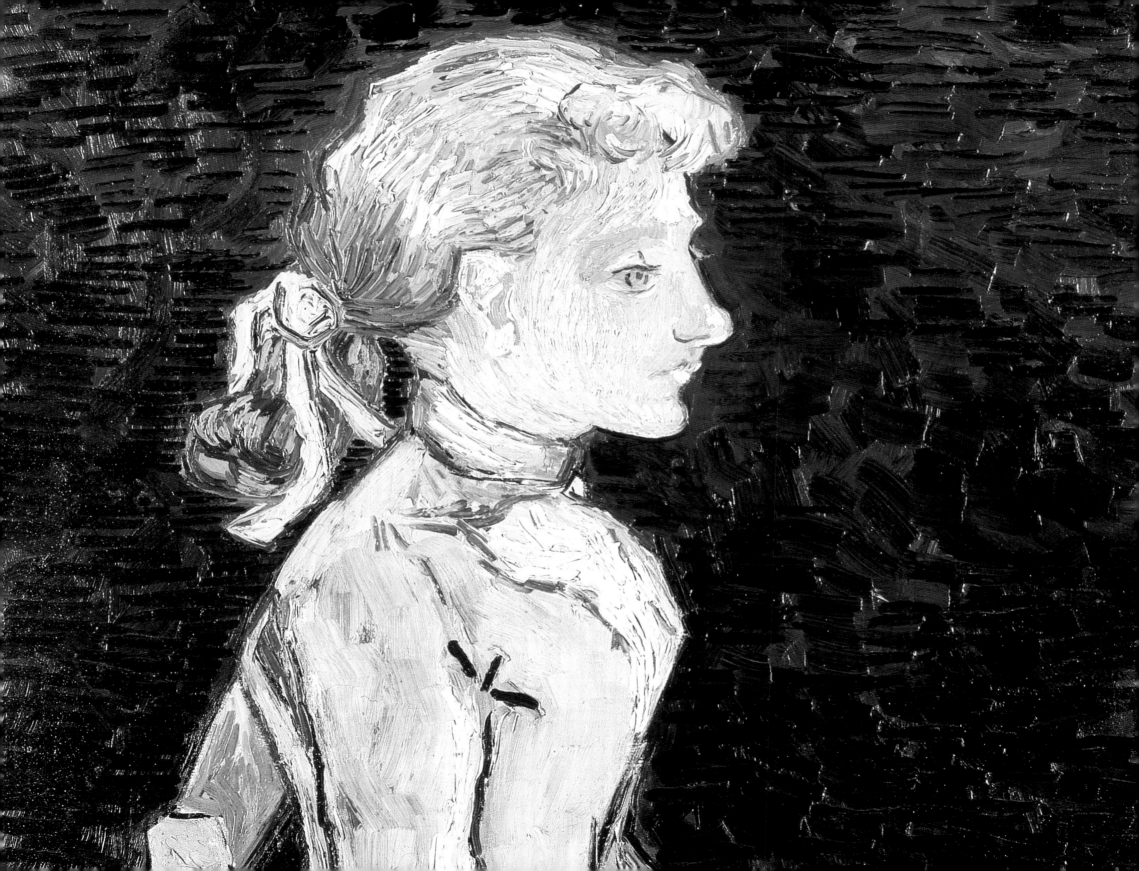

ABOVE
Child with Orange, 1890
Oil on canvas, 19⁵/₈ x 20in (50 x 51cm)
L. Jäggli-Hahnloser Collection, Winterthur

RIGHT and OPPOSITE
Boy in Uniform Cap, 1890
Oil on canvas, 24³/₄ x 21¹/₄in (63 x 54cm)
Museo de Arte, São Paulo

Thought by some to be Camille Roulin, this is probably the painting done at Saint-Rémy, which Vincent said was of a boy at the asylum who wanted it to send to his mother.

Accordingly, he made a second version that he gave to Dr. Gachet. In this version, the books on the table (novels by the Goncourts) have gone but the foxglove remains, no longer in a glass but loosely held in Gachet's left hand. This second picture (page 382) is probably more familiar, as it was eventually bequeathed to the Louvre (it is now in the Musée d'Orsay) by Gachet's son and daughter. Dr. Gachet accumulated a number of van Goghs, probably more than twenty, and although he does not seem to have bought any, he was not being paid any consultancy fees and the paintings were accepted in lieu. Most of them came from Theo, not Vincent.

The first version of Dr. Gachet's portrait has a much more eventful history, having been bought and sold many times. In 1897 Johanna sold it to the famous (and grasping) Paris dealer Ambroise Vollard for about 225 francs, who sold it on to a Danish collector for about 300. It passed through many hands and it was in Germany in the 1930s, where it was condemned as 'degenerate' art by the Nazis. Hermann Göring sold it for $53,000 and bought some tapestries of hunting scenes with the proceeds. In 1990 it was sold at a famous auction at Christie's, New York, at the height of the art-buying hysteria. An obscenely rich Japanese businessman bought it for $82.5 million, a record (the previous record, also a Van Gogh, *Irises*, was $53.9 million).

The same man also bought Renoir's marvellous *Au Moulin de la*

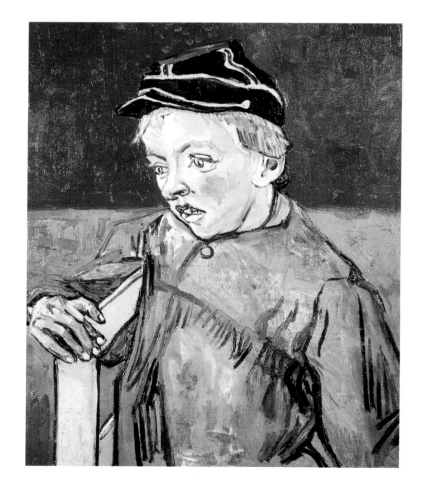

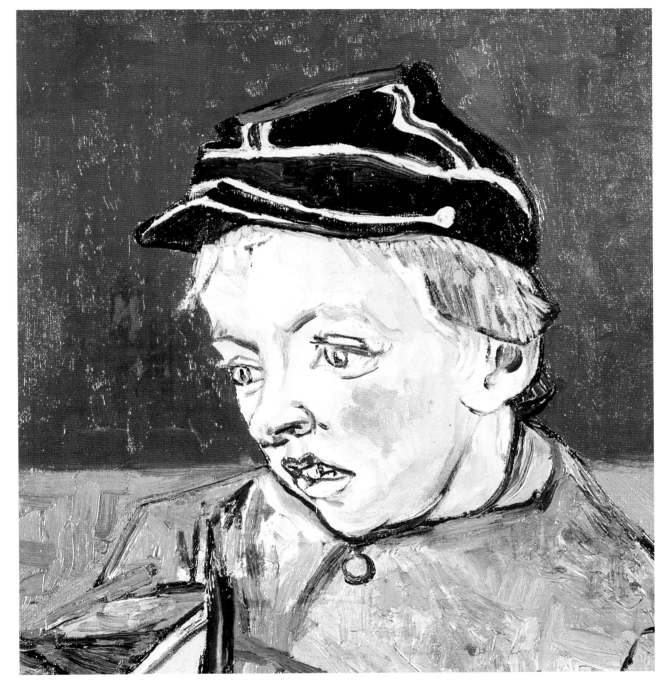

Galette at Sotheby's a few days later for a mere $78 million. On their delivery to Tokyo, the two paintings were carefully packed and shut up in a high-security vault in a secret location. A few years later their owner was convicted of corruption and he died in 1996. The whereabouts of the portrait remains a mystery; it is assumed to have been sold secretly to a private collector who does not wish to reveal his or her identity.

Vincent also painted a portrait of Gachet's daughter Marguérite, *Marguérite Gachet at the Piano* (page 384), heavily impasted, and in the form of a double square except that this time, naturally, the squares were arranged in 'portrait' rather than 'landscape' format so that the painting is twice as high as it is wide. 'It is a figure that I enjoyed painting – but it is difficult,' he told Theo. Nevertheless, he completed it in two days. A second portrait of Marguérite enhances one of several paintings he did of Gachet's garden (page 389).

As always, sitters were rather a problem. Vincent had hoped that Gachet would be helpful in this respect, rounding up clients for portraits among his many friends and patients in the neighbourhood, but apart from his own family Gachet does not seem to have come up with anyone.

Vincent painted several members of the Ravoux family, especially the pretty thirteen-year-old Adeline, whom he may have painted at least three times. The first (now in Cleveland, Ohio) was

RIGHT and OPPOSITE
Two Children, 1890
Oil on canvas, 20¹/₈ x 20in (51.2 x 51cm)
Musée d'Orsay, Paris

Vincent made two paintings of this subject.
Jan Hulsker thought 'we must regard them
as hasty studies in oils, which ... because
of their sketchy treatment and the poorly
rendered facial expressions', do not
measure up to, for example, the much
more successful picture of the little girl
with an orange (page 396).

in profile, and years later its subject called it a 'symphony in blue', that being the colour of her eyes, dress and hair ribbon, as well as the background.

Another, better known, is the painting sometimes called *Young Peasant Girl* (page 393), as there is some doubt whether this, or the one mentioned below, can be identified with Adeline. Vincent was not entirely satisfied with it ('I'm afraid it's really a bit coarse'), perhaps because of the background of ears of wheat, a subject that, as he explained in a letter to Gauguin, was currently giving him trouble (they are the subject of an unusual and delicate painting, now in Amsterdam). The girl in this picture certainly looks older than Adeline was at the time, but then the same might be said of *La Mousmé* (page 262). He painted the same girl standing, in a white dress, against a similar background (the painting now in the National Gallery, Washington).

We know (because he told Theo) that Vincent gave a copy of his first portrait of Adeline to the Ravoux family, and he also promised them his painting, *The Town Hall on 14 July*, which Theo handed over after Vincent's death. In 1905 Ravoux sold both pictures to a sharp-eyed American dealer, Harry Haranson, for 40 francs the pair. 'My father was so simple', Adeline recalled, 'that he thought it was the buyer who had got a bad bargain.'

Vincent's love of children was evident when his brother's family visited Auvers, a visit encouraged by Gachet, who entertained them

at his house, for therapeutic reasons. Vincent enjoyed introducing his little nephew to the animals that inhabited the Gachet premises, a veritable menagerie, according to Vincent, consisting of '8 cats, 8 dogs, besides chickens, rabbits, ducks, pigeons, etc.'. Adeline Ravoux, although her later testimony must be interpreted in the light of her desire to make her family appear more intimate with Vincent that they really were, said that he used to amuse her in the evenings by drawing a funny little man in chalk, never the same but always doing something different.

Vincent painted, with the instinctive (but never sentimental) affection shown in virtually all his studies of small children, a child, sometimes identified with the Ravoux's youngest, clasping a large and vivid orange (hence the sometime name of the painting, *Child with Orange*, page 396), against the complementary blue of the child's dress, and a background of buttercups. The child's carmine cheeks are rendered in the same manner as in *Young Peasant Girl*, and might merit the description 'a bit coarse', but many would agree with the conclusion of Hans Bronkhorst that this is the best of all Vincent's portraits of young children.

THE LAST, GREAT LANDSCAPES

The paintings that Vincent completed in the last few weeks of his life include some of the most famous images in the history of art. They have also been the subject of endless speculation and

OPPOSITE
Daubigny's Garden, 1890
Oil on canvas, 20 x 20in (50.7 x 50.7cm)
Rijksmuseum Vincent van Gogh, Amsterdam

RIGHT and OPPOSITE
The Church at Auvers-sur-Oise, 1890
Oil on canvas, 37 x 29¹/₃in (94 x 74.5cm)
Musée d'Orsay, Paris

*Vincent himself linked this hugely
impressive and disturbing picture with the
old church at Nuenen, while remarking,
with notable understatement that 'the
colour is probably richer and more
expressive'. Astonishing though it may
seem, this scene was painted in the same
week as the* Portrait of Dr. Gachet.

extravagant theorizing. There is no denying that paintings such as *The
Church at Auvers* or *Wheatfield with Crows* (page 404–405) have a
disturbing effect on viewers who see them as portents of tragedy, but
such a reaction may be largely subjective, for it is hard to discount the
effect on the viewer's feelings made by their knowledge that indeed
tragedy was about to happen. Moreover, the sense of doom that we
apprehend in these pictures is entirely absent from other works painted
at about the same time. *Wheatfield with Crows*, with its stormy sky
and sinister black birds, used to be cited as Vincent's last painting (a
conception that film-makers reinforced), but it was probably painted
quite early in July and predated, among other works, *Daubigny's
Garden* (page 400), an image of suburban peace and calm.

Vincent painted the church at Auvers several times but only once
from close at hand, in July. It is one of the finest paintings of his last,
almost frantic period when he seems to be painting against the clock,
and its presence today in the Musée d'Orsay is the result, like the
portrait of the doctor, of a bequest of the Gachets.

In *The Church at Auvers* the sky, of deepest blue merging into
black, is so dark that someone once suggested it was painted partly at
dusk, apparently not noticing that the comparatively bright foreground
is clearly lit by the sun, shining from the south-east, and unaware that
Vincent himself remarked on the greenery, flowers and sand 'in the
pink light of the sun'!

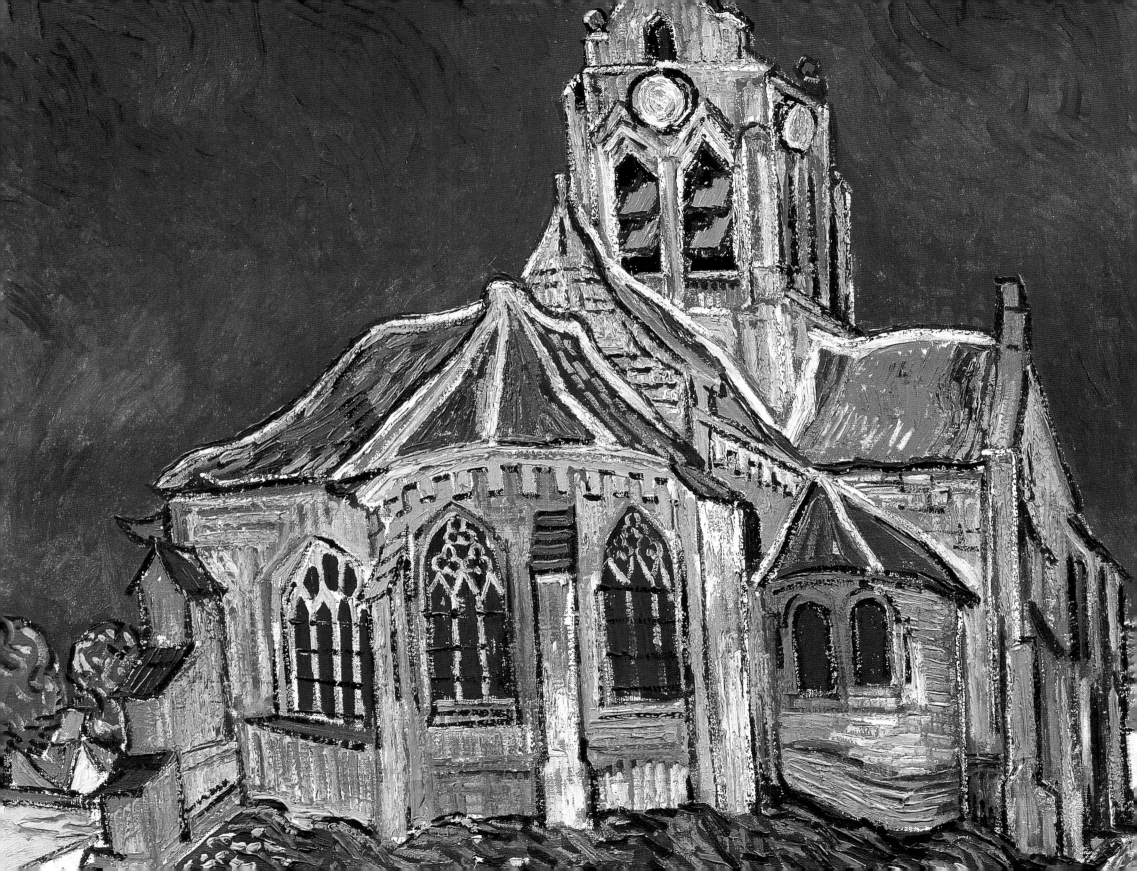

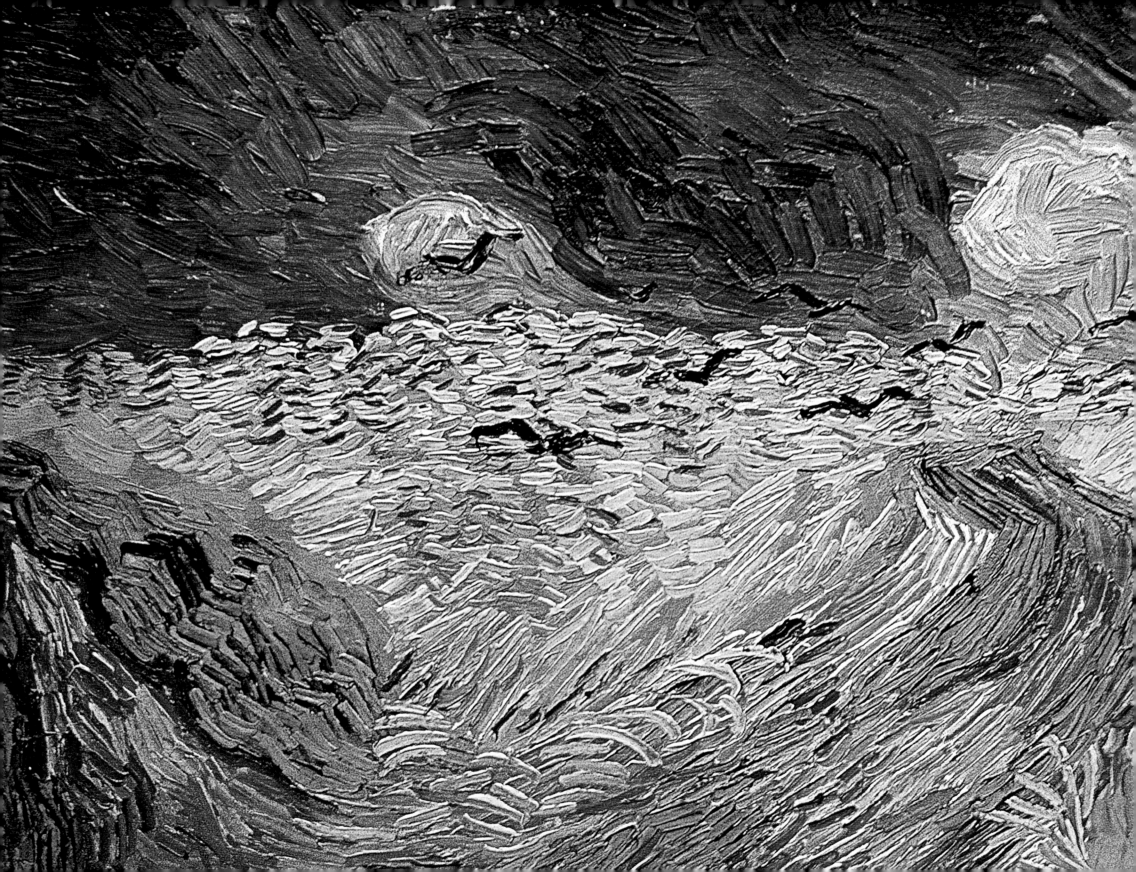

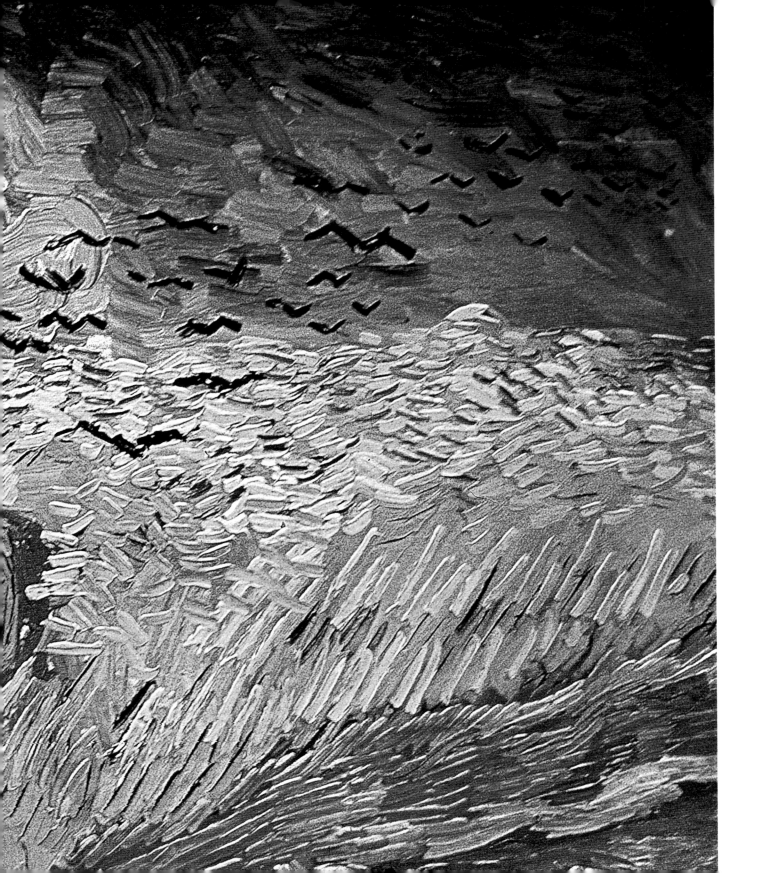

Wheatfield with Crows, 1890
Oil on canvas, 19⅞ x 40½in
(50.5 x 103cm)
Rijksmuseum Vincent van Gogh,
Amsterdam

It is easy to understand the temptation to
suppose that this was Vincent's last
wheatfield, and perhaps his last painting,
though it was probably neither. It is
generally assumed, as here, that this was
one of the two paintings of 'vast
wheatfields under troubled skies' that he
mentions in a letter (see page 409), but
this painting hardly fits his stated purpose
– to 'express ... what I see in the
countryside that is wholesome and
invigorating'.

RIGHT
Cows *(after Jordaens)*, 1890
Oil on canvas, 21⁵/8 x 25¹/2in (55 x 65cm)
Musée des Beaux-Arts, Lille
Vincent copied an etching, owned by Dr.
Gachet, of Jordaens's painting.

OPPOSITE
Landscape at Auvers after the Rain, 1890
Oil on canvas, 28¹/3 x 35³/8in (72 x 90cm)
Pushkin Museum, Moscow

To Wil, Vincent described '... a large
landscape showing endless fields seen from
a height, different kinds of green, a dark-
green potato field, the earth rich and
purple ..., and the little figure of a mower,
a field of tall full-grown grass in a pinkish
tint; also grain, poplars, a last range of
blue hills on the horizon, and at the foot of
these a train passing by with a huge cloud
of white smoke trailing behind it in the
greenery. A white road crosses the canvas.
On the road a little carriage and beside the
road white houses with bright red roofs. A
fine rain leaves blue and grey streaks over
the whole scene'.

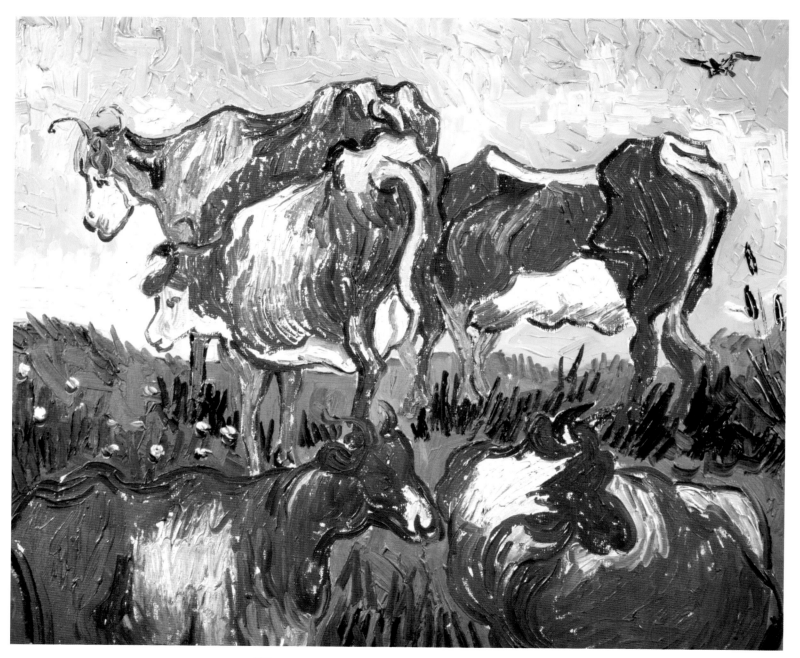

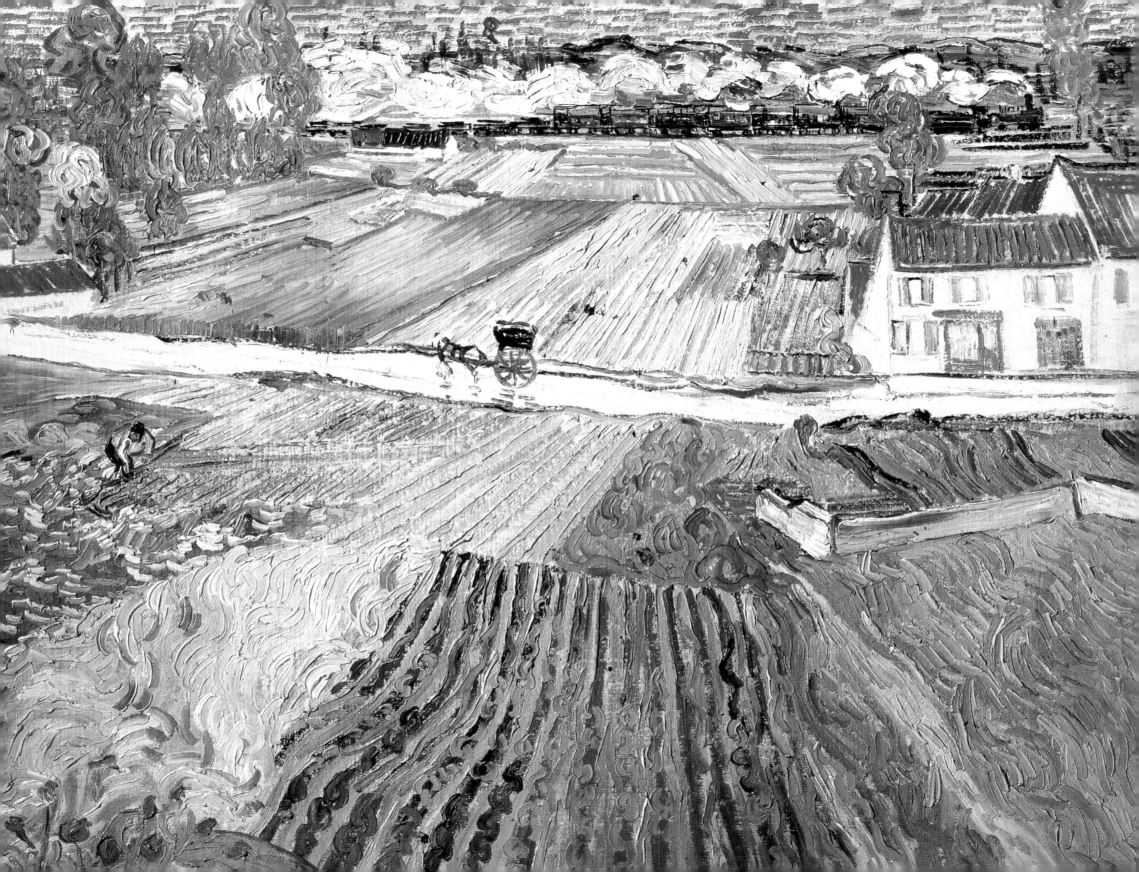

The church itself is largely Gothic but with some Romanesque features remaining, and a faint suggestion of the Low Countries lingers about the tower. It probably reminded Vincent of the old church tower at Nuenen, as well as the church at Groot Zundert, where his father was buried, just as the town hall reminded him of the one in his birthplace (they are indeed very similar in form); in a letter to Wil describing this painting he makes a comparison with his Nuenen studies, although 'now the colour is probably more expressive'. Reproductions, as so often with van Gogh's paintings, make this hard to judge. It is instructive to compare the illustrations of his work in different books. Sometimes it is hard to believe they derive from photographs of the same painting or that this is the painting we see hanging in the Musée d'Orsay.

Although it was painted at a time when Vincent was feeling comparatively calm, there is certainly something feverish in this remarkable painting. A.M. Hammacher described Vincent's looser line, evident in the Auvers paintings generally, as 'sometimes an "Art Nouveau" line. His colour was in turn greyish and mixed or highly intensified, as in *The Church at Auvers*'. The short brush strokes, which once defined form, have become a kind of decorative convention.

Others have seen signs of internal turmoil in details of this essentially Expressionist painting. The path to the right, empty and leading away from the painter's position, allegedly leads to the graveyard. The woman receding along the other path has been said to represent an amalgam of all the women Vincent had loved returning to the past, though to others she looks like a good old village woman on her way to clean the church brasses. The fact that the church has no visible door, no way of entering, is seen as significant in terms of Vincent's reaction against organized religion, although no entrance would be evident in most Gothic churches painted from this angle. Others see the church 'buckling under the tremendous pressure of the sky', or alternatively, 'attaining a noble dignity'.

News from Theo was disturbing, and Vincent returned early from a brief visit to Paris early in July depressed and worried, so upset that he found it difficult to work. Theo seems to have been less than his normal tactful self in troubling Vincent with his problems, no doubt because he was far from well. There had been a more serious scare over the health of the child. For a time, Theo reported, even the doctor had been worried. Little Vincent's welfare had always concerned his uncle intensely, and he constantly pestered the parents to bring him to the country, where the air was more healthy, though we may suspect that he had an additional motive in his desire for the company of the family. Now, Theo and Jo were planning to holiday in the Netherlands, not at Auvers as Vincent had hoped.

These small disappointments had a disproportionate effect on his emotions. Moreover, Theo was again talking disconsolately about resigning his post and setting up his own business, after more arguments with M. Boussod who, in spite of the fact that Monet, for one, was now selling reasonably well, later complained that Theo 'had stored repulsive works which were a disgrace to this house'.

Little Vincent soon improved and his uncle was cheered by a letter of reassurance from Jo, reassurance in particular that Theo's proposal to start up on his own did not conceal a wish to terminate his monthly subsidies to Vincent. Expressing relief, he replied that he was back at work, 'though the brush almost slipped from my fingers, but knowing exactly what I wanted, I have painted three more big canvases ... They are vast fields of wheat under troubled skies, and I did not need to go out of my way to try to express sadness and extreme loneliness ... The third canvas is Daubigny's garden, a picture I have been thinking about since I came here' (he had made a sketch of it soon after arriving in Auvers). All three paintings probably occupied him for some time, although in the end they were painted swiftly, probably around 9–10 July.

The two wheatfields were no doubt *Wheatfield under a Cloudy Sky* and *Wheatfield with Crows* (both in Amsterdam). The first has a great empty expanse of green under a sky that threatens an imminent deluge. It seems to echo Vincent's fear that he was losing his

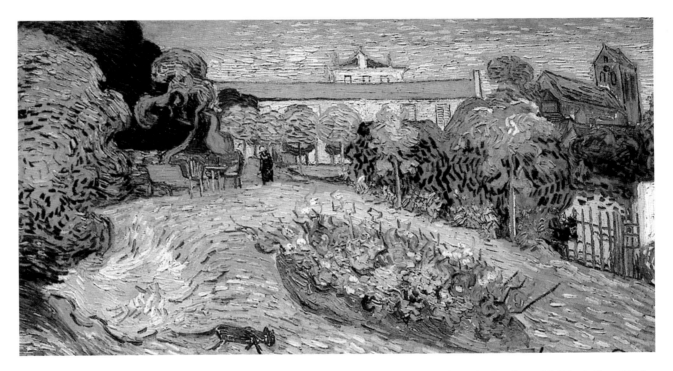

capacity to work 'more quickly and more easily than the pains it has cost to acquire it. And the prospect grows darker, I see no happy future at all'.

The melancholy emptiness of the first picture (though to some eyes it is a peaceful evocation of Infinity) becomes, in *Wheatfield with Crows*, an altogether more turbulent scene. The wheat, now

Daubigny's Garden with Black Cat, 1890
Oil on canvas, 21⁷⁄₈ x 40in
(55.5 x 101.5cm)
Kunstmuseum, Basel, on loan from Rudolf Staechelin

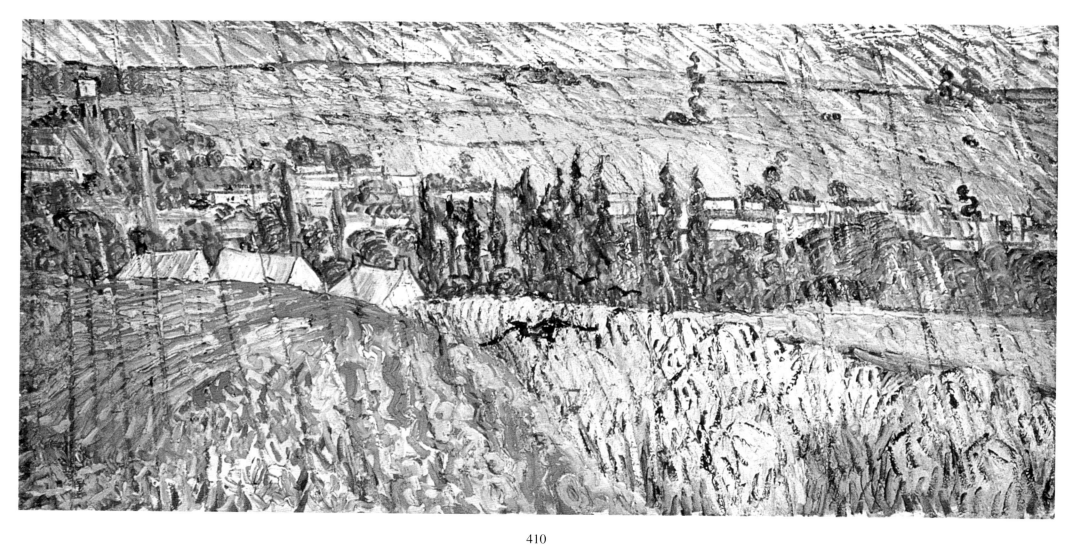

close up and ripening, appears as a rough sea of yellow and red, largely rendered with horizontal brushstrokes, and the storm seems to be breaking just beyond the horizon. A broad path leads from the bottom of the canvas into the centre of the field, where it appears to end, going nowhere (although, it could as well be interpreted as taking a turn to the right and thus becoming obscured by the crop). A flock of crows (more likely rooks, to be pedantic), each rendered with a couple of quick, black brushstrokes, flies low over the field. They have generally been seen as harbingers of doom, but their sinister effect depends largely on which way they are seen to be flying: are they approaching, bearing death on their wings, or are they flying away, in search of calmer skies? Either is possible but, since the more distant birds have achieved greater altitude, it is rather more likely that they are flying away.

Landscape in the Rain, another 'panorama' (now in Cardiff), was also painted about this time, possibly later than the Wheatfields paintings. It betrays no sign of internal turmoil in spite of the appearance of a solitary crow. It is more or less an Impressionist landscape, though in muted colours, and the falling rain is represented by dark, straight, irregularly slanting broken lines, rather as if the viewer were looking through a window streaked by the rain – a novel device that is remarkably successful.

In the debate over what was Vincent's last painting, *Daubigny's*

Garden is now favoured by many. Vincent sent Theo a sketch of it, 'one of my most purposeful canvases', with his letter of 23 July – his last letter, apart from one, unfinished, that was never sent and may have been a rejected draft of the former. However, at the same time he included sketches of *Landscape in the Rain* and the two Wheatfields. There are two versions of *Daubigny's Garden with Black Cat* (page 409), the original (in Basel) being, as usual, more 'finished' than the copy (in Hiroshima). It is distinguished by the presence of a black cat stalking across the lawn in the foreground. Whether it was the last painting or not, it displays no evidence of a mind at the end of its tether, being a lovely, decorative picture of thickly painted, colourful flowers and shrubs, the long, pink house beyond with blue-shuttered windows, and the church appearing over trees and rooftops in the right background. (See also page 400.)

THE LAST DAYS

Soon after Vincent's arrival in Auvers, Dr. Gachet had reassured him about his mental health. 'He says he thinks it most improbable that it will return,' wrote Vincent to Theo on 3 June, 'and that things are going on quite well.' Perhaps Gachet was unlikely to say anything else, at least to the patient himself, but in the next few weeks several incidents occurred that suggested Vincent's mental balance was fragile indeed.

OPPOSITE
Landscape in the Rain, 1890
*Oil on canvas, 19⁷⁄₈ x 39³⁄₈in
(50.3 x 100.2cm)
National Museum of Wales*

Vincent also adopted the double-width format for this painting of heavy rain falling on Auvers, perhaps less appropriately here than in the two Wheatfields. The most remarkable things about Vincent's last paintings, considered as a group, is the vast differences in mood that they suggest.

AUVERS-SUR-OISE

Among the Impressionist paintings in Gachet's house was a nude by Armand Guillaumin, one of the finest paintings of that now relatively little-known member of the original Impressionist group. Vincent admired Guillaumin, and was on friendly terms with him while living in Paris, often calling at his studio. He was upset to see that the painting (today in the Musée d'Orsay) had not been framed, and peremptorily insisted that his host get the village carpenter to make a frame immediately. Next time he came to the house, observing that the picture was still unframed, he flew into a rage and, at one moment, put his hand in his pocket as if to pull something out. Gachet glared at him and he backed down. Some writers have supported Gachet's later suspicion that Vincent was about to threaten him with a pistol, but although the exact date of this incident is in doubt, it surely occurred before he had a pistol in his possession, and the gesture, as reported, is a puzzle.

The younger Gachets never expected to see Vincent in their house again, but those with longer experience of him would not have been surprised when he turned up next day acting as if nothing had happened. Paul and Marguérite could not tell whether he simply wished to ignore the incident or whether he genuinely did not remember it.

On another occasion, during one of the interminable Sunday luncheons at the Gachet household of which Vincent complained, he suddenly got up from the table in the middle of the meal and marched off to get on with his painting.

This kind of behaviour, though disturbing, was not that of a madman. But no less a threat to Vincent than his bouts of insanity was his fear, not stated but implicit in his letters, of another attack.

Having moved his family to the Netherlands to stay with Johanna's parents in Amsterdam, Theo returned briefly to Paris and was surprised and slightly worried to find no word from Vincent. On 22 July he wrote himself, enclosing a 50-franc note (all Vincent's income from Theo was transmitted as banknotes through the post). Vincent began the reply found on him after his death. Fittingly, almost his last written words to his beloved brother were an acknowledgement of their joint achievement: '...there is this that I have always told you, and I repeat it once more with all the earnestness that can be expressed by the effort of a mind diligently fixed on trying to do as well as possible – I tell you again that I shall always consider you to be something more than a simple dealer in Corots, that through my mediation you have your part in the actual production of some canvases, which will retain their calm even in the catastrophe.'

On his last visit to the Gachets' house, Vincent seemed calm enough. Paul Gachet the younger recalled later that, as they watched him leave, they had a vague presentiment that something was wrong,

though such testimony after the event is always suspect.

Sunday, 27 July was a hot day. Vincent went out painting in the afternoon but failed to reappear in time for supper, something very unusual as he liked to go to bed early. He did not appear until after the Ravoux had finished and were relaxing on the veranda in the fading light. He seemed to be walking strangely, with his hand over his stomach. He was about to pass them without speaking, but Mme. Ravoux stopped him to ask if he was all right. 'I am wounded,' he told them and went slowly up the stairs to his room. They listened and, after a while, heard him groan. Mme. Ravoux told her husband to go up and see what was wrong. Vincent was lying with his face to the wall. 'What is the matter with you?' He turned and indicated a small, bleeding hole in his stomach. 'I have shot myself, I only hope I haven't botched it.'

Vincent had gone out into 'the fields' and shot himself with a pistol he had borrowed from Gustave Ravoux on the implausible premise that he wanted to scare off the birds (the crows over the wheatfield?). He had meant to shoot himself through the heart but aimed too low. Afterwards he had dropped the pistol, which, curiously, was never found, perhaps because people were looking in the wrong place – there was an unresolved dispute over where exactly the deed occurred.

The Ravoux called in the local doctor, Dr. Mazéry. Vincent did not know him and asked that his friend Dr. Gachet also be summoned. The two doctors examined the wound by candlelight. There was little bleeding, no traumatic symptoms, no breathing difficulties, not even any appreciable shock. The bullet had missed the heart and all the vital organs, but had lodged in a relatively inaccessible place near the base of the spine. After conferring, they concluded that it would be unwise to attempt to remove it.

Dr. Mazéry was accustomed to dealing with rheumatism, childbirth and the like. Gunshot wounds were beyond his experience, while Gachet's aversion to surgery was well established. It is hardly surprising that they decided not to operate but merely dress the wound and try to make the patient comfortable. The question remains why they did not consider moving him to a hospital. There may have been reasons against it, but it still seems surprising that the possibility was apparently not even discussed. The suggestion has been made that Dr. Gachet, an unconventional physician, felt Vincent's motive should be respected: he intended to die and it was not for others to frustrate his purpose.

Dr. Mazéry then left, while Gachet went to sit beside Vincent, who asked his permission to smoke. Gachet helped him light his pipe and asked for Theo's address. Vincent refused to give it, so Gachet was forced to send a message to the gallery the following morning. Meanwhile, a couple of policemen called and, getting little

response from the wounded man; but satisfying themselves that foul play was not in question, they left again. Vincent lay back, saying nothing, puffing on his pipe.

Theo arrived at about noon on Monday. He found Vincent looking better than he had expected, and quite thought he was going to recover. Alone together, they talked sporadically and reminiscently, reverting to Dutch, the language of their childhood. In the evening Vincent's condition deteriorated fast. It was clear that the wound was infected, and he had difficulty breathing. Theo sat on the bed, cradling his head. At one-thirty in the morning, Tuesday 29 July, Vincent van Gogh died. He was thirty-seven years and four months old.

EPILOGUE

Vincent van Gogh was buried in the afternoon of the day following his death. In spite of the short notice, a number of old friends managed to get to Auvers in time, bringing yellow flowers. Among them were Emile Bernard, the younger Pissarro, Charles Laval (the artist who had accompanied Gauguin to the Caribbean), and old Tanguy. The local priest refused to let them use the parish hearse because Vincent had committed suicide, but a neighbouring village was less pig-headed. Vincent was buried in the churchyard, at the edge of the wheatfields that he had painted with such intensity of feeling.

Whether or not Vincent shot himself 'while the balance of his mind was disturbed', that perennial verdict of kindly coroners in the days when suicide was illegal, it was a deliberate act and one that in his last hours, throughout which he maintained a remarkable stoicism in spite of pain, he did not regret. To Dr. Gachet, who tried to reassure him that he stood every chance of recovery, he pointed out the disadvantage of such an outcome with a flash of that directness of which he was sometimes capable: 'I should do it again.' He only regretted that he had, as he said, 'botched' it.

Sad though Vincent's end was, the coda to the story is even more distressing.

Vincent had often said, with much truth, that his work was the result of a partnership, in which Theo was no less important than himself. In poor health for some time, Theo was profoundly distressed by Vincent's death. Nevertheless, he devoted himself to the task he would now have to carry out single-handedly, first by acquiring sole control of Vincent's estate, which the rest of the family was only too willing to grant. (They also agreed that, on Theo's death, control should pass to his son.) He started to compile an inventory, which involved a return to Auvers, and he tried to organize an exhibition in Vincent's memory through the dealer Paul Durand-Ruel. When he declined, Emile Bernard said he would try to arrange one, though it did not take place until two years later and contained only sixteen paintings. Albert Aurier was also approached to write an appreciation, perhaps a full biography, but he died suddenly a year or so later.

Theo's behaviour became noticeably erratic. He had lost a lot of weight and was troubled by a persistent cough. Now, he contracted a kidney infection and became very ill. Although he recovered from the fever, his mental state deteriorated further. He became subject to fits of rage, quite out of character, and even threatened his beloved family with violence. Dr. Gachet was consulted, but meanwhile Theo, after a violent argument at work, put himself voluntarily into a mental clinic. His employers did not wait for his resignation and swiftly appointed another man to his post – a severe blow to those artists whom Theo, at considerable cost to himself, had championed.

EPILOGUE

When he was released, Jo took him back to the Netherlands, to Utrecht, where she had lived before her marriage. But he was not cured, and soon had to be confined again in a Dutch asylum. A few weeks later he suffered a massive stroke and passed into a coma from which he never awoke. He died, aged 33, on 25 January 1891, six months after his brother Vincent.

Theo was originally buried in Utrecht, but in 1914 his remains were removed to the little graveyard at Auvers where, today, simple, identical gravestones, side by side, commemorate the lifelong devotion of the brothers van Gogh.

Wilhemien, or Wilhemina (Wil), the youngest sister and the one to whom both Vincent and Theo were closest, also suffered from depression, which led to mental breakdown and confinement in an asylum a few years later. She lived, apparently in total silence, until 1941. Of the other sisters, Anna never forgave Vincent for the way he treated their father, and Elizabeth was never very close to him, although she wrote a book of recollections of Vincent as a child. Both sisters died in the 1930s. Their mother died in 1907, at the age of 88, having outlived all three of her sons, since the youngest, Cor, died in South Africa in 1900.

GUARDING THE VAN GOGH HERITAGE

With the death of Theo, the heritage of Vincent van Gogh acquired a new guardian, Johanna van Gogh-Bonger, Theo's widow. After Theo's death, she moved to a house in a village near Amsterdam, where she supported herself and her son by taking in boarders and making English translations, while devoting herself to the protection and advancement of Vincent's work.

Johanna was a very determined and intelligent person, but this was a remarkable decision nonetheless. She had never met Vincent until a few weeks before his death, and then only during the three days he spent with them before going to Auvers, and on a few subsequent occasions. Although married to a highly knowledgeable dealer, she knew comparatively little about painting herself, and she cannot have been much attracted by Vincent's work. Not many people were, of course: apart from Aurier's article and a few showings in obscure exhibitions, he was still unknown, and in market terms his works remained almost totally valueless. When Jo tried to sell two or three paintings through Durand-Ruel, the dealer could not find a single buyer. Albert Aurier's sister, on his advice, picked up a still life from some cheap shop for 15 francs.

Johanna's devotion to the protection of Vincent's work made it desirable to have it under her own control, and she determined to collect the great bulk of it in the Netherlands. Her brother Andries at first urged her to sell the lot, and Emile Bernard pleaded with her to leave the paintings in Paris, where contemporary artists might see

them. Although many pictures did remain (for instance, in the possession of Bernard himself and other friends), nearly three hundred were shipped to the Netherlands in the spring of 1891.

Besides the control and assembly of Vincent's works, Johanna took on the gigantic effort of assembling, collating, editing and eventually translating into English some six hundred of Vincent's – mostly undated– letters to Theo, the product of nearly twenty years' correspondence which she discovered, in their yellow envelopes, in the drawer of a desk.

Thus her life's work took shape. Of course, it was begun as duty and tribute to Theo. Less than a year after Theo's death, she wrote of Theo in her diary, 'Besides the care for the child, he left me another task. Vincent's work – to show it and to let it be appreciated as much as possible.' Soon, and no doubt inevitably, she developed into Vincent's greatest champion. To what extent she came to truly appreciate his work we cannot tell, but in 1901 she married again, a Dutch artist and critic who shared her self-imposed mission until he, too, sadly died young in 1911.

Johanna carried on alone, and the letters were first published in Dutch in 1914. Her English translation was still unfinished when she herself died in 1925.

Long before then her son, Vincent Willem, having come of age, had taken over his inheritance, and he pursued an even more conservative policy than his mother. Johanna had always been ready to sell an occasional piece, usually to a great museum in order, as Theo would have wished, to promote wider, international appreciation of Vincent's work. But Vincent Willem was determined to maintain the integrity of the family's collection, and stopped all sales. Although he was prepared to lend individual works for exhibitions, the bulk of the pictures remained in the family home at Laren where, since only a tiny proportion could be hung on the walls, they were stored unseen. Ultimately, this proved a benefit, since the family collection eventually passed to the nation by an arrangement that included construction of the National Van Gogh Museum (Rijksmuseum Vincent van Gogh). It opened in Amsterdam in 1973, and was without doubt the outcome that Vincent himself would have desired.

VAN GOGH'S GENIUS RECOGNIZED

In the first few years after his death, Vincent attracted more critical attention and his works appeared in a number of exhibitions, although there was still almost no demand for his works in the market. In Copenhagen, for example, an avant-garde group mounted an exhibition of Gauguin's and van Gogh's work. Several Gauguins but only one van Gogh was sold, a drawing, but probably because Johanna refused to reduce her prices. Since the drawing cost 200

EPILOGUE

francs, they must have been on the high side. In 1897 she reported that, in the Netherlands, where Vincent, as a native son, aroused greater interest than he did in France, she had sold paintings for up to 1000 francs, though she may have been exaggerating since, in the same year, the dealer Ambroise Vollard sold *Portrait of Dr. Gachet* for only about 300 francs.

Things began to change in the early years of the 20th century. An exhibition in Paris in 1901 attracted the attention of the new generation of artists, including Matisse and André Derain, among the leaders of the group called the Fauves ('Wild Beasts') who emerged a few years later. In 1902 Derain wrote, 'It is almost a year now since we saw the van Gogh exhibition, and truly, the memory of it haunts me ceaselessly.' More important, as far as sales were concerned, the exhibition introduced the work of Vincent van Gogh to the dynamic, 30-year-old German dealer, Paul Cassirer. Berlin, much the largest city in Europe's largest and richest country, was by 1900 becoming a centre for modern art, with eight thriving art galleries of which six had opened in the previous two or three years. For a time, Germany was the leading market for van Goghs. Among many other paintings, Cassirer sold *Vase of Irises* in 1908 for 9000 marks.

Van Gogh himself was recognized as a major influence not only on the Fauves but also on the artists of Die Brücke ('The Bridge'),

the first manifestation of German Expressionism, which emerged from a butcher's shop in Dresden in 1905 and corresponded to just the sort of artistic community that Vincent had always hoped to belong to. In 1905 there were substantial retrospective exhibitions in Amsterdam, organized by Johanna and her husband, and at the Salon des Indépendants in Paris. A few years later Helene Kröller-Müller began her collection of modern art and eventually amassed the largest van Gogh collection in private hands (now housed in the Rikjsmuseum Kröller-Müller at Otterlo).

The image of van Gogh as the ultimate example of the artist-as-martyr, an inspired but unrecognized genius working with single-minded devotion and dying in impoverished obscurity, may be roughly accurate, but it involves a paradox. He died unknown, certainly, but he died at only 37. Had he lived as long as, say, Monet or Renoir, he would have experienced several decades of fame and wealth.

CHRONOLOGY

1853

Birth of Vincent van Gogh (30 March), eldest surviving child of Theodorus van Gogh, Protestant minister of Zundert, North Brabant, and his wife Anna.

1857

Birth of Vincent's brother Theo.

1864

Attends boarding school at Zevenbergen for two years.

1866

Attends school at Tilburg for two years.

1869

Employed by Goupil's gallery in The Hague (March) through the influence of his Uncle Cent.

1872

Beginning of the lifelong correspondence between Vincent and his brother Theo (August).

1873

Is transferred to the London branch of Goupil's (January) and falls in love with the daughter of his landlady.

1874

Unrequited love results in severe emotional crisis. Work deteriorates, is transferred to Paris (October), but returns to London in December.

1875

Recalled to Goupil's Paris headquarters in May; neglects work and spends much time studying the scriptures.

1876

Is given notice (April), leaves Goupil's, and obtains employment as a teacher at a school in Ramsgate, England. In June, walks to London and becomes an assistant to a Methodist minister in Isleworth as teacher and occasional preacher. Returns home, now at Etten, in December.

1877

Accepts a job as assistant in a bookshop in Dordrecht (January). In May, goes to Amsterdam to study for the entrance examinations in theology at the university, lodging with his Uncle Jan.

1878

Theo is employed at Goupil's in Paris. Vincent gives up attempt to enter university and goes to a mission school at Laeken near

CHRONOLOGY

Brussels (July), hoping to become an evangelist. After three months, fails, but is given probationary employment at Wasmes in the Borinage, a mining area in Belgium (December).

1879

Dismissed, effectively on the grounds of excessive zeal (July); continues working independently as an evangelist at Cuesmes (August). Begins to draw seriously and interest in art grows.

1880

Leaves the Borinage for Brussels (October) and, having lost his religious vocation, decides to become an artist. Studies drawing assiduously. Theo puts him in touch with another aspiring artist, Anton van Rappard.

1881

Returns home to Etten (April), and that summer falls in love with cousin, Kee Voss. Spends a month in The Hague (November–December), where he admires the artists of The Hague school; returns to Etten for Christmas and quarrels with his father, returning to The Hague on New Year's Eve.

1882

Is given lessons by Anton Mauve and admires The Hague School of artists. The pregnant Sien Hoornik, a prostitute, and her small daughter move in with him. This relationship and his defiance of social conventions alienates Vincent from Mauve and other 'respectable' friends. In June, undergoes hospital treatment for a venereal disease, while Sien gives birth to her second child. He becomes increasingly interested in colour and oils.

1883

Affair with Sien ends in September, when Vincent goes to Drenthe, staying first in Hoogeveen, then, in search of company, at Nieuw-Amsterdam. In December, returns home, now at Nuenen, reaching an understanding with his father. Remains there until November, 1885.

1884

Becomes the painter of dark landscapes and the hard life of the peasants, emphasizing character and expression with relatively little concern for academic technicalities. A neighbour, Margot Begemann, falls in love with him and attempts suicide when her family opposes her association with Vincent. He gives art lessons to aspiring amateurs in Eindhoven. Van Rappard makes several visits.

1885

Theodorus van Gogh, Vincent's father, dies suddenly (March).

VAN GOGH

Vincent is at work on *The Potato Eaters*, his first undisputed masterpiece but, feeling a need for instruction and direction, goes to Antwerp in November.

1886

Is restless at the Antwerp Academy, where instruction is rigid and old-fashioned, and soon gives it up, arriving in Paris in March and moving in with Theo. Remains in Paris two years. Discovers Impressionism; palette becomes lighter, subject matter changes dramatically and he is intensely interested in colour theory. Attends Cormon's studio, becomes friendly with many avant-garde artists, including Bernard, Gauguin, Pissarro, Signac and Toulouse-Lautrec, and absorbs or learns from many contemporary influences, including Japanese prints and Divisionism.

1887

As well as a series of self-portraits, paints increasingly out-of-doors, sometimes at Asnières with Bernard, and becomes a heavy drinker. Exhibits pictures in such places as Le Tambourin café, where he has some sort of affair with the proprietor, Agostina Segatori, and at Tanguy's shop. Completes more than a hundred paintings in the two years in Paris, but less is known of the day-to-day details of his life, as correspondence with Theo, whose apartment he shares, is suspended. From the summer, shows growing signs of disillusionment with the city and the artistic circles of Montmartre.

1888

Attracted by the sun and the idea of Provence as a kind of European Japan, leaves Paris for Arles (February), lodging in the Hôtel Carrel. The 'orchards' series, landscapes such as the Langlois drawbridge, and the marine paintings at Les Saintes-Maries-de-la-Mer herald the summation of his art. While the sun figures largely in landscapes, he also develops a fascination with the moon and stars and paints several nocturnal scenes. Moves lodging to the Café de la Gare and rents the Yellow House (May). Keen to establish an artists' community, urges Gauguin to join him. Although lonely, has friends, who include: the family Roulin, frequent portrait subjects; the Ginoux, who own the Café de la Gare; a young soldier, Lt. Milliet, who accompanies him to Montmajour; also, more briefly, works with visiting artists such as Eugène Boch.

Subsidized by Theo, Gauguin arrives (20 September). Vincent is already overwrought at the longed-for visit and, after a promising beginning, with both artists drawing inspiration from each other, powerful tensions develop. Vincent, after allegedly threatening Gauguin with violence, slices off part of his own ear, which he

CHRONOLOGY

presents to a friendly prostitute. Apparently insane, he is conveyed to hospital (24 December). Gauguin returns to Paris.

1889

Vincent returns to the Yellow House (7 January), but is back in hospital following a relapse (9 February), and is again confined following complaints of neighbours (19 March). Signac visits him. In all, he suffers three mental breakdowns between December and April. Agrees to enter the asylum of Saint-Paul-de-Mausole at Saint-Rémy-de-Provence (April).

His art undergoes changes characterized by nostalgia for earlier times in the north, further departure from Impressionism, and greater symbolism. Adopts darker colours and his line is more undisciplined, perhaps reflecting inner chaos, with spiralling, turbulent forms. Nature becomes less of a comfort, more of a threat. Suffers a further breakdown in July–August and again in December.

1890

The first article on Vincent van Gogh's work, by Albert Aurier, is published, and six of his pictures are shown at the exhibition of Les XX in Brussels (January). One, *The Red Vineyard*, is sold for F400. Vincent is increasingly anxious to leave the asylum and return to the north. After a further attack in January and a lengthier one in February–April, travels to Paris (May) and spends a curtailed visit with Theo, who now has a wife (Johanna Bonger) and baby son.

Goes to Auvers-sur-Oise, where Dr. Paul Gachet undertakes to keep an eye on him, and lodges in the Café Ravoux. Works at an ever more frenetic pace, and although his work is highly uneven, paints several masterpieces, including *Portrait of Dr. Gachet*, *Wheatfield with Crows* and *The Church at Auvers*. On 27 July shoots himself with a borrowed pistol. Dies two days later and is buried in the churchyard at Auvers.

1891

Theo van Gogh, Vincent's brother, dies insane (January).

1914

First, Dutch, edition of Vincent van Gogh's *Letters* published by Jo van Gogh-Bonger.

1973

The Rijksmuseum Vincent van Gogh opens in Amsterdam.

CHRONOLOGICAL LIST OF WORKS
& ACKNOWLEDGEMENTS

The publishers have made every attempt to trace the holders of copyright in the pictures reproduced in this book, but in the event of omissions having been made we would be glad to hear of them.

Portrait of Theodorus Van Gogh, 1881
Private collection/Bridgeman Art Library, London
Page 6

The Sower, c. 1881
Noortman, Maastricht/Bridgeman Art Library, London
Pages 40–41

The Sower, 1881
Private collection/Bridgeman Art Library, London
Page 46

Still Life with Beer Mug and Fruit, 1881
Von der Heydt Museum, Wuppertal
Page 29

The Young Gardener, 1881
Rijksmuseum Kröller-Müller, Otterlo
Page 50

The Bakery on de Geest, 1882
Gemeentemuseum, The Hague/Bridgeman Art Library, London
Page 65

Beach at Scheveningen in Stormy Weather, 1882
Stedelijk Museum, Amsterdam
Page 60

The Cradle, 1882
Rijksmuseum Vincent van Gogh, Amsterdam/Bridgeman Art Library, London
Page 9

In the Rain, 1882
Gemeentemuseum, The Hague/Bridgeman Art Library, London
Page 52

Man with a Spade Resting, 1882
Private collection/Bridgeman Art Library, London
Page 64

Man with His Head in His Hands, c. 1882
Rijksmuseum Kröller-Müller, Otterlo/Bridgeman Art Library, London
Page 10

Orphan Man Sitting with a Young Girl, 1882
Christie's Images/Bridgeman Art Library, London
Page 71

Sorrow (Sien), 1882
Walsall Art Gallery, England/Bridgeman Art Library, London
Page 66

The State Lottery, 1882
Rijksmuseum Vincent van Gogh, Amsterdam/Bridgeman Art Library, London
Page 56

The Street Cleaner, 1882
Gemeentemuseum, The Hague/Bridgeman Art Library, London
Page 8

Women Miners Carrying Sacks of Coal, 1882
Rijksmuseum Kröller-Müller, Otterlo/Bridgeman Art Library, London
Page 70

Wood with Girl in White, 1882
Rijksmuseum Kröller-Müller, Otterlo
Page 62

VAN GOGH

CHRONOLOGICAL LIST OF WORKS & ACKNOWLEDGEMENTS

VAN GOGH

VAN GOGH

VAN GOGH

The Garden of Saint-Paul Hospital, Saint-Remy, 1889
Museum Folkwang, Essen/Interfoto/Bridgeman Art Library,
London
Page 319

The Garden of Saint-Paul Hospital, Saint-Rémy, 1889
Private collection/Giraudon/Bridgeman Art Library, London
Page 323

Green Wheatfield with Cypress, 1889
Národni Gallery, Prague/Bridgeman Art Library, London
Page 329

Irises, 1889
J. Paul Getty Museum, Los Angeles/Bridgeman Art Library,
London
Page 326

Joséph-Etienne Roulin, 1889
The Barnes Foundation, Merion, Pennsylvania/Bridgeman
Art Library, London
Page 246

Landscape in the Rain, 1889
Museum of Art, Philadelphia/Peter Willi/Bridgeman Art
Library, London
Page 334

The Lilac Bush, 1889
Hermitage Museum, St. Petersburg
Page 209

Moonlit Landscape (The Evening Walk), 1889
Museu de Arte, São Paulo
Page 362

Mountain Landscape Seen across the Walls, 1889
Rijksmuseum Kröller-Müller, Otterlo
Page 325 left

The Mulberry Tree, 1889
Norton Simon Collection, Pasadena/Bridgeman Art Library,
London
Page 290

The Olive Trees, c. 1889
Musée des Beaux-Arts, Tournai/Bridgeman Art Library,
London
Page 204

Olive Trees: Bright Blue Sky, 1889
National Gallery of Scotland/Bridgeman Art Library,
London
Page 315

Olive Trees in Mountain Landscape, 1889
Collection Mrs. John Hay Whitney
Page 366 right

Pietà (after Delacroix), 1889
Rijksmuseum Vincent van Gogh, Amsterdam
Page 343 right

*Pine Tree with Figure in the Garden of Saint-Paul
Hospital, 1889*
Musée d'Orsay, Paris/Bridgeman Art Library, London
Page 318 left

Portrait of Dr. Félix Rey, 1889
Pushkin Museum, Moscow/Bridgeman Art Library, London
Page 298 right

Portrait of the Postman Joséph Roulin, 1889
Museum of Modern Art, New York/Bridgeman Art Library
Page 248

*Portrait of Trabuc, an Attendant at Saint-Paul Hospital,
1889*
Kunstmuseum, Solothurn/Bridgeman Art Library, London
Page 318 right

VAN GOGH

Rembrandt
The Jewish Bride, c. 1662
Rijksmuseum, Amsterdam
Page 108

Pierre-Auguste Renoir
La Grenouillère, c. 1869
Pushkin Museum, Moscow
Page 24

Pierre-Auguste Renoir
Les Grandes Baigneuses, 1884–87
Pennsylvania Museum of Fine Art, Philadelphia
Page 135

Georges Seurat
Sunday Afternoon on the Island of the Grande Jatte, 1884–86
Art Institute of Chicago/Bridgeman Art Library, London
Page 139

INDEX

INDEX

INDEX

INDEX